SEP 20

D1233322

Faces *of* Civil War Nurses

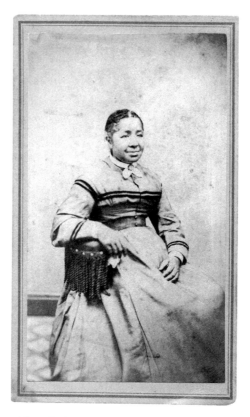

A woman identified (from that period) in pencil on the back of the mount as a nurse at the general hospital in Hampton, Virginia. Her name and other details of her life and service are not known. *Carte de visite* by T. Holmes (life dates unknown), about 1866. This *carte de visite* is printed at actual size. The photographs in this collection have been enlarged.

Faces *of* Civil War Nurses

Ronald S. Coddington

JOHNS HOPKINS UNIVERSITY PRESS

BALTIMORE

© 2020 Johns Hopkins University Press
All rights reserved. Published 2020
Printed in the United States of America on acid-free paper
2 4 6 8 9 7 5 3 1

Johns Hopkins University Press
2715 North Charles Street
Baltimore, Maryland 21218-4363
www.press.jhu.edu

LIBRARY OF CONGRESS CATALOGING-IN-PUBLICATION DATA
Names: Coddington, Ronald S., 1963– author.
Title: Faces of Civil War nurses / Ronald S. Coddington.
Description: Baltimore : Johns Hopkins University Press, 2020. | In-
cludes bibliographical references and index.
Identifiers: LCCN 2019033963 | ISBN 9781421437941 (hardcover) |
ISBN 9781421437958 (ebook)
Subjects: LCSH: United States—History—Civil War, 1861–1865—
Medical care—Pictorial works. | United States—History—Civil War,
1861–1865—Women—Biography. | United States—History—Civil
War, 1861–1865—Women—Portraits. | United States—History—Civil
War, 1861–1865—Health aspects.
Classification: LCC E621 .C63 2020 | DDC 973.7/75—dc23
LC record available at https://lccn.loc.gov/2019033963

A catalog record for this book is available from the British Library.

The frontispiece is from the Foard Collection of Civil War Nursing.

Special discounts are available for bulk purchases of this book. For more information,
please contact Special Sales at specialsales@press.jhu.edu.

Johns Hopkins University Press uses environmentally friendly book materials,
including recycled text paper that is composed of at least 30 percent post-consumer waste,
whenever possible.

For Anne

Contents

Preface

NORTHERN AND SOUTHERN WOMEN RADIATED PATRIOTIC fervor equal to their male counterparts during the American Civil War. Outlets to express their patriotism differed considerably. A man could walk into the nearest recruitment office and join the army or navy. This simple, voluntary act inaugurated a formal process that might end in battlefield glory or honorable death—the final measure and ultimate expression of patriotism. A tiny fraction of women successfully concealed their gender and enlisted in the army. The vast majority of women, however, followed a path that ended in the parlor of a prominent family home, a church nave, or other community gathering place. There they formed charitable societies to aid brothers, sons, and husbands far away on the front lines. Membership in such societies allowed women to contribute to the war effort in critical support roles that bettered the lives of military men and their families. Yet these roles did not offer opportunities for battlefield heroics and honor.

In the North, a subset of aid society volunteers extended their work beyond home and hearth through two national philanthropies founded early in the war, the U.S. Sanitary Commission and the U.S. Christian Commission. These organizations established formal paths for women to contribute to the military effort as relief workers. The Union Army created an additional path when it appointed social reformer Dorothea L. Dix as superintendent of army nurses in June 1861. Women entered the service as paid nurses through Dix and, later in the war, through the Surgeon General's Office. The accepted estimate of women nurses in the North is more than three thousand.

In the South, no organizations on the scale of the Sanitary and Christian Commissions existed. Though slowed by economic

conditions and military necessity, uncounted numbers of Southern women founded local aid associations and provided hospital care. As federal forces invaded their territory, the collision of the war and home fronts created new challenges. This grim reality set them apart from their Northern sisters, with few exceptions—notably Gettysburg.

Several terms are used in this volume to describe these women in their wartime roles. A "nurse" is any woman who was on the payroll of the state or federal government or a philanthropic organization, or who was an unpaid volunteer working under the auspices of a philanthropic organization. "Caregivers" and "relief workers" refer to all such women, regardless of their compensation status. On both sides of the conflict, another and much smaller group of women followed a less conventional path when they accompanied husbands and sons in hometown regiments off to war. Known as *vivandières*, mothers of the regiment, daughters of the regiment, or simply by their own names, these freelancers occupied unofficial roles on the regimental level.

No matter how any of these relief workers came to be part of the military, all of them blazed their own trails to major seats of the war and, in some cases, the front lines. Witness the well-educated reformer who left her native New England and received basic training in Washington, D.C., then served on transport vessels and hospitals in the capital region. Witness the Pennsylvanian who traveled to western Maryland to tend to huge numbers of wounded and sick soldiers in the wake of the fighting at Antietam, then went on to serve in hospitals in the East. Witness the Iowan who followed her son's regiment off to war, cared for patients in the immediate aftermath of Shiloh, and later joined the corps of nurses in Memphis, Tennessee. Witness another Iowan, a newlywed wife who went on to serve as a nurse in the war's Western Theater after her soldier husband suffered a mortal wound in battle.

Representative stories of these intrepid women are told here. Their personal narratives are as unique as fingerprints, each a distinct entry point into the larger social history of the brutal

and bloody conflict. Every story is illustrated with an original wartime photograph of the subject. Most of these portraits were displayed on fireplace mantels or inside albums and cherished as personal mementoes. In a few instances, likenesses of better-known individuals were mass produced to meet public demand or to be used for fundraising purposes.

After the war, some of the images appeared in history books and other publications created by the veterans. Eventually, these portraits faded from memory and disappeared into attics and basements. Decades passed. Then the Civil War centennial spurred a wave of popular interest that gave rise to a community of collectors eager to own a piece of history. Dubbed the "centennial generation" by noted author and collector Ross Kelbaugh,[1] they bought, sold, and traded relics dug from campsites and battlefields, as well as weapons, uniforms, and an array of paper items, including photographs. A number of images that emerged from this community and its marketplace now occupy a place alongside the famous battlefield photographs by Mathew B. Brady and other pioneer photographers.

Photography was twenty-two years old in 1861, and the women who posed for these portraits belonged to the first generation of Americans to grow up in front of a camera. Essentially a democratic medium, photography individualized the identity of the common soldier and sailor. The paper prints and hard plates that hold their likenesses are part of an evolution of vernacular photography that continues today in the form of digital images.

The purpose of this book follows the lead of its companion volumes—about Union soldiers, Confederate soldiers, African American soldiers and other participants, and sailors who served in the Union and Confederate navies—to humanize the Civil War through the stories and images of women who served, and, through their lives and military experiences, to increase our understanding of the revolution that resulted in a new America, free of slavery and rededicated to equality for all its citizens. The individuals pictured here hailed from a variety of backgrounds: rich and poor, college educated and unschooled, single and mar-

ried, religious and secular, young and old. All responded to a common call to serve that propelled them out of their homes and into uncharted territory. Most of these trailblazers possessed little if any formal knowledge of nursing beyond practical skills learned from mothers, grandmothers, and other caregivers when they embarked upon their duties. A few of the seventy-seven women profiled here either had professional nursing experience or described themselves as nurses prior to the war. This group includes nuns and women of other religious orders who were well trained, thanks to their life of service to society's disadvantaged. One woman graduated with a medical degree before the war, and six others earned degrees after the expiration of their service.

It is difficult to imagine any of the women in this book being unfamiliar with Florence Nightingale, the founder of modern nursing. A social reformer from a wealthy family, in 1854 she organized a group of women to nurse British soldiers during the Crimean War. Nightingale's efforts propelled her into the global spotlight. A cursory search for her name in English-language newspapers on Newspapers.com reveals 6,534 results during the years 1853 to 1865. One quarter of these instances date to 1860 and 1861, the two years following publication of her *Notes on Nursing: What It Is and What It Is Not.*

In her brief preface to *Notes*, Nightingale explained, "Every woman, or at least almost every woman in England, has, at one time or another of her life, charge of the personal health of some-body, whether child or invalid,—in other words, every woman is a nurse." She emphasized that nursing is a profession distinct and separate from medicine. Moreover, she encouraged all women to think and teach themselves. The foundation on which Nightingale constructed her "hints" is the physical law of God. "He is teach-ing while you are not learning," she warned any nurse who might ignore obvious symptoms and cause the death of a patient.[2]

In America, as in Britain, Christian faith anchored nursing practices. The women profiled here grew up during the Second Great Awakening that began about 1790 and peaked in the 1840s. This wave of religious zeal and evangelism, following a period of

deism during the Age of Enlightenment, increased the membership of denominations and spurred reform movements. A Third Great Awakening began in the late 1850s. During the Civil War, the organization of the influential U.S. Christian Commission (USCC), founded in New York City during the autumn of 1861, illustrates the religious tenor of the times. The commission's volunteers, or delegates, served spiritual and material needs of Union soldiers and sailors. A Ladies Christian Commission was established in 1864. This faith-based mission of the USCC had a secular counterpart, the U.S. Sanitary Commission (USSC). Founded in mid-1861, the USSC was modeled on an organization established in Britain during the Crimean War. It is best remembered today for the hugely popular Sanitary Fairs conducted in major cities across the North that raised funds to support the troops. Often downplayed in accounts of the USSC is its precursor organization, the Women's Central Association of Relief (WCAR), founded in New York City in April 1861.

Nightingale's message of empowerment rooted in Christianity resonated with American women, occurring against a backdrop of social reforms that challenged traditional gender roles and societal order amid a growing culture of activism. The concept of the independent-thinking, educated, and trained professional nurse she defined built on the work of women in the history of caregiving that dates to ancient times. In the spring of 1860, a new and inexpensive edition of Nightingale's *Notes*, printed in Boston, landed on bookstore shelves. A news brief in Connecticut's *Hartford Courant* noted, "There is not a family in the land that can afford to be without it. There is not a mother, old or young, that would not learn something useful by reading it."[3] Those who took this advice found a biographical sketch of Nightingale that referenced her experience in the Crimea. It included a romantic passage that may have inspired patriotic American women to apply to be army nurses a year later, following the bombardment of Fort Sumter: "Surely, if there was heroism in dashing up the heights of Alma, seeking glory at the cannon's mouth in defiance of death and of all mortal opposition, amid the shouts of the vic-

tors and the cries of the vanquished, there was heroism unparalleled in calmly volunteering to minister to the fever-stricken and the dying."[4]

Whether familiar or not with Nightingale, the women profiled here benefited from the practical instructions and advice for the sanitary nurse offered in *Notes*. The personal accounts in this volume offer numerous examples of the application of her methods. They include her emphasis on the importance of ventilated wards to allow the flow of air, access to pure water, and clean surroundings. Her guidelines for personal management promoted a culture of thoughtful nurses who maximized their time to plan for various contingencies in a systemic manner that promoted a consistent and stable environment for patients, visitors, and staff. Her suggestions for the types of and proper ways to administer food to repair broken and diseased bodies, and the importance of cheerful surroundings, broke the monotony and routine of hospital life. Above all, Nightingale's belief in the proactive woman who teaches herself is evident in the profiles in this volume. These women, most with minimal if any training, learned how to treat and care for soldiers who suffered gaping wounds caused by soft lead minié bullets and shell fragments in battles small and large. They also tended to victims of disease and sickness, which claimed many more lives than those who suffered from the effects of muskets and cannon.

The accomplishments of these women occurred in the face of intense discrimination from medical men. Nurse Georgeanna Muirson Woolsey Bacon observed, "No one knows, who did not watch the thing from the beginning, how much opposition, how much ill-will, how much unfeeling want of thought, these women nurses endured. Hardly a surgeon whom I can think of, received or treated them with even common courtesy. Government had decided that women should be employed, and the army surgeons—unable, therefore, to close the hospitals against them—determined to make their lives so unbearable that they should be forced in self-defence to leave."[5] She then added, "These annoyances could not have been endured by the nurses but for

the knowledge that they were pioneers, who were, if possible, to gain standing ground for others,—who must create the position they wished to occupy. This, and the infinite satisfaction of seeing from day to day sick and dying men comforted in their weary and dark hours, comforted as they never would have been but for these brave women, was enough to carry them through all and even more than they endured. At last, the wall against which they were to break, began to totter; the surgeons were most unwilling to see it fall, but the knowledge that the faithful, gentle care of the women-nurses had saved the lives of many of their patients, and that a small rate of mortality, or remarkable recoveries in their hospitals, reflected credit immediately upon themselves, decided them to give way, here and there, and to make only a show of resistance. They could not do without the women-nurses; they knew it, and the women knew that they knew it, and so there came to be a tacit understanding about it."[6]

Bacon made these statements in 1899, more than three decades after the end of the war. The memory of her experience and the confidence with which she wrote about it reveals an appreciation for the shift in the power dynamics between genders and an acknowledgment of her role in it. As Lisa A. Long observed in her 2004 book, *Rehabilitating Bodies: Health, History, and the American Civil War*, "Many turn-of-the-century women writers reclaimed Civil War nursing as a position of power and authority, one that superseded that of the patients they had tended."[7] The roots of power and authority that grew during the war spread over the following decades. The bonds of sisterhood continued long after the cessation of hostilities, such as through veterans' associations, writings in books and magazines, and active participation in social reforms, notably the suffrage movement. These nurses and the organizations they created played an important and often overlooked role in the march to equality that continues to this day.

One of these reformers, American Red Cross founder Clara Barton, reflected on her Civil War experience and the place of women nurses in its larger history. "If I were to speak of war," she

explained, "it would not be to show you the glories of conquering armies but the mischief and misery they strew in their track; and how, while they march on with tread of iron and plumes proudly tossing in the breeze, someone must follow closely in their steps, crouching to the earth, toiling in the rain and darkness, shelterless like themselves, with no thought of pride or glory, fame or praise or reward; hearts breaking with pity, faces bathed in tears and hands in blood. This is the side which history never shows."[8] Herein are selected profiles from that side of history.

The Wartime Prevalence of Cartes de Visite

On November 27, 1854, André-Adolphe-Eugène Disdéri patented the *carte de visite* format. His goal was to make the production of photographs more cost effective. The concept was simple: instead of making one exposure from a single collodion-treated glass negative, he divided the negative into ten separate exposures. That number was later revised to a more practical eight. The print that resulted was cut into rectangles, and each was pasted onto a thin sheet of cardboard that measured about two-and-a-half by four inches. This change reduced the cost of a *carte de visite* to a fraction of the earlier daguerreotypes, ambrotypes, and tintypes. A multilensed camera was later introduced to make the production more efficient.

Cartes de visite were social media for the nineteenth century, and the phenomenon came to be known as "cardomania," or "cartomania." So big had the craze become that one of the great American men of letters, Oliver Wendell Holmes Sr., proclaimed the influence of the little *carte de visite* in an essay published in the July 1863 issue of *Atlantic Monthly* magazine. "Card-portraits," declared Holmes, "as everybody knows, have become the social currency, the sentimental 'Green-backs' of civilization."[9] Cardomania dominated the American photographic scene throughout the Civil War years.

The arrival of the *carte de visite* in America coincident with the start of the Civil War is noteworthy. The inherent strengths of the format—affordability, reproducibility, and share-ability—served

anxious families on both sides of the conflict who sent their sons off to war, perhaps never to be seen alive again. Long periods of separation might be made somewhat more endurable if parents were able to receive a letter containing the latest *carte de visite* portrait of their soldier son from some faraway camp. Conversely, a homesick husband might find consolation by carrying a *carte de visite* of his wife and children while in camp and on campaign, and the boy away from home for the first time might feel less lonely by having a portrait of the girl he left behind. The *cartes de visite* also had an advantage that was particularly useful in wartime. The front and back of the cardboard mount provided ample space for a soldier to sign his name, rank, company and regiment, and even a note, while options for soldiers to inscribe an ambrotype or tintype were limited.

By the end of the war, cardomania had reached its zenith. The introduction of the five-by-seven-inch cabinet card in 1866 marked the beginning of the end for *cartes de visite*. By the early 1870s the cabinet card was all the rage, and the *cartes* faded into oblivion. Today *cartes de visite* appear as a blip on the timeline of photographic history, wedged between the celebrated qualities of the daguerreotype and the brilliant results achieved when paper formats matured a bit later in the century. The bulk of surviving *cartes de visite* have been ravaged by time. Decades of exposure to the elements have deadened the brilliant shine of their albumen surfaces and drained the resonance of their purplish eggplant hues, obliterating the finest details and leaving behind a lifeless sepia tone. Ragged and scuffed mounts prevail, their corners clipped under instructions from album manufacturers to prevent creasing as the thin images were inserted into thick and inflexible album pages.

Cartes de visite, ambrotypes, and tintypes compose the earliest photographic record of volunteer American soldiers and sailors during a major war. These relics are a primary source for the study of weapons, uniforms, equipment, and aspects of a soldier's life. They are also a relatively new source for scholarship. For years they lay tucked away, largely forgotten, in attics and basements.

The centennial commemoration of the Civil War inspired a new generation of Americans to take an active interest in blue and gray relics, and the old photos began to surface. At first, little or no monetary value was placed on them. They were given away as a bonus to the buyer of a musket or sword. Before long, however, sellers of Civil War antiques realized that there was a market for photographs, and by the end of the 1970s a thriving community of photo collectors bought, sold, and traded portrait images.

The legacy of the *cartes de visite* is their stunning impact on the democratization of photography. A cheap and reproducible form of social media, they were accessible to all, no matter where they stood on the economic scale. "Here there is no barrier of rank, no chancel end; the poorest owns his three inches of cardboard, and the richest can claim no more," pronounced the *London Review* in 1862, and added, "When they serve as pegs on which to hang our knowledge and sentiment, our memories and associations, they may be the highest use."[10]

The importance of photography to those who participated directly and indirectly in the war is profound. Nurse Harriet Dada, who is profiled here, shared one experience during her stay at a Chattanooga, Tennessee, military hospital in 1864: "Often, as I passed through the wards, the tears would dim in the eyes of the patients, as they spoke of a wife, or a mother, or a sister at home, and showed me the photograph of some dear one that they had sacredly preserved."[11]

About This Volume

This book has two distinct points of origin, separated by a decade. The first is a 2004 conversation that occurred after the completion of my first book, *Faces of the Civil War: An Album of Union Soldiers and Their Stories*. My editor, Robert J. Brugger, encouraged me to explore the roles of women in the Civil War. I liked the idea. But I also worried that finding images to support such a book would be an impossible challenge. My concern had its roots in my experience as a collector of wartime military and civilian portrait photography. The women pictured in many of

the images in my collection are either not or only partially identified—for example, "Emma" or "Mrs. Smith." Many soldier and sailor portraits in my collection also lack identification, but those that have them typically include the name, rank, and either the regiment or the vessel where the man served.

The second dates to the summer of 2014. Chris Foard, a fellow collector and a nurse by profession, approached me at a Civil War show, where I had set up a table in my position as editor and publisher of *Military Images* magazine. Chris told me about his collection of photographs and other materials related to Civil War nurses. We set a time to meet, and on an August day he visited my home with a plastic storage container. Inside were rare and unusual wartime portraits of women caregivers. I have never seen, nor expect to see, such an assemblage of such images in one place again. Chris has spent a lifetime bringing together this unique material, all part of the three-thousand-plus item Foard Collection of Civil War Nursing.

I made digital scans of many of the photographs that day. "Ministering Angels," a curated selection of twenty-one identified and unidentified portraits, was featured in the Spring 2015 issue of *Military Images*. I selected one of them, a tintype of Caroline Wilkins Pollard, to illustrate the cover of that issue. I agonized over the decision, concerned that the magazine's audience, accustomed to seeing a man in uniform as the main image, might react negatively. Turns out my concerns were misplaced, as feedback on the cover and the women's pictures was overwhelmingly positive.

Producing the *Military Images* gallery with Chris gave me confidence to begin this project. In the summer of 2016, I began the search for original portraits from the war period by reviewing all the Foard Collection scans made two years earlier for *Military Images*. I had not used all of the items in the magazine, due to space limitations in the print edition. In November, Chris visited me again with additional portraits. About this time I established a spreadsheet to track my progress. I cataloged thirty-eight identified or partially identified images from the Foard Collection, about halfway to the seventy-seven images required for the book.

How seventy-seven became the magic number dates to the submission of the manuscript for my first book, *Faces of the Civil War: An Album of Union Soldiers and Their Stories*. I had originally estimated that seventy-two soldier images and related text, plus front and back matter, would add up to a reasonable page count. At some point after submission, Bob Brugger contacted me to find out if I had any additional profiles to fill extra pages. I had written five more and promptly revised the manuscript to include them. Thus seventy-seven became the goal for future books in this series.

For the current volume, I ultimately used thirty-three images from the Foard Collection. These became part of the Liljenquist Family Collection at the Library of Congress late in the production of the manuscript. With Tom Liljenquist's approval, the images retain the Foard Collection credit, in recognition of Chris's contribution to preserving the history of Civil War nursing. One unidentified portrait from the Foard Collection appears in the frontispiece: a woman who, according to an inscription on the back, worked as a nurse in Hampton, Virginia. She is the only African American woman pictured in this volume. One of the unrealized goals of my project was to include women of color who were documented as having cared for soldiers and sailors. Despite my best efforts to find images of these courageous individuals, I failed to uncover portraits that met my criteria. I hope this book will help such images surface.

I opted not to include profiles of two African Americans who had portraits that did meet my criteria, Sojourner Truth and Harriet Tubman. I also omitted two prominent white women, Clara Barton and Dorothea L. Dix. In all four cases, I concluded there was little I could add to the already plentiful visual and textual records of these pioneers. Their omission made room for four women whose names and deeds were otherwise lost in time. Truth and Tubman are not mentioned in the text, and Barton just a few times. Dix, however, shows up in numerous profiles. Many of the references recount rejections by Dix of patriotic nurse applicants for whom she refused admission because they failed

to meet the minimum age requirement of thirty-five. This appears to have been her first question to determine the fitness of an applicant—evidently her first line of defense to weed out undesirables and others she deemed unworthy. Dix's adherence to the age requirement illustrates her modus operandi. Reformist, journalist, and muckraker Jane Swisshelm, who is profiled in this volume, summed up Dix in her memoirs: "Emergencies were things of which she had no conception. Everything in her world moved by rules, and her arrangements were complete."[12] Moreover, Swisshelm did not hit it off with Dix from the get go: "I had never before seen her, but her tall, angular person, very red face, and totally unsympathetic manner, chilled me."[13]

Southern women are also underrepresented, as finding relevant photographs proved extremely challenging. Only three of them are featured on these pages. Still, their stories speak to the difficulties of providing aid to sick and wounded military men in rural and urban areas with limited resources and under the constant threat of invasion and occupation. Compared with their Northern counterparts, this lack of wartime images can be attributed to a smaller overall population, shortages of photographic supplies, and no philanthropies on the scale of the Sanitary and Christian Commissions. The disparity is similar in military images.

The second-largest source for such photographs is the U.S. Army Heritage and Education Center (USAHEC) in Carlisle Barracks, Pennsylvania. I happened upon this grouping thanks to Maxine Getty, whom I met at the Civil War Heritage Music Gathering and Encampment in Windham, New York, in August 2016. Maxine provided me with a list she had collected of nurses who had known portraits. One of those women led me to the massive collection of the Military Order of the Loyal Legion of the United States (MOLLUS) Massachusetts Commandery, held by USAHEC. This assemblage of 120-plus scrapbook-style albums is well known to students of the Civil War. Assembled by two Bay State veterans, Col. Arnold A. Rand and Brig. Gen. Albert Ordway, it figured in two landmark twentieth-century projects,

Francis Trevelyan Miller's ten-volume *Photographic History of the Civil War* and Ken Burns's documentary *The Civil War*, as well as other media. Inside these albums I found thirty-eight images of identified nurses that met my criteria, a number equal to the Foard Collection. From these, I selected twenty-two for inclusion in this book. I also chose one additional photograph from this collection, a view of Annie Bell with two patients in a Nashville military hospital, as a secondary illustration to accompany her story. All of the USAHEC images are of *cartes de visite*, separated from their mounts and pasted onto the album pages. Most of those mounts probably contained the name and location of the photographer, and possibly inscriptions added by the nurse or others. This information, unfortunately, is lost.

The remaining twenty-three portraits came from public and private holdings as single images, with the exception of four from the Michael McAfee Collection and three from the Library of Congress. One image is from the author's collection, added during the course of this project. I finished the search for photographs in July 2017, though a few more came in while researching and writing the manuscript. I found the last image, of Felicia Ann Grundy Eakin Porter of Nashville, Tennessee, in August 2018, while working on a project with Dr. Anthony Hodges about the photographic history of Lookout Mountain.

The majority of portraits in this volume are in the *carte de visite* format. Altogether, seventy-one profiles are illustrated by these small paper prints attached to cardboard mounts. The other six are tintypes. Each portrait is reproduced in its entirety and original condition, including the dents, tears and other blemishes common to these relics. In the present book, I followed the same research method used in my previous volumes, and I documented this journey on my Facebook author page. One of my first acts was to establish a baseline to evaluate women for inclusion. To do so, I performed basic biographical research for about two dozen women for whom I had acquired photographs and discovered a range of experiences. The common element shared by all of them is that they attended to a wounded soldier on at least one occa-

sion. This became my dominant criterion as I worked my way through the images I collected, which allowed me to tell stories that document a wide range of experiences common to women during the war.

For example, Jessie Benton Frémont, indomitable wife of "the Pathfinder," John C. Frémont, is mentioned only once as having visited military hospitals in St. Louis. But she played a much larger and little-recognized role in establishing a women-friendly environment in the Western Sanitary Commission. Fanny Ricketts ventured into Confederate lines to nurse her husband, Union artillery officer James B. Ricketts, after he had suffered a severe wound at the First Battle of Manassas. The war literally entered the front door of Carrie McGavock's planation home, Carnton, during the bloody Battle of Franklin, Tennessee. Elizabeth Smith, wife of U.S. Secretary of the Interior Caleb B. Smith, opened her home in the Union capital as a hospital for soldiers and organized a Christmas dinner for twenty-five thousand patients in various hospitals in Washington, D.C. Sister Ignatius Farley, a Catholic nun, and other Sisters of Saint Joseph in Wheeling, West Virginia, nursed soldiers in their own church. Quaker missionary Sybil Jones embarked on a tour of hospitals after the death of her soldier son in battle. Mary Ann Bickerdyke toiled in the field during most of the war, suffering privations and hardships and eating the same food as her patients.

Three robust databases provided much useful information: Ancestry.com for genealogical information, Fold3.com for military pension records, and Newspapers.com for related stories. I also made extensive use of other online resources, including digital books and the finding aids of collections, historical societies, archives, and libraries. Although much has moved online, nondigitized materials required occasional trips to physical locations, notably the National Archives in Washington, D.C., to access military pension files. I purchased books when necessary.

Two books published in 1867 proved invaluable. Linus P. Brockett and Mary C. Vaughan's *Woman's Work in the Civil War* and Frank Moore's *Women of the War* include detailed profiles of

scores of women who served during the conflict. The publication of these volumes so soon after the war allowed their authors to capture personal details and anecdotes while the events were still fresh in the minds of those who participated. Many of them were still living and in their prime. I referenced profiles in these books and other similar materials, namely letters, diaries, memoirs, life sketches, and obituaries, with a clear understanding that they are representative of a time and place, subject to various agendas by the authors that can include class, race, gender, and religion. Mindful of these issues, I added context where necessary to provide perspective. This included researching other wartime and postwar writings and consulting contemporary works. A typical cycle averaged about a month per person, and I had four to six subjects in progress at any given time. I spent eighteen months researching and writing their stories.

The profiles are informal biographies, not genealogical histories. Dates, names of sister nurses and superior officers, family members, and other particulars may have been omitted in order to focus on the salient points of each story. Details and histories of places, military operations, government acts, social movements, and other contextual information are included in the text and endnotes when relevant, but without interrupting the dominant personal narratives of the stories of the caregivers.

The profiles are arranged in a rough chronological order, according to a key date in which each woman's central story revolves. This date is usually indicated in the opening paragraphs of the story. Two profiles are set before the war, seventeen in 1861, twelve in 1862, sixteen in 1863, twenty-five in 1864, four in 1865, and one after the war. The captions below each photograph note the women's first, middle, and married names. The names, home cities, and life dates of the photographers are included when available.

Faces *of* Civil War Nurses

THE PROFILES

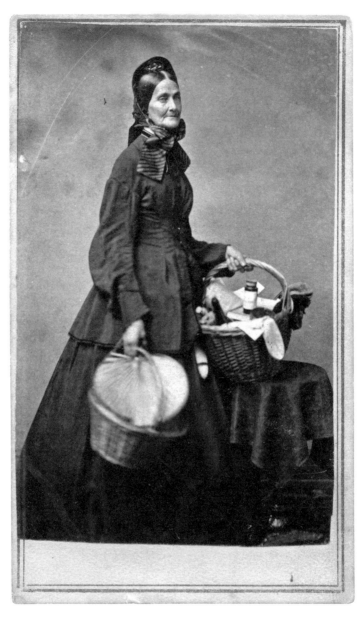

Almira L. Newcomb McNaughton Lockwood Fales. *Carte de visite* by Jesse Harrison Whitehurst (1819–1875) of Washington, D.C., about 1862–1864.

Foard Collection of Civil War Nursing

Portents of Rebellion

ALMIRA FALES ACTED IN A MOST PECULIAR WAY DURING the first weeks following the election of Abraham Lincoln. She began preparing lint for bandages and squirreling away hospital supplies for a war she believed would descend upon the country. Frightened friends and acquaintances ridiculed her as a crazed freak.[14] They later praised her as prescient when, a few months later, rebels bombarded Fort Sumter and inaugurated a long and bloody conflict. Almira, fifty-one, had attracted attention long before her one-woman crusade to stockpile goods. She was a towering figure with beaming blue eyes. One anonymous writer recalled that she possessed "an electric temperament, a nervous organization, with a brain crowded with a variety of memories and incidents that could only come to one in a million—all combine to give her a pleasant abruptness of motion and of speech, which I have heard some very fine ladies term insanity."[15]

The facts of Almira's early life reveal joys and sorrows. One of eight children born in the New York hamlet of Pittstown to a cooper and his wife, she lost her father before her twelfth birthday. Two marriages ended with the untimely deaths of her young husbands and left her in Iowa with a brood of children and stepchildren. There she managed a large hotel and taught domestic economy to Winnebago Indians in Iowa.[16] At some point along the way she met Joseph T. Fales, auditor for the state of Iowa.[17] They wed in 1847. Six years later, Joseph accepted an appointment as an examiner in the U.S. Patent Office and they relocated to the nation's capital.

Almira took on boarders in their Washington home for extra income. In 1854 she welcomed a lady who had recently moved from New Jersey and landed a clerking job at the Patent Of-

fice—thirty-two-year-old Clara Barton.[18] The two got along very well together, according to Barton biographer Elizabeth Brown Pryor, who noted that Almira "believed strongly in the necessities of charity and pursued her private projects with a drive that matched Barton's own. Her enthusiasm and passionate devotion to her northern background would cause her to wholeheartedly embrace relief work during the Civil War—work that was to have a direct effect on Barton's own role in that conflict."[19] Barton followed Almira's lead and also collected supplies before the war began.

A family genealogist recorded that on April 19, 1861, Almira became one of the first women to offer aid to Union soldiers. They belonged to the Sixth Massachusetts Infantry and had arrived in the capital bloodied and bruised after pro-secession mobs pelted them with brickbats and other debris as they marched through Baltimore earlier in the day.[20] Thus began a nursing career marked by unbridled energy and passion. Almira flew into action with the force of a hurricane. She tended the wounded and sick in the wake of the Battle of Shiloh, on hospital transports for the Peninsula Campaign, and, with her former boarder Clara Barton and other courageous women, during the campaign that culminated with the Second Battle of Bull Run. She slept in tents and ambulances, sharing the rigors of life in the field alongside boys less than half her age. Behind the front lines, Almira personally delivered reading material to about sixty to seventy forts, opened more than seven thousand boxes filled with supplies, and distributed in excess of $150,000 worth of comforts to needy patients.

An anonymous writer noted, "Every day you may find her, with her heavily-laden basket, in hovels of white and black, which dainty and delicate ladies would not dare enter. No wounds are so loathsome, no disease so contagious, no human being so abject, that she shrinks from contact, if she can minister to their necessity."[21] Through it all, she managed to keep her quaint sense of humor, which brought smiles to the faces of patients in all the hospitals she visited. Not even the death of her soldier son,

Thomas, a corporal in the Second Rhode Island Infantry who perished during the Chancellorsville Campaign,[22] slowed her down. "The loss was to her but a stimulus to further efforts and sacrifices. She mourned as deeply as any mother, but not as selfishly, as some might have done," observed the anonymous writer.[23]

Almira continued her caregiving efforts and the same whirlwind pace as long as the bloodshed continued. She barely survived the close of hostilities, dying in 1868. The family genealogist attributed the cause of her death to her great exertions during the war. Many mourned Almira's passing. The anonymous writer paid tribute to her in a letter published about a year before she died: "If the listless and idle lives which we live ourselves are perfectly sane, then Almira Fales must be the maddest of mortals. But would it not be better for the world, and for us all, if we were each of us a little crazier in the same direction?"[24]

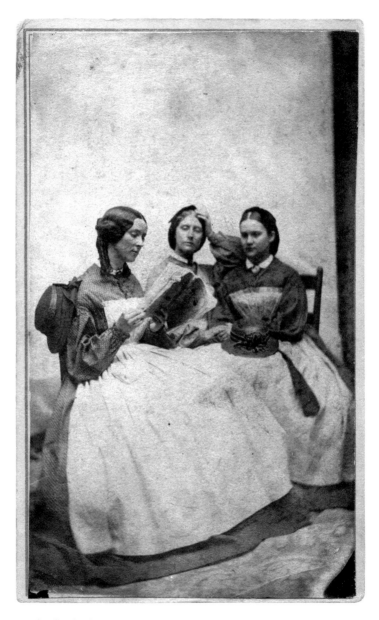

Sarah Elizabeth "Sallie" Dysart (*left*) with sister nurses. *Carte de visite* by an unidentified photographer, about summer 1863.

Foard Collection of Civil War Nursing

Do Unto Me

UNION LOYALISTS CELEBRATED THE 129TH BIRTHDAY OF
George Washington with a level of enthusiasm beyond any in
heretofore recent memory. In Pennsylvania's capital, Harrisburg,
the arrival of the president-elect of the now fractured country
heightened the patriotic fervor. On the afternoon of February
22, 1861, Abraham Lincoln stood on the portico of a local inn
and spoke for a few minutes to the masses that had gathered. In
reassuring tones, he acknowledged the large military force pres-
ent and humbly pledged to do all in his power to avoid bloodshed
and preserve peace.[25] Somewhere in the crowd, a young woman
visiting town from nearby Lewisburg listened intently. Captivated
by Lincoln's rawboned physique and stirred by his eloquence,
Sarah "Sallie" Dysart came away inspired. She later recalled, "All
that was good was with him—there was no bad."[26]

Weeks later, after the bombardment of Fort Sumter called
the North and the South to arms, Sallie may have remembered
Lincoln's words as she watched fresh-faced citizen soldiers march-
ing through the streets on their way to war. As they passed, she
wondered who would take care of them when they became sick
or were wounded in battle. By the time the last soldier marched
by, she resolved to get involved, even if it cost her life.[27]

Those who knew Sallie most likely expected nothing less.
Raised on a sprawling estate nestled in the rolling hills west of
Harrisburg, in the Blair County hamlet of Tipton, Sallie and her
eight siblings hailed from a family that included a Revolutionary
War officer and a prosperous ironmaster.[28] Sallie wanted for little.
She had careful religious instruction in the Baptist church, sing-
ing lessons in Baltimore, and formal education at the respected

Lititz Seminary and, later, the Lewisburg Female Academy at Bucknell University.[29]

The war interrupted Sallie's academy life. She enlisted as an army nurse and started her service on or about New Year's Day 1862. Medical authorities assigned her to Harpers Ferry, Virginia. Here she joined the hospital of the Twelfth Army Corps, to which organization she developed a deep and lasting attachment. The Twelfth, composed of two divisions rather than the usual three, made up for its smaller size with its reputation for hard-fighting crack regiments. It fought with distinction at Antietam, Chancellorsville, Gettysburg, Lookout Mountain, and elsewhere, led by some of the Union's finest generals—among them Alphaeus S. Williams and Henry W. Slocum. All wore the Twelfth's five-pointed star badge to distinguish them from other corps.[30]

Sallie treated the wounded and sick of the Twelfth along the way, often singing to her patients in an unusually lovely voice. She also proved a capable leader, as evidenced by her leadership of Ward 3 at Camp Letterman after the Battle of Gettysburg. During that long and difficult summer, Sallie took a moment to pose, periodical in hand, with two Pennsylvanians and Lewisburg Female Academy graduates with whom she served: her cousin, Annie Bell, and Sarah Chamberlin.[31] This trio of sister nurses later served in Tennessee, and Sallie spent the rest of the war at hospitals in Chattanooga and Nashville. In one of the hospitals in the latter city, she headed up the kitchen staff in addition to her regular duties.

In May 1865, Sallie received a discharge from the army. She left with two parting gifts. A group of patients took up a collection and bought her a gold watch as a token of their appreciation. A cadre of medical staff presented her with a star-shaped pendant crafted of gold and set with a cross and pearls. One side included an engraved dedication, "To Sarah E. Dysart, from the Medical officers of the Twelfth Army Corps." The other included a biblical passage from Matthew 25, the Parable of the Ten Virgins: "In as much as ye have done it unto one of the least of these, ye have done it unto me."[32] One other tribute is worthy of note: a letter

from the man who impressed her in Harrisburg on Washington's birthday in 1861. It read, in part, "Your glorious contribution to the morale of the Union Forces, my dear Lady, will remain as a bright page of this terrible period and the succor you gave the dead and dying shall remain forever as a blessing."[33] The letter from President Lincoln, along with part of a uniform of one soldier boy who never made it home, numbered among the relics stored by Sallie in an old chest after she returned to Tipton.

She spent the rest of her days involved in activities connected to her church and charitable organizations, including temperance and missionary societies. In 1893, she received a government pension for her war service. She donated the money to philanthropies until her death from pneumonia in 1909, at age seventy-one. She never married. Five of her brothers and sisters survived her. Several hundred mourners attended her funeral. Sallie's remains were laid to rest in the Dysart family cemetery. A line she penned on a postcard for a Sunday school exercise might have served as a fitting epitaph: "Without courage one cannot be strong and without strength one cannot be courageous."[34]

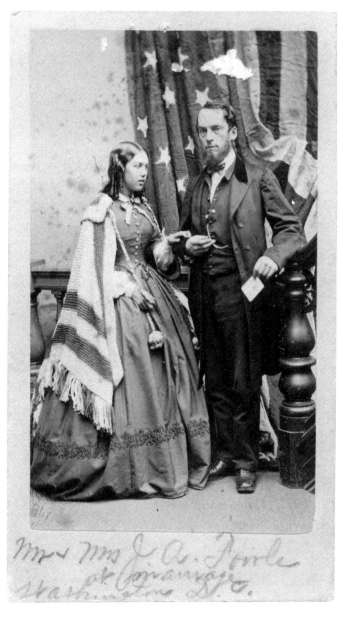

Elida Barker Rumsey Fowle and John Allen Fowle. *Carte de visite* by James Wallace Black (1825–1896) of Boston, Massachusetts, about March 1, 1863.

Foard Collection of Civil War Nursing

Songbird of the North

I F A W A R T I M E S C U L P T O R H A D C R E A T E D A M E M O R I A L T O
Elida Rumsey in bronze or stone, she would probably be shown
at the zenith of her influence: her head uplifted in song, with one
foot firmly planted on a rebel flag, and her arms full of library
books and religious tracts. This is how uncounted numbers of sick
and wounded Union soldiers who passed through Washington,
D.C., remembered this especially ardent patriot. The daughter
of a New York City hosiery shop owner, she and her family had
relocated to the nation's capital around the start of the war. Elida,
then eighteen years old, was shaken by the level of secession senti-
ment in the city. The undercurrent of disunion fueled her love of
country, which expressed itself in charitable efforts for soldiers.
Soon after her arrival, she joined a quartet of vocalists who sang
during Sunday services at the U.S. House of Representatives.
There she met a widowed father of two, John Allen Fowle. A
Boston dry goods merchant sixteen years Elida's senior, he had
arrived in Washington in 1861 to accept a clerical position in the
Navy Department.[35]

It was a match made in heaven, for the two shared the same
philanthropic impulses. John became the chairman of a navy
relief organization and sponsored a series of religious meetings
for soldiers. Elida joined the effort, and, according to one account,
her singing sustained the gatherings and boosted attendance.[36]
In November 1861 they began to visit local hospitals. Elida's voice
brought cheer to the patients, most notably at Columbian College
Hospital, where John and Elida conducted prayer meetings in a
room connected to a ward. The highlight of the gatherings was
Elida's singing. One writer described how popular she was with
the patients: "That room was crowded night after night, and over-

flow meetings were held in a grove near by. The interest steadily increased, the boys often doing double duty in order to be present, and they were continued as long as it was safe; but the enthusiasm of the soldiers could not be repressed when Miss Rumsey's sweet voice stirred the souls and rekindled the noble, self-sacrificing spirit that had brought them to such a place, and cheers shook the very walls. The soldiers planned what they wanted her to sing from week to week, and she threw into the songs all her great desire to bring the boys back to their better selves, and help them to feel that they were not forgotten nor alone."[37]

About this time, Elida and John shared a situation that prompted one of the most often-told stories of their war experience. When news came that a group of Union prisoners held in Richmond were being exchanged, they went to the railroad station to see the soldiers as they left the cars. "They looked utterly disheartened and demoralized by disaster and suffering; and their enthusiasm was all gone," noted one of Elida's biographers.[38] Someone in the forlorn group recognized Elida and asked her to sing. John called out "Boys, how would you like a song?" to gain attention and to give Elida time to prepare.[39] Though John's question was met by a tepid response, Elida launched into "The Red, White, and Blue," one of the popular songs of the period. Her biographer recounted what happened next: "Soon they crowded around her with more interest than they had yet shown since leaving prison; but comparatively few could see her. At the close of the song they called for another, and a pile of knapsacks was thrown on the ground. Standing on this rude rostrum she sang 'The Star-Spangled Banner.' Her natural enthusiasm was intensified by the surroundings, and the desire to inspire the boys with the courage they had all but lost. Her voice was full of power, and her whole attitude instinct with patriotism, as she brought her foot down on the imaginary rebel flags." The biographer added, "Our boys, now restored to the former earnestness, rent the air with cheer after cheer."[40]

Elida and John experienced the horrors of war firsthand when they went on a mission of mercy following the Second Battle of

Bull Run. On August 31, 1862, the day after the fighting ended, they set out in a wagon loaded with 450 loaves of bread, meats, spirits, bandages, shirts, and other supplies for the thirty-mile trip to Manassas Junction. "They had no government pass, so it was really a hazardous undertaking," noted one writer, who revealed that Elida had applied for a position to Dorothea Dix, chief of nurses in Washington, and been rejected. "While Miss Dix and her faithful nurses were detained three miles away, little Miss Rumsey, who she could not accept as a nurse because she was too young and not as homely as a hedge-fence, was inside the lines carrying succor to men who had been without food for twenty-four hours."[41] These and their other encounters impressed upon Elida the need for positive influences to help soldiers cope with depressing circumstances and surroundings. From this realization sprang the idea of providing pictures and books to stricken soldiers as an alternative to card playing and idle chatter. In short, to displace evil with good.

Her solution was the Soldiers' Free Library, and she was joined by a supportive John to make it a reality. Located on land granted by Congress near the Judiciary Square Hospital, not far from the U.S. Capitol, it opened in late 1862. The sixty-five by twenty-four-foot building, with a reading room that seated 250, was constructed with funds donated by wealthy benefactors and earned from musical concerts organized by Elida. Thousands of volumes and newspaper and magazine subscriptions were collected as word of their mission spread. Bibles, hymnbooks, and other religious materials were given away for free. The War Department, with the permission of Secretary Edwin M. Stanton, detached a convalescent soldier to keep the library organized.[42] The library was Elida's crowning wartime achievement.

By this time the couple were engaged. On March 1, 1863, they tied the knot in a highly publicized event on the floor of the U.S. House of Representatives, reportedly a first. The great hall and galleries filled with an estimated 2,500 to 3,000 people, including senators, Secretary of the Treasury Salmon P. Chase, and other dignitaries. President and Mrs. Abraham Lincoln had hoped to

attend, but official duties kept him away, so they sent a bouquet of flowers. The audience looked on as John and Elida, who was attired in a simple poplin dress adorned with a red, white, and blue bow and a matching bonnet, took their vows in front of the Speaker's desk. The reverend who performed the Episcopal ceremony, Chaplain Alonzo H. Quint of the Second Massachusetts Infantry,[43] had been the pastor of the church attended by John before he moved to Washington.[44] At the end of the ceremony, "Sing us something!" was shouted from the galleries. Elida launched into the "Star-Spangled Banner."[45]

The library flourished throughout the remainder of the war, after which the American Missionary Society became its new occupants. The building was utilized as a meeting place and, later, as a school for children of color. In 1869 it became part of the new National University, an ambitious initiative originally advocated by George Washington and other founding fathers.[46] The library was used as a temporary lecture hall until 1873, when it was demolished to make way for improvements to Judiciary Square.[47] Though the building was gone, the significance of its existence was not forgotten. Elida and John were hailed as important pioneers in the free library movement by philanthropist Andrew Carnegie, who funded the establishment of libraries across America and other English-speaking countries during the latter part of the century.[48]

Elida and John left Washington at the end of the war and lived in Brooklyn, New York, until 1877, when they settled in Dorchester, Massachusetts. They started a family that grew to include four children of their own, three of whom lived to maturity, and an adopted war orphan. John supported his family with a lucrative career in the wool business. Elida became involved in numerous volunteer organizations and founded Grandchildren of the Veterans of the Civil War. She also established a free library for neighborhood children.[49] Her home became a frequent stop for veterans whom she had touched with her musical and charitable work. She was always ready to share anecdotes and sing.

In 1913, a fictional account of Elida's Civil War exploits was the

subject of the film *Songbird of the North*. The movie premiered on or about July 4 and was advertised in theaters across the country throughout the rest of the year. Two giants of the silent screen era portrayed the lead characters—Anita Stewart as Elida and Ralph Ince as Abraham Lincoln. It is not known if Elida and John ever saw the film. Three years later, John died at age ninety. Elida passed away in 1919 after she suffered a cerebral hemorrhage. She was seventy-seven.

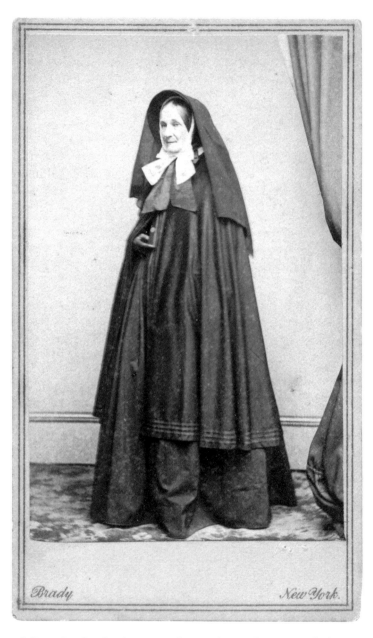

Adeline Blanchard Tyler. *Carte de visite* by Mathew B. Brady (1822–1896) of New York City and Washington, D.C., about 1863–1864.

Foard Collection of Civil War Nursing

First Nurse

Fridays were usually reserved by Sister Adeline Tyler for her weekly errand of mercy to prisoners in the Baltimore jail. She was about to leave home for the crosstown carriage ride on April 19, 1861, when word arrived that a riot had rocked the city. She could never have guessed that the event would set her on a course for a new mission that touched uncounted lives—and make her a footnote in American history. The first news Sister Tyler received indicated that the route to the jailhouse was unsafe, and it prompted her to delay her journey by a few hours. When she finally did set out, the violence had largely subsided. But she sensed heightened tensions as her carriage moved through the streets. She observed injured citizens being helped into homes and other places to be treated.

By the time Sister Tyler arrived at the jail, or sometime soon afterward, she had learned the basic facts of the event that would become known as the Baltimore Riot of 1861, or the Pratt Street Riots. Pro-secessionist mobs had attacked a regiment of Union troops as they marched through town to catch a connecting train to Washington, D.C. The soldiers hailed from Massachusetts, and a certain number of them had been killed or wounded.[50] The latter detail touched her personally, for Sister Tyler was a Bay State native. Born Adeline Blanchard more than a half century earlier, she had spent most of her fifty-five years in Boston. She might have remained in her home state, but fate intervened with the death of her husband, John Tyler, a well-known auctioneer in the city, in 1853.[51] Twenty-six years Adeline's senior, he had suffered a stroke.

Adeline, an active member of the Episcopal Church, advanced to deaconess and laid the groundwork for a mission of charity to

the sick. A major step in her development involved a trip to the Deaconesses' Institute in Kaiserswerth, Germany, to study nursing. One of its notable students, Florence Nightingale, had trained there in 1851.[52] Sister Tyler returned to America at the conclusion of her classwork and embarked on her mission. Her good works in Boston ended in 1856 when she accepted an invitation to lead a church-funded infirmary in Baltimore. She proved an able leader who managed a rapidly expanding organization, though some insiders privately complained that she was overzealous in her charity. In early 1860, her power was curtailed after the church created a new leadership position and installed a man to run the infirmary. Sister Tyler promptly resigned as chief deaconess but stayed on to train apprentice deaconesses. The change also allowed her to invest more time with the sick, the poor, orphaned children, and prisoners.

She worked in this capacity when Southern military forces bombarded the federal garrison of Fort Sumter in South Carolina on April 12, 1861. A week later, the war came to Baltimore when secession sympathizers pelted the Sixth Massachusetts Infantry with bricks and stones as it marched through the city in response to President Abraham Lincoln's call to put down the rebellion of Southern states. That afternoon at the jailhouse, Sister Tyler absorbed the enormity of the news and took action. She dashed off a note to a friend to help her find out the fate of the wounded Massachusetts soldiers, cut short her visit to the jail, and left for home. The friend soon reported back to Sister Tyler. She learned that some of the wounded soldiers had been left behind as the rest of the regiment escaped aboard the Washington-bound train. The abandoned men were taken by the police to a station house and had received medical attention—though the latter report could not be verified.

"This roused the spirit of Mrs. Tyler," noted biographers Linus P. Brockett and Mary C. Vaughan in their 1867 book, *Woman's Work in the Civil War*: "Here was truly a work of 'charity and mercy,' and it was clearly her duty, in pursuance of the objects to which she had devoted her life, to ensure the necessary care of

these wounded and suffering men who had fallen into the hands of those so inimical to them."[53] The carriage carrying Sister Tyler soon arrived at the police station. By this time, night had fallen. She knocked on the door and explained to the individual who answered that she had come to care for the injured soldiers. Her physical presence must have added emphasis to her heartfelt plea. Standing six feet tall and presumably clad in clothing similar to the outfit worn in the *carte de visite* pictured here, she cut an imposing figure.

Her request was denied, with the explanation that the most serious cases had been transported to a local infirmary, and the remainder rested comfortably in an upper room. A skeptical Sister Tyler renewed her request, at least to satisfy herself that they were comfortable. She was again refused admission. Sister Tyler pushed back. "I am myself a Massachusetts woman, seeking to do good to the citizens of my own state. If not allowed to do so, I shall immediately send a telegram to Governor Andrew, informing his that my request is denied," reported *Woman's Work*.[54] The threat of contacting Massachusetts governor John Andrew worked. Sister Tyler entered the station and was escorted to the upper room to see the soldiers.

Her worst fears were realized. Two of the soldiers were dead. Two or three more lay in beds, and the rest on stretchers. All were still dressed in their uniforms, and their wounds had been minimally treated with large pieces of cotton cloth, despite hours having passed since their injuries had occurred. It appeared that they had been drugged. Sister Tyler determined that two of the men were in critical need of care and negotiated their release. One man, a private, had been shot in the hip. The other, a sergeant, had been clobbered with a glass bottle that left a ghastly wound, with shards still sticking in his neck. She and her carriage driver managed to enlist the services of a furniture van to transport the soldiers to the Deaconess's Home, where Sister Tyler lived. There they were treated and eventually released.[55] It may be fairly stated that Sister Tyler was the first nurse to attend to Union soldiers wounded in the hostilities.[56]

A year later, on the first anniversary of the riot, Sister Tyler received a formal "Vote of Thanks" from the Massachusetts House of Representatives for her actions.[57] By this time, however, Sister Tyler had left Baltimore under a cloud of suspicion. Following her life-saving efforts after the riot, she was placed in charge of a military hospital on Camden Street in Baltimore. Here her patriotism came into question after she stated that patients who entered her hospital were to be treated equally, no matter where their loyalties lay. This left an impression that she was a rebel sympathizer, and she was discharged.[58] Her situation could have been much worse, for others suspected of disloyalty had been stripped of their positions and imprisoned. Sister Tyler left Baltimore with no formal charges lodged against her and found refuge with friends in New York City.

By mid-1862, the patriotism paranoia that had swept Baltimore and some Northern cities has largely subsided. Sister Tyler lobbied to get back into action. Her reputation was resurrected when she was offered and accepted a leadership position at a military hospital in Chester, Pennsylvania. In this role, and later at the Naval School Hospital in Annapolis, Maryland, her talents for organization benefited staff and patients. Stress from her unrelenting schedule led to exhaustion that ended in her resignation in May 1864. She traveled to Europe to restore her health and returned to the United States in November 1865. Sister Tyler went on to become lady superintendent of the Midnight Mission, a New York City facility for prostitutes and other women deemed "fallen" by society. She resigned her position in 1872 after learning she was ill with breast cancer. She succumbed to the disease in Massachusetts three years later, at age sixty-nine. "She will always be remembered as identified with the war from the very beginning," observed an admirer. "She was the only woman in Baltimore who came forward on the 19th of April, 1861, when the men of our Massachusetts Sixth were massacred in passing through that city."[59]

Leader of the Patriot Daughters

ON SUNDAY, APRIL 21, 1861, A MINISTER PREACHED TO his flock from the pulpit of Saint James Episcopal Church in Lancaster, Pennsylvania. He was Rev. Jacob I. Mombert,[60] a German national who had witnessed much suffering during the recent war in the Crimea.[61] Now, just a week after the fall of Fort Sumter to rebel forces, he gave the women of the congregation a piece of advice. He recommended that they organize a group to provide aid and care to volunteer soldiers. The Society of Patriot Daughters of Lancaster was born the next day. Its membership elected seventy-year-old Rosina Weaver Hubley as president. She had reigned supreme as proprietress of the White Swan Tavern in the heart of town since her marriage to its owner, Joseph Hubley, in 1814. After he passed away about 1830, Rosina operated the business on her own.[62] "She was a woman of great strength and character, which, combined with a natural refinement, made her an ideal hostess, and her hotel became very popular," noted a Lancaster historian.[63]

As president, Hubley brought her considerable skills into play almost immediately. Word came in that two companies of Ohio boys had arrived outside Lancaster without overcoats and blankets. The Patriot Daughters went into action to meet the need.[64] This event was the first of many to which Hubley's society responded over the next four years. Supplies sent to Keystone State soldiers during the 1862 Peninsula Campaign prompted a reply from a grateful officer: "Could the 'Patriot Daughters' of Lancaster have but seen the countenances, and heard the grateful expressions, which fell from the lips of the survivors of the bloody conflicts before Richmond, they would have been in some measure repaid for their generous offering."[65]

Perhaps the high-water mark of their service was caring for wounded soldiers after the Battle of Gettysburg. Five women from the organization, along with a considerable amount of hospital supplies, were dispatched to Gettysburg in the immediate after-

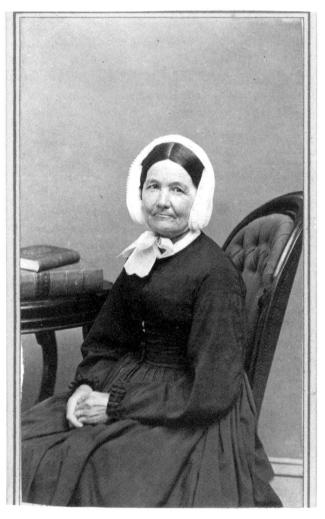

Rosina Weaver Hubley. *Carte de visite* by an unidentified photographer, about 1862–1864.

Collection of Faye and Ed Max

math of the fighting. They attached themselves to the hospital at Christ Lutheran Church, also known as College Church, as many of the congregants were connected to the nearby theological seminary. For more than a month the five women cared for about 150 soldiers from almost every state in the Union.[66] After a brief respite, they returned to Gettysburg and nursed Union and Confederate soldiers encamped around the seminary.

Rosina's support for the Union cause was also evident in a Sanitary Fair invitation she extended to President and Mrs. Abraham Lincoln in early 1864: "You will receive a hearty welcome from many, who will remember with gratitude for years to come, your faithfulness to your country, and your straight forward integrity, in its hour of danger; You will also receive the warm grasp of sympathy from many who appreciate the trials of your great and high position and who pray that you may be guided aright."[67] Lincoln elected not to attend the event.

When the war ended, Rosina and other society officers issued a report of the contributions of the Patriot Daughters. More than a thousand boxes and barrels of supplies had been sent to the volunteers, including more than five thousand flannel shirts and a long list of other items.[68] Rosina made one more major contribution to Lancaster. She and the Society of Patriot Daughters played a leading role in raising funds for a monument to the county's Civil War soldiers and sailors. On July 4, 1874, a huge crowd of citizens and war veterans gathered in the town center to unveil the memorial. Andrew Curtin, the wartime governor, delivered a soothing address that recognized the need for the nation to heal during the final, painful years of Reconstruction. Afterward, he and four young girls, all daughters of Pennsylvania men who died in uniform during the war, unveiled the forty-three-foot-high granite monument. The imposing structure was topped by a statue of a goddess, the "Genius of Liberty."[69] Rosina passed away seven months later, at age eighty-one. Two children survived her. In 1932, the Daughters of Union Veterans established Rosina Hubley Tent No. 45. It faded out of existence in 1958.

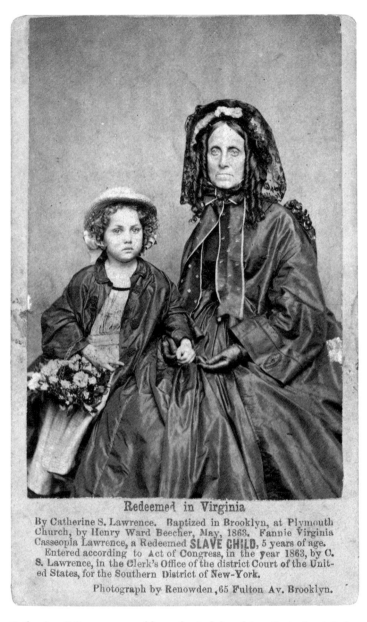

Redeemed in Virginia

By Catherine S. Lawrence. Baptized in Brooklyn, at Plymouth Church, by Henry Ward Beecher, May, 1863. Fannie Virginia Casseopia Lawrence, a Redeemed SLAVE CHILD, 5 years of age.
 Entered according to Act of Congress, in the year 1863, by C. S. Lawrence, in the Clerk's Office of the district Court of the United States, for the Southern District of New-York.

Photograph by Renowden, 65 Fulton Av. Brooklyn.

Catherine S. Lawrence and her adopted daughter. *Carte de visite* by John Renowden (life dates unknown) of Brooklyn, New York, about 1863.

Collection of William A. Gladstone, Library of Congress

White Slave

CATHERINE "KITT" LAWRENCE BUTTED HEADS WITH DORO-
thea Dix from the get-go. During Kitt's initiation to nursing in
Washington, D.C., in the middle of 1861, Dix, newly appointed
chief of nursing, escorted her on a tour of several hospitals. Rep-
resentatives of the Catholic Sisters of Charity served in one of
them. After the visit, Kitt recalled that Dix "gave me orders not to
speak to those Catholic nurses."[70] Kitt struggled with the moral-
ity of Dix's statement: "Is this a military order? Am I to lay aside
the common courtesy of life because I am to care for the sick
and dying? I don't see it." She added, "To reject persons because
they differ from us in their opinion on the subject of religion is
not Christlike."[71]

Details of exactly what transpired between the women during
the days and weeks that followed are not known. But the chal-
lenging nature of most of Kitt's assignments over the next year
and a half seemed more punishment than reward. In Kalorama
General Hospital, her own health was severely compromised
when she spent about a year tending patients with smallpox and
other eruptive contagions. Seventh Street Hospital was a filthy
facility, lacking beds and just about everything else. The aptly
named Camp Misery, a God-forsaken convalescent camp, was just
across the District of Columbia border in Alexandria, Virginia.[72]

Kitt's fortunes turned for the better when, in late 1862, she was
transferred to a relatively clean and well-managed hospital in
Fairfax, located in Virginia not far from Washington. Here, as she
adjusted to her new duties, a chance encounter before Christmas
dramatically altered her life. Among the regular flow of escaping
slaves from area plantations were three sisters who appeared
more white than black. The youngest, Fanny, caught Kitt's atten-

tion: "The little girl had flaxen hair and dark blue eyes, but dark complexion, or terribly sunburned."[73] Fanny was of African and European extraction. Her biological father was Rufus Ayres, an unmarried, college-educated plantation owner murdered in 1859 by a neighbor in a running dispute that stemmed from an argument over a farm gate. Her biological mother, Mary Fletcher, was a slave owned by Ayres. The nature of the relationship between Ayres and Mary—beyond that of master and slave—is unknown. The three children had made their escape from nearby Fauquier County as part of a large group of runaways.[74]

Kitt had experienced her own difficult childhood. Born Catherine S. Lawrence in Schoharie County, New York, her mother and father died within the space of a year, in 1831 and 1832. Kitt, or "Kittie," as she was known to friends, became an orphan at fourteen. She survived by taking on sewing jobs and then becoming a teacher. During these tough times, and throughout the rest of her life, she was buoyed by a fiercely independent spirit, grounded in Methodism. She was also inspired by naval hero Capt. James Lawrence, from whom she claimed to be a lineal descendant.[75] Capt. Lawrence, mortally wounded while in command of the frigate *Chesapeake* during a War of 1812 fight, uttered words that became an American battle cry—"Don't give up the ship."

Kitt came of age as the temperance, abolition of slavery, and women's rights movements gained traction. She embraced them all, especially temperance, with a fervor that repelled more than it attracted. "I have frequently been told that I was too much outspoken and made enemies," she observed. "I am apt to call things by their right names. With a certain class this will not be well received. I have no wish to become popular through deceit."[76] Though Kitt did not name names, Dorothea Dix might have been in the class she referenced. Kitt's outspokenness impacted her life's journey and, ultimately, led the unmarried and childless nurse to adopt Fanny, the half-white slave. "I at once took the child, thinking I would find a home for her. She was a beautiful child, and I soon became very much attached to her."[77]

Kitt knew that a military hospital in a war zone was no place for the little girl. She found a temporary refuge for Fanny in the home of a friend in Washington and returned to her regular duties at the Fairfax hospital. By this time, Kitt had become concerned for her own health, which suffered from her ceaseless activities as a relief worker. She requested and received a furlough and set out for New York to rest, as well as to find a suitable home for Fanny until the war was over. Kitt's first stop was at the home of her friend in Washington, to pick up Fanny. Here she made the acquaintance of a wealthy gentleman visitor from Brooklyn. During the conversation, Kitt shared her plans for Fanny's immediate future and noted that she'd like to have her baptized. Toward the conclusion of the visit, the gentleman asked Kitt if, while she was passing through New York City, she would hand deliver a letter to his clergyman in Brooklyn. Kitt readily agreed, and some days later made good on her promise. She presented the letter to Plymouth Church minister Henry Ward Beecher, the noted abolitionist and brother of *Uncle Tom's Cabin* author Harriet Beecher Stowe.

Kitt and Reverend Beecher hit it off, which is not surprising, considering their mutual activism in the popular reforms of the day. Beecher learned about Kitt's desire to have Fanny baptized and offered to include the little girl in an upcoming ceremony at his church. On May 10, 1863, Beecher baptized a long line of children, saving Fanny for last. According to the *New York Times*, Beecher paused and informed the audience that one more child was left, whose story contained a moral. Then, with Fanny in his arms, he ascended the pulpit steps. "She was born into slavery," he announced to the hushed congregation, in a voice quaking with emotion. "A benevolent woman, who was nursing our sick soldiers in the hospital at Fairfax, found her, sore and tattered and unclean, and requested the good sister who has adopted her, to bring her North and take care of her. She will be treated as this lady's own child, and it is designed to educate her as a teacher for her race."[78]

Beecher denounced slavery in harsh terms his sister Harriet would no doubt have appreciated: "While your children are brought to fear and serve their Lord, this little one, just as beautiful, would be made, through Slavery, a child of damnation. The whole force of my manhood rises up in enmity against an institution that cruelly exposes such children to be sold like cattle." He concluded, "May God strike for our armies and the right, that this accursed thing may be utterly destroyed."[79] Beecher then baptized Fanny as Virginia Casseopia Lawrence, and she was formally admitted into the Christian church. The story made headlines in newspapers across the Union and in Britain.

The ceremony also marked the end of Kitt's career as a military nurse. She did, however, return to Virginia once more to bring back Fanny's older sisters, Viana and Sallie. Kitt found homes for them in New York, and then set off with Fanny on a grand tour through New England. Along the way, Kitt sold copies of the *carte de visite* pictured here and others to raise funds. There are twenty-one variations of the portraits known to exist, taken by photographers in Brooklyn, Boston, and Hartford, Connecticut.[80] Kitt exploited Fanny's story and her own celebrity for financial gain. She was not alone in doing so. A number of Union veterans maimed in the war and unable to make a living as a result of their injuries told their battle stories and sold photographs, some picturing family members, to supplement meager pensions.[81]

Kitt and Fanny's eventful journey ended on a tragic note when they arrived in Hartford, Connecticut, on April 14, 1865, to news of the assassination of President Abraham Lincoln. Tragedy also lay in store for Kitt's Southern children. Viana and Sallie succumbed to consumption before they reached maturity. Her beloved Fanny married, gave birth to a child, and was abandoned by her husband. She also died young.[82] For Kitt herself, alone and destitute by the middle of the 1870s, a chronic lack of money plagued her for the rest of her days. To make ends meet, she filed for and received a modest pension from the government for her service as a nurse. In 1893, she published her autobiography to raise supplemental funds. Toward the end of the volume, she

shared an anecdote about the afterlife: "A friend asked me if I were permitted to choose employment in heaven, what would it be. My answer was: A group of children to look after among flowers."[83] She also noted, "Let my epitaph be—'She worked for temperance.'"[84] Kitt died in 1904 at age eighty-five.

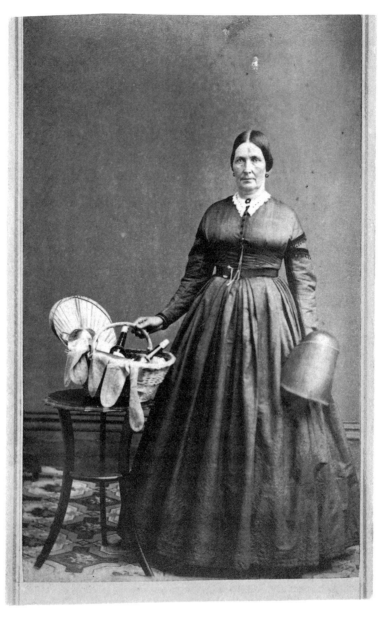

Elmina Maria Oltz Pierce Brainard. *Carte de visite* by Benson
(life dates unknown) and Hough (life dates unknown) of Pontiac,
Michigan, about 1861–1863.

Collection of Theresa and Dale Niesen

Michigan's Florence Nightingale

ONE DAY IN THE SUMMER OF 1864, NURSE ELMINA BRAIN-ard was tending to her hospital duties in City Point, Virginia, when a man caught her attention. He was curious about how the soldiers were getting along, and Elmina shared what she knew. The nature of these questions and his overall demeanor suggested to her that he was probably a Christian Commission volunteer checking on hospital affairs. At one point, recalled Elmina, the man asked, "'You are from Massachusetts, are you not?' I replied: 'No, I am from Michigan.' He said to me: 'Take good care of the Michigan boys, they fight nobly.'"[85] The man spoke with authority about the troops, for he was the overall commander of the Union forces, Lt. Gen. Ulysses S. Grant.

Elmina could speak with her own authority about Michigan's citizen soldiers, for she had a long history as a caregiver in the state. A New York native, she had arrived in Michigan in 1836 as a newlywed with her husband David Oltz, settled in Pontiac, and started a family that grew to include a daughter and son. She raised the children practically on her own. David had disappeared at some point early in their lives; whether by death or another cause is lost in time. Two more husbands, both farmers, came and went in the 1850s: Jarvis Pierce, almost twenty years her senior, and Philo B. Brainard. By 1860, Elmina had relocated to nearby Lapeer, where she worked as a nurse and took in boarders to support her family.[86]

Everything changed a year later. "When the first gun was fired at Fort Sumpter, I regretted very much that I could not carry a musket in the field, and do duty in defense of my country's honor and flag," Elmina stated, adding, "After a time I thought it my duty as a woman to try and minister to the comfort of those who did

carry arms on the field of battle. So, in the first year of the war, I left my home and devoted my time until the war was over to the sick and wounded soldiers."[87] In the summer of 1861, Elmina joined the Seventh Michigan Infantry in an unofficial capacity. She had a special interest in this regiment for family reasons—her son, Charles, had enlisted in Company G as a corporal.[88] He and his comrades, with Elmina in tow, left the state for Virginia—and, before the summer's end, for the East—to participate in their first engagement in Virginia at the disastrous Battle of Ball's Bluff. Charles emerged unscathed and went on to fight with his fellow Michiganders.

Elmina's service with the Seventh ended in early 1862, when she joined the Michigan Soldiers' Relief Association of the District of Columbia. "Mrs. Brainard was early engaged, and perhaps the first among our regular workers—she certainly was the last to leave," according to an organization report.[89] Elmina and others in the association participated in relief efforts during the Peninsula Campaign in 1862—the first of many such missions. Elmina proved indefatigable as she moved from hospital to hospital here and elsewhere in Virginia, Maryland, and Washington, D.C., throughout the rest of the war, stating, "I am a worker, not a talker."[90]

On one occasion, when pressed to describe her service, the always humble Elmina responded, "I have been a witness of many noble deeds of our brave soldiers, and the patient suffering of those who were dying. One-half of the story could never be written or told of the heroic conduct of our Michigan soldiers." She added, "I have seen them on different battle-fields, dying far away from their homes, without mother or sister or any one to minister to their wants, or to receive their dying words, except their fellow soldiers and the few ladies who were fortunate enough to be there. I consider that the years in which I was allowed to do this work were the happiest years of my life; and I shall ever be grateful that I was supported and had the means of rendering what service I did by the liberal donations of those at home."[91]

One state politician summarized her wartime efforts: "She has

done heroic service on the battle-field for the cause of our country, she has been eminently a Florence Nightingale, ministering to our falling and fallen braves; speaking words of hope, comfort and consolation to the dying soldier."[92] Perhaps her greatest praise was offered by iconic nurse Clara Barton during an 1867 speech in Detroit to raise funds for a monument to soldiers and sailors: "It is impossible to estimate what the State of Michigan owes to this lady—how many a mother, wife and child owes to her the blessed presence of son, husband and father. He only knoweth who knows not only what he has, but saddest of all, what 'might have been.'—I speak from personal knowledge; I have seen this noble woman stand, tireless, changeless through day and night, under exposure and toil which sunk the strongest men—cheerful, uncomplaining—an angel of mercy, amid scenes than which human necessity knows no greater want, human misery no deeper woe. True, some brave men live to tell the story of her deeds and bless her name, but for every Union soldier who may give his grateful record here, five have gone above to write on the spotless pages of Eternity the blessed name of her who went with him down to the slippery bank, to the dark rolling river—clasped his hand and steadied his arm as he stepped into turbid waters, and took back almost from the other shore the last message to the dear ones waiting here."[93]

Elmina played a leading role in raising funds to build an imposing monument to Michigan's Civil War veterans, which was erected in Detroit between 1873 and 1881. Four years later, Elmina died from dropsy, known today as edema. She was seventy-one. Her funeral at a Pontiac church was well attended, including a large delegation of members of the local Grand Army of the Republic post.

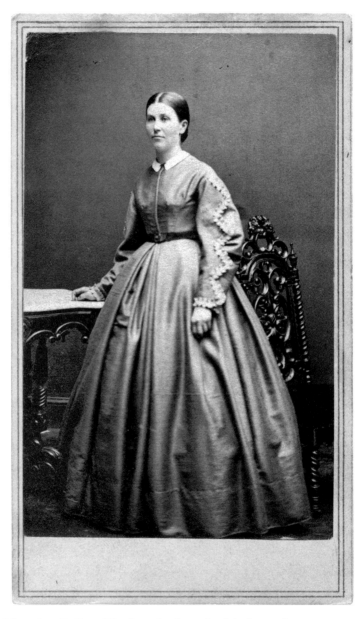

Mary Ann E. Keen Woodworth. *Carte de visite* by Mathew B. Brady (1822–1896) of New York City and Washington, D.C., about 1862–1864.

Foard Collection of Civil War Nursing

A Soldier in the Army of Nurses

A UNION PRIVATE PASSED AROUND THE PORTRAIT OF A young woman with more than a little pride. "In showing it to my comrades it has been my boast that it was the picture of my sister who has been a soldier as long as I have," he wrote during the war.[94] The private, farmhand Thomas E. Keen of the First Nebraska Infantry,[95] initially had no plans to join the army. But the combination of a lackluster crop and a call to arms from the territory's governor prompted his enlistment on July 3, 1861. A few weeks later and nine hundred miles east in his native state of Pennsylvania, Thomas's older sister Mary Ann, age twenty-five, joined the army of nurses. She had been living in Pittsburgh with her parents, Lewis and Susannah, when the war began. Though her exact motivation for enlisting is not known, evidence suggests that neither she nor her brother was aware of the other's decision to serve.

On July 23, 1861, Mary Ann reported for duty at Seminary Hospital in Georgetown in the District of Columbia. She remained on duty there for the next two-and-a-half years, tending to patients wounded from many of the major battles fought in the East. During this time, she kept up a lively correspondence with her brother. Some of his letters to Mary Ann have survived, and they reveal her concerns for his welfare as he and his comrades garrisoned various outposts in southern Missouri and eastern Arkansas.

In August 1862, Thomas wrote from camp near Helena, Arkansas: "I heartily reiterate your wish of being close enough to you so as you could send me a box of 'goodies,' but if you have them to spare give them to some other soldier and believe me there is nothing encourages a soldier more than such small attentions. It makes him feel that he is remembered at home."[96] In this same

letter, Thomas compared Mary Ann's assessment of care during the Peninsula Campaign with his own experience at the recent Battle of Shiloh: "I am much pleased with your description of the kind treatment of the poor wounded in the battles before Richmond. What a difference between that and the treatment of the wounded of Shiloh. There many of our wounded laid for days in tents and on the river bank for days without hardly anything to eat or drink, their wounds undressed and uncared for. The sanitary committees of Ills. and Ohio found them in a horrible condition, both friend and foe. They soon had things fixed a little different. Really, if it was not for those kind and good sanitary committees, the sick soldiers of the west would fare badly."[97] A year later, in May 1863, Thomas wrote to Mary Ann and referred to her as a soldier. He added, "Us western soldiers have great respect for you nurses. In all my wanderings, and I believe I have been in every hole occupied by our troops in the west, I have never seen but six lady nurses in hospitals."[98] The photograph he shared with his comrades on this and other occasions may be the *carte de visite* pictured here.

Thomas left the army in August 1864, when the regiment concluded its three-year term. Mary Ann continued on at Seminary Hospital until November 1864, when she transferred to Chesapeake General Hospital in Old Point Comfort, Virginia, part of the sprawling complex of care facilities in the vicinity of Fortress Monroe.[99] She remained until July 1865, when she was discharged after almost four years of service. Mary Ann made Washington her home after the war and clerked for a time in the Treasury Department. In 1870 she married fellow clerk Milton Woodworth. A few years later, they became parents to George, their only child. Mary Ann maintained a low profile in the nation's capital. Records indicate she did not participate with her sister nurses in reunions or related activities. This may be explained by nervous exhaustion, with which she claimed to have suffered after the war.[100] Despite that condition, she lived until age eighty-six, dying in 1922. Her husband and son survived her. Brother Thomas, her reliable correspondent during the war, died in 1908.

The Strong, Silent Type

CIVIL WAR HISTORY HAS ITS SHARE OF STORIES OF FIGHTing men who personified the strong, silent type. Long on courage and short on words, they could be found in the thickest of battles, performing deeds of valor. They were born leaders, at their best in the worst situations. At least one woman also perfectly fit that persona: Anna Etheridge. Known as "Gentle Annie" or "Michigan Annie" to the troops, one admirer described her as "thoroughly modest, quiet, and retiring, while her habits and conduct are correct and exemplary. Though on the battle-field she seems to be possessed and animated by the single desire of saving the lives of wounded men, she seldom speaks of herself, or refers to anything she has done."[101] A daughter of Detroit, Anna faced adversity during her youth. She survived the early and untimely death of her mother. She endured tough times when her blacksmith father fell into financial straits and moved to Wisconsin for a time. A marriage in her teens to David S. Kellogg ended in estrangement.[102] Just after the Civil War started, so a popular story goes, Anna became one of nineteen *vivandières* who accompanied the newly formed Second Michigan Infantry to the East. True to character, Anna outlasted them all. And her exploits became legend.

She had her first exposure to enemy fire in northern Virginia on July 18, 1861, when she tended the wounded during an engagement along Bull Run at Blackburn's Ford. A few days later, the much larger Battle of Bull Run ended in Union defeat and a withdrawal to the defenses of Washington, D.C. Anna and her brother Michiganders soon moved across the Potomac River to Alexandria, Virginia, and settled into quarters for the cooler months. In March 1862 she married James Etheridge, an original member of the regiment who had recently been discharged

Lorinda Anna Blair Kellogg Etheridge Hooks. Tintype by an unidentified photographer, about 1863.

Foard Collection of Civil War Nursing

for disability. About this time the Second left winter camp with the rest of the Army of the Potomac on the full-scale invasion of Virginia known as the Peninsula Campaign. Anna participated as a volunteer with the Hospital Transport Service, a fleet of vessels operated by the U.S. Sanitary Commission. On the *Knickerbocker*, she tended sick and wounded soldiers shuttled from various landings to Washington-area hospitals.

After her work on the transports ended in early August 1862, Anna rejoined her regiment and returned with it to Bull Run for the second major battle fought there in less than a year. During the hostilities, noted a writer, Anna knelt alongside a fallen soldier and was bandaging his wounds when a gruff voice startled her. She looked up and saw Brig. Gen. Phil Kearney, the popular and courageous career officer who had suffered the loss of an arm during the Mexican War. He answered Anna's look of astonishment with words of encouragement: "That is right; I am glad to see you here helping these poor fellows, and when this is over, I will have you made a regimental sergeant."[103] A rebel bullet found Kearney before he could act, and his promise went unfulfilled.

Anna continued on and suffered the rigors of army life without complaint. According to one biographer, she kept everyone at arm's length: "With strangers she is very reticent, and has a reserve and apparent pride of manner. With the soldiers, though sharing all their hardships, she never spoke familiarly, and was held by them in the highest veneration and esteem, as an angel of mercy. While the contest was going on, she took the deepest interest in the issue, eagerly reading all the newspapers that she could find in camp, and keeping well informed as to the progress of the war."[104]

In early 1863, the Second received orders to go West. Anna decided to remain in the East with the Army of the Potomac and transferred to the Third Michigan Infantry. Husband James rejoined the army as a private in the Seventh Michigan Cavalry. His tour of duty ended later in the year, after he deserted and disappeared from Anna's life.[105] Meanwhile, Anna's deeds had become the stuff of legend. "At the commencement of a battle, she

fills her saddle-bags with lint and bandages, mounts her horse, and gallops to the front, passes under fire, and regardless of shot and shell, engages in the work of staunching and binding up the wounds of our soldiers," recounted the writer of a letter widely published in newspapers. "On many occasions her dress has been pierced by bullets and fragments of shell, yet she has never flinched and never been wounded."[106] The writer added, "If England can boast of the achievements of a Florence Nightingale, we of America can present a still higher example of female heroism and exalted acts of humanity in the person of Anna Etheridge."[107]

Anna added to her laurels at the Battle of Chancellorsville on May 2, 1863. Though accounts of her exact movements vary, one version holds that she rode out with skirmishers and, on making her way back, shouted words of encouragement to entrenched Union troops. They cheered in reply, and the huzzahs caught the attention of nearby Confederates, who let loose a volley. Anna moved quickly to the rear of the line, paused near a tree, and turned her horse to observe the situation. As she did so, an officer on horseback pushed between her and the tree just as a second enemy volley erupted. One bullet struck the officer and he toppled from the saddle, his lifeless body striking Anna before falling to the ground. In a moment another bullet hit Anna in the hand and tore through her dress, then continued on and wounded her horse, which took off in a frightened panic through dense woods. Anna held on to the pommel and managed to avoid being knocked off her mount by low-hanging branches. The horse emerged from the woods into a mass of Union soldiers, who checked its advance and cheered Anna once more.[108]

Two weeks later, Anna received the Kearney Cross for her bravery. "This cross is in honor of our leader and the wearers of it will always remember his high standard of a true and brave soldier and will never disgrace it," noted Brig. Gen. David B. Birney, who led Kearny's division.[109] Birney awarded the commendation to thirty-five members of the Third and hundreds more from other regiments in his command. Anna was one of two women to receive the honor. The other, Mary Tepe,[110] served as a *vivandière*

in the 114th Pennsylvania Infantry.[111] Anna again proved her battlefield bravado at Gettysburg. A Pennsylvanian recalled seeing her on horseback and in uniform as she directed care for the wounded near the Trostle House on July 2, 1863: "She was cool and self-possessed and did not seem to mind the fire," the soldier noted.[112] A Maine soldier also observed her in this same sector of the battlefield: "I remember the wounded crying for water, and that noble woman, Anna Etheridge, trying to alleviate their sufferings. I have seen her under fire riding along as unconcerned as the headquarters staff."[113] Fantastical stories of Anna's battlefield heroics added to her mystique. Anecdotes of her in command of troops, riding off into the thick of battle astride her trusty horse and rallying troops with the Stars and Stripes in hand, firing muskets, capturing Confederates, and other feats can be found in newspapers and books.

Tall tales to the contrary, Anna had her limits. In an episode during the fighting along the Boydton Plank Road outside Petersburg, Virginia, in October 1864, she became disoriented in the chaos and confusion as battle lines ebbed and flowed. "The surgeon advised her to accompany him to safer quarters; but she lingered, watching for an opportunity to render assistance. A little drummer boy stopped to speak to her, when a bullet struck him, and he fell against her, and then to the ground dead," noted a biographer. Eerily similar to the death of the officer next to her at Chancellorsville, the shock spooked her, and she sprinted toward the front lines. Anna soon came to her senses and returned to safety.[114]

Anna remained with the army until July 1865, ending her storied service with the surviving members of the Third, who had been consolidated with Michigan's Fifth Infantry. She left with an impressive record of participation in more than two dozen battles and the appreciation of many soldiers. They included one of the Army of the Potomac's most beloved leaders, Maj. Gen. Winfield Scott Hancock. "She was with a regiment in my corps, and came occasionally under my eye, and more frequently under my notice," he observed. "It was universally acknowledged that her services

were valuable and disinterested; especially valuable, because it was well understood that she was respected by both officers and men, from the highest in rank to the lowest."[115]

Anna settled in Washington and clerked for the U.S. Treasury. Talk of a memoir never materialized, though other authors prominently mentioned her in their writings. In 1868, she put her personal affairs in order after she annulled her marriage to second husband James on the grounds that her first husband, David, still lived. She then divorced David and resumed her maiden name, Anna Blair. Two years later, she married Charles Hooks, a watchman who also worked at the Treasury Department. A war veteran who had enlisted as a private in the Seventh Connecticut Infantry, his service had ended abruptly in June 1862 when grapeshot shattered his left arm at the Battle of Secessionville in South Carolina. Surgeons amputated the mangled limb above the elbow.[116]

The marriage eventually cost Anna her job after the enactment of a policy that prohibited two individuals from the same family from holding government offices. Charles remained on duty in the U.S. Treasury for many years and died in 1910. Three years later, Anna joined him in death. She was seventy-three. Her remains were interred alongside Charles at Arlington National Cemetery. The Anna Etheridge Tent No. 58, Daughters of Union Veterans, in Long Beach, California, was named in her honor.

A Heroine among Heroes

Frances "Fanny" Ricketts peered out the second-story window of the stone house and glanced at a single severed leg beneath a tree in the yard. She turned away, her anxiety rising, and gazed upon her prostrate husband. He lay next to her in a room swarming with flies buzzing through air thick with the effluvia of blood and death. Her eyes paused at his grotesquely swollen left leg, where rebel lead had shattered the bone near the knee joint.[117] This moment passed on July 27, 1861, the third day of an odyssey that pushed the limits of Fanny's endurance—and made her, according to one wartime newspaper, a "heroine among the heroes of the war for the Constitution."[118]

Looking back, Fanny's life read like a novel. Her father, former British naval officer J. Tharp Lawrence, came to America on the hunt for new opportunities after he squandered a family inheritance built on the backs of hundreds of slaves on a Jamaican plantation. Her mother, Julia, was remembered as a keen observer, wise beyond her years. Her father died in 1847, and the boarding school established by her widowed mother supported Fanny and her nine brothers and sisters.[119] In 1856 Fanny married dashing career artillery officer James Brewerton Ricketts, a West Point graduate, Mexican War veteran, and widowed father with a young daughter.[120] Frontier army experiences along the Rio Grande in Texas followed, where she endeared herself to the soldiers of her newlywed husband's battery of the First U.S. Artillery with random acts of kindness and care of the sick—one of the few bright spots in a grim garrison existence.[121]

In late 1860, military officials summoned James and his men back East as growing political and military tensions inched the country closer to open hostilities. Meanwhile, in South Carolina,

Frances Ann Lawrence Ricketts and James Brewerton Ricketts.
Carte de visite by Mathew B. Brady (1822–1896) of New York City
and Washington, D.C., about 1862–1864.

Collection of Tom Glass

another battery of the First Artillery found itself at the center of the conflict. Commanded by Maj. Robert Anderson,[122] it garrisoned Fort Sumter. On April 12, 1861, rebel forces launched a massive bombardment of the fort that compelled Anderson's surrender and inaugurated civil war. In Washington, D.C., authorities moved quickly to establish a defensive perimeter. James and his battery numbered among the units detailed for this duty. Fanny took up residence in the city with their young daughter, who had been born in Texas.

Three months later, on July 21, 1861, James and his men participated in the first large-scale battle of the war near Manassas Junction in Virginia, a mere twenty-five miles from the capital. Anxious Washingtonians learned of the stunning defeat of the Union troops later that day as disorganized masses of exhausted soldiers stumbled into the capital with the news. They also brought back word to Fanny that James had been killed. She listened at first with disbelief to vivid descriptions of his wounds and death. Then Col. Edward D. Baker arrived,[123] bearing James's sword and a message: "Give this to my wife; tell her I have done my duty to my country, and my last words are of her and our child." How Baker came into possession of the sword is not known. According to a wartime interview with Fanny, an unnamed comrade found James after he had been hit: "'Take my sword,' said he, 'cut it off, and carry it to my wife; *I will never surrender it*, tell her I died defending the flag of my country.'"[124] The comrade may have been either Baker or someone else who then passed the sword and the message to him.

Following this devastating news, Fanny met with one of James's subordinates, 1st Lt. Edmund Kirby.[125] Choked with emotion, the young West Point graduate told Fanny of the fruitless search for his captain's remains. Two days later, Fanny received a telegram that shed new light on James's fate. The sender, James S. Wadsworth, a volunteer aide to Union army commander Irvin McDowell,[126] informed her that James had survived the battle, suffered dangerous wounds, and fallen into enemy hands. He had been injured in the arm, shoulder, and knee while in command of

his battery. His cannon had also been captured. None of the men involved in this drama—Baker, Kirby, and Wadsworth—lived to see the end of the war.

Less than twenty-four hours later, on the morning of July 25, Fanny left her daughter in safekeeping and rode in search of James. Armed with a basket of food and a military pass, she departed Washington in a light carriage drawn by two horses and driven by a man with Southern sympathies. The carriage rolled through the Virginia countryside and passed into Confederate territory. At some point, Southern cavalrymen rushed the vehicle, shouts and curses spewing from their mouths like artillery fire. "Shoot her; she is a damned Yankee; shoot her," they screamed, with muskets pointed.[127] They did not shoot, however. Following a tense negotiation, they allowed Fanny to continue on her mission of mercy. There were more stops and starts throughout the day and into the evening before she arrived at the headquarters of Brig. Gen. Joseph E. Johnston, who had played a critical role in the victory at Manassas. The general and his subordinates received Fanny with restrained courtesy, informed her of James's whereabouts, and provided her with lodging for the night.

The next morning, Fanny set out for a short ride to Portici, a stately home occupied by Johnston during the battle and now a hospital. Human remains littered the grounds around the residence, including a pile of corpses, rotting in the broiling sun, that provided a feast for local hogs. She entered into a house of horrors and found some forty men in various stages of life and death. Putrid smells struck her like a cannon blast. Blood streamed from wounds and pooled on the floors. One man lay on a table as medical personnel sawed off his leg. Two more legs previously separated from their owners lay at the base of the staircase, where she paused to allow attendants, carrying two bodies, to pass by her. Fanny made her way upstairs, her clothing flecked with gore as she turned into her husband's room. She found him on a stretcher, covered in blood. By now it was four days after he had suffered his wounds.

Thus began an eight-day ordeal at Portici as James clung to life. In her diary, Fanny never mentioned the injuries to his arm and shoulder, which suggests they were minor. But the swollen, distorted leg caused her grave concern. She feared the doctors would remove it. "One Surgeon, the principal one I understood, was heard to remark that he wished it was as easy to cut out the damned Yankee's hearts as it was to cut off their legs," she told an interviewer.[128] James kept the leg, thanks in part to Fanny's care. With the help of other, less seriously wounded prisoners, she cleaned the room, using fireplace ash to absorb the blood on the floors before sweeping it away. A makeshift table constructed of two planks provided a semblance of home life. Kindly Confederates shared food and drink.

During the wee hours of August 3, Fanny and James left Portici for Richmond. Their departure could not come soon enough for Fanny, who knew that without proper nourishment and better care, James would not survive. The train trip to the Confederate capital lasted all day and into the night. The herky-jerky motion of the engine and cars as it rolled along the tracks left Fanny's back aching and increased her fear for the well-being of her husband. In a stop at Gordonsville, a new enemy emerged, in the form of curious citizens anxious to see captured Yankees. Fanny drew special attention because of her gender. Hate-filled townspeople filed aboard, tugged at her dress sleeves, and hurled insults and abuse. Finally, Fanny confronted the lieutenant in charge and asked him if he intended the car they occupied to be some kind of menagerie. The officer apologized and cleared the car.

There were many more curiosity seekers in Richmond after the train arrived that night. After considerable delays, authorities transferred Fanny and James to the city poorhouse, which had been converted into a prison. Here Fanny broke down for the first time since leaving Washington. She soon gathered herself together, however, and made the best of a new situation. The conditions were miserable, though much better than the horrors of Portici, thanks in part to the assistance of some Catholic Sisters

of Charity and other benevolent individuals. Their ordeal ended in late December 1861, when Union and Confederate authorities exchanged James for artillery colonel Julius De Lagnel, a New Jersey native who had settled in Virginia and cast his lot with the South. He had been captured by Union forces shortly after the Battle of Rich Mountain, in western Virginia. The *Richmond Examiner* announced the exchange in its December 18 issue and also mentioned Fanny, who "voluntarily came and surrendered herself as a prisoner of war, in order that she might be in attendance upon her wounded husband. This service she has rendered unremittingly since that time, and, judging from the captain's condition when the reporter saw him on a recent occasion, she will have to continue it for many months in Yankee land."[129] She did, and James completed his recuperation by the spring of 1862, when he received a promotion to brigadier general and returned to active duty.

He became a casualty twice more. During the Battle of Antietam in September 1862, he reinjured his left leg after enemy fire struck down the horse he sat on. Two years later, in the Shenandoah Valley, he suffered a near-fatal wound when a bullet hit him in the right chest at Cedar Creek. Fanny came to his rescue for the second time during the war. In an eerie repetition of her Bull Run experience, Fanny rode in company of a single escort from Washington through hostile territory—this time threatened by Col. John Singleton Mosby and his cavalry raiders. She made it unharmed to her husband's side and nursed him back to health. She was not able to save her daughter, however, who succumbed to disease in November 1864.[130] James returned to duty in time to participate in the final dramatic days of the Appomattox Campaign. He remained in the army until 1867 when, weakened by his war wounds, he retired. James died in 1887 at age seventy.

A careful journal keeper, Fanny faithfully recorded her five months as a volunteer prisoner. Much of the story in this profile is taken from a transcript of that diary. The facts as she noted them are substantially the same as those in an interview published in at least two New York newspapers in June 1862, as well as in the

1867 book *Women of the War*. Fanny later gave birth to two more children, daughter Frances in 1867 and son Basil in 1868. Both lived to maturity. Fanny remained in Washington after James died and lived a relatively quiet life until she passed away in 1900 at age sixty-six. Her remains were interred alongside James in Arlington National Cemetery.

Jessie Ann Benton Frémont. *Carte de visite* by Edward (1819–1888) and Henry (1814–1884) T. Anthony, about 1863.

Collection of the Missouri History Museum, St. Louis

The "She-Merrimac" Sails to Victory

As she visited soldiers in the military hospitals of St. Louis, Jessie Benton Frémont witnessed the horrors of war firsthand. The trips may have inspired her to observe, in the autumn of 1862, "The restraints of ordinary times do not apply now. How many women—many of them rich in the good gifts of youth and beauty, and charm of mind—minister daily at the bedsides of men whose very names are unknown to them."[131] Jessie, thirty-eight, held strong opinions on many important subjects of the day, for she followed in the footsteps of her father, Sen. Thomas Hart Benton of Missouri. A political giant on the national stage, he is remembered as an early and outspoken voice for the westward expansion of U.S. territory that later became known as Manifest Destiny. The doctrine resulted in the migration of large numbers of settlers from the East and the midwestern frontier, and a massive disruption and displacement of Native Americans. Benton's interactions with prominent leaders across the financial, literary, and scientific landscapes shaped Jessie's outlook. "From the beginning, she had a sense of movement in a large world, with several poles," observed historian Allen Nevins.[132]

One of those poles was Washington, D.C., Virginia-born Jessie's home during her father's five-term service as U.S. senator from Missouri. A rebellious child, described as precocious and a tomboy, she enjoyed a formal education that left her fluent in several languages and steeped in science and the humanities. She honed her political savvy early on as a substitute hostess for her mother, a partial invalid. Jessie played the part well, bringing into play a low, sweet voice and a smile reported by one admirer as "peculiarly fascinating."[133]

Meanwhile, a dashing young Southern soldier with ambitions

to survey the uncharted West had traveled to the capital city to meet Jessie's father in his capacity as chairman of the Senate Committee on Military Affairs. John C. Frémont also met Jessie—and romance ensued. In 1841, then sixteen-year-old Jessie eloped with John, who was a dozen years her senior. Her father strenuously opposed the marriage but eventually came around and became the young man's powerful patron. Jessie and John formed a dynamic duo. Their meteoric rise in the public eye stands as a testament to their enduring partnership. By the mid-1850s, John had logged in successful explorations of the West and a pioneer role in the new state of California. With Jessie's help as a writer, advisor, and confidant, they crafted a narrative that portrayed the West as a jewel and John as the accomplished soldier and statesman who reveled in its beauty.[134]

When the fledgling Republican Party cast about for a candidate in the 1856 presidential contest, it turned to John. The *New York Times* reported that "'The Path-Finder of the Rocky Mountains,' the chivalric John C. Frémont, the type and embodiment of Young America," was nominated on the first ballot by convention delegates.[135] As the campaign unfolded, the slogan "Frémont and Jessie too" took hold. "If the gallantry of the country demanded a Queen at the head of the nation, the lovely lady of the Republican nominee would command the universal suffrages of the people. She is a woman as eminently fitted to adorn the White House as she has proved herself worthy to be a hero's bride," boasted one Frémonter in an editorial headlined "Give 'em Jessie."[136]

The Frémonts did not win the White House.[137] But the campaign catapulted them into the national spotlight as the darkness of war approached. After hostilities erupted in 1861, President Abraham Lincoln promoted John to major general and appointed him to command the Department of the West, with headquarters in St. Louis. In this capacity, John declared martial law in Missouri on August 30, 1861. The proclamation included a section that freed the state's slaves. The decree was perhaps expected, as John and Jessie were ardent abolitionists. Yet the news landed

at the White House with a thud. Lincoln chafed at being painted into a diplomatic corner. He fretted that Missouri, a border state packed with Southern loyalists, might leave the Union at the slightest provocation, so he moved to countermand the offending section of the decree.

John's interference in the emancipation question went down in history as a blunder that forever tarnished the reputations of the Frémonts. It also overshadowed another event that unfolded at the same time—Jessie's efforts to aid suffering soldiers. As Lincoln's directive wound its way to St. Louis, Jessie had focused on a humanitarian crisis as growing numbers of sick and injured Union soldiers poured into the city. Already involved with the local Ladies' Union Aid Society, she brought her political and military influence to bear in support of a larger relief organization with a regional scope. A committee of five prominent civic leaders drafted a plan and submitted it to John's medical director, Samuel De Camp.[138] According to Rev. William G. Eliot,[139] a committee member who delivered the document to De Camp, the veteran surgeon endorsed it with the stipulation that it be formally authorized by John. Eliot recounted, "I took it directly to headquarters, where, at my request, it was copied by Mrs. Frémont, and taken by her to the general's office. He was surrounded by earnest and excited friends, having just received the countermand of conditional emancipation in Missouri; but he examined it, and, after learning that it met the approval of the medical director, he submitted it to his chief of staff, and then signed it."[140]

The plan, now formalized as Special Order No. 159, established the Western Sanitary Commission. Jessie's fingerprints were all over the document. Its eleven provisions included the employment of women caregivers to be commissioned by Dorothea Dix, the all-powerful superintendent of nurses in Washington, D.C. Jessie had already reached out to Dix and made arrangements for her to visit St. Louis. The new organization received praise and criticism. Supporters viewed it as a progressive leap forward to provide care for soldiers. Detractors worried that its indepen-

dence would drain resources from the already established U.S. Sanitary Commission. Both groups ultimately flourished, receiving widespread support from the Northern populace.

Though Jessie played a key role in the birth of the Western Sanitary Commission, she had no time to bask in its success. She soon left for Washington in what became a failed attempt to persuade Lincoln to reconsider his countermand. Less than two months later, Lincoln revoked the proclamation and removed John from the Department of the West. His brief and controversial tenure ended with Missouri firmly in the Union. Effectively shelved, John eventually resigned his commission and left the army. Jessie continued on, full of fight. Her friend and staunch supporter Thomas Starr King commented in the spring of 1862, "She is sublime, and carries guns enough to be formidable to a whole Cabinet,—a She-Merrimac, thoroughly sheathed, and carrying fire in the genuine Benton-furnaces."[141] Jessie compared herself to a vessel in a quote attributed to her by numerous sources. "I am deeply built like a ship," she reportedly said, "I drive best under a stormy wind."

In early 1863, a collection of previously published articles defending her husband's actions in St. Louis was printed in book form as *The Story of the Guard: A Chronicle of the War*. The conclusion included Jessie's comment about the somewhat novel role of female nurses quoted at the beginning of this profile, adding that readers should "not think this attempt to relieve suffering [is] more unwomanly or less needed than any of the other new positions in which women are finding themselves during this strange phase of our national life."[142] Her book failed to resuscitate her husband's reputation or revive the upward momentum of their public lives. Still, Jessie remained active in her work with the Sanitary Commission throughout the rest of the war, raising much-needed dollars that touched the lives of uncounted Union soldiers who sacrificed themselves for the cause.

Jessie continued to write, and she did so with urgency after John's unwise business speculations ended with bankruptcy in 1873. Various stories, sketches, and memoirs were published in

the popular magazines of the day and in book form. "Her warmth of feeling, romantic touch, and the ability to dramatize situations lighted up her wealth of memories and made her work popular," noted historian Nevins.[143] Proceeds from these ventures helped rehabilitate their family finances and support her three children and an adopted daughter. After John died in 1890, the federal government awarded Jessie a pension that allowed her to live in relative comfort in Los Angeles until her death in 1902 at age seventy-eight.

Her passing made national headlines. One writer declared, "There is no possible question that Jessie Benton Frémont was the greatest woman in the history of the West," and added, "No other woman in the history of America has had the like influence upon the destiny of any portion of the Union."[144] She was also remembered as much for her accomplishments as, in the words of one newspaper, "the reverse of that passage from obscurity to fame which is the common history of American celebrities."[145] Lost in the tributes was her victory in establishing the Western Sanitary Commission.

Modenia R. Chadwick McColl Weston. *Carte de visite* by an unidentified photographer, about 1861–1865.

Collection of the U.S. Army Heritage and Education Center

Mother of the Regiment

MEASLES AND OTHER CONTAGIONS WERE A GRIM RITE OF passage in rookie regiments. The Third Iowa Infantry was no exception. By October 1861, just a few months into its service, the ranks had been thinned from 965 to just 300 men. One individual who helped the boys through the health crisis was forty-four-year-old Modenia McColl. An unpaid volunteer, her service in this and other efforts on behalf of the Iowans earned her the unofficial title "Mother of the Regiment."[146] She also happened to be the biological mother to one of its soldiers, Daniel, a corporal in Company F.

Born Modenia Chadwick in Albany, New York, details of her early life are sketchy. She married John McColl and moved to Ohio, where their three sons were born in the 1840s. At some point during the following decade, the family relocated to Iowa. By 1860 her husband had died, and she lived with a brother and his family in West Union, a township in the northeastern part of the state. She worked as a tailor.[147]

In May 1861, just weeks into the Civil War, Daniel joined the Third Iowa Infantry. In her brief memoirs, which were published in the 1895 book *Our Army Nurses*, Modenia reported her arrival at the regimental hospital near the Third's Missouri camp in September 1861. Though she did not explain why she made the several-hundred-mile trip from Iowa to Missouri, the probable reason was Daniel, who, like many of the men, had fallen ill. In November, Modenia accompanied the regiment to Benton Barracks in St. Louis. By this time a full-blown outbreak of measles had swept through the ranks. "I was the only women connected with the Department, and I had my hands full," she recalled as she labored throughout the winter months.[148] Meanwhile, various

camp diseases compromised Daniel's health. He left the regiment in February 1862 with a disability discharge, eventually recovered from his ailments, and went on to live a long and productive life.

Modenia remained with the regiment and was present when the men went into action at the Battle of Shiloh, or Pittsburgh Landing, on April 6, 1862. She worked until 11 p.m. binding up wounds on the battlefield, then made her way to a steamer docked at the landing to continue her caregiving. Her work with Shiloh patients from the Third and other regiments continued for months at various hospitals. During this period, she made the acquaintance of other female volunteers. Eventually she became part of a team of nurses stationed in Jackson, Mississippi.

In the spring of 1863, Modenia was called first to Memphis and then on to Washington, D.C., by Dorothea Dix. The draconian superintendent of army nurses commissioned Modenia as a full-fledged nurse on April 20, 1863, and placed her on the government payroll. Before long, Modenia returned to Memphis and reported to a smallpox hospital to serve as its matron, or chief administrator. She remained on duty there until discharged in October 1866. Modenia married a man named Weston and eventually settled in Bay Saint Louis, Mississippi, where she died in 1898. She was eighty-two years old.

The Beloved Mrs. Colfax

When Harriet "Hattie" Colfax stepped into City General Hospital in St. Louis one November evening in 1861, she ended an arduous trip from her Indiana home. She also began a life-altering journey as a nurse. That same evening, soon after she checked in with the night nurse, Hattie first glimpsed wounded soldiers. The sight profoundly inspired her. "The thought of their sufferings, and of how much could be done to alleviate them, made her forget herself, an obliviousness from which she did not for weeks recover," noted a biographer.[149]

Hattie inherited her compassion from her family. As a girl, she often accompanied her mother Mary, a benevolent, selfless woman who routinely assisted sick neighbors. As Hattie gained experience and confidence, her mother sent her off on various errands in the vicinity of their home in Michigan City, Indiana. Hattie's father, an invalid, was a supportive parent until his early death. By the time she was a young woman, Hattie displayed the same caring instincts as her mother. In 1854, Hattie wed a promising newspaperman, Richard W. Colfax, said to be a cousin of influential Indiana politician and future vice president Schuyler Colfax.[150] The marriage ended tragically when Richard died less than two years later. Hattie, a widow at twenty-five, moved in with her mother.[151]

Meanwhile, the Civil War began. In the summer of 1861, the Western Sanitary Commission was formed in St. Louis to care for the rapidly growing numbers of sick and wounded soldiers. Its administrators called for able-bodied women to serve as nurses. Hattie applied for and was offered a position, overcoming significant opposition to her enlistment from friends and family.

Harriet Reese Colfax Stevens. *Carte de visite* (unmounted) by an
unidentified photographer, about 1861–1865.

Collection of the U.S. Army Heritage and Education Center

On October 31, 1861, she left Michigan City, located on the shores of Lake Michigan, and made the 350-mile journey to St. Louis. Two days later, she went to work in City General Hospital—also known as Fifth Street Hospital—an imposing five-story building constructed of marble. Easily accessible to railroad depots and steamboat landings, the hospital received the sickest and most dangerously wounded soldiers. One Sanitary Commission report described the 450-bed facility as a "really excellent hospital."[152]

Hattie was assigned to the five-room First Ward, located on the ground floor near the reception area. Here she encountered many of the most desperate cases. "She was uniformly the same industrious, indefatigable, attentive, kind, and sympathizing nurse and friend of the sick and wounded soldier," noted Surg. Robert H. Paddock, who worked with her.[153] She also spent time in the basement cooking area, where she supervised the preparation of foods in the diet kitchen.[154] Hattie served in this capacity through July 1862, with the exception of detached duty aboard the hospital ship *City of Louisiana* to aid wounded and sick men from operations around Island No. 10 in March, and the Battle of Shiloh in early April.

In August 1862, Hattie accepted a new assignment as a nurse in Jefferson Barracks General Hospital. She continued her efforts until the end of 1863, worn down and exhausted by more than two years of constant service. One of the surgeons at Jefferson Barracks noted upon her departure, "She has borne an irreproachable character, has been industrious and faithful in the discharge of her duties, and leaves the institution, much to the regret of her friends."[155] Surgeon Paddock, who also worked alongside Hattie at Jefferson Barracks, paid her a high compliment in a letter written soon after the end of the war. "No female nurse in either of the hospitals," he observed, "and there was a large number in each of them, was more universally beloved and respected, than was Mrs. Colfax."[156]

Hattie then returned to Michigan City. In 1867, she married George G. Stevens, a Union veteran and widowed father of three,

who was a dozen years her senior. They spent the majority of their married life in Rushford, Minnesota, where George rose to become a prominent banker and civic leader. Hattie was very involved with church work and other benevolent societies. She died at age eighty-two in 1912, outliving George by about a decade.[157]

The Cairo Angel

THE DAYLONG BATTLE IN THE FIELDS AND WOODS AROUND the Missouri town of Belmont on November 7, 1861, resulted in a nightmare landscape of carnage and debris. The fire from an abandoned Confederate camp, burned by federal forces, had spread, leaving in its wake the charred remains of soldiers. Looted baggage and supplies from the camp lay strewn everywhere, intermixed with discarded weapons, equipment, and more bodies of dead and wounded men untouched by the flames. In the midst of this wreckage, rescue and recovery efforts were underway. Among the hearty souls who scoured the battleground for survivors was a lone woman, holding aloft a makeshift flag of truce fashioned from a stick and a handkerchief. Accompanied by a man of color, she distributed supplies to the wounded and made them as comfortable as possible until medical personnel arrived to treat them.[158] She was twenty-nine-year-old Mary Jane Safford, later known as "the Cairo Angel." Mary A. Livermore, a friend, journalist, and woman's rights advocate,[159] described her as being "very frail, *petite* in figure as a girl of twelve summers, and utterly unaccustomed to hardship."[160] Yet she possessed a remarkable degree of grit and determination, and an underlying Universalist faith, that fueled her humanitarian instincts.

Mary's base of operations lay a score of miles north, in Cairo, Illinois. Located at the confluence of the Mississippi and Ohio Rivers in the southernmost tip of the state, the town was flanked by Missouri and Kentucky. Both states had significant populations of pro-slavery secessionists, and their adherence to the Union was an open question. Cairo's strategic value attracted federal army and navy forces. The first soldiers were ordered in shortly after

"THE CAIRO ANGEL."

Photographed for "*The Heroines of the Civil War*," to be published soon by N. C. MILLER, New York.

Dr. Mary Jane Safford. *Carte de visite* by an unidentified photographer, about 1864.

Foard Collection of Civil War Nursing

64

the surrender of Fort Sumter, and more than twelve thousand troops were quartered in the area by June 1861.

Mary acted on her own initiative, without organizational support, to establish nursing and hospital care for the rapidly growing soldier population. She was a one-woman relief agency. According to Livermore, "she commenced her labors immediately when Cairo was occupied by our troops. If she was not the first woman in the country to enter upon hospital and camp relief, she was certainly the first in the West. There was no system, no organization, no knowledge of what to do, and no means with which to work. As far as possible she brought order out of chaos, systematized the first rude hospitals, and with her own means, aided by a wealthy brother, furnished necessaries, when they could be obtained in no other way."[161] The hospitals were crude but functional.

The brother who helped fund Mary's effort was Abner, a prosperous Cairo banker. Another brother, Anson, a politically active businessman in California, went on to become governor of Arizona Territory. All three had relocated from their birthplace in Hyde Park, Vermont, to Crete, Illinois, in the late 1830s with their parents, for a fresh start as farmers in the burgeoning Midwest. The children went their separate ways after the deaths of their parents in 1848 and 1849. Anson struck out for the Gold Rush in California. Mary returned to New England for her education, lived in Canada for a time, and eventually returned to Illinois and joined her brother Abner in Cairo.[162]

Meanwhile, word of the crude conditions in Cairo spread. On June 8, 1861, another indomitable woman responded. Mary Ann Bickerdyke, a fifty-four-year-old widow seventeen years Mary's senior, arrived on the scene with medical knowledge and considerable organizational skills.[163] Bickerdyke systematized the hospital, first with funds provided by concerned citizens in her hometown of Galesburg, Illinois, and later under the auspices of the U.S. Sanitary Commission. The relief organization was legislated by the federal government ten days after Bickerdyke showed up in Cairo.

Bickerdyke learned of Mary's efforts upon her arrival. She

sought out Mary, introduced herself, and began a new and lasting friendship. The women worked side by side, though Bickerdyke was the dominant personality. Bickerdyke also collaborated with the senior Union officer in the area, an obscure brigadier general named Ulysses S. Grant, with whom she formed a working relationship that spanned the period of war. Mary, who had had her own success facing up to surgeons and officers initially hostile to her involvement, also befriended Grant.

Bickerdyke helped develop Mary's innate abilities, turning her into a proper nurse. Livermore accompanied her on rounds one day. As they entered the first hospital, she observed her friend Mary's routine with patients: "It would be difficult to imagine a more cheery vision than her kindly presence, or a sweeter sound than her educated, tender voice, as she moved from bed to bed, speaking to each one."[164] Mary carried a basket with her on these visits and from it produced writing paper and ink, newspapers, books, crafting supplies, and other items requested by the bedridden men on earlier visits and carefully recorded by her in a memorandum book. Livermore continued, "One hospital thoroughly visited, Miss Safford departed, leaving it full of sunshine, despite its rudeness and discomforts, and hastened home, rejoining me in a short time in 'Hospital No. 2,' with a fresh installment of baskets and goodies—and so on through the whole number. The visiting done for that day, she hurried home with her filled memorandum book, in which had been noted the wants and wishes for the next day, and began anew the marketing, purchasing, cooking, packing, and arranging."[165]

Mary made trips to surrounding camps as well. Her journey to Belmont in November 1861 marked the first time she encountered the wounded from a major battle. A few months later, in February 1862, General Grant's successful capture of Fort Donelson, Tennessee, resulted in thousands of wounded men and prompted relief efforts. According to one account, Mary and Bickerdyke leapt into action within hours of the victory. They boarded steamers hastily outfitted as hospital ships and, in company with fellow nurses, surgeons, and others, traveled up the Cumberland River

to care for the injured. As one writer noted, "Mary Safford made five trips to Donelson with the boats, standing in the snow, her slight form whipped by the wind, directing men who with pick and axe pried and hacked the wounded out of the mud into which they had frozen fast."[166]

The relentless pace of these events, followed by long days in the Cairo hospitals and a brief stint on the transport *City of Memphis*, drove Mary to the brink of collapse. Her health began to fail, and she retired to her brother's home to recuperate. She returned in time to participate in relief efforts following the Battle of Pittsburgh Landing, or Shiloh, on April 6–7, 1862. Livermore recounted how Mary came to receive her nom de guerre: "She was hailed by dying soldiers who did not know her name, but had seen her at Cairo, as the 'Cairo Angel.' She came up with boat-load after boat-load of sick and wounded soldiers who were taken to hospitals at Cairo, Paducah, St. Louis, etc., cooking all the while for them, dressing wounds, singing to them, and praying with them. She did not undress on the way up from Pittsburgh Landing, but worked incessantly."[167]

Shiloh proved to be her last battle. Her health already compromised, she suffered a complete breakdown that confined her to bed for months. In the summer of 1862, at the urging of her brother, she embarked on a tour of Europe to recover her health. Mary came home in the autumn of 1866. The following year, she entered the New York Medical College for Women and graduated with a homeopathic degree in 1869. She then returned to Europe to study surgery. Upon her return to America in 1872, she joined the faculty of the Boston University School of Medicine as a professor of gynecology.[168] Like other leading women of her time, she embraced a reformist agenda. Mary supported the suffrage movement, campaigned against heavy dresses and tight lacing as a health hazard, and embraced a radical doctrine of free love. She was also active in the Women's Educational and Industrial Union, an organization founded to help needy working-class women and children of Boston.[169]

In 1886, Mary's health began to fail and prompted her retire-

ment. She moved to Tarpon Springs, Florida, where she passed away in 1891. She was fifty-six years old. She was survived by two young girls she had adopted and by her ex-husband, Gorham Blake,[170] to whom she was married from 1872 to 1880. Mary's early demise was not a surprise to those who knew her, as her health had been generally frail since the war. Still, her death was met with sorrow. Her hometown newspaper observed, "Years came and went, leaving their traces in her face; but through it all shone ever the light of love, the cheery spirit that never knew defeat."[171]

Dr. Nurse

A CARRIAGE FILLED WITH JELLIES AND OTHER DELICA-
cies bumped along a country road outside Philadelphia one
November morning in 1861, headed on a relief mission for sick
soldiers at nearby Camp Wayne, a Union training and recruit-
ment center. Inside sat the organizer of the expedition, Debbie
Hughes, who lived a few miles up the road in Charlestown. She
happened to be on furlough from her regular duties as a nurse
in the nation's capital. Her sister nurses in Washington would
probably not have been surprised to learn that Debbie used part
of her break to help those in need. One admirer noted, "When the
dark cloud of war hovered over our country, and the call came for
noble, self-sacrificing women to volunteer as nurses to our 'Grand
Army,' she was among the first to answer it—among the first to
give her services; and heroically, faithfully has she labored ever
since for the poor soldier."[172]

Debbie was overqualified for the job. Five years earlier, she
had earned a medical degree from the Female Medical College
of Pennsylvania. Founded in 1850 to establish a career path for
women as doctors, it was the second such institution in the coun-
try. The first, in New England, had been founded in 1848. Debbie
submitted her thesis on cancer in January 1856. Her "Dissertation
on Carcinoma" reveals a keen sense of observation and a passion
for critical study and problem solving.[173]

After she arrived in Washington, D.C., in 1861, Debbie im-
pressed many with her skills as she treated the war's first sick
and wounded soldiers. Among this number of admirers was the
hard-to-please Dorothea Dix, who superintended army nurses
in the city. According to one writer, Debbie "was one of the most
devoted nurses here, and was a great favorite with Miss Dix and

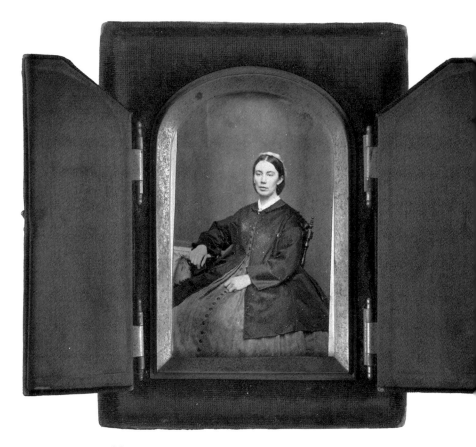

Dr. Debbie A. Hughes. *Carte de visite* by an unidentified photographer, about 1861.

Collection of the Liljenquist Family, Library of Congress

those with whom she was thrown in contact in her labor of love."[174] Debbie was assigned to Columbian College Hospital, where a fellow nurse recalled, "I shall ever remember her dear, pale, interesting face, (which I had a fine opportunity of studying as she sat opposite me at the table.)" The furlough she received in the autumn of 1861 provided her with an opportunity to visit family in Charlestown. When she got wind of suffering soldiers at Camp

Wayne, she characteristically took action. On the morning on November 11, she started out on her relief mission with a sister, Hannah, in a wagon driven by William Williams, a teenager from town.[175]

They never made it to their destination. According to news reports, as the carriage neared a railroad crossing, an approaching train spooked the horse. The vehicle careened toward the tracks, slammed into the engine, and was dragged some twenty feet before breaking loose. Hannah was thrown from the carriage on impact and landed beneath the locomotive. She was crushed to death. William and Debbie, caught up in the leather harnesses and other trimmings, were dragged along with the rest of the carriage. They were found clear of the tracks. William suffered severe injuries that required the amputation of a leg. He died the same day.[176] The doctors who examined Debbie found cuts, bruises, and internal injuries. Despite the serious nature of her injuries, they offered an upbeat assessment of her condition, with hope of a full recovery. As a precaution, Debbie made her last will and testament the same day as the accident. The physicians' initial optimism soon faded, for tetanus set in and she succumbed to the infection a week later. Debbie was thirty-nine. News of her death left many mourners—family, friends, former patients, and fellow nurses. One newspaper summed up her loss when it reported, "The nurse corps of the Army have lost in her one of its most accomplished and kind-hearted members."[177]

Mary Ann B. Young. *Carte de visite* (unmounted) by unidentified photographer, about 1861–1865.

Collection of the U.S. Army Heritage and Education Center

Devoted Siblings

SOME OF THE ENDURING IMAGES OF THE WAR ARE ENGRAVings of soldiers, in new suits of Union blue, bidding farewell to their families before marching off to battle. These idealized illustrations are rooted in real-life scenes that occurred across the North. On one upstate New York farm, however, a different drama played out. In the village of Morristown, 1st Lt. James Young left for the South—and his sister came with him. Mary Ann B. Young, unmarried and in her midthirties, followed in an unofficial support role akin to a *vivandière*. Though her exact motivations are unknown, it is easy to imagine that the same patriotic fervor prompting the menfolk in her hometown to enlist also touched her. Perhaps the strongest impulse was devotion to her forty-two-year-old soldier brother, with whom she shared an exceptionally close bond.

Whatever her reasons, she traveled with her brother and his regiment, the Sixtieth New York Infantry, when it left the Empire State in November 1861 for guard duty along Maryland railroads. According to the authors of *Woman's Work in the Civil War*, Mary Ann "took great pride in the regiment, wearing its badge and having full faith in its honor."[178] The following month, measles, typhoid, and other illnesses common to rookie regiments swept through the Sixtieth's camp near Baltimore. Mary Ann helped the sick, alongside loyal Union ladies from the area who had heard about the regiment's sufferings.[179] In the summer of 1862, the New Yorkers were dispatched to Virginia as the spring campaign season heated up. Mary Ann and her brother parted ways at this time, due to concerns about the rigors of life in the field and the very real possibility of battle. "When the Sixtieth went into active service, she entered a hospital at Baltimore, but *her* regiment

was never forgotten," noted the writers of *Woman's Work*, who added that her brother James kept her updated on the regiment's progress in almost daily letters.[180]

Mary Ann remained in Baltimore and tended patients under the direction of Sister Adeline Blanchard Tyler, a prominent nurse and hospital administrator in the city.[181] When Tyler moved to Annapolis, Maryland, to take charge of the Naval School Hospital in August 1863, Mary Ann and other nurses accompanied her. In 1864, Mary Ann suffered a bout with smallpox, and after her recovery she became the point person to care for all soldiers infected with the disease. She saved many lives that otherwise might have been lost. Not everyone under her care survived, and a number of these men were buried in the hospital cemetery. Mary Ann regularly visited their graves and mourned their deaths, for her own identity had become so thoroughly intertwined with that of a soldier's life and larger sacrifice to the Union cause.

Meanwhile, her regiment went on to fight in numerous engagements, including the Battles of Antietam, Chancellorsville, and Gettysburg. The Sixtieth then moved west and participated in the Chattanooga and Atlanta Campaigns and the March to the Sea. Brother James, now a captain and commander of Company C, survived it all. He might have gone on to serve in the Carolinas Campaign, but he received a discharge dated January 12, 1865. On this date in Annapolis, Mary Ann lost a battle with typhoid fever.

The authors of *Woman's Work* shared an oft-repeated quote made by Mary Ann on her visits to the hospital cemetery: "'If I die in the hospital, let me be buried here among my boys.' This request was sacredly regarded, and she was borne to her last resting-place by soldiers to who she had ministered in her own days of health."[182] Her remains were eventually brought to New York and buried in a cemetery in her hometown of Morristown. James lived until 1890.

November 27

C ORPORAL J ONES B. B ONNEY SUFFERED A GRIEVOUS
wound in the spine during the Battle of Belmont in Missouri.[183]
He joined a long list of casualties in his regiment, the Seventh
Iowa Infantry, which lost more than half of the 410 soldiers en-
gaged in the Union victory on November 7, 1861. Sent back to
Iowa, Jones arrived at his home in Denmark, a town near the Illi-
nois border, in helpless condition on November 21. There, his wife
Mary made him comfortable during his last days. He succumbed
to his wound six days later. Mary's marriage ended a month shy
of what would have been their third wedding anniversary. Now
a young widow, she was consoled by her adoptive parents, Isaac
and Mary Field. Isaac, a success in the leather business back East
in Boston, had moved his family, including then three-year-old
Mary, to Iowa in 1838 in search of better health. Evidence sug-
gests they slipped easily into rural life, becoming active in the
intellectual and spiritual life of Denmark.[184]

Religion was an important part of Mary's upbringing, as evi-
denced by her father's role as a deacon in the local Congrega-
tionalist church. So when she decided to contribute to the war
effort as a nurse, it is perhaps not surprising that she offered her
services to the U.S. Christian Commission. Mary began her mis-
sion as a commission delegate on January 21, 1865. Though the
war was in its final months, military hospitals were packed with
patients in need. She spent her first weeks at Foundry Hospital in
Louisville, Kentucky, and, after it closed, commission authorities
reassigned her to Little Rock, Arkansas. There she reported to
the U.S. General Hospital on the campus of St. John's College,
which had been a Confederate medical facility prior to Union
occupation in September 1863. According to the physician in

Mary Ellen Green Bonney Hancock. Tintype by an unidentified photographer, about 1865.

Foard Collection of Civil War Nursing

charge, Surg. Robert M. Lackey,[185] "She performed her duties as a nurse in a most faithful & efficient manner. She was always ready day or night to render aid & comfort to sick & wounded & dying soldiers. She with one other was the only female nurse in the Hospital which at times contained from twelve to thirteen hundred sick & wounded soldiers. Her services were invaluable."[186] The Christian Commission recognized Mary and others for their missionary zeal, "Many hundreds date the commencement of their new spiritual life to the fidelity of delegates at Little Rock."[187]

In February 1866, Mary ended her service and returned to Denmark. The following year she married Charles Hancock. A minister who had earned a medical degree but never practiced, he had also served with the Christian Commission in the South, though there is no evidence that they met during the war. Mary and Charles rose to become prominent members of Denmark society.[188] Yet Mary's first husband was not forgotten. When veterans formed a chapter of the Grand Army of the Republic in Denmark, it was named the Jones B. Bonney Post, in honor of the first local soldier to die in the war. Mary passed away on November 27, 1918, the fifty-seventh anniversary of the death of Jones.

Harriet Reifsnyder Sharpless. *Carte de visite* (unmounted) by an
unidentified photographer, about 1861–1865.

Collection of the U.S. Army Heritage and Education Center

Happy Day

LATE IN THE AUTUMN OF 1861, AN APPEAL WAS RECEIVED by the townswomen of iron-rich Bloomsburg in Pennsylvania's Susquehanna Valley. Made by the recently established U.S. Sanitary Commission, it requested material support for Union soldiers. A score of volunteers stepped forward. They met at the local Presbyterian church on December 2 and formed the Bloomsburg Ladies' Army Aid Society. Among their number was twenty-four-year-old Harriet "Hattie" Sharpless, a genial young lady with a devotion to her faith and to the Union, rivaling that of any soldier in the field.[189]

Hattie, the eldest of three siblings born to a successful foundry owner,[190] was the second member of her family to step up and serve. Just a few months earlier, the younger of her two brothers, Benjamin,[191] had joined the Sixth Pennsylvania Reserves, also known as the Iron Guards. The regiment mustered into federal service as the Keystone State's Thirty-Fifth Infantry, reported to Virginia's Camp Pierpont, and prepared for the 1862 spring campaign with the Army of the Potomac. Hattie followed the regiment. "She was frequently in their camp," recalled one of the men in her brother's company, and continued with them into the Peninsula Campaign.[192] In a newspaper report, another veteran shared a memory that most likely occurred during the battles along the peninsula: "Many times I have seen her at the front, with the shells bursting on all sides of her, tenderly ministering to the wounded and dying."[193]

At some point, probably in mid-1862, Hattie enlisted her services as a nurse under the auspices of the Sanitary Commission. She spent the rest of the year tending patients in hospitals in Fredericksburg, Warrenton, and Falls Church in Virginia, and in

the vicinity of Sharpsburg, Maryland, after the Battle of Antietam. At the latter locale, Benjamin suffered a wound from which he recovered. It is not known whether he and his sister crossed paths during this time. Hattie embraced nursing. "She is a lady admirably adapted to the hospital-work; tender, faithful, conscientious, unselfish, never resting while she could minister to the suffering, and happiest when she could do most for those in her care," noted a biographer, who added, "Constant and gentle in the discharge of her duties, with a kind and if possible a cheering word for each poor sufferer, and skillful and assiduous in providing for them every needed comfort so far as lay in her power, she proved herself a true Christian heroine in the extent and spirit of her labors, and sent joy to the heart of many who were on the verge of despair."[194] Another source stated, "So sunny was her temperament, always bringing cheer to the soldiers, that she gained the name of 'Happy Day,' which clung to her throughout life."[195] She also adamantly refused to accept pay for her contributions.[196]

Compelled to leave the Sanitary Commission in early 1863 to care for an ailing parent, she returned in May 1864 as matron, or head nurse, of the hospital vessel *Connecticut*. Hattie supervised the care of an estimated thirty-three thousand patients shuttled from the Army of the Potomac's base of operations in City Point, Virginia, to Alexandria, Virginia; Washington, D.C.; Baltimore; and other ports. Hattie served in this capacity until September 1865, when she returned to Bloomsburg and was reunited with her family. She dedicated herself to the care of her aging parents until the deaths of her father in 1900 and her mother in 1901. Hattie died five years later, at age sixty-nine. She was unmarried. Her death was mourned by surviving family members, including nieces and nephews, who called her "Aunt Happy."[197] Veterans of the local Grand Army of the Republic post, who had elected her an honorary member, attended her funeral and buried her with full military honors.

Second to No Woman in the South

The grim realities of war touched Nashville before the end 1861. One of the most visible signs of the cost in blood and treasure in the Tennessee capital could be found in its military hospitals, which overflowed with sick and wounded sons of the South. In early 1862, an urgent appeal by the Soldiers' Relief Society of Tennessee called on citizens throughout the Confederacy for donations of cash and supplies. The society issued the call "with the confident expectation that it will be promptly and favorably responded to by every Southern heart."[198] The appeal bore the signature of charity president Felicia Grundy Porter. The forty-one-year-old Nashville native, noted one of her many admirers, "occupied a place in the public eye second to no woman in the South. Her vigorous mind, strong memory, clear judgment, close observation, studious habits and easy, accurate expression gave her a power that compelled attention and inspired respect and admiration."[199] She inherited these qualities from her father and namesake, Felix Grundy.[200] A respected attorney in the early republic, he had served as a U.S. senator and as attorney general in the cabinet of President Martin Van Buren. A writer compared Felicia to one of Britain's best prime ministers, William Pitt the younger: "If her lot had been cast with the sterner sex, and had been brought to the bar, she would have been a fit representative of her gifted father.—She would have been the younger Pitt of the family."[201]

Despite the gender inequality that ruled in those times, Felicia prospered in a family of wealth and privilege. Still, she suffered sorrow during her early adult years when she buried two husbands. The first, William Eakin, a kind and benevolent Irishman, had risen by his own bootstraps to become a successful

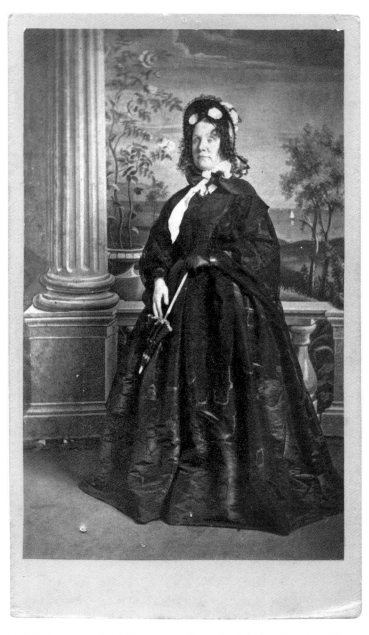

Felicia Ann Grundy Eakin Porter. *Carte de visite* by Theodore M. Schleier (1832–1908) of Nashville, Tennessee, about 1862–1864.

Collection of Dr. Anthony Hodges

merchant.[202] The second, Dr. Robert M. Porter, taught anatomy in the medical department at the University of Nashville.[203] In 1856, he succumbed to blood poisoning, contracted in the dissecting room. Felicia became a widow with a young son, Robert Jr., and two daughters from her previous marriage. Felicia never remarried. She turned her attention to helping the less fortunate of her hometown, most notably orphans. When the war came in 1861, Felicia refocused her energies to support Confederate soldiers. She helped establish hospitals and became president of the Soldiers' Relief Society of Tennessee, one of several such charities formed in the city.

Meanwhile, Nashville was transformed into a beehive of military activity and a major supply and hospital hub. By November 1861, the influx of sick and wounded soldiers taxed local resources. A sister charity, the Tennessee Hospital Association, placed an agent in New Orleans to collect donations from its wealthy citizenry. Felicia's charity followed suit with its own agent and a public appeal "To the Friends of the Sick and Wounded Soldiers of the South." It appeared multiple times in New Orleans newspapers during the fall and winter months.

Both cities soon fell to Union armies. Federal forces captured Nashville in February 1862—the first Southern state capital to be occupied by the enemy. New Orleans surrendered in April. Felicia's exact whereabouts are unknown after the fall of Nashville, but the scant evidence suggests that she remained in the city. During this time she probably continued to support the troops through donations and part of her own sizable inheritance.[204] If Felicia stayed in Nashville, she endured three difficult years of life under Union occupation and the rule of Andrew Johnson, whom President Abraham Lincoln appointed as military governor of Tennessee. One Union writer observed, "Nashville was now a military city. It exhibited many of the features of a conquered city which had been recently relieved from a long investment. It was girdled with a waist of formidable fortifications and encircled by a zone of warlike camps. Its proud capitol, graceful and beautiful, upon the crown of a rocky hill which commanded a charming

prospect of splendid suburbs, and rich mosaic of forests and fields lining the shores of the picturesque Cumberland, was a castle frowning with great guns on its battlements and bristling with glittering bayonets."[205] The occupation ravaged Nashville. A maze of trenches and other defenses scarred the suburban countryside, and picturesque groves and other scenic spots lay wasted.

Felicia went to work with the same vigor after the war as when she entered it. In 1866, as president of the Benevolent Society of Tennessee, she oversaw the collection of funds to purchase artificial limbs for disabled soldiers. Before the decade ended, she became president of the Ladies' Memorial Association. This group raised money for the purchase of a plot of land in Nashville's Mount Olivet Cemetery for the burial of Confederate soldiers. The remains of the 1,500 soldiers were interred in thirteen concentric circles, the first six for soldiers from outside the state, the seventh for unknowns, and the rest for those who served in Tennessee military outfits. On May 16, 1889, civic leaders unveiled a monument in the center of the Confederate cemetery to honor the dead—a final act of respect for the fallen. Felicia, who played a major role in the establishment of the hallowed place, did not attend, due to illness.

Felicia died six weeks later, at age sixty-nine. Her son and daughters survived her. On June 29, 1889, ex-Confederates escorted the hearse that contained her body to Mount Olivet Cemetery for burial. Nashville mourned the loss of one of its most accomplished citizens at a moment in time when the "Lost Cause" narrative embraced the public's memory of the Civil War. According to historian Caroline E. Janney, "the Lost Cause was largely accepted in the years following the war by white Americans who found it to be a useful tool in reconciling North and South."[206] Against this backdrop, Nashville Chapter 1 of the United Daughters of the Confederacy established the Felicia Grundy Porter Auxiliary, Children of the Confederacy. In 1908, Nashville-area chapters of the United Daughters observed Arbor Day by planting trees on the grounds of the Soldier's Home in Nashville. One of those trees honored Felicia.[207]

She Answered the Call

PRESIDENT ABRAHAM LINCOLN'S CALL TO ARMS IN THE summer of 1861 was met by an unprecedented outpouring of patriotism. Massive numbers of raw recruits brimming with romantic visions of war filled the ranks of newly organized regiments across the Union. Ohio was no exception. One of the regiments that formed was the Sixty-Seventh Infantry. On January 19, 1862, its men and officers marched out of the Buckeye State's capital and joined other Northern citizen soldiers to put down the Southern rebellion. Within weeks, the Ohioans met their first enemy—disease—which swept through the camp and decimated their ranks. In a grim turn of events, they beseeched their home state for aid. Among those who answered this call was Lucina Meacham. She had more motivation than most, for two of her sons served in the Sixty-Seventh.

Lucina acted decisively. She packed her bags and headed off to war. Friends would not have been surprised at her response. A deeply religious Baptist, Lucina was admired as a noble woman with a gentle, sympathetic, and cheerful soul. Born and raised in Parma Township to parents who had settled in frontier Ohio from New England, she was no stranger to adversity. As a young woman in the 1840s, she had buried two husbands and a daughter. The death of her first husband, Charles Nicholas, in 1841 left her alone on the farm with a young son, Oscar, and a daughter, Harriett. She married a local man, Levi E. Meacham, and gave birth to her second boy, Levi, in 1846.[208] Two years later, her second husband and her daughter died. Most likely all three were victims of disease.

When the war arrived, and it soon became evident that it would be of longer duration than most Americans had originally imag-

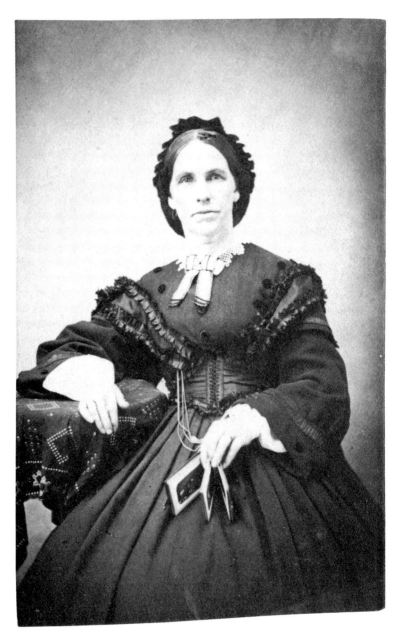

Lucina B. Emerson Nicholas Meacham Whitney. *Carte de visite* (unmounted) by an unidentified photographer, about 1861–1865.

Collection of the U.S. Army Heritage and Education Center

ined, Lucina's sons enlisted. In late October 1861, Oscar became a corporal in Company G. Younger brother Levi enrolled soon after. Oscar, Levi, and their comrades in the Sixty-Seventh were ordered to eastern Virginia in early 1862. Along the way, they fought their first battle in the Shenandoah Valley, at Kernstown, on March 23. By this time disease had begun to take its toll.

Meanwhile, Lucina had arrived in Washington, D.C., and enrolled in Dorothea L. Dix's corps of nurses.[209] The sick list of the Sixty-Seventh continued to grow after the regiment joined the Army of the Potomac for the Peninsula Campaign. Lucina, who had yet to be assigned to a hospital, left the capital and by late spring had joined her sons and their comrades on the Virginia Peninsula. According to a historian, she treated their physical symptoms with medicine and their souls with Gospel songs and the word of God.[210] In November 1862, Lucina embarked upon her formal nursing duties when Dix assigned her to a hospital in Baltimore. She worked in the city until June 1863, when officials transferred her to Hampton General Hospital at Fortress Monroe, Virginia. She served there throughout the rest of the war.[211]

Lucina left the nursing corps in July 1865. Both of her sons had already ended their service. Oscar, who had suffered wounds in the fighting at Fort Wagner, South Carolina, in 1863 and again the following year at Ware Bottom Church, Virginia, was discharged for disability in June 1865. Levi received a medical discharge in the autumn of 1862. Lucina returned to her homestead in Parma. In 1875 she married Joshua Whitney, a Connecticut man about twenty-two years her senior. It was her third and longest marriage. Their union lasted about eleven years, until he passed away in 1886. Lucina lived until age seventy-four, dying in 1895.

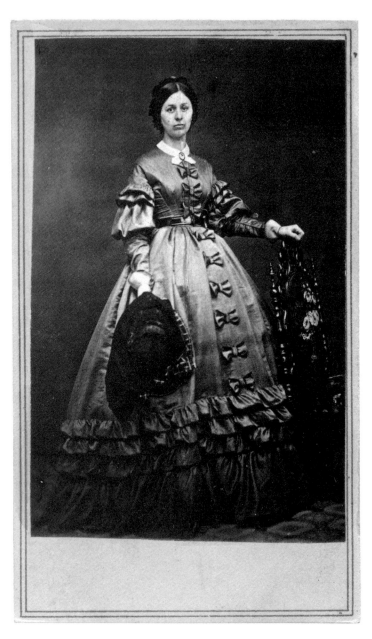

Dr. Arabella Loomis Macomber Reynolds. *Carte de visite* by Edward (1819–1888) and Henry T. (1814–1884) Anthony, about 1864–1865.

Foard Collection of Civil War Nursing

The Making of Mrs. Major Reynolds

CHAOS RULED AT PITTSBURG LANDING. PANIC-STRICKEN Union troops descended on the area along the Tennessee River after Confederates drove them from their camps on April 6, 1862. Half-crazed with fright, the demoralized, disorganized mobs were only intent on saving themselves. "For God's sake," exclaimed one soldier in what might be the order of the day, "run for the river; the rebels are coming."[212] The threat of a Confederate advance was real. As darkness shrouded the scene, the jittery throngs, by now hungry and utterly exhausted, sought refuge from a new enemy—the nighttime cold. Some had already attempted to force their way aboard support vessels anchored in the river, and concerned commanders moved to protect crews and cargo. On the *Emerald*, where about 350 men wounded from fighting earlier in the day were housed, two guards were posted. A captain clutching a pair of revolvers blocked the gangplank.[213] On the hurricane deck above him stood a woman armed with a revolver and ready for action.[214] She was Arabella "Belle" Reynolds. Her deeds at the Battle of Pittsburg Landing, better known as Shiloh, became the stuff of legend.

The story of how Belle came to be there is rooted in a familiar narrative of westward expansion. Born Arabella Loomis Macomber in the village of Shelburne Falls, Massachusetts, as a teenager she had migrated with her family to the Iowa frontier in the mid-1850s. Her parents sent her back East to get an education, and she returned to Iowa as a teacher, reportedly the first in Cass County. "The bright, handsome, independent young lady was a great favorite in the new county and her work as a teacher highly appreciated," noted one writer, who added, "Among the young men who regarded the popular teacher with

a jealous eye was William S. Reynolds."[215] A merchant just a few years her senior, Reynolds had relocated from the same region in Massachusetts. According to one report, they had first met in the Bay State, having attended school in the same building.[216] Romance ensued, and the couple married in April 1860. They soon left Cass County for Peoria, Illinois, where Reynolds went to work as a druggist.

When the war came in 1861, Reynolds promptly enlisted and left Belle in Peoria. Reynolds joined the Seventeenth Illinois Infantry and became a second lieutenant. The newlyweds struggled with separation anxiety, a condition common to countless couples, young and old, on both sides of the Mason and Dixon line. In their case, Belle resolved the issue. On August 11, 1861, she showed up in her husband's camp at Bird's Point, Missouri, located on the banks of the Mississippi River, along the southern border of Illinois. A few days later, as she adjusted to the rigors of camp, the regiment received orders to ship out for southern Missouri. "My husband was anxious to have me accompany him, if the colonel's permission could be obtained; but I feared to make the request, lest it should be denied," Belle stated, so Reynolds applied to Col. Leonard F. Ross.[217] "Wrapped in my husband's overcoat, I sat on my trunk to await events," she noted. Lost in thought, Belle watched as soldiers broke down camp and burned empty barrels and boxes. "I was aroused from my reveries by the voice of our colonel, who said, 'Are you here, Mrs. Reynolds? You will be more comfortable on the boat.'"[218] Her fate decided, Belle left with her husband and the other soldiers.

The regiment had its baptism under fire on October 11, 1861, at the Battle of Fredericktown, a federal victory that secured southeastern Missouri for the Union. Reynolds survived the fight and Belle tended to battlefield wounded—her first experience as a nurse. Belle continued on in this role. "She remained with the regiment, following it in all its campaigning in Southern Missouri, and on the Mississippi River during the fall and winter of 1861 and 1862. Sometimes she rode in an army wagon, sometimes in an ambulance, and sometimes on a mule. At others she marched in

the dust beside the soldiers, with a musketoon upon her shoulder," reported a biographer.[219]

In March 1862, the Seventeenth arrived at Pittsburg Landing. Belle captured the scene in her diary on March 21: "A most romantic spot—high bluffs and deep ravines, little brooks carelessly creeping through the ferns, then rushing down over a rocky precipice, and bounding along to join the river. Blooming orchards meet the eye, and tiny flowers peep out from their green beds. Deserted cabins are scattered here and there, which seem to have been built for ages, and tenantless for years. Shiloh meetinghouse and the cool spring are all that make the place look as if ever having been trodden by the foot of man."[220] Two weeks later, on April 6, everything changed. "At sunrise we heard the roll of distant musketry; but supposing it to be the pickets discharging their pieces, we paid no attention to it. In about an hour after, while preparing breakfast over the camp fire," Belle explained, "we were startled by cannon balls howling over heads." As the long roll was beaten and officers dashed off to form the troops, Belle maintained her position by the fire and fried up a few pancakes for her husband. She finished the task as artillery shells came ever closer, rolled up the cakes in a napkin, and tucked them into Reynolds' haversack just as he mounted his horse to join the regiment.[221] Belle continued, "I little knew then what I should do; but there was no time to hesitate, for shells were bursting in every direction about us. Tents were torn in shreds, and the enemy, in solid column, was seen coming over the hill in the distance."

Belle and another army wife attempted to pack their trunks, but by now the Confederates were close and the Union soldiers were all gone from camp. "The wagon-master told us we must run for our lives; so, snatching our travelling baskets, bonnets in hand, we left the now deserted camp."[222] Caught up with fleeing soldiers and other personnel, Belle made her way to the river landing. A surgeon directed her to the vessels, with certain knowledge that there would be plenty of work to do. She boarded the *Emerald* and treated the wounded into the night, with the exception of a period of time when she was tasked with guarding the vessel.

From an observation point on the hurricane deck, she stood with a revolver which, according to a press report, "she was pledged to shoot in the air."[223]

Belle eventually put down the revolver and returned to her nursing duties. Over the next two days, she cared for the wounded, buoyed by news that the tide of battle turned in favor of the Union and her husband had come through the fighting without injury. On April 9, the third day since she had fled camp, Belle ventured from the *Emerald* to tend to those in field hospitals. In one such place, a house surrounded by tents, she assisted surgeons in a room set aside for amputations. She later recalled, "They would take from different parts of the hospital a poor fellow, lay him out on those bloody boards, and administer chloroform; but before insensibility, the operation would begin, and in the midst of shrieks, curses, and wild laughs, the surgeon would wield over his wretched victim the glittering knife and saw; and soon the severed and ghastly limb, white as snow and spattered with blood, would fall upon the floor—one more added to the terrible pile."[224] This and other events of that day took a toll on her nerves. Belle collapsed in midafternoon, and she was revived with brandy. She prepared to go back to the *Emerald* "when a hand was laid upon my shoulder. The shock was so sudden I nearly fainted. There stood my husband! I hardly knew him—blackened with powder, begrimed with dust, his clothes in disorder, and his face pale. We thought it must have been years since we parted. It was no time for many words; he told me I must go. There was a silent pressure of hands. I passed on to the boat."[225]

Belle continued her labors, but by now she showed signs of exhaustion and, over the days that followed, it became clear that she needed to leave. On April 13, exactly a week after the battle occurred, Belle boarded the transport *Black Hawk* to return home. During the journey, she fell into company with two ladies. The talk turned to the recent battle, and Belle shared her experiences, carefully edited to eliminate the most gruesome details. A crowd formed around her, fascinated by her stories. One of the listeners happed to be the governor of Illinois, Richard Yates. Belle

remembered, "The story seemed of interest to all who heard, and some one suggested, 'She deserves a commission more than half the officers.' 'Let's make one,' said another. No sooner said, than a blank commission was brought, and the governor directed his secretary to fill it out, giving me the rank of major."[226] The original document stated, "Mrs. Belle Reynolds having been duly appointed to the honorary position of 'Daughter of the Regiment' for meritorious conduct in camp & on the bloody field of 'Pittsburg Landing' with the rank of major in the state militia."[227] She was twenty-one years old.

Belle received the commission with many congratulations. "I received it, not so much as an honor which I really deserved, but simply as an acknowledgment of merit for having done what I could."[228] Julia Dent Grant, wife of Lt. Gen. Ulysses S. Grant, came to know Belle and put her own spin on the commission. Julia mused that with the title of major, Belle outranked her husband, and therefore he could not order her away from the front lines.[229] A month later, *Harper's Weekly* magazine featured an engraving of the portrait pictured here, along with an account of her deeds, under the headline "Mrs. Major Reynolds."[230] She was also known as "*Our* Nightingale."[231]

By this time, Belle was back with the Seventeenth. She continued to serve through the Vicksburg Campaign and until the regiment's enlistment expired in June 1864. Belle's postwar activities equaled if not exceeded her services to the Union army. She earned a new title—doctor—and operated a successful practice in Chicago and Santa Barbara, California, for many years. In 1884, she and her husband divorced. Belle resumed the role of army nurse in 1899, under the auspices of the Red Cross. She traveled to Manila in the Philippine Islands during the U.S. occupation of the former Spanish colony. Upon the conclusion of her service in Asia, she returned to Santa Barbara and continued to practice medicine until 1915. She died in 1937 at age ninety-six.

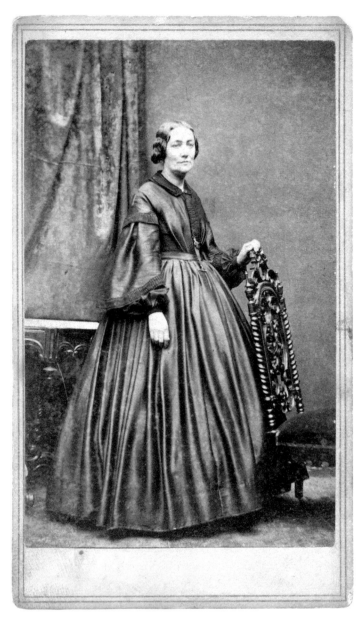

Rebecca Rossignol Holliday Pomroy. *Carte de visite* by Mathew B. Brady (1822–1896) of New York City and Washington, D.C., about 1862.

Foard Collection of Civil War Nursing

The Lady of Massachusetts

In May 1862, an army nurse in the Union capital faced a conundrum: a prominent couple in Washington pressured her to stay in their home for the summer, and she knew that once there it would be hard to leave. If she went with them, the sick and injured soldiers she had solemnly pledged to serve would suffer.[232] The nurse, humble and unassuming Rebecca Pomroy, forty-four, had risen to the crème de la crème of the nursing corps in the city. She had spent the majority of the previous year as the head of a ward in Columbian College Hospital. The power couple who courted her were President and Mrs. Abraham Lincoln. The Lincolns had befriended Rebecca just a few months earlier, in the immediate aftermath of the tragic death of their son Willie, a victim of typhoid. The grief-stricken President, with another sick son, Tad, and a wife in deep mourning, reached out to chief of army nurses Dorothea Dix for help. She selected Rebecca for the task from some 250 women in her charge.

Dix first became aware of Rebecca the previous summer—a time of transformation in the North following the debacle at the Battle of Bull Run. The American mood had shifted from hope for a short, victorious war to fortitude in the face of a long and bloody conflict with an uncertain outcome. Rebecca, a born worker at her best when helping the needy, applied for a position as an army nurse. She overcame significant opposition from friends in her hometown of Chelsea, Massachusetts. "I want to be a mother to those wounded and dying soldiers," she told one old friend who had discouraged her.[233]

By September 1861 she had made up her mind to go. A whirlwind week followed. She applied to Dix on a Thursday, received an acceptance on Sunday, reported for duty in Washington, D.C., on

Tuesday, and met her new boss on Wednesday. Dix took Rebecca on a tour that ended at Georgetown Hospital and left her on temporary duty in a ward with fifty typhoid patients. The odors and moans of the dying tested Rebecca's determination. That night, she presided over her first death, a soldier boy who breathed his last in her arms. Trapped in his death grip, she broke free only after two assistants came to her aid.[234] Less than a week later, Rebecca received a permanent assignment to Columbian College Hospital. Here she made a home for herself and her patients. The ward she supervised, located on an upper floor, accommodated thirty beds. Rebecca decorated the walls with pictures donated by friends, filled a large bay window with houseplants, and established a table in the center of the room for games and other pursuits.

Rebecca's efforts to establish a cheerful, pleasant environment went a long way to ease the suffering of her patients. Many of them called her "Mother" in the absence of their own. Her peers referred to Rebecca as the "Quiet Nurse," in appreciation of her gentle treatment of patients and the discreet manner with which she took on corrupt hospital officials who held back or diverted supplies intended for her boys. "She was, notwithstanding, firm and fearless in a matter of principle, and was none the less known as the woman who always carried her point," noted one admirer.[235] Rebecca shunned promotion, though she was more than capable of greater responsibility. She preferred her ward. "Let me be found sitting at the bed of the poor soldier wetting his parched lips, closing the dying eyes, and wiping the cold sweat from his brow," she confided to a friend.[236]

Dix interrupted Rebecca's mission of mercy with a summons to the White House after Willie Lincoln died on February 20, 1862. Rebecca responded with a tearful protest. Her soldiers needed her, she cried, noting that some of her patients only had a short time to live. Dix, unmoved, reminded Rebecca of the honor in helping the First Family and ordered her to be ready in ten minutes to leave. Rebecca soon met the president, palpable grief etched in his face and coursing through the rest of his body. She

could relate to his pain. Thirty years earlier, in Massachusetts, then fourteen-year-old Rebecca looked on helplessly as her father, the captain of a merchant ship, suffered a fatal injury in a masthead accident.[237] His death left Rebecca, her mother, and her three sisters in financial straits. They sewed clothes to make ends meet.

A few years later, Rebecca married upholsterer Daniel Pomroy and started a family that grew to include two sons and a daughter.[238] Any good times they enjoyed waned when Daniel, an asthmatic, became bedridden. Rebecca opened a confectionery shop to support her family. Then came a series of devastating deaths. One of her sons died in 1856, followed by her only daughter in 1857 and husband in 1860. Rebecca sold her home to pay debts and sank into depression. Her spirits revived after she attended a Baptist religious camp. She left reborn in Christianity as the storm clouds of war shrouded the nation.

Though Rebecca remained at the executive mansion for only a few days, she made a lasting impression on the Lincolns. Word of her service spread, and curiosity seekers disrupted her privacy. "I am truly sorry my name has become so familiar. Even some of the Washington people have had to come and see the lady of Mass, who was so honored as to go to the White House," she wrote to a friend in April 1862.[239] The Lincolns desperately desired Rebecca's return. Conflicted, she shared her thinking with a friend: "Mrs. Lincoln thinks I had better give up the Hospital, and stay with her this summer, but I would like it better to look after the poor soldier who has no friends. I am thinking what is the best to do, as the President thinks I am doing as much good in his family as I am in the Hospital, so I leave my case in the Lord's hands, knowing he will direct my steps aright."[240]

Rebecca ultimately decided that the soldiers were her first priority. She went to great lengths to care for them. The story of Dewitt Clinton Ray illustrates her commitment. A troubled orphan, he ran away from his grandparent's home in Vermont and enlisted in the Twenty-First Massachusetts Infantry. Wounded in the Battle of Fredericksburg, he landed in Rebecca's ward.

She took him under her wing, taught him to read and write, and introduced him to Christianity. He became fiercely attached to her. Beginning in the summer of 1863, his regiment temporarily detached him on invalid duty, and he became Rebecca's attendant.[241] The arrangement ceased before the end of the year, when Dewitt received orders to return to his regiment. "My dear little orphan said to me, as I took his hand for the last time, 'Mother, if I die on the battle-field now, I have found two good friends, a Christian mother and a loving Saviour.' How my heart melted at those words. I feel lonely without him," she later wrote.[242] She never saw him again. In July 1864, on a picket line along the front line near Petersburg, he died instantly after a rebel bullet struck him in the head. Rebecca received the news of his death while on a brief furlough in Chelsea. She traveled to Vermont and told his grandparents of the good boy he has become.

Another patient, her only surviving son, George, served as a private in the Thirteenth Massachusetts Infantry.[243] After he fell sick, medical personnel order him to New York to recuperate. But the conductor of his transport train diverted him to Washington, D.C., after he connected George's name with that of his famous mother. George recovered, went on to become an officer in the Third U.S. Infantry, and survived the war. George's promotion came as the result of an intervention by President Lincoln—one of many favors he granted Rebecca. She remained close to the Lincolns throughout the war, though she never became a permanent resident of their household. Rebecca typically spent brief furloughs with them at the White House and at their retreat at the Soldier's Home, always returning to the hospital, often accompanied by Lincoln in the president's carriage. After Mary Lincoln suffered a serious head injury during a carriage ride, Rebecca cared for her and became something of a confidant to the president. He shared his troubles with her on numerous occasions, including his struggles connected to the Emancipation Proclamation and other burdens of state.

In early 1865, Rebecca revealed to a friend, "My soul is in the Lincoln family, and why I am so distressed for them all God only

knows. Sometimes I think God has put this heavy burden upon me for some wise purpose best known to himself. My heart cries out to God in behalf of Mrs. Lincoln and our dear, good President. I feel that I can pray for him hourly."[244] Word of Lincoln's assassination reached Rebecca at the hospital. Barely able to move, as she had fallen severely ill with typhoid, she struggled to her feet and paid her respects to his remains and to the family at the White House. Days later, on April 20, 1865, she reluctantly resigned her position and had to be carried from the hospital, due to her weakened condition.

Rebecca returned to Massachusetts, her career as an army nurse over. A month later, still recuperating from typhoid, she reflected on the hundreds of patients she had cared for and remembered the nearly eighty soldiers who died on her watch: "Taking all things, I have passed through trying scenes, but this morning the sun shines just as bright as ever, God is still good to us, and may it never be in my heart to complain or murmur while my experience is so full of God's unbounded love."[245] Rebecca recovered and settled in Newton Center in suburban Boston. In 1872, she established the Newton Home for Orphans and Destitute Girls. Following her death from a heart ailment in 1884, the charity was renamed the Rebecca Pomroy Newton Home for Orphan Girls. It continued in operation into the middle of the next century.

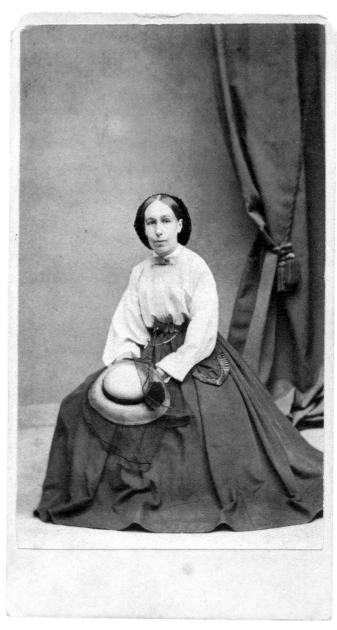

Katherine Prescott Wormeley. *Carte de visite* by James Wallace
Black (1825–1896) of Boston, Massachusetts, about 1862–1864.

Foard Collection of Civil War Nursing

Waves of Wounded after Seven Pines

SOFT LIGHT PERMEATED THE NIGHTTIME JUNE SKY ALONG the James River and revealed the outlines of a hospital transport anchored in the darkness. The faint glow intensified to a shine and illuminated the distorted figures of hundreds of wounded soldiers inside the *Wilson Small*. The light caught the attention of nurse Katherine Wormeley, who glanced up from her duties and glimpsed the source—a lunar rainbow.[246] The rare atmospheric phenomenon capped a frantic week, during which Katherine and her fellow nurses cared for casualties from the Battle of Seven Pines, Virginia.

The activity began on June 1, 1862. On that date, a Sunday, the first wave of wounded soldiers arrived by train from the battlefield amid the boom of distant cannon. The men were distributed among the convoy of vessels organized by the U.S. Sanitary Commission, dressed in the muddy, filthy, and blood-saturated uniforms worn when they fell. Katherine made the soldiers as comfortable as possible until they could be examined by surgeons: "There were some too far gone to know anything more in this world, but there were others, almost as badly hurt, who were cheerful, bright and even talkative,—so different from the dreary sadness and listlessness of sick men. They seldom groan, except when their wounds are being dressed, and then their cries are agonizing."[247]

The pain and suffering that Katherine witnessed was new to her. She had joined the Hospital Transport Service just a month earlier from the comforts of her adopted home in Newport, Rhode Island. Born in Britain, Katherine hailed from a distinguished military and political family with deep ties to Virginia. Her grandfather, James W. Wormeley, was a British army captain during the

Revolution. Her grandmother, Ariana J. Randolph, was the sister of Edmund Randolph, the first attorney general of the United States. Grandfather Wormeley fled with his family to Britain, where Katherine's father, Ralph Randolph Wormeley, was born and raised. He joined the Royal Navy and rose to the rank of rear admiral. The Wormeleys had been on an extended visit to America in 1852 when her father died. Katherine, her widowed mother, and other siblings remained there, dividing their time between Boston and Newport. Katherine thanked God that her late father, a liberal who had spent time in his ancestral Virginia homeland, had not lived to see the Civil War: "How could he have borne it?—the Virginia he loved so passionately rent and bleeding for a cause he would have utterly condemned! He sometimes spoke of the possibility of the struggle with such anguish that I used to think of it as of a horror, only to be spoken of with bated breath. When he went into Virginia how he would urge them to forestall the danger and get rid of slavery by their own act."[248]

When the war began, Katherine leapt into action. The thirty-one-year-old emerged as the leader of Newport's Woman's Union Aid Society. She also applied for and received a government contract to produce clothing for the soldiers. By late April 1862, the terms of the contract were fulfilled, and the Aid Society had raised significant sums of money for the boys in blue. Katherine itched for other opportunities to help the war effort. Meanwhile, the Sanitary Commission's Hospital Transport Service began in earnest on April 25, 1862, when it secured the *Daniel Webster* as the first in its fleet of vessels, or "floating hospitals." Katherine applied for a position in the original company of nurses and received an acceptance on May 7. The next day, Katherine reported for duty in New York City and then joined the Peninsula Campaign in Virginia.

The first battle casualty she ever encountered was in late May, at Yorktown. "A man with a ghastly wound," Katherine recalled in a letter, "asked for something; I turned to get it, with some sort of exclamation." She recorded that the surgeon in charge of the *Daniel Webster*, Dr. James M. Grymes,[249] pulled her aside and

said, "Never do that again; never be hurried or excited, or you are not fit to be here." She added, "I've thanked him for that lesson ever since."[250] Katherine stated, "It is a piteous sight to see these men; no one knows what war is until they see this black side of it. We may all sentimentalize over its possibilities as we see regiments go off, or when we hear of a battle; but it is as far from the reality as to read of pain is far from feeling it. We who are here, however, dare not let our minds, much less our imaginations, rest on suffering."[251]

An onslaught of thousands of wounded soldiers in the wake of the Battle of Seven Pines arrived soon after. The whirlwind of activity—wave after wave of mass casualties—rolled in at regular intervals and replaced the natural cycle of night and day. Shattered and screaming men, contorted in pain and suffering, passed through her care for two solid days, with Katherine having little rest or food. During the days that followed, she worked almost as hard. On June 8, Katherine took a moment to reflect on the ordeal through which she had passed in a letter to a friend: "I have seen many men die, but never one to whom such a word as one might wish to say could be spoken. Our work here is not like regular hospital work. It is succoring men just off the battle-field, and making them easy, clean, and comfortable before we turn them over into other hands." She continued, "When you think that four thousand men have passed through our hands this week, you will understand that we can do little beyond the mere snatching from physical death."[252]

Katherine continued on through the rest of the Peninsula Campaign and then returned to Newport. Her work, however, was not finished. On September 1, 1862, she took charge of the nurses, kitchens, and laundry of the 2,500-bed Lovell General Hospital in Portsmouth Grove, Rhode Island. Katherine's service at Lovell and her active duties as a caregiver ended a year later, after health and family reasons compelled her to resign. Still, she had more to offer as a writer. In 1863, her *United States Sanitary Commission: A Sketch of Its Purpose and Work*, was published. All proceeds from sale of the book were donated to the commis-

sion. She also wrote *The Other Side of War*, a collection of letters penned during her experiences throughout the Peninsula Campaign. Katherine's indefatigable spirit continued unabated until one day in July 1908, when she fractured a hip after a fall at her summer home in Dublin, New Hampshire. She died two weeks later, at age seventy-eight.[253]

Though her contributions to the war effort were many, it was her work as a prolific translator of French literary classics for which she was best remembered. A dedicated Francophile, she had spent time in that country as a girl. In 1840, when she was ten years old, Katherine witnessed the impressive ceremonies surrounding the return of the remains of exiled emperor Napoleon Bonaparte to his homeland.[254] Among the many works she brought to English-speaking readers were the writings of novelist and playwright Honoré de Balzac.

Aunt Rebecca and Charley

Rebecca Wiswell fought back anxiety as she carefully removed bandages caked with blood and feces that oozed from a gaping hole in her soldier patient's back. She applied another round of clean compresses and waited. A half hour later, she changed them again. Hours turned into days. Between dressings, she watched him with wonder and prayed that his life might be spared.[255] The patient, sharpshooter Charley Shepard, was shot in the abdomen during the fighting at Malvern Hill on July 1, 1862. The minié bullet passed entirely through the body of the twenty-year-old private from New Hampshire. Carried from the battlefield by two comrades, he was eventually picked up by an ambulance and transported to a field hospital, where a surgeon declared the wound to be mortal and left him to die.[256] The next morning, Charley still clung to life. A passing rainstorm somewhat revived him, and, using his gun as a crutch, he hobbled some three miles before crossing paths with a wagoner, who helped him to a transport bound for Washington, D.C. Charley passed out, and when he regained consciousness the vessel was docked. He was all alone, stripped naked and again left for dead. He crawled away from the boat and was found by two clerks, who covered him with some of their own clothes and helped him to a hospital for enlisted men. His grave condition prompted an upgrade to Seminary Hospital in Georgetown, a facility normally reserved for officers.

Here Charley met Rebecca. He could not have landed in better hands. Just a few months earlier, back home in Boston, she had contributed to the war effort by making bandages. In what became a familiar routine, Rebecca dropped by the state house each day with a new batch. The volunteers who received them

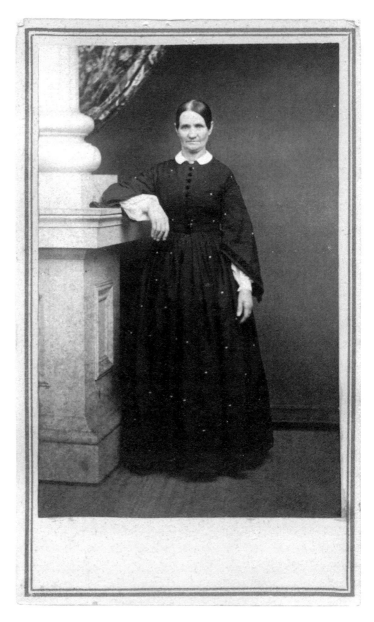

Rebecca Wiswell. *Carte de visite* by an unidentified photographer, about 1862–1864.

Foard Collection of Civil War Nursing

told her they were the best bandages they had seen. This was perhaps no surprise to anyone who knew her, for she was an expert weaver and quiltmaker. She was also, at fifty-five, old enough to remember the British invasion of 1812 and the devastation caused by war.[257] Rebecca later recalled, "One day they asked me if I had ever nursed," and she replied, "I told them I had for twenty years in Boston," having made a career as a caregiver, with a special interest in the welfare of sailors. After asking her to recommend suitable women to apply for positions as army nurses, the volunteers came to what was probably a foregone conclusion: "You ought to be out at the front." She soon was. After an exchange of telegraph messages between Boston and Washington, D.C., Rebecca journeyed to the Union capital and met Dorothea Dix, the chief of nurses: "I spent the first night with Miss Dix. Next day she took me to Seminary Hospital." This was the first week of March 1862.

Rebecca's experience as a nurse, her age, and her abiding faith in the Baptist church inspired sister nurses and the sick and wounded soldiers. She was given the nom de guerre "Aunt Rebecca" by those whom she healed with her physical and spiritual gifts. Humble to the core, she turned to God when confronted with a daily dose of misery as broken bodies were brought into the hospital. "We are told not to be over anxious about anything. I think, sometimes, I am too anxious for my patients, but I can't help it. Oh, I hope God will make me faithful in doing my duty to soul and body," she observed, adding, "I feel, sometimes, I long to be there with Jesus my savior, but that is not right. I know He will do all things right and when there is no more for me to do then He will take me home to dwell with Him in heaven."[258]

Rebecca tended to a steady stream of hard cases during her two years at Seminary Hospital. Charley Shepard's proved one of the most difficult. His life hung in the balance as Rebecca swapped out bandages and, at the surgeon's request, allowed him to drink only enough water to live and deprived him of food, to stop the flow of fecal matter. Three days later, his condition took a turn

for the better, and he began a long and gradual road to recovery that spanned months. Charley's mother received regular updates from Rebecca during his recuperation. In October 1862, Charley received his discharge papers and returned home to New Hampshire. He lived a long and useful life.

Though Charley would forever hold a special place in Rebecca's heart, another unusual case stirred her soul. On March 4, 1863, at about 9 p.m., she was summoned by attendants, who had heard the cries of a baby abandoned on the front steps of the hospital. Rebecca took charge and named the infant, a boy, Washington Gay, for the cross streets at which the hospital was located. Over the next two days, she carried the child through the wards and raised $60 toward his future. Other nurses made a suit of clothes for him. The little boy was brought to officials at the city's poorhouse, in hopes they would find a suitable home for him. Rebecca later recalled, "I saw him when he was two years old, and he was a smart little fellow." She never encountered him again.[259]

By this time, about December 1864, Rebecca was dispatched to Virginia to aid needy soldiers. She spent four months in the hospitals at Winchester and then served a stint of similar duration in the medical complex at Fortress Monroe. In July 1865, Rebecca was discharged from her duties, returned to Boston, and eventually settled in Plymouth. She took an active interest in the Grand Army of the Republic and became a regular at veterans' gatherings. Her skills at the spinning wheel and as a weaver were on public display in 1876, when she demonstrated the textile arts at the nation's centennial celebrations in Philadelphia—one of many such exhibitions she gave during her lifetime.[260]

As the years passed and her financial resources dwindled, Charley, with whom she had kept in contact, came to her aid. He supported her efforts to obtain a government pension for her war service. In an 1886 affidavit he stated, "I think she was the most faithful person I ever saw. She saved my life by her vigilance and skill in nursing. And others, if alive, can testify to the same thing."[261] The following year, Rebecca's pension was approved.

She received monthly payments until 1897, when God called her home. Her death from heart disease at age ninety-one made national headlines, as she was believed to be the oldest surviving Civil War nurse. "Aunt Rebecca" was mourned by a large circle of veterans and family, including Charley, who lived until 1922.

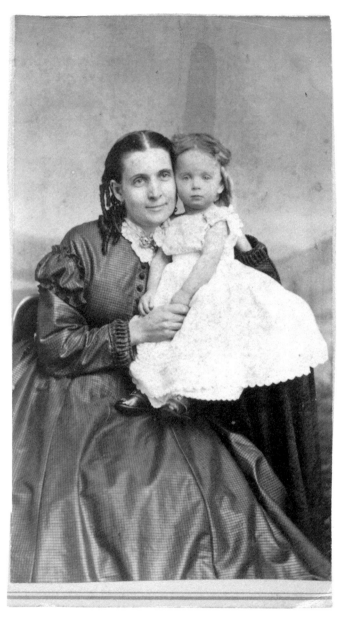

Otelia Voinard Butler Mahone and her daughter Otelia. *Carte de visite* by Charles Richard Rees (1825–1914) and George W. Minnis (1819–1877) of Petersburg, Virginia, about 1862–1863.

Foard Collection of Civil War Nursing

All Mahone's and Otelia's

Richmond rejoiced when news arrived of the success of Southern arms at the Second Battle of Manassas in late August 1862. But victory came with a long list of casualties that eventually topped 8,300 Confederates. The wounded included a general the army could ill afford to lose—William Mahone. The talented military leader looked nothing like the beau ideal of an officer. Exceedingly small of stature, with a body more like a boy than a man, "Little Billy" stood five-feet, five-inches tall. "He was every inch a soldier, though there were not many inches of him," cracked one officer.[262] Even Mahone's wife of seven years, the witty Otelia, could not resist poking fun at his physique. When a messenger who delivered the news about Mahone's injury attempted to soften the blow by describing it as only a flesh wound, she reportedly said, "Now I know it is serious," and then added, "for William has no flesh whatever."[263]

Behind Otelia's quip lay genuine concern. As a nurse working in Richmond, she knew firsthand how even the slightest battlefield injuries could end in death. Otelia Voinard Butler Mahone had arrived in the capital from Norfolk, Virginia, at some point after the war began, and it is likely that she brought her three young children and family slaves with her.[264] She also carried a notable pedigree. Her father, Robert N. Butler, had a long and distinguished career as a physician, adjutant general of Virginia during the War of 1812, and treasurer of the Commonwealth before his death in 1853.

Two years later, she married Mahone, a Virginia Military Institute graduate employed as chief engineer for the Norfolk and Petersburg Railroad. The two must have attracted attention from their differences. Otelia's grace, beauty, and cultured manner

contrasted with the dyspeptic Mahone's high degree of energy and activity. Still, a story handed down through the generations suggests that they enjoyed a tight bond. According to local lore, Otelia named a number of railroad towns established along the line, including Ivor and Waverly, while reading Sir Walter Scott's historical novel *Ivanhoe*. Though Otelia receives the credit, Mahone participated in the naming of at least one town, Disputanta, a compromise choice that resulted after the couple could not agree on a suitable name.

Mahone had risen to become president of the railroad by 1860. After the war began he followed the path of most prominent men of the times—he placed his career on hold and claimed a leadership position in the army. In his case, this was the lieutenant colonelcy of the Sixth Virginia Infantry, a regiment stationed in the Norfolk area. Within months he received his brigadier's star and brigade command. In May 1862 his brigade reported to the outskirts of Richmond for duty, and it is likely that Otelia relocated to the Confederate capital about this time. Mahone suffered his wound at Manassas a few months later and recovered from it.

Otelia kept busy in Richmond. A postwar newspaper reference to her character suggests her ability as a caregiver: "She was a woman of strong and determined mind, yet of tender and affectionate disposition, and the Confederate soldier always had a warm welcome from her at all times and under all circumstances."[265] In 1864 she followed her husband to Petersburg, where Mahone and the bulk of his men remained steadfast until the bitter end of hostilities, playing a key role in the Battle of the Crater and other operations. According to one report, on the night before the surrender at Appomattox, Mahone sat for a lengthy talk with Gen. Robert E. Lee, who had already decided to capitulate: "'Well,' said Lee, in closing the conversation, 'it is ended, and forever. Slavery disappears never to be known again. The wise thing is to accommodate ourselves to the new order of things, and go home and go to work.'"[266]

Mahone and Otelia obeyed Lee's advice. Mahone returned to

the railroad business and played a key role in the formation of the Atlantic, Mississippi, and Ohio Railroad. Chartered in 1870, the lines stretched from Norfolk to the Mississippi River. As aggressive in business as in war, Mahone made his share of enemies as he lobbied Virginia powerbrokers. A story about an individual upset with what he viewed as Mahone's greed appeared in the *St. Louis Railway Register*: "One day as a train of freight cars marked 'A.M. and O.' was backing into the freight yard in Norfolk a pessimistic gentleman remarked dolefully: 'Yes, there is it. A.M. and O.' That means, All Mahone's and Otelia's."[267]

If Mahone rubbed railroad men the wrong way with his business tactics, he turned almost all former Confederates against him when he became involved in Virginia politics after conservative forces raised taxes and eliminated social services to pay down the Commonwealth's debt. As leader of the Readjuster Party, a coalition of black and white Republicans, Mahone sought to reduce the debt and restore services. His alignment with African Americans and the party of Abraham Lincoln helped him to become elected as a U.S. senator. It also resulted in his widespread condemnation of Confederates who embraced the dominant "Lost Cause" narrative.[268]

The success of Mahone and the Readjuster Party was short lived. By the late 1880s, Democrats had taken control. Mahone lost his senatorial seat and left public life, retiring to Petersburg with Otelia and a daughter. In an 1892 interview, Mahone stated, "My fight during the war was nothing to compare with my fight since the war, because I have had to fight the hates and prejudices of my own people and still live in the midst of them. My wife and daughter have been driven away from their home, but I shall stay in this contest as long as I live, and I think I shall live about a hundred years."[269] He did not. Mahone died at age sixty-eight in 1895, following a stroke. Otelia, never a fan of politics, largely withdrew from public life. She remained involved with the United Daughters of the Confederacy until her death in 1911, when she was seventy-five years old.

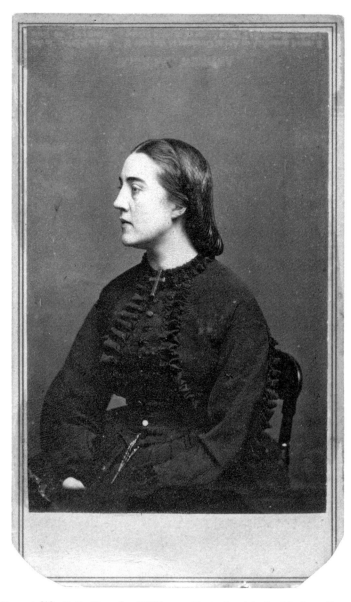

Rose Adèle Cutts Douglas Williams. *Carte de visite* by Mathew B. Brady (1822–1896) of New York City and Washington, D.C., about 1864.

Collection of the author

A Visit to Her Hospital Home

Captain James M. Gaston had made it through the worst of a fever that left him feeble but alert. This was the condition in which Adèle Douglas found him on September 1, 1862, during a visit to a Washington, D.C., military hospital. Adèle asked if she could do anything for him. "I have not written for some time to my wife. I would like you to write and tell her about me," Gaston replied. Douglas promptly produced a letter to Tillie Gaston, a mother of three in western Pennsylvania, outside Pittsburgh.[270] "Your brave husband is not among the wounded or dying, and God had spared him for you for I trust a long and happy life," Adèle stated. She added, "You must dismiss as much anxiety from your mind as is possible while you are away from your husband, and I know you find gratitude that he has spared you from these last dreadful battles. They are all our heroes, sick and wounded as well as those who have fallen."[271]

Adèle did not mention that she had recently been touched by fever. Just a few months earlier, her husband had succumbed to typhoid. His death ended the reign of one of Washington's elite couples, for her husband was Sen. Stephen A. Douglas of Illinois. The pair had been wed in 1856. The Senator, forty-six years old, was a widowed father with two boys. He had come of age in the rough-and-tumble world of politics as the chief architect of the Kansas-Nebraska Act, for which he became both celebrated and vilified. He had narrowly lost the 1856 Democratic presidential nomination to James Buchanan.

His bride, born Rose Adèle Cutts, or "Addie," belonged to the crème de la crème of Washington society. A correspondent in the capital described her, at age twenty, as "the very embodiment

of youth, beauty and accomplishments; indeed, she has been considered *the* belle of the city for some time."[272] Tall, gracious, and modest, she was descended from Virginia and Maryland aristocrats. Her father, James Madison Cutts, was the nephew and namesake of the fourth president. Her mother, Ellen, was the sister of Rose O'Neal Greenhow, whom federal authorities famously imprisoned as a Confederate spy and deported to the South.

Adèle spent much time during her childhood in the company of her great-aunt, Dolley Madison. Raised in the Catholic faith, she received her education at a private school in the District of Columbia and at the Academy of the Visitation in Georgetown. She met Senator Douglas at a White House reception during the 1856 campaign, and a whirlwind courtship ensued. They were married by a Catholic priest on November 20, 1856. Adèle was accompanied by several bridesmaids, and Douglas by a few politician friends, including James Shields and John Slidell.[273]

Adèle had an immediate and visible impact on Douglas. According to a biographer, "The Senator had grown slovenly in dress after the death of his first wife; under Adèle's influence he became somewhat of a beau, cut down his drinking, gave up his cigars, and grew a beard." She baptized the senator's two sons as Catholics but suffered in the wake of a miscarriage and then the loss of an infant daughter only weeks after her birth. Though she never completely regained her health, Adèle was a social epicenter of the Washington scene. She managed this despite the animosity of another powerful woman in town, Harriet Lane, the niece and stand-in first lady to President Buchanan. Lane resented Douglas, her uncle's chief rival in the Democratic Party, and carried on a polite social war with Adèle in retaliation.[274]

Douglas, meanwhile, won a hard-earned victory in the 1858 senatorial campaign against fellow Illinoisan Abraham Lincoln. Adèle accompanied her husband throughout the state as the two candidates famously debated slavery. According to a biographer, Adèle played her part as the political wife, "winning favor for him in all eyes, even including those of the 'ablest whig rascal in all

Springfield, Abe Lincoln.'"[275] Adèle stood by Douglas's side after he lost the presidential contest to Lincoln in 1860, as well as by his casket after the senator's unexpected death in June 1861. His untimely passing deprived the minority Democratic Party of its leader as civil war tore the nation apart—and left Adèle a widow at twenty-five. She withdrew to a villa adjacent to the Douglas mansion, one in a row of three brick residences on the corner of I Street and New Jersey Avenue in Washington.[276]

Before the end of the year, the trio of houses became a soldier's hospital, one of many established across the capital as the war grew in size and scope. Designed for a capacity of three hundred patients and named Douglas Hospital, the facility soon gained a reputation as one of the best in the city.[277] Adèle visited regularly, making the short trip from her villa to comfort patients, including Capt. Gaston. The upbeat report she provided to his wife proved accurate. Gaston made a complete recovery and returned to his comrades in the First Pennsylvania Cavalry. He went on to fight at Gettysburg, where he suffered the first of three later battle wounds, and ended his service as the regiment's major.[278]

Adèle's life of relative seclusion ended as the war waned. Early in the winter of 1865, she was the guest of honor at a dinner hosted by her friend Clara Harris, who later occupied the presidential box at Ford's Theater on the night Abraham Lincoln was assassinated. Other dinner guests included Maj. Robert Williams, a West Pointer and native Virginian who remained loyal to the Union. A career officer, he served as an administrator in the Adjutant's General's Office. Williams fell immediately for Adèle, and thus began a courtship that led to their marriage in 1866. The couple started a family that grew to include six children raised at military posts in the West. By all accounts, Adèle proved as capable in her new role as a mother and army wife. Williams rose in rank to adjutant general of the U.S. Army with the rank of brigadier general in 1892 and retired the following year. He and Adèle returned to Washington, where she passed away quietly in 1899, at age sixty-four. He followed her in death two years later. They are buried in Arlington National Cemetery.

Cynthia Russel Tuell Denham. *Carte de visite* by Joshua Appleby
Williams (1817–1892) of Newport, Rhode Island, about 1864.

Foard Collection of Civil War Nursing

The War Comes to Rhode Island

THE CIVIL WAR ARRIVED IN RHODE ISLAND ON TWO SIG-
nificant occasions. The first, in May 1861, occurred with great
fanfare when the *Constitution* docked in Newport. The famed
frigate carried members of the U.S. Naval Academy, who relocated
that institution from Annapolis, Maryland, to keep it out of rebel
hands. The second, in July 1862, took place with far less atten-
tion when the steamers *America* and *Atlantic* arrived with 1,724
patients plus medical personnel from the Peninsula Campaign.
All were transported to a new hospital located at Portsmouth
Grove, a former vacation resort along Narragansett Bay.[279] The
latter event inspired Newport-born Cynthia Denham to join the
corps of nurses—one of three members of her immediate family to
serve the country. Her only brother, Arthur, served a three-month
enlistment in the First Rhode Island Infantry and survived the
First Battle of Bull Run. Her husband, Daniel, joined the Ninth
Rhode Island Infantry in 1862. He fell ill soon after his enlistment
began, while the rest of his company manned Fort Davis, part of
the southeastern section of the defenses of Washington, D.C.[280]

Daniel returned to Newport after his stint in the Ninth and
reunited with Cynthia. By this time, in the late summer of 1862,
the new hospital in Providence was fully operational. Named
Lovell General Hospital after Joseph Lovell, a former surgeon
general of the army, the facility was familiarly known as Ports-
mouth Grove Hospital. The overflow of sick and wounded men
from Washington-area hospitals occupied most of its 2,500 beds.
Confederate prisoners of war and Union soldiers convicted by the
military courts also received treatment there. At some point after
Daniel's enlistment ended in September 1862, he and Cynthia
volunteered as hospital aides. Cynthia became a paid nurse in late

1863, just a few months after the arrival of five hundred casualties from the Battle of Gettysburg.[281] Cynthia proved an indefatigable force of good. She worked steadily and quietly behind the scenes and cared for an uncounted number of the 10,593 patients who passed through its wards. She continued on duty until May 1, 1865.

The war left Rhode Island three months later. On August 9, the Naval Academy returned to Annapolis. On August 26, Portsmouth Grove closed. Cynthia and Daniel resumed their peacetime lives in Newport. Daniel went on to become a prominent jeweler and civic leader. He died in 1911. Two years later, Cynthia passed away at age seventy-four. A daughter survived her.

Eyewitness to the Horrors of Antietam

THREE WEEKS AFTER ANTIETAM, THE MASSIVE NUMBERS of wounded soldiers still blanketed the battlefield, tucked away in crude field hospitals scattered across the land. The lack of proper food, medical supplies, and shelter amounted to a humanitarian crisis. The sheer volume of casualties overwhelmed area aid societies. This is the situation Anna Holstein found after she arrived on October 6, 1862. The experience transformed her. "As I passed through the first hospitals of wounded men I ever saw, there flashed the thought—*this* is the work God has given *me* to do in this war," she explained, and continued, "From the purest motives of patriotism and benevolence was the vow to do so, faithfully, made. It *seemed* a long time before I felt that I could be of any use—until the choking sobs and blinding tears were stayed; then gradually the stern lesson of calmness, under all circumstances, was learned."[282] From these humble beginnings, Anna served for three years as a nurse, referred to by one veteran as "the woman who has closed the eyes of more dying men and made their last moments comfortable than any other woman in the world."[283]

Anna's journey began four decades earlier, in a Quaker household in central Pennsylvania. Her father, William Cox Ellis, was an attorney and member of the U.S. House of Representatives, and he enjoyed a reputation as an eloquent spokesman for civic improvement.[284] In 1848 she married fellow Quaker William H. Holstein, who was described by one writer as "gentle and comely—pacific as well as patriotic—retiring and yet public spirited, he possessed a personality that called forth admiration and affection,"[285] Holstein and his bride settled into farming life outside Philadelphia, in Montgomery County.

When the war came and the state's border was threatened

Anna Morris Ellis Holstein. *Carte de visite* by David (1840–1915) and Daniel (1836–1914) Bendann of Baltimore, Md., about 1864–1865.

Collection of John W. Hennigar

by the invasion of Gen. Robert E. Lee's Confederate army in the autumn of 1862, Holstein joined the Seventeenth Pennsylvania Militia. Authorities dispatched the regiment, one of twenty-five hastily organized to protect the state, to various locations to repel the invaders.[286] In this capacity, Holstein observed the immediate aftermath of the fighting at Antietam. He came home and told Anna about the desperately wounded and dying men he encountered, and she resolved to help. Together, they gathered as many supplies as they could from friends and neighbors and set off to aid the soldiers.

Nothing could prepare Anna for what she saw after they set foot on the battleground on October 6. "The name of Antietam is ever associated in my mind with scenes of horror," she wrote. They eventually found the U.S. Sanitary Commission headquarters and worked with the organization to shuttle supplies to the makeshift hospitals set up at various points. At one of these locations, the German Reformed Church in Sharpsburg, they found six women from Montgomery County. Anna recalled, "In this uncomfortable, little place, crowded with boxes and swarming with hospital flies, the six ladies continued their labors during the day, waiting and working faithfully among the wounded."[287] Anna and her husband worked for about a week before supplies ran out. Then they went to the Philadelphia home of one of their relatives. Their visit coincided with a well-attended wedding for a dear friend. Anna noted, "Think of the *contrast*! Only yesterday walking among, and waiting upon the mangled, brave defenders of our country's flag; men who were in want of suitable food, lying upon the hard ground; needing beds, pillows, clothing, covering,—is *it* any wonder that I turned away, sick at heart, coldly calculating how many lives of noble men might have been saved with the lavish abundance of the wedding festivities which I saw? Of the wedding, I knew nothing more; but quietly withdrew to an upper room."[288]

Anna soon returned to Antietam and worked, with her husband, in the hospitals for many weeks. She spent the majority of the rest of the war as a nurse, with the exception of periods

when her husband's delicate health called them home for brief periods of rest. During these times of respite, she traveled through eastern Pennsylvania and explained to groups of women what they could do to help soldiers in the field. Following the Battle of Gettysburg, she served as matron of the general hospital at Camp Letterman. According to an account in the *Philadelphia Inquirer*, Anna stood outside the camp hospital one day and took in the view down a long street with neatly arranged tents on each side. In the distance, she spied Little Round Top and was impressed by its majesty as she reflected on the great fight that saved the Union's left flank on July 2, 1863. The article stated that "Mrs. Holstein wrote to her home friends in Montgomery, telling them that it would be nice to unfurl a big flag on Round Top." They responded with a flag that measured twenty-four feet long and thirteen feet wide. The flagstaff was cut and erected by Camp Letterman patients. This banner floated over the crest of Little Round Top until winter storms prompted its removal.[289]

Anna tended to patients in two additional significant events. From the spring through the autumn of 1864, she aided casualties from the Overland Campaign. In early 1865, she traveled to the hospitals in Annapolis, Maryland, and comforted those who had endured the systematic starvation and mental abuses inside Andersonville Prison. Anna talked with many survivors and heard their stories. "The appearance of those with whom I had been conversing reminded me of the skeletons I had seen washed out, upon Antietam, Gettysburg, and other battle-fields, only *they* had ceased from suffering, and were at rest; *these* were still living, breathing, helpless, *starved* men," she observed.[290]

On July 3, 1865, Anna ended her service as a military nurse. In 1867, her wartime memoirs, *Three Years in Field Hospitals of the Army of the Potomac*, were published. Anna remained active with Civil War veterans' groups and other organizations, including the Mount Vernon Ladies' Association. Her membership in this group led to a prominent role to preserve the historic site of Valley Forge. In 1878, Anna led a group of patriotic women to raise funds to purchase the residence occupied by Gen. George

Washington, a century after he and his Continental army endured a harsh winter there during the Revolution.[291]

Anna's husband passed away in 1894, and she joined him in death on New Year's Eve 1900, at age seventy-five. A few years before her demise, she shared her perspective on the historic events of 1861 to 1865: "The wonderful narratives of self-sacrifice and devotion to principle of the women who nobly did their part in the great civil war, have all yet to be written. Not until this generation sleeps beneath the clods of the valley, and the children of today, to whose sight distance will lend 'enchantment to the view,' will begin to inquire if these tales that seem so like romance are true. Forgotten letters and papers will be brought to light and closely read. Events that were to the participants as only every day duties will then appear—a glorified vision of saintly wife or mother, in whose ministry of mercy was included a great nation's army fighting to preserve the nation's life."[292]

Sarah Gallop Gregg. *Carte de visite* by Finley McNulty (about 1827–unknown) of Springfield, Illinois, about December 27, 1864.

Collection of Richard Hart / Kathleen Heyworth

Mother Gregg's Path to Camp Butler

ONE DAY IN LATE 1862, A WORRIED SARAH GREGG AR-rived at a military hospital in Mound City, Illinois, in search of her sick husband, David. Her concerns faded when she found him in better health than she had imagined. In fact, he had regained enough strength to perform light duties around the hospital.[293] She turned her attention to the poor conditions in which David and other patients existed. In a small diary with a red cover, she recorded her observations, which included pitiable sights of sick and wounded soldiers lying on the decks of an ill-equipped hospital steamer, as well as a general lack of supplies.[294]

Sarah fired off a request for action, and it landed on the desk of the woman in charge of the regional division of the U.S. Sanitary Commission, Mary Livermore. The influential organizer and social reformist dismissed the request on the grounds that Sarah did not act in any official capacity. Angry at this rejection, Sarah vented her feelings in her diary, "Too much red tape about this matter. God forgive them, for no one else will."[295] Undeterred, Sarah embarked on a one-woman crusade against the bureaucracy, which ended with her realization that she had to work within the establishment to provide supplies to the soldiers.[296] Sarah's initial frustration and subsequent actions to make change happen illustrated her impulsive nature and bias for action. These traits had long served her well.

Born in 1810 in New York, Sarah Gallop married David R. Gregg and set out for the Illinois frontier in 1840. They lived in Chicago for a while before settling permanently in nearby Ottawa in 1848. David, a painter, had served in the regular army during the Mexican War. She owned a millinery shop on Main Street, where she made clothes for women and children in the latest

styles—and, characteristically, on short notice.[297] The couple had two children: a daughter who died young and a son, William, who followed his father into war against Mexico as a volunteer in the First Illinois Infantry. When the Civil War began, father and son rejoined the military. In 1861, they joined state regiments for three-month enlistments, then went on to enroll in the First Illinois Light Artillery. David served in this capacity when he fell ill and landed in Mound City.[298]

The letter Sarah fired off to Mary Livermore after her visit to Mound City had an unexpected consequence. A few weeks later, Mary reached out to Sarah and invited her to Chicago. They met there, and she offered Sarah the position of matron at Camp Stebbins Hospital in Ottawa. Sarah accepted, and David joined her after he received a disability discharge in the spring of 1863. Sarah spent the rest of the year at Camp Stebbins, with the exception of a month-long stint on detached duty aboard a Sanitary Commission steamer, the *City of Alton*. She and David attended to patients from Maj. Gen. Ulysses S. Grant's operations against the Confederate stronghold of Vicksburg.

Meanwhile, in Illinois, disease ran rampant at the Camp Butler federal training facility in Springfield. The military responded with measures to bring the situation under control, which included offering Sarah the job of matron at the base hospital. She asked for $50 a month. When they balked at this proposed salary, she told them, "I could do as much good in the army as a Colonel and I ought to have good wages!" They finally settled on $25.[299] By this time, David had rejoined the army as a private in the Fifty-Third Illinois Infantry and served as a corporal for the remainder of the war.

Sarah set about bettering the lives of soldiers at the Camp Butler hospital. In her diary she vowed, "With God's help I will make them more comfortable." She decorated the walls of its nine wards with illustrations cut from magazines, planted a vegetable garden, and showered the soldiers with personal attention.[300] Sarah brought cheer and change to the hospital. An assistant steward recalled, "All the boys called her Mother Gregg." He noted

that she had three assistants, adding that "their work was the distribution and preparing of delicacies for the very sick ones, and it was surely appreciated by the boys. We were pretty well supplied with jellies, jams, canned fruits and such other articles as were contributed by the Sanitary Commissions throughout the country."[301]

The local headquarters of the Sanitary Commission happened to be in the Springfield home of President Abraham Lincoln, which had been rented for the purpose while the First Family was away in Washington. Sarah stayed overnight there on more than one occasion and noted the fact with pride in her diary. Her dedication to Lincoln turned to profound grief after his assassination. She learned of his death on April 16, 1865, and recorded in her diary, "Sadness pervades everything…everyone feels as though they have lost a father. This is the saddest day our nation ever experienced." She added a few days later that the alleged assassin, John Wilkes Booth, was a "low and miserable wretch."[302]

Two months later, Sarah received her discharge and ended both her service at Camp Butler and her role as a Civil War nurse. Before she left the hospital, one hundred remaining patients presented her with a letter of praise for her efforts. She soon reunited with husband David, and they returned to Ottawa. Sarah died in 1897, at age eighty-six. She outlived David by two years.

Marie Brose Tepe Leonard. *Carte de visite* by Robert Wilford Addis
(about 1829–1873) of Washington, D.C., about 1863.

Collection of Michael J. McAfee

The Legend of French Mary

Shellfire and the patter of musket balls greeted a regiment of nattily attired Zouaves as it crossed a pontoon bridge over the Rappahannock River, opposite Fredericksburg. The soldiers advanced rapidly into position and paused to form ranks for imminent battle. While they prepped for their first fight, an officer ordered band members out of the line to safer ground.[303] They obeyed and fell back. Another individual ordered to the rear refused to go—the regiment's *vivandière*. Marie Tepe looked up at the officer as he sat on his horse: "'Maybe I am not so scared as you are,' she laughed, and made no sign of obedience."[304] If the officer replied, the writer did not record it. Soon after the exchange a bullet hit Marie in the left ankle and knocked her to the ground. She landed beneath the feet of the officer's horse, extricated herself, and hobbled out of harm's way. This is one version about how Marie, better known as "French Mary," suffered a battlefield wound on December 13, 1862. Though the veracity of this story is not known, it is consistent with eyewitness accounts that place her in several major battles.

Marie's exploits at Fredericksburg and elsewhere during the war made her a larger-than-life figure as writers told and retold her story based on facts, unsubstantiated claims, and flat-out fiction. From these often-contrasting narratives emerges the tale of an immigrant woman who struggled to make a life for herself in a new land. Marie Brose, so the story goes, hailed from the French port city of Brest and became an orphan during her youth. One account states that Marie was all of ten years old when her father, a native Turk, was beheaded, and the shock of his death killed her French mother. Another source states that her father died in a French revolution, which might connect to another claim that

Marie lived in Paris in 1848, at which time the country's conservative government came out victorious after a bloody insurrection by workers.[305]

In 1849 her life took another turn when Marie, now about fifteen, met a kindred spirit in the adventurous Bernhard Tepe. He had arrived in her city from his home in Germany to complete his education as a tailor. They fell in love and married after a brief courtship. One writer claimed that the newlyweds moved to London, where Bernhard joined the army and fought in the Crimea. Marie supposedly followed her husband and campaigned with his regiment. If true, she probably served as a *vivandière* or *cantinière*—a female sutler—and gained valuable experience.[306]

America provided the backdrop for their next big adventure. They may have arrived as early as 1853,[307] which calls into question the Crimean War story. By 1856, the couple had settled in Philadelphia and set up a tailor shop. After the Civil War began in 1861, Bernhard was anxious to enlist but did not want to leave his wife by herself, according to a postwar interview with Marie. His hesitation may have been rooted in a more practical matter: someone needed to run the shop. Marie urged him to go and to take her with him. He then cast his lot with a half-German regiment, the Twenty-Seventh Pennsylvania Infantry, in June 1861. Marie followed him there.

Marie's initial opportunity for glory—the First Battle of Bull Run—occurred soon after she and the regiment arrived in Washington, D.C. Any hopes she may have had were dashed when army leadership held the Twenty-Seventh in reserve. Though no evidence exists that she set foot on the battlefield during this time, a later account of her life made perhaps the most outlandish claim about her wartime escapades: "The young woman showed she was a better soldier than many of the men. She alternately fought and ministered to the needs of the wounded. She apparently cared nothing for the singing of scores of bullets around her."[308]

Setting aside the myth of the warrior nurse, Marie most definitely served in multiple roles as sutler, helpmate, and nurse to the

regiment. A description printed in a postwar newspaper touched on her jobs and her attire: "Her uniform was similar to that of the women who followed the eagles of France. She wore a blue Zouave jacket, a short skirt trimmed with red braid, which reached to just below the knees, and red trousers over a pair of boots. She wore a man's sailor hat turned upside down. She purchased a store of tobacco, cigars, hams and other things not issued by the Government, and sold them to the soldiers. She also did a thriving trade selling contraband whiskey. She carried the whiskey in a small oval keg strapped to her shoulder." The report continued, "When the regiment was not in action she cooked, washed and mended for the men."[309]

Sutler sales proved extremely lucrative. By the end of the year she reportedly amassed the tidy sum of $1,600, far more than one could earn in a tailor shop over the same period of time. Marie awoke one morning to find the boot inside which she stowed the cash slit up the middle and the greenbacks gone. She suspected Bernhard, the only person who knew the location of the money. One rumor had it that he had shared the information with his comrades, who plied him with liquor and induced him to steal her savings. Whatever did occur, the episode ended in Marie's estrangement from Bernhard and the Twenty-Seventh. She returned to Philadelphia alone, with $13 and bitter feelings about army life.[310]

The bitterness did not last long. In the summer of 1862, she joined a new Keystone State regiment, the 114th Infantry, whose members were dressed in uniforms inspired by the French Algerian Zouaves who had fought in the Crimea. Marie could not have been more at home. She later told a writer that the regiment's commander, Col. Charles H. T. Collis, had recruited her, and she consented to accept the invitation only after much persuasion.[311] Marie marched off to the war for the second time with her new comrades and, before the end of the year, suffered the wound at Fredericksburg described at the beginning of this profile. In his reminiscences about the war, regimental band member Frank Rauscher did not mention her injury, perhaps because he and his

fellow musicians had already left the front lines. He did, however, place Marie with medical personnel setting up a field hospital after the fight. Marie later claimed that a fragment of rebel lead remained in her ankle and caused her lameness.[312] The wound did not slow her down during the war. Six months later, at the May 1863 Battle of Chancellorsville, bandsman Rauscher noted, "She was a courageous woman, and often got within range of the enemy's fire whilst parting with the contents of her canteen among our wounded men. Her skirts were riddled by bullets."[313]

Two weeks after the fight, Marie received the Kearney Cross for her bravery. The medal—named for beloved Maj. Gen. Phillip Kearny, killed in battle in 1862—was presented by his successor, Brig. Gen. David B. Birney.[314] He awarded the commendation to twenty-five members of the 114th and hundreds more from other regiments in his command. Marie was one of two women to receive the honor. The other, Anna Etheridge,[315] served as a *vivandière* in the Third Michigan Infantry.[316]

Bandsman Rauscher observed that few of the recipients wore the badge of honor. "Even Marie," he noted, "would not wear it, remarking that General Birney could keep it, as she did not want the present. Had it been made of gold, instead of copper, Marie would have set a higher value upon the souvenir."[317] The *carte de visite* pictured here refutes Rauscher's reference. Marie stands proudly with the medal pinned to her jacket. She posed for this portrait around the summer of 1863, after the fighting at Gettysburg. She had arrived on the battlefield with her fellow Pennsylvanians during the evening of July 1. The following day, the regiment went into action as part of the defense of the Peach Orchard salient and suffered severe casualties. Marie probably spent this time in and about the field hospital established along nearby Rock Creek. The large number of wounded overwhelmed the medical staff.

Several eyewitnesses mentioned Marie, and one account stands out above the rest. During the second day, a group of soldiers moved along the front line, searching for Zouaves. When they eventually happened upon the 114th, they asked for and met

Marie. They went on to describe a badly wounded soldier in the Wheatfield who wanted to see her. Convinced that the man was her estranged husband, she set off to see him, despite warnings not to attempt it. But she insisted and, accompanied by a guard, found him. She supposedly arrived just in time to see Bernhard die. Bernhard did not die, however. He fell into enemy hands and spent six months as a prisoner of war before he gained his release and returned to his regiment. He mustered out about a year after his capture and disappeared from official records.

The story was most likely fabricated, perhaps by Marie herself, as a convenient explanation for marrying another soldier without obtaining a divorce from Bernhard. The other man, cavalry trooper Richard Leonard, had also been at Gettysburg and suffered a minor hand injury after a fall from his horse. Richard, like Bernhard, hailed from Germany and settled in Pennsylvania. He started his military service in April 1861 with the state's Sixth Infantry. After the expiration of his three-month term, Richard saddled up with the First Maryland Cavalry.[318] There is no evidence that Marie and Richard met at Gettysburg, though it is possible he had heard of "French Mary." Chances are they became acquainted later in the summer of 1863 and fell in love. According to another dubious story, they planned to tie the knot in Culpeper, Virginia. But drama ensued during the ceremony, when Confederates interrupted and scattered the wedding party before a certificate could be signed. This anecdote may have been a smokescreen to conceal a common-law marriage.

Bandsman Rauscher does not mention this marriage or Richard in his reminiscences. He does, however, note a plague of gambling that swept through the winter encampment of the Army of the Potomac. Marie tried her hand, lost $50 due to her inexperience, and vowed never to play again. The spring campaign of 1864 ended the camp's games. By this time the Zouaves had been assigned as headquarters guards, first to Maj. Gen. George G. Meade, the commander of the Army of the Potomac, and later to Lt. Gen. Ulysses S. Grant after his promotion to lead all the Union forces. During this period, details of men from the regiment were

sent out on various duties that placed them in precarious positions.

A narrative from this time places Marie in entrenchments at Spotsylvania. "At one time the shower of musket-balls, shrapnel, and every sort of projectile falling in our midst of us was trying to the nerves of our coolest," recalled 1st Lt. Thomas F. Galwey of the Eighth Ohio Infantry. He then heard a man call out a woman's name. "I looked around. Sure enough, there was a woman! She was about twenty-five years of age, square-featured and sunburnt, and dressed in Zouave uniform in the Vivandiere style. She was with two men and they seemed to be looking for their regiment, the 114th Pennsylvania Infantry, they said, which was also known as the Collis Zouaves. Hers was the only face in the vicinity which seemed any way gay. She was laughing and pointing very unconcernedly, as she stumbled over axes, spades, and other obstacles, on her way through the trench!"[319] Her carefree demeanor is reminiscent of other soldiers who remained cool in harm's way.

In August 1864, Richard received a discharge and returned to Pittsburgh, where he had worked as a coal miner before his enlistment. Marie joined him. In the autumn of 1864 they settled in Baldwin, about four miles from Pittsburgh. Here they were wed by a justice of the peace in 1872. Why they married at this time is a mystery. One reason may have been that Bernhard had died, though his actual death date is unknown. By all appearances life was good for Marie and Richard. She operated a tavern and he labored in the mines. But tough times soon followed. A *Chicago Times-Herald* report picked up by other newspapers stated that Richard drank heavily and beat Marie. He convinced her to sell the tavern, then squandered its $3,000 earnings. "He capped the climax of his conduct by burning her zouave suit, which she had carefully preserved since the war."[320] Marie kicked him out of the house. She then filed for divorce in 1897. The *Times-Herald* report added, "When asked why she did not have him punished, she replied simply: 'He was a soldier. I would never have a soldier locked up.'"[321]

The courts found in Marie's favor. Free of Richard and his abuse, she lived a meager existence in a cheap frame house surrounded by a poorly kept picket fence. According to the *Times-Herald*, "In one room there is a pitiful attempt at a store, where a few dollars' worth of pipes, tobacco, tobies [drinking mugs] and some handfuls of ancient candy are displayed. But purchasers are few, and the profits will not serve to keep starvation from the little dwelling. But for the charity of neighbors 'French Mary' would often go hungry. She is at times sorely pressed to find enough to keep her alive."[322]

Hunger must have been an unwanted companion for some years prior to the divorce, as evidenced by an episode held during a reunion of the Zouaves four years earlier. An account of the event, attended by 160 veterans from the regiment, stated that Marie showed up using a cane to support her lame leg, the famed keg strapped across her shoulder and the Kearny Cross pinned to her chest. The old soldiers greeted her with handshakes, questions, and a bit of good-natured ribbing about bygone days. "Boys," she finally stated, "I'm glad to see you very much, but I'm hungry."[323] The regiment's former leader, Charles Collis, escorted Marie to the head of the banquet table, and everyone enjoyed a hearty repast. Speeches followed dinner, and they ended with a few words from Marie. As she finished, one of the veterans laughingly uttered a phrase repeated throughout the evening: "Mary, tap the keg." She regretted that it was empty, then "she said that when she died her little vivandiere whiskey keg would go 'to the One Hundred and Fourteenth men, and nobody else.'"[324] On a May day in 1901, Marie swallowed a lethal dose of Paris green, a toxic compound used in insecticides and fine art paints. She was sixty-six years old. Richard survived her and lived until 1918.

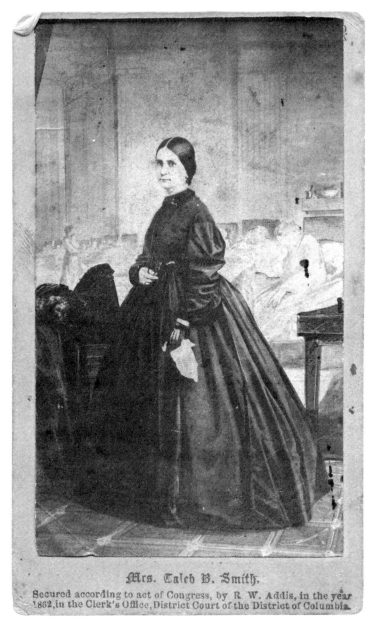

Mrs. Caleb B. Smith.
Secured according to act of Congress, by R. W. Addis, in the year 1862, in the Clerk's Office, District Court of the District of Columbia.

Elizabeth B. Watton Smith. *Carte de visite* by Robert Wilford Addis (about 1829–1873) of Washington, D.C., about 1862.

Collection of Michael J. McAfee

Dinner for Twenty-Five Thousand

The grand Patent Office Building in Washington, D.C., hosted numerous functions during the war years. One of the more unusual events occurred at noon on December 17, 1862. In Room F, women gathered to tackle a massive logistical challenge—how to serve Christmas dinner to twenty-five thousand sick and wounded soldiers in hospitals across the city.[325] The individual who called the meeting was the originator of the ambitious plan, Elizabeth Smith. Known for extreme acts of kindness, she also wielded political influence as the wife of U.S. Secretary of the Interior Caleb B. Smith.

The couple had married back in 1831. Caleb, a young attorney and newspaperman with a gift for oration, aspired to a political career.[326] Elizabeth, a native of Ohio, had moved with her pioneer family to the Hoosier State in girlhood. Elizabeth gave birth to four children over the next dozen years. Her first, a boy, died in infancy. The three that followed, two sons and a daughter, lived to maturity. Caleb's fortunes rose and fell as a three-term congressman, president of a railroad company that went bankrupt, and a lawyer. During his time in Congress in the 1840s, he befriended fellow Whig Abraham Lincoln. Caleb stumped for Lincoln in the 1860 Republican presidential contest. As chairman of the Indiana delegation to the party's national convention in Chicago, Caleb, noted a biographer, "was no small factor in bringing about the nomination of Lincoln. Such were his services in the campaign of 1860 in behalf of Lincoln that the President recognized him by making him a member of his cabinet."[327]

In the capital, Caleb took up his official duties and Elizabeth went to work on behalf of soldiers. By early 1862, she received positive press, along with other Indiana women "who are devot-

ing their time and attention to mitigating the sufferings of sick and wounded soldiers."[328] According to another report, Elizabeth opened her home as a hospital for soldiers, who were cared for by a younger brother, George, a physician.[329] One correspondent observed, with reference to soldiers in the Army of the Potomac, "Mrs. Smith, a true hearted and noble woman, is exerting herself to obtain comforts such as they would enjoy at home, for the brave men who are stricken down by disease, and in the name of the mothers, the wives the sisters and the sweethearts of Indiana."[330] Her plans for the Christmas feast began in early December, and she solicited funds from women across the North. Donations small and large poured in. Even men got into the act, including retired Lt. Gen. Winfield Scott and President Lincoln, who reportedly donated $650. The total pledges added up to $10,000.[331]

Meanwhile, in Virginia, massive Union losses in the Battle of Fredericksburg resulted in an influx of casualties to Washington that dampened holiday cheer. Hospital officials toned back plans to decorate their facilities, out of respect for new patients fighting for their lives. In one hospital, however, personnel hung evergreen boughs throughout the wards during the wee hours of Christmas Day. Patients awoke to an agreeable surprise. According to a correspondent for the *New York Herald*, "There was sunshine in the hospitals to-day," thanks to Elizabeth and her army of volunteers.[332] Organized in committees assigned to each hospital, they served dinner throughout the afternoon. By all accounts the food was abundant and well cooked. Menus differed from facility to facility. In the Patent Office Hospital, turkey, chicken, assorted vegetables, rice, plum pudding, pies, and fruit were served. President Lincoln turned up at Armory Hospital to meet and greet soldiers, which added even more cheer to the day.[333] The *Herald* paid tribute to Elizabeth: "Her efforts were crowned with success."[334]

Christmas dinner turned out to be Elizabeth's farewell gift to Washington. That same day, Caleb resigned his position. In poor health, he had never warmed to the job and had grown dissatisfied with cabinet politics. He longed for a less stressful life as a

judge, and Lincoln rewarded him with an appointment as a U.S. judge for the District of Indiana.[335] Elizabeth and Caleb returned home and settled in Indianapolis. As the war ground down to its bloody conclusion and the nation began the gradual process of reunification, Elizabeth suffered a triple tragedy: Caleb passed away in early 1864, and two of her children died, one in 1865 and the other in 1866. They were in their twenties. Elizabeth lived in relative obscurity until her own death from stomach issues in 1878 at age sixty-five.[336]

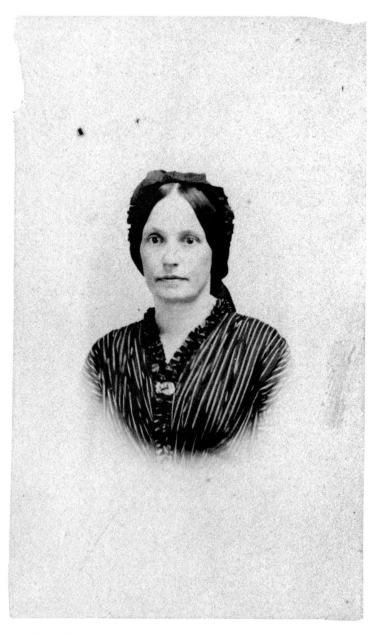

Caroline Cheeseborough Wright Hagar Edwards. *Carte de visite* (unmounted) by an unidentified photographer, about 1861–1865.

Collection of the U.S. Army Heritage and Education Center

New Lease on Life at Hickory Street Hospital

THE HOSPITAL ON HICKORY STREET IN DOWNTOWN ST. Louis occupied two sturdy brick homes and was configured for twenty-five patients. Sick and wounded soldiers filled the rooms beyond capacity. Though tiny by comparison with other facilities, more than 1,200 souls passed through its doors during its first year of operation.[337] The number had grown considerably higher by the time Caroline "Carrie" Hagar reported for duty as matron, or head nurse, in early 1864.[338] She worked quietly and without fanfare to care for the men as they battled for life.

Carrie's own life experience informed her work as a caregiver. Born in New York, she relocated to Illinois as a child and married Calvin Hagar in late November 1842, only a few weeks after her sixteenth birthday. He was about twenty-three. Years passed, during which they scratched out a living to feed a growing family on a farm in Greene County, about a day's ride from Springfield. Carrie spent much of her young adult life pregnant or nursing babies. Records indicate that she gave birth to six or eight children, most of whom died young. In 1859, the couple had their last child together. By the time the war started two years later, Carrie and Calvin had gone their separate ways, for reasons unknown. Carrie and her eldest child, Sarah Jane, became nurses under the auspices of the Western Sanitary Commission. Dispatched to St. Louis, they served at City General Hospital and Jefferson Barracks, beginning in January 1863.[339]

While mother and daughter tended to patients, two of the most decisive campaigns of the war came to a conclusion—Gettysburg and Vicksburg. The latter victory directly impacted Carrie and Sarah Jane when the Sanitary Commission responded to a request for help from the National Freedmen's Aid Commission to send

teachers and assistants to help educate the former slaves of Vicksburg.[340] Sarah Jane volunteered. The reasons she gave reflected humanity and pragmatism, perhaps instilled by her mother. According to a surviving account, Sarah Jane "was well and strong, and felt a real interest in the welfare of the freed people; that she had no prejudices against them, and that while there were enough who were willing to fill the office of nurse to the white soldiers, it was more difficult to get those who would render equal kindness and justice to the black troops, and to the freed people, and therefore she felt it her duty and pleasure to go."[341]

In early 1864, Sarah Jane bid her mother farewell and headed downriver to Vicksburg, never to return. In late April she suffered an attack of malarial fever and succumbed to its effects after a brief illness. The news devastated Carrie. By this time, she had gained the respect and esteem of her peers and received a promotion to matron of the Hickory Street Hospital. Here she had met Albert G. Edwards, an 1861 graduate of St. Louis Medical College who had put his plans to open a practice on hold and joined the First Missouri Cavalry as a corporal. The army needed men with medical knowledge as much as it needed soldiers, and the regiment detached Albert for hospital duties during much of his enlistment.[342]

Albert married Carrie on July 31, 1864. All things considered, it is fair to state that Carrie received a new lease on life at the Hickory Street Hospital. The newlyweds finished their military service before the end of the year and settled in Marysville, an emerging community in northeastern Kansas. Albert opened a successful medical practice and became actively involved in various local groups. He also served a stint as a pension examiner for the federal government. Carrie flourished as a leader in local religious affairs. She was credited with founding the first Sunday school, as well as playing a key role in the establishment of the Presbyterian church in Marysville. Fellow townspeople recognized the pair as pioneers and model citizens. They brought their only child, a daughter named Lillian, into the world about 1868. She grew up and married in the autumn of 1895.[343]

Carrie's good times ended when Lillian died a few months after her marriage, following a brief illness. In 1903, Albert unexpectedly passed away during a trip to Oklahoma to tend to Carrie's sick brother, who succumbed to his affliction.[344] Aged and feeble, Carrie joined her husband and daughter Lillian in death in 1905, at age seventy-nine. Two children from her first marriage survived her. A large number of mourners paid respects at her funeral. Her obituary noted, "Many good and lasting things remain to her credit in the history of this city. She was one of the patriotic women to whom the whole country and all humanity will forever owe a debt of gratitude."[345]

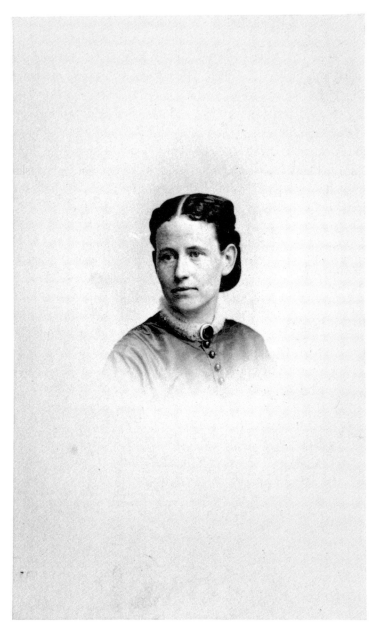

Susan Ellen Marsh. *Carte de visite* (unmounted) by an unidentified photographer, about 1861–1865.

Collection of the U.S. Army Heritage and Education Center

Life in the Chateau

Nurses had little time and space to call their own. The constant flow of patients, ward duties, and myriad other tasks limited life's basics. Still, loyal caregivers on both sides sought some refuge from the relentless pace of hospital routines. The dozen or so nurses at Armory Square Hospital in Washington, D.C., found solace in a cluster of dorm rooms they playfully named "the Chateau." One of their number, Susan Ellen Marsh, occupied room 3. The memoirs of a peer indicate that Susan kept up the spirits of this band of sister nurses with music, mince pies, and merriment.[346]

Susan hailed from Massachusetts, one of six children born to Boston stationery store owner John Marsh and his wife Caroline. In 1852, then fourteen-year-old Susan suffered from the untimely death of her father. One of her two older brothers, also a stationer, probably took over the family business.[347] In 1863, Susan joined the nursing corps—the only member of her surviving family to serve in the military. She reported for duty at Armory Square on February 15, her twenty-fifth birthday. The thousand-bed hospital, located between the Capitol Building and the Smithsonian Castle, became her home for the next nineteen months. Here she tended to sick soldiers and waves of the wounded, beginning with the Battle of Chancellorsville in May. One of the hospital's surgeons praised her abilities: "No one did more for the welfare of the sick and wounded soldiers, and they in return appreciated her, for she was always gentle and sympathetic and competent."[348]

The Chateau provided Susan with a place to relax and unwind after exhausting days in her wards. A cup of coffee, slice of mince pie, and casual conversation helped ease the tension. On a memorable January night, ten of the nurses gathered together

to honor one of their own, who was preparing to leave the hospital. One of them, inspired by the gaiety, penned a poem titled "A Directory for the 'Ladies' Chateau.'"[349] Two of the verses poked good-natured fun at the chatty Susan and her roommate, fellow Bostonian Nancy M. Hill:[350]

In Room No. 3
You will find if you please,
Our dear Sister Hill
And her wonderful "sneeze."
With her, sister Marsh
Is obliged to reside,
Who complains that the talking
Is all on her side.

In July 1865, Susan received a discharge and returned to Massachusetts. In 1878, she left the reunited states for Great Britain and joined one of her older brothers, John, an executive with the Liverpool and Great Western Steamship Company, also known as the Guion Line. For many years the company catered to immigrant passengers seeking a better life in America. Though she lived a continent away, Susan belonged to the National Association of Army Nurses of the Civil War. According to this organization, she kept in close contact with members through beautifully written letters.[351] About 1909, Susan showed the first signs of senility, and she died two years later from influenza and heart issues at age seventy-three. Susan never married, and she was survived by her brother.[352]

In the Kitchen at Adams Hospital

Adams Hospital in Union-occupied Memphis had the lowest mortality rate of any military care facility in the city. It also happened to be the largest hospital in town, with a patient population in excess of 1,200 at one point in early 1863. An inspector from Washington, D.C., toured Adams, measuring a block long and six stories high, in early 1863. During the visit, he asked the surgeon in charge how he managed to keep the percentage of deaths so low—a full 2.5 percent better than any of the others. The doctor replied by showing the inspector the well-appointed kitchen facilities and the supply of milk, eggs, fruit, and other fresh foods for the sick and wounded. The kitchen exemplified the surgeon's commitment to using the funds at his disposal for the direct benefit of his patients.[353]

There is no record whether the surgeon mentioned the staff who prepared the fresh food. One of these individuals, nurse Lettie Covell, is representative of those who labored from dawn to dusk with little recognition. An Illinois native in her midtwenties, she owed her position to the U.S. Sanitary Commission, which enlisted her in September 1862. She reported to Adams soon after and joined the staff of about 361 men and women. According to one report, its number included a "well organized corps of female nurses in constant attendance."[354] Lettie spent the majority of her nineteen months in the service at Adams. Though best remembered for her efforts in the kitchen, she also attended to patients in Ward B. One source noted that she "did excellent work."[355] Another reported, "Her services were very valuable and are highly commended by the surgeons under whom she served."[356] One former patient spoke on behalf of Lettie and the other caregivers at Adams when he stated, "A careful observation of over two years

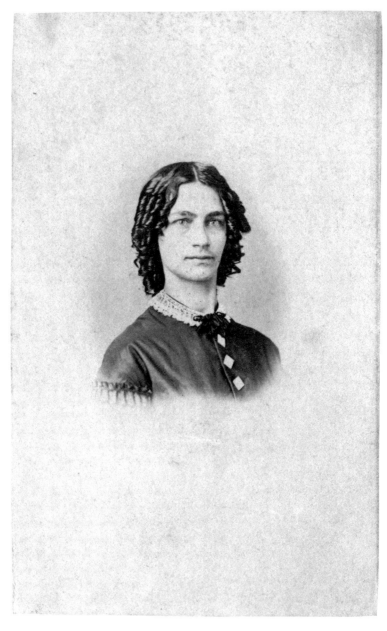

Lettie E. Covell Buckley. *Carte de visite* (unmounted) by an unidentified photographer, about 1861–1865.

Collection of the U.S. Army Heritage and Education Center

has taught me that nursing is fully as important as medicine. In the wards where there was the best nursing, there were always the fewest deaths."[357]

Lettie received her discharge in May 1865 and settled in Chicago. In 1872, she married a veteran, James Buckley, who had served in the Forty-Fifth Illinois Infantry and as a regular army hospital steward. They became parents of a daughter, Grace.[358] James supported the family as a bookkeeper. At some point, Lettie became active in the National Association of Civil War Army Nurses, established by Dorothea Dix in 1881. Members participated in coordinated activities with Grand Army of the Republic veterans and assisted former nurses in applying for pensions. Lettie rose through the ranks to serve as president of the Chicago Department and chief of staff on the national level.[359] After James died in 1910, Lettie moved to California and settled in the Los Angeles suburb of Inglewood, where she died in 1922 at about age eighty-five. Her daughter and a granddaughter, Helen, survived her.

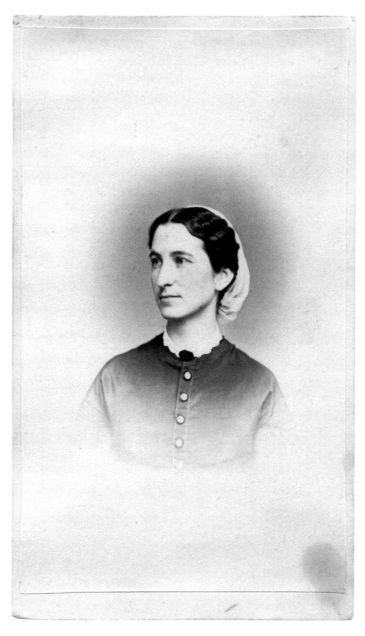

Jane Jennings. *Carte de visite* by Henry Ulke (1821–1910) of Washington, D.C., about 1864–1865.

Foard Collection of Civil War Nursing

An Angel in Two Wars

Dorothea Dix's first line of defense in an ongoing battle to rid herself of nurse wannabes included asking the age of the applicant. The autocratic Dix, chief of nurses in Washington, D.C., most likely knew before she posed the question that many of the earnest faces staring back at her did not meet the minimum requirement of thirty-five years old. Uncounted numbers were turned away, their hopes forever dashed. Some of the applicants, however, refused to accept Dix's ruling. One of them, Jane Jennings, a Wisconsin schoolteacher in her midtwenties, had traveled to the nation's capital after her brother Dudley suffered a debilitating gunshot wound through the side and hip at the Battle of Chancellorsville in May 1863.[360] Jane's sister Nettie recalled that she "made up her mind that her brother and other wounded soldiers needed her help in nursing them, she had experience in nursing members of her family."[361]

Born in Canada and known as "Jennie" to intimates, she was raised on a farm about two miles outside the village of Monroe, Wisconsin, with eleven brothers and sisters. Nettie stated that their mother "often said 'Jane was once a little girl but never a child.' She never romped and played as the other children did. At the age of five Jane assumed duties in caring for the children younger than herself. She was her mother's constant helper. She was the leader of the family."[362] Nettie added, "Courage, charity and self-sacrifice were her greatest characteristics with innate refinement that gave her retiring nature a manner which appeared unresponsive and cold. It was difficult to understand why her thoughts were always for others and never for herself."[363]

Future events highlighted another characteristic: persistence. After Dix refused to admit her to the nursing corps, Jane dis-

cussed her situation with Dudley and took action. She approached the surgeon in charge of Armory Square Hospital, where Dudley convalesced. The physician, D. Willard Bliss, became a household name two decades later when he attended to President James Garfield after an assassin's bullet struck him down.[364] Bliss sympathized with Jane's plight. "He was greatly impressed with this serious and determined young woman, who was tall and so slender she almost looked frail. Dr. Bliss told her he would give her a chance to nurse soldiers in tents; there were many of them from the over-crowded hospitals," Nettie reported.[365]

The tents to which Dr. Bliss referred occupied grounds adjacent to his hospital—one of the largest facilities in the District of Columbia, with one thousand beds organized in twelve pavilions located on the National Mall within sight of the Capitol. Armory Square happened to be a favorite destination for high-profile visitors, including poet Walt Whitman and President Abraham Lincoln. Jane possibly crossed paths with them. One individual she did meet during this time, Clara Barton, became a close friend and valued colleague.[366]

Bliss made good on his word and set Jane to work in the tent camp. Within two weeks, administrators placed her in charge of a group of unpaid volunteers there. Just how long she remained in this position is unclear, as the exact date she ended her service went unrecorded. She may have left in July 1864, after Dudley received a discharge from the hospital and joined the Veteran Reserve Corps, which had been established by the military for partially disabled veterans able to perform light duties. Alternatively, she might have remained until the removal of the overflow tents in early 1865 or the closing of the hospital later that summer.

Jane returned to Wisconsin suffering the effects of exhaustion, a common fate of many nurses. Unlike others, her recuperation period was brief, and before long she was back in Washington with a job at the Treasury Department. She took a leave of absence in late 1871 and traveled to Omaha, Nebraska, to care for Dudley, who had never completely recovered from his war wound. She nursed him during his final days, then brought his body home to

Wisconsin to be buried.[367] The following year, Jane purchased a home for herself and her family in Monroe. Here she discovered the joy of writing, and with characteristic energy and enthusiasm launched a career in newspapers as Janet Jennings. She worked her way into the Washington press corps and wrote for many top publications, including the *Milwaukee Sentinel*, *Chicago Tribune*, and *New-York Tribune*. Her professional travels took her to various spots around the globe.

In 1898 she set out for Cuba—not as a reporter, but as a nurse. The war with Spain prompted her to join Red Cross founder Clara Barton and other of the organization's personnel to assist the army in caring for American soldiers. Janet distinguished herself on numerous occasions during the relatively short conflict. She is best remembered for her work aboard the troop transport *Seneca*. In July 1898 she accompanied a shipload of casualties from Cuba to New York City. The journey was, by all accounts, a nightmare. Fever-ridden men suffered from ill-prepared doctors, a lack of supplies, and inclement weather. Janet's efforts became legend among the patients, who afterward honored her with the nom de guerre "Angel of the *Seneca*."

News reports of the situation aboard the *Seneca*, combined with other questionable developments in the military's medical practices, outraged and incensed President William McKinley. Janet was summoned to the White House and arrived on the morning of August 2, 1898. When asked by reporters if she had met with McKinley and discussed the *Seneca* incident, she replied, "Yes, I have seen the President. I am quite satisfied to leave the matter in his hands." Formal investigations followed.[368]

Janet's friendship with Clara Barton deepened during the years following the Spanish-American War. These were tough times for Barton, as a new generation of Red Cross leaders forced her out of the organization she had built. Janet remained a loyal and supportive friend during the post–Red Cross period. In 1912, she offered to help Barton write her memoirs. "We, you and I, mean to do some work together, in the near future," Janet wrote to an ailing Barton on January 9, stating, "You will get stronger—and

direct the work, and I will be the helper." Janet added, "*I want to help you put this great story in shape to be lasting—It will hold its place with Lincoln, Grant—It will be the story of a great life—but it must be in your own words—no other words.*"[369]

Janet's mention of Lincoln and Ulysses S. Grant may have been not-so-subtle references to her own recent books. In 1909, her *Abraham Lincoln: The Greatest American* was published. The *Blue and the Gray* landed in bookstores in 1910. The collaboration Janet had in mind with Barton did not come to pass. Two months after she proposed the idea, Barton succumbed to tuberculosis at age ninety. The *Life of Clara Barton* appeared in print three years later. The author, however, was an admiring minister and lifelong friend, Percy H. Epler—not Janet. In July 1915, a few months before an announcement of Epler's book appeared in the press, Janet suffered a stroke. She died two years later at age seventy-eight.[370]

The Crusader

J ANE S WISSHELM LISTENED TO THE WELL - INTENTIONED
doctor's story in astonishment. Here, inside crowded Campbell
Hospital in the heart of the well-provisioned Union capital, ac-
quiring lemons proved almost impossible. The staff needed as
many as they could get to treat an incursion of gangrene respon-
sible for the needless deaths of soldier patients. The doctor com-
plained to Jane that a recent visit to the Sanitary Commission
yielded only half a box for 750 patients. The wife of the hospital
chaplain had written in desperation to friends in Boston and
hoped for a full box in the coming week. "To Boston for a box of
lemons!" exclaimed Jane, her voice dripping with sarcasm.[371] She
had heard enough. Jane had nursed wounded men at Campbell,
many of them amputees, for the past ten days. Filled with rage
and indignation at the half measures, excuses, and indifference
she encountered at every turn, she hunted down the head nurse,
who had received an earful from Jane on another matter earlier
in the day.

Jane demanded writing materials from the nurse, and they
were duly provided. Thus armed, Jane fired off a note to the *New-
York Tribune* under a dateline of May 19, 1863: "I want whiskey—
barrels of whisky—to wash feet, and this keep[s] up circulation in
wounded knees, legs, thighs, hips. I want pickles, pickles, pickles,
lemons, lemons, lemons, oranges. No well man or woman has a
right to a glass of lemonade. We want it all in the hospitals to
prevent gangrene."[372] The *Tribune* promptly published her letter.
The next day a box of lemons and a $5 greenback was delivered
to Jane, courtesy of Schuyler Colfax, the powerful Speaker of the
House of Representatives. Included was a note that asked Jane to
contact him if more lemons were needed. They were not. "Lem-

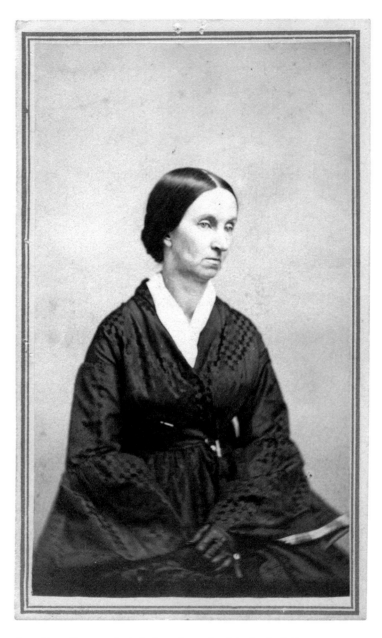

Jane Grey Cannon Swisshelm. *Carte de visite* by Joel Emmons
Whitney (1822–1886) of St. Paul, Minnesota, about 1862–1863.

Foard Collection of Civil War Nursing

ons began to pour into Washington, and soon, I think, into every hospital in the land," Jane noted with characteristic bravado.[373]

The reaction to Jane's letter was no surprise, for her reputation preceded her: staunch feminist, veteran journalist and newspaper publisher, outspoken opinionator, and muckraker, decades before the term became popular. A *Chicago Tribune* correspondent observed her in one of the House galleries inside the Capitol later in 1863. "There," the reporter began, "is a woman who will not flinch under my pencil—or anybody's," and continued, "She has a very large head, high over firmness and self-esteem, wide at combativeness, massive in the intellectual-moral regions, and a forehead as square as a marble block—causality jutting out in the most defiant manner. Added to this, a face full of self-assertion, a controversial mouth, which plainly says, 'No compromise'—an inquisitive nose, sharp almost to fierceness, and eyes four times as sharp as her nose."[374]

That reporter then credited her as "the most widely read and popular female writer in this country. Her recent miscellaneous articles show the same warm-hearted and genial style, but party warfare had wearied and worried her, and on political topics, the ink flows from her acrid pen. As an opponent she is disagreeably witty, and in debate as unrelenting as Parson Brownlow." The sketch continued, "As she makes a zealous champion, I am certain she would make an admirable martyr—for she would risk the stake any time for the privilege of the last word. She is positive, progressive and aggressive, and usually on the 'other side.' Her decision, courage and self-reliance, the availability of her knowledge and the power of her personal magnetism, endow her with the qualities of a leader; and if she, with five hundred other American women, should be wrecked some fine morning, on any desolate island in the Pacific, Mrs. Swisshelm would be elected Queen in fifteen minutes, and have a provisional government organized before dinner."

Jane's path to fame followed a circuitous route that began about a half century earlier, in Pittsburgh. Born Jane Grey Cannon in 1815 to Scotch Irish parents and raised in an orthodox

Calvinist home, tragedy visited the family when her father died of consumption and an older brother succumbed to yellow fever. The losses profoundly impacted Jane and her mother. As Jane recalled in her memoirs, "She and I believed that 'a jealous God,' who can brook no rivals, had taken away our loving husband and father; our strong and brave son and brother, because we loved them too much, and I was brought up to think it a great presumption to assume that such a worm of the dust as I, could be aught to the Creator but a subject of punishment."[375] Her religion also informed her of the evils of slavery. When still a child, she collected names for a petition to abolish slavery in the District of Columbia.[376] As a teenager, she visited bedsides of the sick and dying in her tight-knit community as a nurse and preacher when her mother, who normally performed this function, was unable to do so.

In 1836, twenty-year-old Jane wed James Swisshelm. The marriage was rocky from the start. The union of strong-willed Jane and tyrannical James ended after years of estrangement, internecine legal battles, separation, and finally divorce. The cumulative effects of a young life filled with fire and brimstone, as well as turmoil and uncertainty, sparked a creative genius that ignited blazes of her own, via pen and ink. Her early efforts, beginning in 1842 under the nom de plume "Jennie Deans," were widely praised. "I wrote abolition articles and essays on woman's right to life, liberty, and the pursuit of happiness," she stated.[377]

Five years later she established the *Pittsburgh Saturday Visiter*, a family newspaper "designed for the instruction and entertainment of the home circle, and the promotion of moral and social reform." Chief among the latter was what Jane termed the "Great Abolition War." The *Visiter* caught the attention of fellow publishers, notably Horace Greeley of the *New-York Tribune*. By this time, the slavery question had consumed the nation. Jane longed to add her voice to forces bent on the destruction of the "Peculiar Institution." She convinced Greeley to commission her on a freelance basis to write a series of letters, under the *Tribune* banner, on observations of life in official Washington.

Jane took the capital by storm in 1850. She successfully lobbied a wary vice president, Millard Fillmore, for a seat in the Senate Press Gallery, and from this perch her caustic wit spared no one. The first female political reporter in American history, she reserved her sharpest attacks for Daniel Webster. An especially vicious letter, published in the *Visiter*, revealed the distinguished senator's over-indulgence in alcohol and penchant for mistresses of color. Jane lost her gig as a *Tribune* correspondent after only a couple of months and returned to Pittsburgh, but the scandalous commentary had increased Jane's appeal. According to an 1853 editorial in the *New York Herald*, "Mrs. Swisshelm may be regarded as the champion and representative of the strongest-minded women of America."[378]

Following in the vanguard of Americans searching for opportunity, Jane moved West. She landed in St. Cloud, Minnesota, and re-established the *Visiter*. During the summer of 1862, Sioux warriors launched a series of attacks on settlers in the wake of rising political tensions instigated by the U.S. government. Jane hid forty-two white women and children inside her house for weeks to protect them from harm. During this time, she continued publication of the *Visiter*. The events and experience changed Jane from a supporter of Native Americans and their ways to a vocal opponent who called for genocide.

In early 1863, she traveled to Washington to wage her own war against the government and East Coast elites, whom she believed favored a policy of tolerance toward Native Americans. Should the government fail its obligation to protect the settlers, Jane declared in a speech in late February that year, whites would take matters into their own hands: "Whenever they get out from Uncle Samuel's wing, we will hunt them, shoot them, set traps for them, *put out poisoned bait* for them, kill them by every means we would use to exterminate panthers. We cannot breathe the same air with these demon violators of women, crucifers of infants. Every Minnesota man *who has a soul* and can get a rifle will go to shooting Indians, and he who hesitates will be blackballed by every Minnesota woman, and posted as a coward in every Min-

nesota house."[379] Two months later, the government declared all treaties with the Native Americans in Minnesota null and void and expelled them from the state.

Jane remained in Washington. One day during a tour of the city's defensive perimeter, she perceived deficiencies in the care of sick and wounded soldiers. The case of one soldier, who wanted straw to make his bed more comfortable, led her to seek out Dorothea Dix, the chief of nurses. "I had never before seen her, but her tall, angular person, very red face, and totally unsympathetic manner, chilled me," reported Jane, who requested assistance for the strawless soldier.[380] Jane failed to persuade Dix to take action, however. She later took the chief nurse to task in her memoirs: "Emergencies were things of which she had no conception. Everything in her world moved by rules, and her arrangements were complete."[381]

This experience prompted Jane to use her powerful pen to expose deficiencies in the Union hospital system. She began her investigations with the lemon crisis at Campbell General Hospital, just a few miles north of the White House. Next she moved to Fredericksburg, and, in May 1864, attended to the wounded from the Battle of The Wilderness. Collected observations from her experiences formed a large part of her memoirs, which she described as "an inside history of the hospitals during the war of the Rebellion, that the American people may not forget the cost of that Government so often imperiled through their indifference."[382] Jane nursed soldiers until sickness forced her return to Washington, where doctors found her to be suffering from the same hospital gangrene she railed against at Campbell Hospital. Her condition deteriorated and left her on the point of death. Somehow she managed to recover, though her health was never again quite the same.

In 1866, Jane launched another attack against the government. This time, an editorial in her newly established newspaper, the *Reconstructionist*, raised questions about President Andrew Johnson's connections in the wake of the Lincoln assassination. "When President Lincoln was murdered nearly all loyal people be-

lieved the South had made a serious mistake. A very few thought otherwise. Of these two said to us: 'You are mistaken. They know what they are about. Andy Johnson is their tool,'" noted Jane in a conspiratorial tone. The editorial ended with a sensational question: "Could the people be made to feel that the assassins of President Lincoln are now the honored guests of the White House?"[383]

The government retaliated by dismissing Jane from a clerkship to which she had been appointed. Officials cited disrespectful language against the president as the reason for her removal. This job loss deprived her of the financial security she had hoped would support her during her later years. Jane left for Pittsburgh and settled on a modest farmstead in Swissvale, named for her former husband's family. She remained there until her death at age sixty-nine in 1884.

Sister Ann Alexis Shorb. *Carte de visite* by an unidentified photographer, about 1863.

Foard Collection of Civil War Nursing

A Change of Mission

CARNEY HOSPITAL IN BOSTON OPENED ITS DOORS ON A
June day in 1863 with forty beds and a noble ambition to serve
the city's Irish Catholic community. Many of its first patients,
however, were not the sick, poor, and suffering who inhabited
the fringes of society. They were soldiers. Their care became the
responsibility of the hospital administrator, Sister Ann Alexis
Shorb, a fifty-seven-year-old nun. "She was one of the most thor-
oughly Christian, lovable, intelligent, bright, and happy women I
ever met," recalled one physician, a passionate abolitionist, who
helped her organize the hospital staff.[384] Sister Ann Alexis had
arrived in Boston three decades earlier to open an orphanage
and school for poor Catholic children. She went about her work
dressed in the conspicuous blue habit, white collar, and dramatic
white cornette of her order, the Sisters of Charity of Saint Joseph.

The order's origin dates to 1809, when Elizabeth Ann Seton
established a Catholic enclave in Emmitsburg, Maryland.[385]
Mother Seton modeled her community on the Daughters of Char-
ity, which had been founded in France to care for the ailing poor
and for orphans, educate girls, provide sanctuary for boarders in
its facility, and proffer social ministry. Small groups of sisters were
dispatched from Emmitsburg on charitable missions to various
cities, an effort that continued after Mother Seton's death in 1821.
A few years before Seton settled in Emmitsburg, the future Sister
Ann Alexis was born as Harriet Shorb in York County, Pennsyl-
vania. The Shorbs, who descended from immigrants from the
ancient German city of Koblenz, relocated to the Emmitsburg
area at some point during Harriet's childhood. The move exposed
her to the Daughters of Charity and led to her taking the sister-
hood's sacred vows.

On May 2, 1832, Sister Ann Alexis arrived in Boston with two other nuns,[386] and they set about a new phase of their life's work. Amid a storm of prejudice and bigotry aimed at the burgeoning population of Irish immigrants, as well as general anti-Catholic sentiment, they founded St. Vincent's Female Orphan Asylum. Sister Ann Alexis became the mother superior of the institution, which sheltered and educated girls between the ages of four and sixteen. On average, St. Vincent's admitted 137 girls each year.[387] According to one Catholic historian, "Sister Ann Alexis had a dignity that won the respect of Bostonians, and a tenderness with children that made the youngest of them lisp out her name as 'Mama 'Lexis.'"[388] In 1863, church officials named her administrator of Carney Hospital, the first such Catholic facility in New England.[389] Following the lead of other hospitals during the Civil War, some of the beds she oversaw were occupied by soldiers. Between 1864 and 1865, Carney took in 175 soldiers, for which the hospital was paid $4.50 per week for each enlisted man. Officers received free care.[390]

Sister Ann Alexis continued to serve the hospital after the war. Upon her death at age seventy in 1875, Bostonians celebrated her pioneer work with St. Vincent's and the three thousand girls she had cared for over four decades. "Sister Ann Alexis was the head and heart of this charity, and in that time she won a widespread reputation as an able and untiring worker in this noble field," her obituary noted, adding, "She was a Sister of Charity in name and in deed, and the work of her hands will not die with her."[391]

The Road to Gettysburg

Nurse Harriet "Hattie" Dada rode in a supply-laden ambulance wagon through the streets of Gettysburg and into the Pennsylvania countryside on July 8, 1863. Just a few days earlier, brutal fighting had engulfed the fields, orchards, and woods she now passed through while traveling to a hospital assignment. In its place were scenes of devastation. "The road was filled with army wagons, ambulances and wounded soldiers on their way to the railroad," Hattie recalled. "All the way the houses, trees and thrown-down fences showed where shot and shell had sped on their mission of death and destruction." She added, "Nearly every house had the red hospital flag, and here and there were stacks of guns which had been gathered from the battlefield. Off at the left of the road, in the edge of the woods, could be seen the newly-made graves of those who had fallen."[392]

Hattie's journey to Gettysburg began four decades earlier, in upstate New York, near the shores of Lake Ontario. Harriet Atwood Dada was the youngest of three children born to cabinetmaker and minister Lemuel Dada and his wife Merinda. Hattie grew up in the towns of Hannibal and Fulton, graduated from a local academy in 1854, and dedicated her life to missionary work through the auspices of an influential Christian ministry, the American Board of Commissioners for Foreign Missions.

Sent to Indian Territory, Hattie became, at age twenty, a teacher to the Choctaw people, learned their language, and earned the name Imponna, meaning "skillful." She might have spent the rest of her days there, but political tensions that polarized the country led to unrest in the territory. In the winter of 1860, Hattie and other Northern missionaries fled in the face of growing violence by Southern sympathizers.

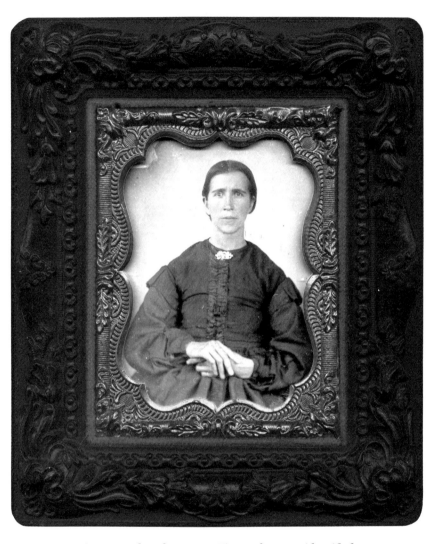

Dr. Harriet Atwood Dada Emens. Tintype by an unidentified photographer, about 1861.

Foard Collection of Civil War Nursing

Back in New York State, Hattie awaited a favorable opportunity to return to the Choctaws. But the bombardment of Fort Sumter is April 1861 changed everything. She signed up to be an army nurse with the newly formed Women's Central Association of Relief in New York City.[393] Her application was accepted in early June 1861, and she took a crash course on nursing in the city's hospitals. "Daily, for six weeks, I visited the different wards, witnessed the operations, learned the mysteries of bandaging, etc.," Hattie recounted.[394] The call to serve came on July 22, 1861, the day following the Battle of Bull Run. By 6 p.m. that evening, Hattie boarded an overnight train for the nation's capital as news and rumors swirled across the North about the defeat of Union forces. Susan Hall, a fellow missionary and nurse-in-training,[395] accompanied Hattie on the trip.

Hattie and Susan reported to chief of nurses Dorothea Dix upon arriving in Washington, D.C., on the morning of July 23 and were immediately assigned to a post in nearby Alexandria, Virginia. That afternoon, they set out in a hack for the normally short trip across the Potomac River. "Our progress was slow. The streets were filled with soldiers, worn out and hungry, straggling in from the field of battle," Hattie noted, adding, "Seeing a newly-equipped regiment marching through the streets of a northern city was one thing, and that same regiment subsequently marching in disorder and confusion, their uniforms soiled with dust and they chagrined with retreating, was quite another thing."[396] The two women eventually reached their destination and encountered soldiers lying everywhere. "We found some on beds, others on mattresses on the floor. Many were covered with the dust of the retreat, because wounded arms could not wash faces and wounded legs could not move about; so we were soon at work," Hattie explained.

There were more trips and many experiences with soldiers ahead. About a year later, on May 25, 1862, Hattie tended to patients in Winchester, Virginia, when the town was captured by rebel forces during Maj. Gen. Thomas J. "Stonewall" Jackson's victorious Shenandoah Valley Campaign. "Our troops came pour-

ing through the town, followed by Confederates, shouting, firing guns and causing a confusion which cannot be described," she remembered. Hattie came close to being injured herself after a volley of bullets flew through the hospital, wounding a nurse and a child.[397] The following year at Gettysburg, Hattie's ambulance ride through the wrecked town and countryside ended at the George Bushman farm. The main house, barn, and surrounding fields had been converted into a temporary tent hospital for the Twelfth Corps. Over the next three months, she and other nurses and medical personnel cared for hundreds of wounded and sick men there and, after July 21, at the more permanent general hospital closer to town. In addition to the many Union soldiers she nursed, Hattie also cared for injured Confederates. In response to one wounded Southern soldier who asked her if he would be treated, she replied, "We treat you just as we want our boys treated when they are taken prisoners."[398]

Hattie preferred assignments that took her to field hospitals, such as at Gettysburg. She found that in these situations the welfare of the soldiers was the chief concern of caregivers, as compared with city hospitals, which all too often were tangled in the red tape of bureaucracy. One Indiana soldier described Hattie in her element: "With sleeves rolled up and towel in hands she would meet the wounded comrade fresh from the battle field, take charge of loving messages from the dying, and assist in Christian services for those desiring them."[399] Hattie strove to counter the loneliness and homesickness that plagued many of the men. On one occasion, she engaged schoolchildren back in New York to make comfort bags for soldiers. Each bag, intended to hold personal items, included a note from the child who made it. In her thank-you note to the youngsters, Hattie encouraged them to send letters and papers to the soldiers to keep them from turning to tobacco and alcohol to ease their pain and suffering.[400]

After leaving Gettysburg in October 1863, Hattie traveled to Tennessee and tended patients in hospitals at Murfreesboro and Chattanooga. In September 1865, her service ended after four years and two months, an impressive stint that few of the thou-

sands of her sister nurses attained. "It was a mental strain and nervous tax which but few could endure," Hattie remarked in reference to her friend Susan, who had served the same amount of time, much of it with Hattie, and suffered ill health as a result.[401] Hattie made this comment in "Ministering Angels," a ten-part series of stories about her war experience published in the *National Tribune* in 1884. By this time she had earned a medical degree from the New York Medical College for Women in New York City and worked as a homeopathic doctor in Syracuse, New York. She specialized in diseases of women and children. In 1909, Hattie died at age seventy-four after suffering a hemorrhage related to uterine fibroids. She barely outlived her husband of more than three decades, Rev. Peter Walter Emens. The Daughters of Union Veterans of the Civil War in Cortland County, New York, named the Harriet Dada Emens Tent No. 63 in her honor.

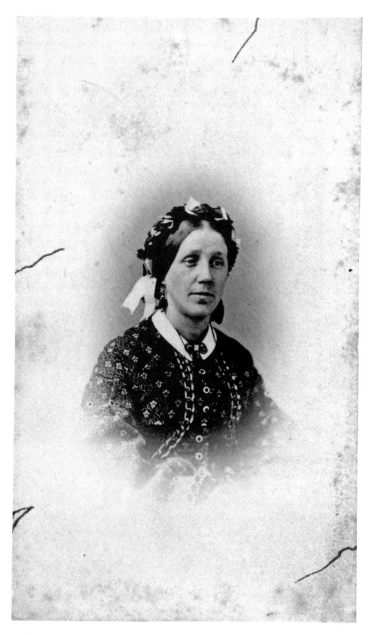

Phebe Mary Agett May. *Carte de visite* (unmounted) by an unidentified photographer of Norristown, Pennsylvania, 1863.

Collection of the U.S. Army Heritage and Education Center

First-Time Nurse at Gettysburg

PHEBE MAY JOINED OTHER VOLUNTEERS HEADED TO Gettysburg to aid the massive number of casualties left behind in the aftermath of the recent battle. On July 11, 1863, she left Washington, D.C., by rail for a difficult journey through a region unsettled by the rebel invasion. In Baltimore, she fought her way through the city and wrangled a military pass from the provost marshal to continue on. She eventually crossed into Pennsylvania and changed trains at Hanover Junction, which had been sacked by Confederates just before the battle. An exhausted Phebe, along with other passengers, climbed aboard a boxcar for the last leg of the trip. Once inside, she discovered it was filled with empty coffins. She lay down on one of them and fell asleep.

Phebe, the youngest daughter of British immigrants who farmed in upstate New York, was no stranger to soldiers' care. A year and a half earlier, she had followed her husband, Dr. Henry May,[402] off to war. As he tended to the sick and wounded of two Empire State regiments in the Army of the Potomac, she stayed in Baltimore and spent time visiting hospitals and observing nurses at work. Life changed in May 1863, when Henry received new orders to report to the army hospital in York, Pennsylvania. Phebe joined him there and might have remained, but the Battle of Gettysburg intervened. Military authorities dispatched Henry and other medical personnel to the front lines, while Phebe left for the safety of Washington, D.C.

During the three-day engagement, Henry performed his duties in the field with the Twelfth Army Corps, commanded by Maj. Gen. Henry W. Slocum. The men and officers wearing the star-shaped corps badge distinguished themselves in the successful defense of Culp's Hill—and suffered heavy casualties. After the

battle, Henry continued to treat the injured from the corps, first in a temporary field hospital and then in Camp Letterman, a facility swiftly organized for longer-term care. Meanwhile, Phebe left the capital at her earliest opportunity to join Henry. She recalled, "I had as a travelling companion Miss Dorothea Dix who was on her way to Gettysburg to supervise the work of ladies at work in the different hospitals and wherever they could be useful. With permission of the Hospital authorities I at once commenced work on my husband's ward, and did all I could, night and day, for our sick and wounded soldiers. We remained here, in Camp Letterman General Hospital until the wounded were transferred to other Hospitals."[403]

Gettysburg marked her first experience as a nurse. Later that year, Henry traveled to Nashville, Tennessee, to work in the hospitals there. Phebe accompanied him, this time as a paid nurse. Early in their journey, they stopped at a photographer's studio in Norristown, Pennsylvania, where she sat for this portrait. Soon after they arrived in Nashville, New York governor Horatio Seymour appointed Phebe as a state agent, entrusted with funds to purchase and distribute various items for the betterment of patients. She acted in this capacity in Nashville and Murfreesboro, in addition to her duties as a nurse. "I was enabled to do much good, and to cheer many sick and wounded men not only of my own state, but of other states as well," she stated with satisfaction.[404] During her stay in Tennessee, she suffered a personal tragedy when she learned of the death of her brother, James, a private in the Eighth New York Heavy Artillery, at the Battle of Cold Harbor in June 1864.[405]

In the autumn of 1865, Phebe and Henry returned to their home in Corning, New York. They started a family that grew to include two children, a boy and a girl. In 1886, Phebe received a request from army veteran Arnold A. Rand to share her war experiences.[406] She sent him an account of her activities and the photograph pictured here. The portrait became part of an enormous collection of artifacts, including about thirty-six thousand photographs, assembled by Rand and others under the auspices

of the Military Order of the Loyal Legion of the United States, or MOLLUS. In her letter to Rand, Phebe noted, "My work during those eventful years I recall with pleasure as one of pure love for our country's course, and which I know gained the gratitude of many soldiers and their friends."[407] A few years later, in 1890, Phebe relocated to Washington, D.C., with Henry after he accepted the position of medical examiner in the Pension Bureau. Henry died of cancer in 1894, and Phebe passed away four years later. She was about sixty-seven. Perhaps her finest tribute was offered a few years before she died by a sister nurse, who stated, "There were none who labored more constantly and efficiently, and whose services were more highly appreciated, by surgeons and patients, than Mrs. May."[408]

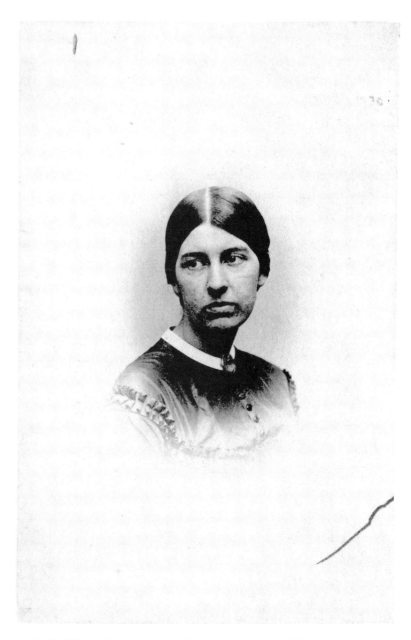

Emily Wheelock Dana. *Carte de visite* (unmounted) by an unidentified photographer, about 1861–1865.

Collection of the U.S. Army Heritage and Education Center

Maine-Stay

The chief surgeon of the general hospital at Annapolis, Maryland, playfully referred to nine of his nurses as the "Maine-stay" of the staff. They were all from that state and served the Union cause with notable fidelity.[409] Their number included Emily Dana, who had reported for duty at the end of August 1863. A rookie on her first assignment, she hit the ground running as casualties from the recent Battle of Gettysburg and elsewhere required attention. Before long, hospital brass entrusted her with some of its hardest cases.

There is no evidence that twenty-three-year-old Emily had any nursing experience prior to her arrival in Maryland. She was the eldest of five children born to Vermonters who settled in Wisconsin. Her father, Oscar, prospered as an attorney and county clerk in Kenosha. In the mid-1850s, he and his family returned to New England and settled in Maine. They had a significant connection to the Pine Tree State—Judah Dana, a respected judge who had served briefly as a U.S. senator. Her namesake, also called Emily Wheelock Dana, was Judge Dana's daughter.[410] At the start of the Civil War, the Dana family resided in Portland and eventually added a summer home in Falmouth. Why Emily joined the nursing corps in not exactly known. But the timing of her enlistment followed the tragic death of her younger brother Richard. A cadet at the U.S. Naval Academy's temporary location in Newport, Rhode Island, he lost his battle with typhoid in April 1863.[411] Emily's assignment had another navy connection. The Annapolis hospital where she served happened to be located on the grounds of the permanent U.S. Naval Academy. It had been relocated to Rhode Island in 1861, amid concerns that the campus and its personnel might fall into Confederate hands.

The Naval Academy Hospital, as it came to be known, included about a score of women nurses. Emily and the eight others from Maine composed almost half the staff—giving rise to the surgeon's "Maine-stay" reference.

At some point after her arrival, Emily took on the task of caring for recently released Union prisoners of war. According to one account, those in her ward died in greater numbers, due to old wounds and starvation suffered during their imprisonment: "Dana always strove to keep the spirits of the patients up. She was impressed with the uncomplaining endurance of the soldiers and recalled that she rarely heard a word of regret."[412] In April 1864, Emily tendered her resignation after seven months in service, a relatively brief tenure compared with that of her peers. Though the reasons for her departure are unknown, they may relate to the difficult cases in her care.[413] Emily returned to Portland and worked for many years as a high school teacher. In 1927, she received national attention after her name appeared in newspapers as one of forty-six surviving Civil War nurses pensioned by the federal government. Altogether, about 2,448 women received benefits for their wartime service. Emily died in 1929 at age eighty-eight. She never married. In 2011, the Maine legislature dedicated a plaque in honor of women veterans in the state house's Hall of Flags. The design features four faces, one for each of century of service. Emily's likeness represents the nineteenth century.[414]

The Abolitionist Angel of Hospital No. 8

MARY JEWETT FLUNG THE REJECTION LETTER INTO THE fireplace, a burnt offering to her own righteous indignation. She did not need a physical reminder that her hopes of becoming an army nurse were dashed for a second time.[415] Less than two years earlier, in the summer of 1861, she had first been denied a position. Like so many young women, Mary had applied with unbridled patriotism to support the Union war effort. She expected to be accepted without reservation, for the twenty-two-year-old schoolteacher had led her local Soldiers' Friends Society in Lima, Michigan. The indomitable Dorothea Dix, head of nurses in Washington, D.C., rejected her, however, because she did not fulfill the minimum age requirement of thirty-five.

Though young, Mary had been exposed to the great questions that tore at the moral fabric of the country. Her earliest memory was of a runaway slave who had paused on the family farm in Seneca, New York, a stop along the Underground Railroad. "She stood clinging to her father's knees, watching the chattel as he examined a pistol," recounted her biographer years later. Mary's father asked the slave if he would use the gun in self-defense. "'You would not shoot?' said her father. 'I wouldn't be taken,' was the reply."[416] Mary's father, Dr. Lester Jewett, and her mother, Hannah, loomed large in her upbringing in New York. In 1846, they relocated to Michigan to raise Mary and her nine brothers and sisters. "Her parents were uncompromising temperance people and shared fully in the abolition principles of the Quakers. Anti-slavery and temperance lecturers always found a refuge and a welcome at their fireside, and round that hearth there was much intelligent discussion," noted a biographer.[417] Thus enlightened, and schooled at home, for she was frail, Mary blossomed. At

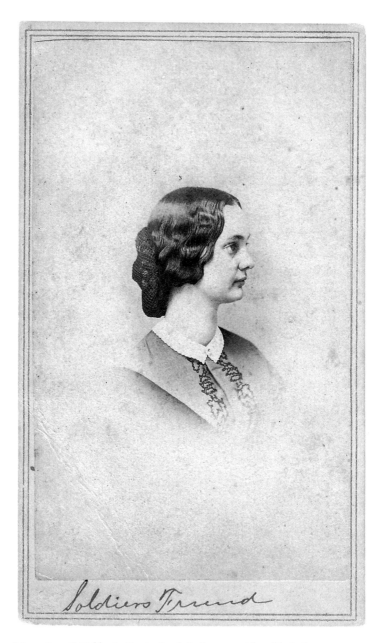

Mary Jewett Telford. *Carte de visite* by an unidentified photographer, about 1863–1864.

Foard Collection of Civil War Nursing

fourteen, she became a schoolteacher and worked in this capacity during the years before the war. Her résumé included a stint as an instructor of French and music at an academy in Morganfield, Kentucky. She lasted only a year there before returning home. Mary's biographer hinted that her abolitionist beliefs became a problem in this largely pro-slavery town.[418]

Following the bombardment of Fort Sumter in 1861, Mary might have been the first of her siblings to serve in the war effort had Dix not refused her admission to the corps of nurses. Two of her brothers, one older and another younger, joined the Union army during the second half of 1862.[419] When her little brother, William, succumbed to disease in Nashville just a few months after he enlisted, Mary renewed her efforts to volunteer and was again rejected. This is the letter that went into the fireplace. Two days later, Mary left Lima for Nashville, armed with a recommendation letter from Michigan governor Austin Blair, a friend of her father. Mary arrived in the Southern city and visited Hospital No. 8, a complex of buildings dominated by a majestic Presbyterian church with two steeples. She learned from one of the nurses that no one could play an organ that had been donated to the hospital. Mary could, and accepted an invitation to stay for a few days and play for the patients.

The chief surgeon of the hospital, William Carter Otterson, became aware of Mary.[420] She told him of her desire to land a nurse's commission and showed him her recommendation from the governor, plus other letters she carried for that purpose. He cut through the red tape. On November 28, 1863, just two days after the Union celebrated a day of thanksgiving to commemorate the recent victory at the Battle of Gettysburg, Mary's commission took effect. She made daily visits to each of the seven wards in the 615-bed hospital. Uncounted numbers of soldiers were touched by her efforts, including one veteran who recalled, years later, "This blessed woman, who I've always called 'my angel,' snatched me from the grave down in Tennessee and saved my life; sick and discouraged and homesick, she made me live and get well."[421]

Mary's ceaseless activities ended in exhaustion, a condition

common to so many overworked nurses. She resigned in June 1864. Upon her return home to Lima, she married Jacob Telford, a young man whom she had first met when she was a girl in New York.[422] He had recently left his regiment, the Fifteenth Indiana Infantry, with a disability discharge, due to a gunshot wound in the groin received at the Battle of Stones River. Mary and Jacob never regained the health they enjoyed before the war. Still, they lived productive lives and started a family that grew to include several adopted war orphans, all girls. In the early 1870s, the Telfords moved to Denver, Colorado, in search of a more hospitable climate for Mary, who suffered from asthma. Here, in 1883, she became a charter member of the Woman's Relief Corps, an auxiliary of the powerful Union veterans' organization, the Grand Army of the Republic.

By this time she had become an influential writer on the topic of temperance and embraced women's suffrage.[423] In 1884, she founded and edited the *Challenge*, a journal aligned with the Women's Christian Temperance Union, to which she belonged. Mary toured the country delivering lectures on the subject. "A silvery tongue gave voice to heaven-born thoughts in speech so clear, so convincing, so true, that, like the reverberations of the great canyons in which her heart took delight, the echoes scintillated and came back again and again with such telling force as to stamp her words forever on the minds of those who heard," proclaimed one of her compatriots in the Woman's Relief Corps.[424] In 1894, the Prohibitionist Party of Colorado nominated her as a candidate for lieutenant governor. Though she did not win, the bid placed her in the vanguard of a small but expanding community of American women seeking statewide and other offices. Mary did not live to see women get the right to vote. She died in 1906 at age sixty-seven, a year after her beloved husband Jacob passed away.

Her Greatest Role

JEAN LANDER BURST UNANNOUNCED INTO A HOME IN
Union-occupied Beaufort, South Carolina. "Gentleman," she de-
clared to startled officers quartered there, "to-day I must remove
every bedstead in the house to the hospital building."[425] Most
likely her entrance and lines were not as spontaneous as they
may have seemed. They were probably well rehearsed and calcu-
lated for effect, for she was a celebrated stage star, known across
America as Jean Davenport. The story of how she came to Beau-
fort might have flowed from a playwright's pen. Born in England,
Jean practically grew up on stage. Her father, Thomas, had set
aside his legal career to become an actor and theater manager.
Her mother also acted. Jean made her first appearance in a play
at age eight, starring as Little Pickle in *The Manager's Daughter*.
The London *Observer* declared that she performed the part with
"an archness and an intelligence far beyond her infantine years."[426]
According to one account, Jean's stage presence inspired literary
master Charles Dickens. He modeled the Crummels family, an
acting troupe in his classic *Nicholas Nickleby*, on Jean and her
parents. The star of the fictional family, Ninetta Crummels, the
"Infant Phenomenon," bore a striking resemblance to Jean.[427]

Over the next two decades, Jean performed to packed houses
in the great dramatic centers of Europe and America, winning
acclaim from critics and adoration from theatergoers. In the early
1850s, she made the United States her home and continued to
tour on both sides of the Atlantic. Along the way, she met a dash-
ing engineer from Massachusetts, Frederick W. Lander, who had
made a name for himself in California. During the Gold Rush
years, the government had hired him to survey western railroads.
In the latter 1850s, he led another survey team to blaze a new

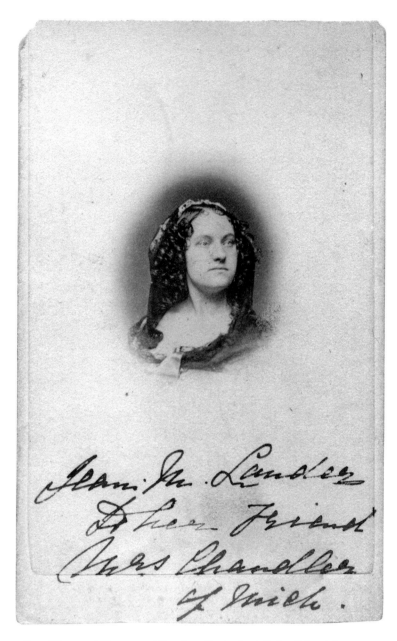

Jean Margaret Davenport Lander. *Carte de visite* by John Adams Whipple (1822–1891) of Boston, Massachusetts, about 1861–1863.

Foard Collection of Civil War Nursing

route to California through Wyoming Territory. The Lander Trail, as it was later known, became part of a national wagon road for eager settlers seeking new lives in the West. Lander's exploits made him a celebrity on a par with another popular pathfinder, John C. Frémont.

Jean and Lander wed in San Francisco in October 1860. "She has left the stage forever, and will hereafter reside in California. By this marriage the American stage had lost one of its finest artistes, and the public will have to wait a long time before they see her equal in certain characters," stated one press report, which also noted that her acting career had earned her a fortune, estimated as high as $100,000.[428] Six months later came the bombardment of Fort Sumter and the start of the Civil War. The newlyweds headed back East, where Lander accepted a brigadier general's commission and distinguished himself in early actions in western Virginia. But a severe leg wound received in battle and the rigors of the campaign ended with his death from pneumonia in March 1862 at age forty-one. Northerners and Southerners mourned his loss. A report in the *New Orleans Delta* paid him a compliment, at the expense of his fellow Union generals, when it observed, "Our generals always lead their commands; theirs generally sniff the battle from afar off. Lander, however, was not one of these; he was a fighting man and an energetic officer."[429]

A widow at thirty-two, Jean devoted herself to perhaps her greatest role—the aid of Union soldiers. Getting started proved a great challenge. According to Thomas Wentworth Higginson, the reform-minded minister, abolitionist, and soldier from Massachusetts,[430] "She had tried to establish hospitals, but had always been met by the somewhat whimsical opposition of Miss Dorothea L. Dix, the national superintendent of nurses, a lady who had something of the habitual despotism of the saints."[431] It is easy to imagine that the stern and autocratic Dix, who preferred older and plainer-looking nurses, frowned on the independent-minded Jean's involvement. In December 1862, Jean finally scored a success when the federal government engaged her to serve in hospitals located in the Department of the South.

She made her headquarters in Hilton Head, South Carolina, and toured various locations in the Palmetto State and into northern Florida.

Meanwhile, efforts were underway by Higginson and others to recruit a regiment of escaped slaves for military service. Their efforts were successful. The First South Carolina Infantry mustered into federal service in January 1863, with Higginson as colonel and commander.[432] One of his friends, Dr. Seth Rogers, served as the regiment's surgeon. Rogers described a dramatic encounter with Jean in an April 1863 letter home: "Mrs. General Lander drew up her splendid steed before my tent door this afternoon and assured me she would do all in her power for our General Hospital for colored soldiers, now being established in Beaufort."[433] At some point later that year, Jean occupied a small home in Beaufort and converted it into a shelter. Ironically, two of its inhabitants were Rogers and Higginson.[434] Both officers were recuperating from illnesses when Jean barged in and demanded beds for the new building she had secured for a hospital. Higginson did not note whether she obtained enough beds to convert the building for its intended use.

By the middle of 1864, both officers had returned to Massachusetts. Jean also went back to the North about this time. In October 1864 she announced her intention to resume her career. She made her triumphant return to the stage in February 1865 as Mrs. General Lander. She continued to act until her retirement in 1877.[435] Jean split her later years between residences in Washington, D.C., and Lynn, Massachusetts. Her death in 1903 at age seventy-four made national news. An adopted son, Charles Frederick Lander, survived her.[436]

Adjutant Noble's Sword

Minutes after the roar of battle died away and the gunsmoke dissipated, a Southern captain surveyed the carnage around him. His attention was drawn to a fallen enemy officer nearby. "I stepped to where his body was. I particularly noticed him as he was such a nice looking young man. He was dead when I got to him," the captain later recalled. The dead man's fine sword also caught his attention. He took it as a replacement for his own worn blade and continued on.[437] The deceased officer was William Noble. The youngest of four children born in Philadelphia to Scottish immigrants, he worked as a clerk in Detroit when the war came. William promptly enlisted in the Second Michigan Infantry, which formed in the wake of the attack on Fort Sumter. He started as a first sergeant and earned his way to first lieutenant and adjutant of the regiment.[438]

William's advancement ended in eastern Tennessee. On the morning of November 24, 1863, he and his comrades assaulted beleaguered Confederates at Knoxville. The charge landed squarely on the defenders in rifle pits at Fort Sanders. A corporal who carried the Michiganders' flag that day recounted that he planted it on the rifle pits despite a warning from William, who was just behind him, "not to be so daring with the colors." Moments later, according to the corporal, the Confederates retaliated with an overwhelming force that stopped the attackers cold, including an enfilading fire from a masked battery that raked the Union ranks with destructive canister shot. William was struck in the head and instantly killed. He was about twenty-one years old.[439] Word of William's death hit the family hard. His widowed and sickly mother, Jane, felt the loss emotionally and financially, for he had supported her with part of his soldier's salary. When

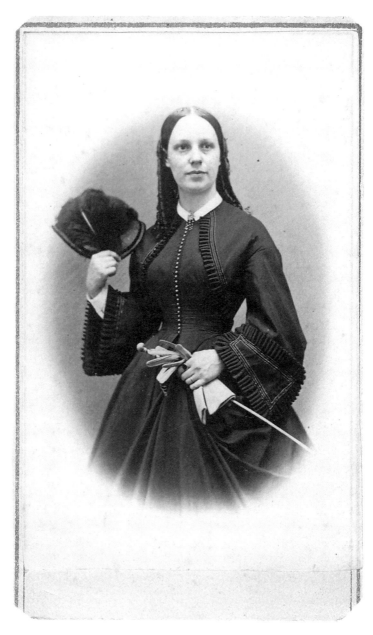

Martha Noble Brainerd. *Carte de visite* by James Janeway Randall
(1815–1875) of Detroit, Michigan, about 1865.

Foard Collection of Civil War Nursing

she filed an application for a federal pension in 1864, her successful claim was supported by an affidavit sworn by Martha Noble Brainerd, William's only sister.[440]

Few documents detail Martha's life. They reveal that she lived in Michigan, married a man named Brainerd, nursed sick and wounded Union soldiers, and donated money for their welfare. Though scant, this information was enough to satisfy her own claim for a nurse's pension after the war. With support from officers in her brother's regiment, the pension was approved. Martha received modest monthly payments, which, added to her salary as a clerk in the state's Auditor General's Office in Lansing, provided her with a comfortable life as she grew old.[441]

In 1879, Martha learned more about her brother's death when she received an unsolicited package in the mail. Inside was William's sword and a letter penned by the man who captured it, Capt. Henry H. Moseley of the Fourth Alabama Infantry. He explained what happened that fateful day sixteen years earlier: "When the 2d Michigan Infantry charged our skirmish line it was very near exhausted when it reached that portion of the line which I commanded; a large portion were killed and wounded before they reached us by an enfilading fire from another portion of our line. Adjutant Noble being one of the number that reached us, was killed within a few steps of where I was, with most of the balance of his comrades who got that far. The firing ceased in less than five minutes after he was killed."[442] Moseley took the sword at this time. The next day, November 25, 1863, he suffered a severe wound and fell into Union hands. He hung on to the sword until he was paroled and exchanged a year later, and he kept it with him through the surrender at Appomattox Court House on April 9, 1865. Citing the generous terms offered by Lt. Gen. Ulysses S. Grant, Moseley informed Martha, "You are aware that General Grant allowed all our officers at the surrender to retain their side arms, hence I brought your brother's sword home with me."[443] Martha presumably kept the sword in her possession until 1914, when arteriosclerosis caused her death at age seventy-six. She outlived Capt. Moseley, who passed away in 1899.

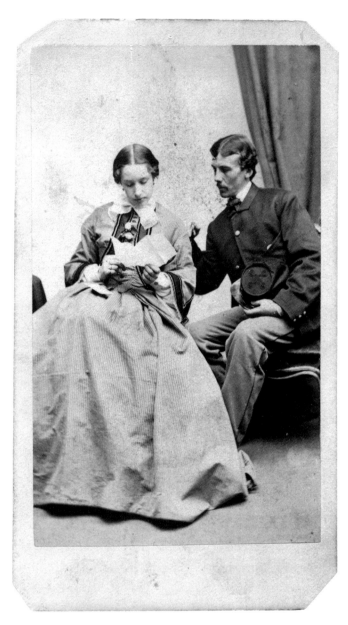

Josephine Shaw Lowell and Charles Russell Lowell. *Carte de visite* by James Wallace Black (1825–1896) of Boston, Mass, about 1863–1864.

Collection of Richard Carlile

Genius in the Shadows

CAREFUL LISTENERS INSIDE UNION HOSPITALS IN AND about Vienna, Virginia, during the winter of 1863–1864 might have overheard a young lady chatting up immigrant soldiers. She moved among the patients, bringing them cheer in their native tongues. "She delighted the Frenchmen, Italians and Germans by conversing with them in their own languages, that so vividly recalled their early homes," recalled Chaplain Charles A. Humphreys, who worked alongside her in the wards.[444] She was Josephine Shaw Lowell, or "Effie" to friends and family. Only twenty years old, she knew all too well the separation caused by the death of a loved one. Her only brother, Col. Robert Gould Shaw, had recently been killed on the ramparts of Fort Wagner in South Carolina. He had led his troops in the African American Fifty-Fourth Massachusetts Infantry on a failed assault that debunked the myth that the black men in blue would not fight.

Though the Shaws honored Robert as the shining light of the family for his sacrifice, they recognized Effie as the genius among the five Shaw children, according to her mother Sarah. By age ten, Effie spoke foreign languages, wrote poetry, cooked, and sewed. She also played croquet and rode horses. At thirteen, her philanthropic impulses emerged. Not far from her home on New York's Staten Island lived a community of poor Irish families. "She became interested in them and used to have the mothers and children come to spend the afternoon on her father's lawn, where she would give them ice cream and cake," noted a biographer.[445] Effie's progressive-minded Unitarian parents encouraged her charitable instincts. Her father, Francis George Shaw, a Boston blueblood, inherited a vast family fortune. An ardent and outspoken reformist, he supported the abolitionist and feminist

movements. He and his family had lived in Europe for some years before settling in Staten Island.

When the Civil War came, Effie reflected an idealistic view consistent with her upbringing. "These are extraordinary times and splendid to live in. This war will purify the country of some of its extravagance and selfishness, even if we are stopped midway. It can't help doing us good; it has begun to do us good already. It will make us young ones much more thoughtful and earnest, and so improve the country. I suppose we need something every few years to teach us that riches, luxury and comfort are not the great end of life," she noted in her diary on August 15, 1861, just a few weeks after the Union debacle at the Battle of Bull Run.[446] A couple of days later she added, "We never knew how much we loved our country. To think that we suffer and fear all this for her! The Stars and Stripes will always be infinitely dear to us now after we have sacrificed so much to them, or rather to the right which they represent. What can be the end of this misery?"[447]

Part of the answer to her rhetorical question was the death of her brother Robert. By this time, Effie had become engaged to his close friend, Charles Russell Lowell, a Harvard-educated Boston business executive eight years her senior. Chaplain Humphreys noted, "Lowell was easily the first in everything to which he laid his hand."[448] As an aide to Maj. Gen. George B. McClellan early in the war, Lowell had distinguished himself during the Antietam Campaign. In May 1863, a month after he became engaged to Effie, Lowell organized the Second Massachusetts Cavalry in Boston. He commanded the new regiment as colonel. Lowell soon received orders to report with his troopers to Washington D.C. Before leaving Massachusetts, he gave his fiancée a Virginia roan named Berold. The big horse had been wounded beneath Lowell at Antietam and was no longer fit for fighting. Effie rode the horse for many years.[449]

In Washington, military officials placed Lowell in command of the outer defenses of the city, and he made his headquarters in Vienna. He took a break from his duties and married Effie in Staten Island on October 31, 1863. The couple traveled to Vienna

and started their new life together in a cozy farmhouse. Through the autumn and winter of 1863–1864, Lowell guarded a thirty- to forty-mile section of the defenses against guerilla activity by the likes of Col. John Singleton Mosby and his partisan rangers. Effie dedicated herself to caring for the sick and wounded. Chaplain Humphreys, who had joined Lowell's regiment, appreciated her assistance: "Her presence in camp had a refining influence upon officers and men, and in the hospital, by her tender sympathies and beautiful bearing and sweet simplicity, she was like an angel visitant. She often assisted in writing letters for the disabled soldiers; and when I sought to give comfort to the dying, her presence soothed the pangs of parting."[450]

Their marital bliss ended on October 19, 1864, in the Shenandoah Valley. Lowell was leading a charge in the thick of the fighting at Cedar Creek with characteristic zeal when a spent ball struck him in the chest. The bullet did not draw blood, but it severely damaged his right lung. Down but not out, he insisted on leading another charge. Too weak to mount his horse, comrades helped him into the saddle. Almost immediately after he and his mount galloped off, a bullet tore into his body from shoulder to shoulder, severing the spinal cord. Carried to a farmhouse in nearby Middletown, his life ebbed. The surgeon who treated him recalled, "As the night wore on and his strength failed, I said: 'Colonel, you must write to your wife.' He answered that he was not able, but I said it could be managed; so, putting a scrap of paper on a piece of board, I held his arm above him, putting a pencil between his fingers, and holding the hand against paper, told him I thought he would find that he could use his fingers. And thus he wrote a word or two of farewell to her."[451]

A month later, the widowed and very pregnant twenty-one-year-old Effie gave birth to a daughter. She named her Carlotta Russell for the father she would never know.[452] "A friend describes her at that time as 'going about the house with her little girl in her arms, not sad but with the quiet look as if she were living in another world,'" reported Effie's biographer, who added, "She had a sitting room in her father's house in which she kept near her

Lowell's sword and other treasures, and there she used to work."[453] Here, surrounded by relics of her late husband, Effie recommitted herself to progressive causes. She rose to become one of America's highest-profile social reformers of the late nineteenth century, distinguished as the first woman to serve as commissioner of the New York State Board of Charities and the founder of the New York Consumers League.

Effie died of cancer in 1905. The press celebrated her long list of contributions and achievement in service to the betterment of those in need. "She was always a worker for results, and no ephemeral or unpractical cause could enlist her sympathy," stated the *New York Times*, adding, "Mrs. Lowell lived very simply and quietly in private life and never entertained generally. Her social position, her charm of manner, and quiet and unassuming methods of work combined to make Mrs. Lowell a very striking personality."[454]

The Soldier's Friend

On December 22, 1863, at 11 a.m., a large crowd attended dedication ceremonies for a new soldier's home in Philadelphia. Mostly women, they represented volunteer charities from across the city, gathered to celebrate a successful six-month collaboration. A brass band, singing, speakers, and a reception added to the excitement.[455] Among the large number of Philadelphians who had helped make the 150-bed home possible was one woman widely recognized as having played a critical role in its formation—Anna Maria Ross, an indefatigable humanitarian known to many as "the Soldier's Friend." Her story traces the origins of soldier care in Philadelphia. Back in October 1861, Ross became associated with the new Cooper Shop Hospital, an offshoot of the popular Cooper Shop Volunteer Refreshment Saloon. Appointed lady principal, or head nurse, she poured every ounce of her considerable mental and physical energy into her work. "Day and night she was at her post—watching while others slept, dressing with her own hands the most loathsome wounds; winning the love and admiration of all with whom she was associated. Her tasks were arduous, her sympathies were drawn to the utmost, her responsibilities were great," noted a biographer.[456]

Ross's journey began in Philadelphia, where she was born in 1813. From her mother Mary's family, she descended from Revolutionary War patriots that included a great-uncle who served as a captain in the Continental army,[457] and a great-grandmother who volunteered as a molder in a bullet-making establishment. Her father, William, hailed from County Derry in Ireland. He emigrated to America in 1788 and became an accountant. At some point, Ross dedicated her life to Christian piety and service to society's needy children, fugitive slaves, and those who struggled

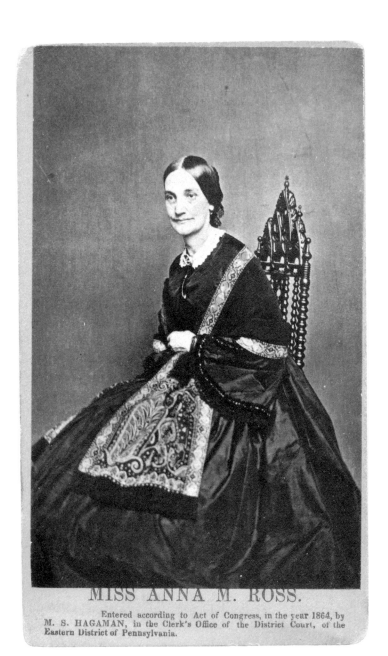

MISS ANNA M. ROSS.

Entered according to Act of Congress, in the year 1864, by
M. S. HAGAMAN, in the Clerk's Office of the District Court, of the
Eastern District of Pennsylvania.

Anna Maria Ross. *Carte de visite* by Moses S. Hagaman (about
1818–1892) of Philadelphia, Pennsylvania, about 1863.

Foard Collection of Civil War Nursing

with alcohol. "Endowed by nature with great vigor of mind and uncommon activity and energy, of striking and commanding personal appearance and pleasing address, she was remarkably successful in the prosecution of those works of charity and benevolence which made her life a blessing to mankind," reported an admiring biographer in *Harper's New Monthly Magazine*.[458] When the Civil War began, she took up the banner of caring for soldiers with a patriotic zeal that harkened back to her ancestors in the Revolution. Numerous anecdotes survive of her interactions with patients: the Massachusetts officer who left her care in good health and, inspired by her words, with a newfound desire to be a better man; her trip to Newport News, Virginia, to secure the discharge of a Pennsylvania boy who was dangerously ill; her composure and perseverance after the hospital was inundated with the wounded after the Battle of Gettysburg. One story stands out among the rest. A Union soldier, formerly dangerously ill and despondent, had rallied and taken a turn for the better. As he recuperated, the soldier struck up a conversation with a companion. "Do you want to see Florence Nightingale?" he asked. "If you do, just come to our hospital and see Miss Ross."[459]

Her manner in dealing with patients followed a familiar routine, observed the author of the *Harper's* sketch. It began with hope and love: "The benevolence expressed in her glowing countenance, and the words of hearty welcome with which she greeted a humble coadjutor in her loving labors, will never be forgotten." For those soldiers who recovered from their ailments, Ross conducted a final review: "When they were about to leave her watchful care forever a sister's thoughtfulness was exhibited in her preparations for their comfort and convenience. The wardrobe of the departing soldier was carefully inspected, and every thing needful was supplied. It was her custom also to furnish to each one who left a sum of money, 'that he might have something of his own' to meet any unexpected necessity by the way."[460]

Ross also excelled as a fundraiser—perhaps an outgrowth of her father's skills with money. An excerpt of an appeal she made for aid on March 1, 1862, illustrates her passion: "The defend-

ers of our bleeding yet glorious Union implore your help. The cause of humanity begs you for assistance, and the soldier—sick and stranger among us—asks you to give, and he knows that to ask is to receive."[461] Her ability to raise capital fueled her most ambitious project, a permanent home for soldiers. In June 1863, after negotiations with the city, an old building and surrounding frame structures once used as a military hospital were acquired, and possession was taken in September. The weeks that followed were a frenzy of activity for Ross as the site was remade into a 150-bed facility named the Cooper Shop Soldier's Home.[462] As the autumn days passed, Ross secured funds and provided necessary furnishings. She worked night and day as the December 22 dedication ceremony approached. Shortly before the event, at the end of a long and grueling day of shopping for last-minute items, Ross fell sick with a chill. Her condition worsened and she rapidly deteriorated.

Ross died of exhaustion on dedication day. Two versions of her last words were recorded. According to one report, "Her speech momentarily revived, and she said something about the 'Soldier's Home.' This was all that could be understood. She spoke no more, and in the evening breathed her last."[463] A press account had her saying, "I did not think my work was done, but God has willed it so; His will be done."[464] Philadelphians mourned her loss. "She was the very life and soul of the Cooper's Shop Hospital. We have known and loved her for her social qualities, combining the true Christian lady with the uncompromising patriot. In her death our *community* has lost one of its best members, the *Home* one of its brightest stars, and the *Nation* an unwavering and true friend," observed one of her many obituaries.[465] In 1874, Grand Army of the Republic members chartered the Anna M. Ross Post No. 94 in Philadelphia in her honor.

Pockets Full of Miracles

When nurse Mary Husband could not be found tending patients in Union army hospitals, chances are she would be visiting guardhouses. She sought out soldiers convicted of desertion and usually discovered them in various states of neglect. On a trip during the winter of 1863–1864, while the Army of the Potomac was encamped at Brandy Station, Virginia, she encountered one such man. Mary interviewed him and became convinced he was innocent of the charges. Some might have left him to his fate. Not Mary. A familiar face in camp—she was matron of a division hospital in the Third Corps—Mary set out to overturn his sentence. According to an account written soon after the war, she visited the headquarters of the brigade to which the soldier belonged and made a case for his release. Her request failed to make an impression. She continued up the chain of command to the division and corps levels and was again disappointed. Mary then met with the commander of the army, irascible Maj. Gen. George G. Meade, and he rejected the request. Undaunted, she traveled to Washington, D.C., where she finally won the case and saved a life.[466]

Though the account did not specify whom she saw in the capital, it might have been President Abraham Lincoln. She had met with him on other occasions to plead for pardons for an undocumented number of soldiers who awaited execution. The compassionate commander-in-chief was well known for clemency in these cases, much to the bane of generals, who were intent on army discipline. "Probably no woman in the United States did more than she to sustain spirits that had been crushed under the iron wheel of war and to rescue those that were about to suffer

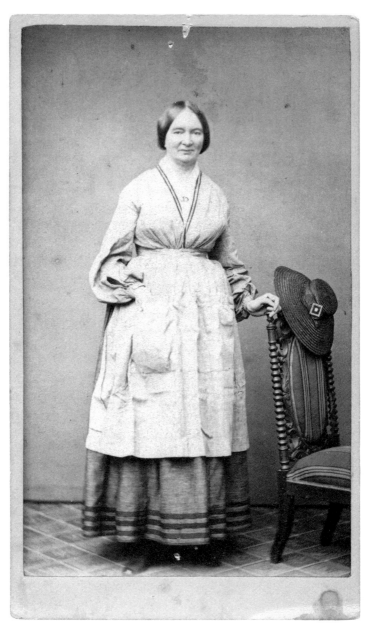

Mary Morris Husband. *Carte de visite* by John White Hurn (1823–1887) of Philadelphia, Pennsylvania, about 1861–1864.

Collection of Michael J. McAfee

injustice under the sentence of a drum-head court-martial," observed one writer in a profile that appeared in a medical journal, adding, "Her exertions to save life in this way were unremitting, and as successful as they were unwearied."[467]

Born Mary Morris in 1820, she hailed from a distinguished family of patriots. Her grandfather, wealthy financier Robert Morris, signed the Declaration of Independence. Her husband, Joshua, was a well-regarded member of the Philadelphia bar.[468] Had the war not happened, Mary might have led a quiet life, caring for her husband and two boys and volunteering at a local library and a hospital. But after hostilities began in 1861, both of her sons joined the army.[469] Mary, then forty years old, also became involved. About July 1, 1862, Mary accompanied a transport from Philadelphia to Harrison's Landing in Virginia to bring back sick and injured soldiers from the Peninsula Campaign. She made several round trips in quick succession, and the experience profoundly moved her. Inspired to become more involved, she laid the groundwork to outfit a mission to bring supplies and care to Maj. Gen. John Pope's Union army forces, who were embarking on what became known as the Second Bull Run Campaign. Her plans never came to fruition, as she was not able to obtain military passes. But another nurse, then little-known Clara Barton, managed to secure passes and supplies at the beginning of what would be her long and brilliant career.

Mary's abilities had, by this time, come to the attention of Washington's top nurse, Dorothea Dix. She invited Mary to serve as temporary matron at Camden Street Hospital in Baltimore. Mary's arrival was timely, as waves of casualties from the battles of Second Bull Run and Antietam crowded area hospitals. After the regular matron returned, Mary traveled to Antietam and spent two months in service at Smoketown Hospital. "Her presence at this hospital brought perpetual sunshine," noted one biographer, who also described how Mary made the double-wide tent she shared with another nurse more visible to patients in need: "She had made a flag for her tent by sewing upon a breadth of calico a figure of a bottle cut out of red flannel, and the bottle-flag flew

to the wind at all times, indicative of the medicines which were dispensed from the tent below."[470]

The biographer also described her distinctive apron: "See her as she comes out of her tent for her round of hospital duties, a substantial comely figure, with a most benevolent and motherly face, her hands filled with the good things she is bearing to some of the sufferers in the hospital; she has discarded hoops, believing Florence Nightingale, that they are utterly incompatible with the duties of the hospital; she has a stout serviceable apron nearly covering her dress, and that apron is a miracle of pockets; pockets before, behind, and on each side; deep, wide pockets, all stored full of something which will benefit or amuse her 'boys': an apple, an orange, an interesting book, a set of chess-men, checkers, dominoes, or puzzles, newspapers, magazines, everything desired, comes out of those precious pockets."[471] She is pictured here wearing that apron next to a bonnet to which is attached the badge of the Third Corps.

Beneath the trappings, Mary's depth of compassion fueled her ceaseless efforts to help soldiers. "She is blonde, with fair hair and sunny laughing blue eyes. The fund of vitality in her seems absolutely inexhaustible, and the flow of spirits perennial," stated a medical journal writer.[472] Mary became inseparable from the Army of the Potomac through the rest of the war. She arrived at Gettysburg on July 4 after hitching a ride in General Meade's mail wagon. She went on to nurse sick and wounded from the 1864 Overland Campaign and showed up in Richmond after the city fell to conquering federal forces on April 3, 1865. On at least one occasion she came close to death when a rifled cannonball passed between her and another nurse.[473] Individual stories of her humanity abound.

The medical journal writer painted a picture of her service with a broad brush: "Her ministrations never had the cold formality and the rigid conformity to system that was seen in the labors of others of less genial composition. The soldiers in the wards that she visited looked upon her with the same confidence and affection with which they were drawn toward a popular commander

in the field. They were her personal friends, for the last one of them she had words of special sympathy and special kindness."[474] Her work to save lives from the military justice system received far less coverage. She took on her first case in the autumn of 1863 and continued without fanfare through to the war's conclusion.

Though not one to seek praise for her contributions, she received the thanks of her patients during the Grand Review in Washington, D.C., in May 1865. The two-day victory parade included soldiers from three corps with which she had been connected—the Second, Third, and Sixth. "As the regiments passed the window where she stood, the boys would pass the word down the line, 'There's Mother Husband!' And cheer after cheer, and shout after shout, ascended from the ranks of stalwart and brawny fellows, beside whose hospital cots her form had so often stood. It was an ovation in which she might justly feel a genuine and honest pride."[475] She responded days later by visiting the men in their encampments as they prepared for their final muster in uniform, distributing food and luxury items collected by her Philadelphia friends. Mary remained active in veterans' affairs for years to come. After the death of her husband in 1880, she moved to Washington and accepted an appointment to a lucrative clerkship in the Patent Office. Mary died in 1893 at age seventy-three. Her sons survived her.

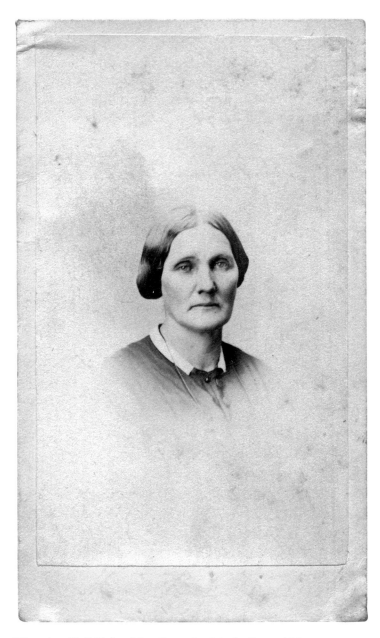

Mary Ann Ball Bickerdyke. *Carte de visite* by Samuel Montague Fassett (1825–1910) of Chicago, Illinois, about September 1863.

Foard Collection of Civil War Nursing

The Nurse of Nurses during the War

Bitterly cold winds howled across southern Tennessee, roared over Lookout Mountain, and swept into the valley below during the last day of 1863. Torrents of freezing rainfall followed in their wake and tore with a vengeance into the Union army troops encamped in and about Chattanooga. No one suffered more than the sick and wounded. In a field hospital on the edge of a forest about five miles from town, mountain gales overturned tents and left about 1,500 patients exposed to the elements. Medical personnel stoked firepits with more and more wood as night set in and the cold intensified. Before long a cordon of crackling blazes provided much-needed warmth around the battered camp. About midnight, the wood ran out. The fires began to die—and when they did, so might the suffering soldiers. The head surgeon believed it would be futile to order men into the icy forest to cut trees and replenish the fuel. He encouraged everyone to hold on as best they could until morning and went to bed.

In this dire moment a nurse stepped up and took charge. Mary Bickerdyke appealed to soldiers of the Pioneer Corps in camp. She asked them to pull down nearby breastworks and harvest the logs. The tired, shivering men were reluctant to do so without orders from a superior officer, but Mary persuaded them to act. She provided them with steaming cups of panado—a concoction of hot water, sugar, crackers, and whiskey—to warm their bones. Thus reinforced, they set out with mules, axes, hooks, and chains. While the members of the Pioneer Corps threw themselves into their life-saving work, Mary directed others to brew caldrons of panado and other hot drinks for the rest of the men. She even prepared warm meal to keep up the strength of the mules as they hauled logs to feed the hungry fires. According to one account,

Mary ran from tent to tent with hot bricks in one hand and steaming drinks in the other as she cheered and comforted all.

Just when the crisis appeared to be averted, thirteen ambulances that had been stranded in the storm creaked into camp. Mary and the rest of the medical personnel leapt into action to aid half-frozen drivers and mules, as well as frostbitten patients with bandages stiff with ice crystals. Soon the surgical staff geared up and sawed off bloodless limbs.[476] Night finally gave way to a cold gray dawn and the realization that many lives had been saved, thanks in large part to Mary's courage. These herculean efforts added to her legend. Beloved as "Mother" Bickerdyke by throngs of soldier boys, one veteran colonel spoke for many when he stated, years later, "She stands distinguished as the nurse of nurses during the war."[477]

Born Mary Ann Ball on the Ohio frontier in 1817, her biographers scoured her past for clues to explain her wartime greatness. They emphasized an ancestry that included Thomas Rogers, a *Mayflower* passenger; Mary Ball, the mother of George Washington; and Mary's grandfather, John Rogers, a Revolutionary War veteran. The biographers lent credence to unsubstantiated claims that she attended Oberlin College and studied medicine with a prominent physician in Cincinnati, where she reportedly volunteered as a hospital nurse after an outbreak of cholera swept through the city in 1837.

Nina Brown Baker, author of the 1952 biography of Mary, *Cyclone in Calico*, argued that little can be proved regarding her early years. Nonetheless, two facts are indisputable: the tragic death of her mother when Mary was only seventeen months old, and that she lived with her grandparents, an uncle, and then with her father David after he remarried. Brown suggested that Mary led an unremarkable pioneer life in Ohio, learning the basic skills common to girls, receiving a rudimentary education, and listening to stories of the Revolution from her grandfather John.[478] The first inkling of her nursing abilities dated to the time she lived on her grandparent's farm near Mansfield. Mary, so the story goes, had a fondness for pets. Chickens, cats, and the occasional

pig followed her as she wandered through the yard. When Mary found an injured or sick animal, she patiently nursed it back to health.[479]

In 1847, then twenty-nine-year-old Mary wed Robert Bickerdyke, a widower twelve years her senior who brought at least three children into the marriage. A native of Yorkshire, England, he had come to America in 1840 and established a life for himself in Cincinnati as a sign and house painter. He also played the bass violin in amateur orchestras. The couple started a new family that grew to include two sons. In 1856 they all left Cincinnati for Galesburg, Illinois, where Robert reinvented himself as professional musician. His career abruptly ended in 1859 when he died after suffering a sudden fit of undefined origins.[480] Robert's death may have forced Mary to reinvent herself. Less than a year later, she listed her occupation as nurse in the 1860 federal census. References to her studying botanical medicine may have figured into her newfound profession.

Then the war came. One day in the spring of 1861, she attended the Congregational church in Galesburg and listened to the minister read a patriotic letter by Benjamin Woodward, a physician who later became surgeon of the Twenty-Second Illinois Infantry. Woodward's description of neglected volunteers who suffered from disease and languished in filthy hospitals 350 miles south in Cairo spurred her into action. On June 9, forty-three-year-old Mary arrived in Cairo with relief funds raised to help the troops.[481] She immediately went to work. "I found a young man in the last stage of typhoid fever, he was so far gone, that he recognized no one in the tent. With the best care that could be given him by the Surgeon and myself we revived him 'till his father arrived," Mary recalled. She added, "These loyal boys from good homes, and to see them so sick and dreadful dirty it was the most pitiful sight I ever looked upon. A laundry must be started—and was. The first laundry washed 25 army blue suits, whilst the patients were laying in the regimental hospital, the change was so great in the three regimental hospitals that the Surgeons and Colonels said the laundries were indispensable."[482]

The bold and decisive action, personal attention to patients, and cleanliness Mary demonstrated on her first day as a nurse were hallmarks of her storied career. Civil War literature is filled with examples of her innate gift for inspiring those around her with cheer and positivity, and for making each man feel as though he mattered. Numerous references can be found about her mania for cleanliness. Mary practically invented the idea of recycling used bedding and clothing, bucking the conventional wisdom of burning or burying soiled and sometimes vermin-infested items. She even washed the bloodstained blouse of Maj. Gen. James B. McPherson after the respected commander died from a mortal wound, then carefully folded and packaged the relic before sending it his grieving family. Two more hallmarks emerged in the weeks and months that followed. She had zero tolerance for incompetent surgeons and did not shrink from cutting through red tape to lobby for the removal of physicians who drank too much or were otherwise ill equipped to handle the demands of the job. She acted similarly to eject those who stole supplies intended for patients.

Mary's physical presence and demeanor were a key to her success. Surgeon Woodward, the letter writer who inspired her, described Mary about this time as "a large, heavy woman of about 45 years; strong as a man; muscles of iron; nerves of finest steel; sensitive, but self-reliant; kind and tender; seeking all for others, nothing for herself."[483] Another veteran echoed Woodward's comments when he stated, "She was physically strong, and mentally strong, and morally strong. She was higher than an ordinary patriot. She was a philanthropist of the highest order; she had a bright intelligence; she was a grand woman."[484] Worthy of mention is one other key to Mary's success: Eliza Porter.[485] A fellow agent with Chicago's Northwestern Branch of the U.S. Sanitary Commission, Eliza was a decade older than Mary. The two formed a dynamic duo that lasted throughout the war. One history of the commission described the relationship as a harmony of contrasts: "Each seemed the complement of the other. Mrs. Porter was gentle, Mrs. Bickerdyke was brusque. The mildness of the

one was an offset to the positiveness of the other; the noiseless efficiency of the one, to the turbulent energy of the other. The culture and social position of Mrs. Porter, gave her ready access to the officers; Mrs. Bickerdyke followed her own bent and adaptations in devoting herself to the rank and file. In person, Mrs. Porter was *petite*; Mrs. Bickerdyke, the reverse; and their very voices acquired, during their wonderful army life, a permanent coloring, which, in Mrs. Porter, was an accent of pity and of sympathy; in Mrs. Bickerdyke, of protest and of cheer."[486]

Mary became a familiar figure as she endured the privations of a soldier's life, dressed in calico, wrapped in a shawl, with her head covered by a Shaker bonnet. Her mission of mercy carried her through numerous operations and engagements—from the fall of Fort Donelson to the Battles of Shiloh, Vicksburg, and Chattanooga; the Atlanta Campaign; the Battle of Franklin; and the Carolinas Campaign. During much of this time Mary followed Maj. Gen. William T. Sherman's army. She became closely associated with the Fifteenth Corps, which Sherman initially commanded. Sherman and Bickerdyke formed a kind of mutual admiration society. "There was something in her character akin to his own. Both were restless, impetuous, fiery, hard-working, and indomitable," observed noted journalist and women's rights advocate Mary Livermore of the Sanitary Commission.[487]

The most often-told story of the general and the nurse involves an assistant surgeon cashiered after Mary accused him of drunkenness and neglect of his duties. The man marched to Sherman's headquarters and demanded to be reinstated. When Sherman asked the doctor who was responsible for the discharge, he replied, "I suppose it was that woman, that Mrs. Bickerdyke." "Oh!" said Sherman, "well, if it was her, I can do nothing for you. She [out]ranks me."[488] Sherman's quip had some truth behind it. At least one surgeon referred to Mary as "Brigadier Commanding Hospitals."[489] The medical director of the Fifteenth Corps declared, "Her services were worth more to General Sherman's army during the Atlanta campaign than any brigadier-general in it."[490]

Mary attended the Grand Review, the celebratory military parade through Washington, D.C., in May 1865. One source noted that Mary, dressed in her trademark calico and bonnet and seated on horseback, was met by none other than Dorothea Dix, the autocratic chief of army nurses. Though no commentary survives of the encounter, it is difficult to imagine the two made a personal connection, considering Mary's disdain for bureaucracy and Dorothea's embrace of it. After the event, Mary sold the dress and bonnet for the princely sum of $100 to an unidentified buyer, to be preserved as a war relic. She used the money to purchase items for soldiers.[491]

Mary went on to own and operate a hotel in Kansas and to work in the laundry of the U.S. Mint in San Francisco. Much in demand as a speaker at veterans' events, Mary maintained a long-term interest in the health and well-being of soldiers. Toward the end of her life she appeared as the guest of honor at a Grand Army of the Republic reunion. In her address to the veterans, she closed by saying, "Goodbye. I shall be mustered out soon and may not see you here again, but we shall find one another sometime somewhere."[492] Mary's death in 1901 was mourned across the country, and numerous tributes were made in her honor.

Iconic Nurse

In a Nashville military hospital one day in early February 1864, representatives from the U.S. Sanitary Commission stopped by to see Anna "Annie" Bell. A veteran nurse at age twenty-four, she knew the commission folks well, but she was wholly unprepared for their request. They asked her if she would pose for a photograph in a hospital scene, with copies of it to be sold at an upcoming fundraising event. "At once I said no," she recounted.[493] Thus began the story of how one of the most enduring nurse-related photographs taken during the Civil War came to be. The commission representatives had chosen well, for Annie's life echoed the best of the American experience. The eldest of six children born to a prosperous pig-iron manufacturer in Elizabeth Furnace, Pennsylvania,[494] she grew up wanting for little. She was named Anna by her parents, but family and friends called her "Annie." She enjoyed the benefits of higher education as a student at the Lewisburg Female Academy at Bucknell University, graduating from there in 1858.[495]

When the war began, Annie lived at home with her family in the township of Antis in central Pennsylvania. Motivated by patriotic impulses, she applied to Dorothea Dix, the chief of army nurses in Washington, D.C., for a paid position. Annie, like so many other women across the North, felt the sting of rejection when Dix denied her admission due to her youth. According to one source, Annie refused to take no for an answer, joined as a volunteer, and earned the respect of Dix.[496] In December 1862, Annie's persistence paid off when she received an appointment to the elite corps of paid nurses. She furthered her skills on the job at major military hotspots within two hundred miles from her home: Harper's Ferry, Aquia Creek, and Chancellorsville in

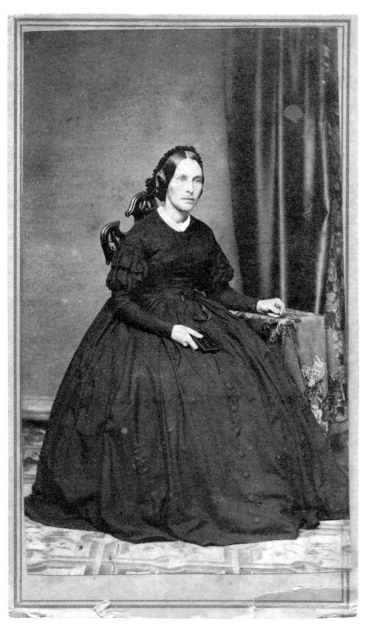

Anna Bell Stubbs. *Carte de visite* by Algenon S. Morse (1830–1922) of Nashville, Tennessee, about 1864.

Foard Collection of Civil War Nursing

Virginia, and Gettysburg in her native state. After the bulk of casualties from Gettysburg had been discharged or moved elsewhere for further treatment, she received new orders to report to Nashville's Hospital No. 1 in the autumn of 1863.

Several months later, Annie turned down the extraordinary request from the Sanitary Commission. "I could not consent to becoming so public," she explained. The determined representatives made a counteroffer. "They said if I did not wish they should not tell my name but only the hospital & what ward—so for the benefit of the soldiers, I consented," Annie noted.[497] The representatives must have been relieved, as the commission had come to rely on the sales of *carte de visite* photographs depicting various scenes—mostly patriotic—to raise monies at more than thirty-five fairs held during the war period. They used the funds for charitable relief efforts on behalf of Union soldiers and their families.[498]

Annie might not have been aware of just how popular photographs were to fairgoers when she posed with two patients whose names are lost to history. "It makes me laugh to think of becoming saleable—and folk's making money out of me, I dont mean that it gives me any pleasure, but makes me feel very strangely," she confided to her mother.[499] "All things considered, it is perhaps understandable that Bell was not able to describe her emotions. She was part of the first generation to grow up with photography, and using the medium as a tool for promotions was in its infancy," observed Chris Foard, owner of the Foard Collection of Civil War Nursing. He possesses Annie's letter.[500]

Annie received advance copies of her *carte de visite* and sent one to her mother. The commission's representatives planned to sell prints of the photograph at the upcoming Northern Ohio Sanitary Fair in Cleveland. The gala opened on February 22, 1864—George Washington's birthday. The event lasted two-and-a-half weeks and added $10,000 to the charity's coffers. The exact amount of money raised from Annie's hospital-scene image is not known. Considering the performance of photo sales at other fairs, it probably contributed a significant amount to the overall

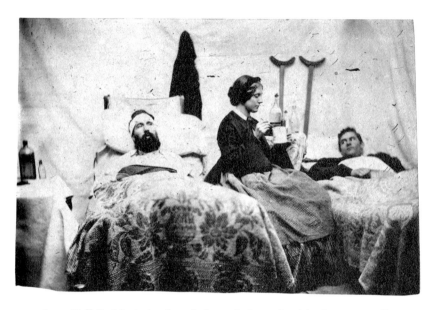

Anna Bell Stubbs in her hospital ward. *Carte de visite* (unmounted) by an unidentified photographer, about February 1, 1864.

Collection of the U.S. Army Heritage and Education Center

revenue. No evidence can be found that Annie's name became associated with the iconic photograph during either the Civil War or her lifetime.

Annie continued on as a nurse through the end of the war, advancing to matron of Hospitals No. 1 and No. 8 in Nashville. During her stay she met and fell in love with Dr. George E. Stubbs.[501] A Maine native who graduated from Bowdoin College and earned a medical degree from Harvard, he served as an army surgeon. The couple married in September 1865 and eventually settled in the Philadelphia suburb of Merion, where they raised four children. Annie died in 1916 from pneumonia at age seventy-six. She outlived George, who had passed away in 1909.

Reunited with a Grateful Patient

On a February day in 1864, Zenas Skinner was standing in his hospital ward, with a pillowcase in each hand, when the new superintendent of nurses walked in. Skinner could scarcely believe his eyes. He recognized her. She was Elizabeth "Lizzie" Brewster, the same nurse who had saved his life months ago at another hospital. He uttered an exclamation of surprise, and Lizzie turned. "Down went the pillowcases & with one bound toward me he threw an arm around my neck and brushed his rough lips against my cheek in a whole souled kiss. I think never in my life was I quite so much astonished. He appeared perfectly astonished himself," she noted in her journal.[502]

The two had met in the spring of 1863. Skinner, a private in the Eighteenth Massachusetts Infantry, was, at about age fifty, old enough to be the father of most of the boys in the ranks and some of the officers. He had fallen ill and spent a month or so in the regimental hospital before being sent to McDougall General Hospital in Fort Schuyler, along New York Harbor. Zenas wound up in section C of the Fourth Ward.[503] The nurse assigned to him was Lizzie, and he was one of her first patients at McDougall.

Like Zenas, she hailed from Massachusetts. Elizabeth Emmeline Brewster was the third of nine children born at Woodside, the family's ancestral homestead in Kingston, conveniently located near Plymouth Rock, the traditional site of where the *Mayflower* pilgrims had landed in 1620. Lizzie's forefather, Elder William Brewster, numbered among those who had made that historic journey.[504]

Lizzie, one of three Brewster sisters who served as nurses during the war, began her Civil War work with the Wisconsin

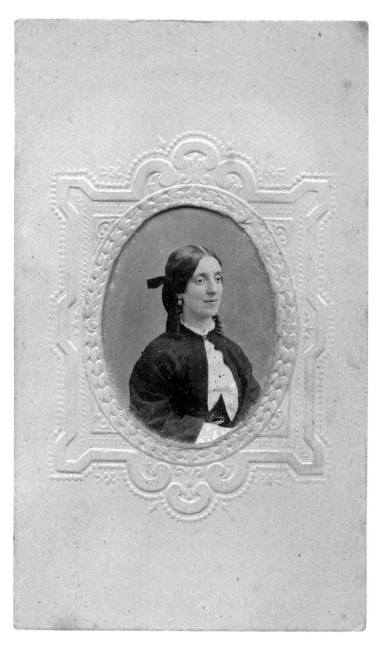

Elizabeth Emmeline Brewster Scribner. Tintype in a *carte de visite* mount by an unidentified photographer, about 1862–1864.

Foard Collection of Civil War Nursing

216

Soldiers' Aid Society.[505] Founded in June 1862, the organization provided relief to that state's soldiers who were hospitalized in the greater Washington, D.C., area. All the Northern states conducted similar operations. Exactly how the society and Lizzie connected is not known. One likely explanation is that Lizzie got wind of the society's need for personnel in the capital and applied for a position. Whatever the origins for her action, Lizzie signed a contract with the society in December 1862 to nurse sick and wounded soldiers in Washington's hospitals and nearby facilities in Georgetown and Alexandria, Virginia.[506]

The relationship only lasted a few months. On April 17, 1863, she entered into an agreement with McDougall Hospital. Soon after, she met Skinner. "The poor old man," she recalled, "lay so many days on the verge of death."[507] Medical authorities later transferred Skinner to Lovell General Hospital in Portsmouth Grove, Rhode Island. Lizzie stayed behind and continued her work at McDougall until August 1863, when authorities converted her fifty-three–patient ward into a surgical room for soldiers wounded at Gettysburg. She described their arrival in her journal: "I wish you could have seen them. As they landed at the dock and wound like a long feeble snake in irregular folds on toward the Wards it was a pitiful sight."[508]

In February 1864, Lizzie left McDougall to accept a promotion as lady superintendent, with a staff of eight, at Lovell General Hospital in Portsmouth Grove, Rhode Island. Here she met up again with Skinner, albeit briefly. A few weeks later, Skinner received his discharge and returned to his family and home in Wrentham, a village outside Boston. He lived until 1874, dying at age sixty. His wife and a daughter survived him. Lizzie remained on duty at Lovell until August 1865. At some point soon after the war she moved to the West. In 1870, she married New York native Eben Scribner, an amalgamator in the mining industry in the vicinity of Carson City, Nevada. There they started a family that grew to include four children, two of whom died in infancy.[509] The family eventually relocated to California, where Eben passed away in 1894. Lizzie lived until 1926, dying at age eighty-eight.

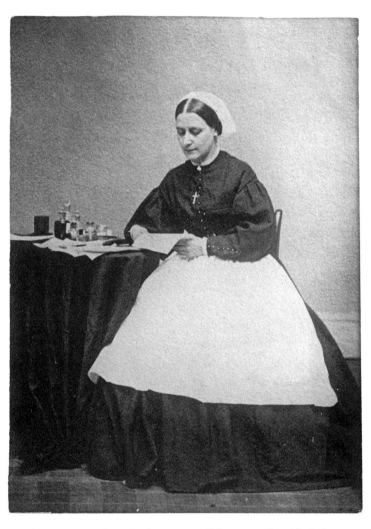

Sarah Low. *Carte de visite* (unmounted) by an unidentified photographer, about 1862–1865.

Collection of the New Hampshire Historical Society

If I Ever Go to Heaven May I Be in Her Ward

Mathew Brady strode into Washington's Armory Square Hospital on a mission one February day in 1864. The famed photographer asked for consent to produce a portrait of all the hospital's lady nurses, for inclusion in his ongoing series of war scenes. The practiced and polished celebrity lensman most likely turned on all his charm in making the request. The women deliberated the pros and cons. In the end, they turned him down, for fear they would receive too much publicity. They suggested an alternative—that Brady photograph a group of patients, one selected from each ward.[510] Had Brady been allowed to make the portrait he wanted, the group would have included Sarah Low, one of the longest-serving nurses on the staff.

Sarah had arrived in the nation's capital in September 1862, leaving behind a comfortable and cultured life in Dover, New Hampshire. Her father, Dr. Nathaniel Low, prospered as a Dartmouth-educated physician. Her mother, Mary Ann, stood tall in the community, thanks in part to her own father, William Hale, a wealthy merchant and shipbuilder who had served two terms in the U.S. House of Representatives. Sarah benefited by an even more powerful political connection: a cousin, U.S. Senator John P. Hale. A longtime champion of antislavery forces, Hale had helped establish the Free Soil Party and became an influential leader of the Republicans. One historian proclaimed him "probably the greatest statesman Dover ever had."[511]

At some point after the war began, Sarah expressed a desire to become a nurse. Though her family disapproved, she wrote to family friend Hannah Stevenson for help.[512] Stevenson, an ardent abolitionist about twenty years Sarah's senior, is credited

by some sources as the first Massachusetts woman to serve as a nurse during the war. She also counseled aspiring nurses, including novelist Louisa May Alcott, who dedicated her 1863 book, *Hospital Sketches*, to Stevenson. Stevenson invited Sarah to join her at the Union Hospital, a former hotel in Washington, D.C. In September 1862, Sarah left home to begin her army adventure. Turns out she was not the only member of her family to go off to war. That same month, her younger brother, Nathaniel Jr., accepted a commission as captain in the Eleventh New Hampshire Infantry.[513]

Sarah arrived in the capital and secured comfortable lodgings for the night, thanks to a letter from Senator Hale. The next day, she made the short trip to Georgetown and the Union Hospital, where Stevenson welcomed her with open arms. By contrast, she met with open hostility from Dorothea Dix, the tyrannical chief of army nurses. A perturbed Dix reacted with characteristic high-handedness, ordering Sarah to leave because she was three years shy of the minimum age requirement of thirty-five. Sarah and Stevenson had anticipated this response from Dix. They had decided before Sarah arrived that the autocratic chief of army nurses should not be informed of her coming. In effect, they attempted to bypass the system. Sarah stood her ground and arranged a meeting with her influential cousin to countermand the order. According to scholar Katelynn Ruth Vance, "Perhaps aware of this meeting, Dix relented. Dix stipulated that Low would be able to stay as a house guest of the hospital, but only to assist Stevenson in her duties. Low found this to be acceptable, since it gave her more flexibility in her duties."[514]

Sarah gained valuable experience at Union Hospital. "A nurse is expected to take charge of a ward as soon as she arrives," she observed in a letter to her mother. "Attending to the wounds is only one part of a nurse's duty, but it is the pleasantest part. The seeing that the ward is kept nice & that the attendants do their duty is the wearing part of it."[515] The work required sustained physical exertion, with little authority inside the army's massive medical apparatus. Female caregivers stood at the low end of the

pecking order. "A nurse ranks only as a private," Sarah stated to a friend early on.[516]

Sarah did not remain long at Union Hospital. The following month, in October 1862, she became one of the first women on the staff of the new thousand-bed Armory Square Hospital. She owed her position to the physician in charge, Dr. D. Willard Bliss. He hired his own nurses instead of accepting Dix's appointees, who answered only to her.[517] Sarah fell into a routine at Armory Square. "The duties of a nurse here are to go round with the surgeon in his morning & evening visits to the patients & take his directions. She takes charge of and administers the medicines and stimulants & also superintends & keeps a record of the special diet. These duties occupy nearly all her time and require great accuracy," Sarah explained to a friend.[518]

Located in the shadows of the distinctive Smithsonian Castle, the hospital became a popular destination for visitors, including President Abraham Lincoln and Mathew Brady—who never took the nurses' photograph he wanted. According to a chaplain of the First New Hampshire Infantry, "It is said that when strangers in the national capital wished to go through a hospital, some one was sure to say 'You must not fail to visit the Armory Square; it is kept with marvelous and exquisite neatness, under the supervision of Miss Low of New Hampshire.'"[519]

Sarah spent the rest of the war at Armory Square. During this time she witnessed battlefield horrors firsthand as waves of broken and mutilated young men, disabled by rebel lead, poured into the hospital. Sick and wounded men from the largest engagements in the East found care and shelter in her ward. She also saw some who suffered emotional trauma. She described one man whom "I pity more than any man I have ever seen, he is as nervous as a very nervous woman. I have to go to him every few moments he looks so wild & points about with his long bony fingers."[520] There were times when the strain pushed Sarah to the brink of collapse. On two occasions, in the summer of 1864 and the spring of 1865, she took furloughs to rest. A reply written to her mother about the time of her first break illustrates

Sarah's frame of mind. In it, she asked her mother to thank a friend for sending an uplifting letter. "It seemed to me as I read it like reading some thing written a hundred years ago. I can't imagine a place, without suffering men, just at this time," Sarah confessed.[521] Her second stint on furlough coincided with the surrender at Appomattox Court House and the assassination of President Lincoln. Sarah had been at home in Dover when these events occurred, and she hurried back to Washington in time to pay respects to the fallen chief executive. She remained on duty at the hospital until August 1865.

Sarah returned home after her discharge and lived a quiet life. She died, unmarried, in 1913. Perhaps her finest tribute came not long after the war, in a letter from Senator Hale to Sarah's mother. In it, Hale shared a story told to him by Anson Morrill of Maine, who served his state in the U.S. House of Representatives during the first half of the war. Morrill had visited Armory Square and observed Sarah in action: "'Think of it, a young Lady who you see at once is educated and refined, having position, friends, home and parlor which she adorned, coming here to look after, and take care of those poor fellows, of whom she knows nothing except they are sick and suffering. With no feelings but such as angels have for us poor fallen mortals. Indeed,' he said, 'it is the most sublime exhibition I have ever seen,' and he added, 'if I ever go to heaven may I be in her ward.'"[522]

Working in the Special Diet Kitchen

Inadequate nutrition in Union military hospitals posed a threat to soldiers' survival. In Chattanooga, Tennessee, a special agent from the influential U.S. Christian Commission found this to be the case in the 1,200-bed hospital at the foot of Lookout Mountain. On March 19, 1864, he proposed a special diet kitchen to combat the problem, and the head surgeon approved the plan the next day.[523] The agent ordered three volunteers into action. For one of them, Caroline "Carrie" Wilkins, the assignment marked her first set of duties as a nurse. A Pennsylvania native, Carrie was ten years old in 1852 when she, her four younger brothers, a sister, and their parents moved from Pittsburgh and started a new life in Iowa. After war divided the country, Carrie became the only member of her family to serve. She joined the Christian Commission in late 1863 or early 1864, just about the time federal forces in Tennessee surged up and over Lookout Mountain and drove Confederate forces out of Chattanooga and the state. Carrie answered the summons from the special agent, left her family farm in Keokuk, and reported for duty at the hospital kitchen on April 22, 1864.[524]

While Carrie settled in to her relief work, Maj. Gen. William T. Sherman and his Union forces set off on a campaign through Georgia. His army made slow but steady progress into the northern part of the state, and it left in its wake injured and ill men who required care. The commission responded with supplies and relief workers. In August 1864, Carrie and another nurse received orders to report to a field hospital in Marietta, a mountain town north of Atlanta. She toiled there until the fall of Atlanta and then moved with the victorious Union forces into the vanquished city. According to official documents, Carrie was one of the last to

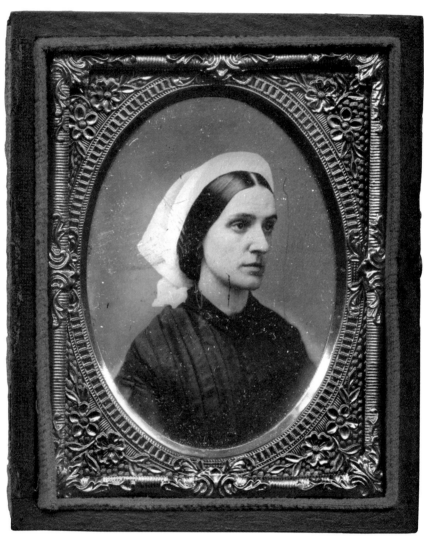

Caroline Wilkins Pollard. Tintype by an unidentified photographer, about 1864.

Foard Collection of Civil War Nursing

leave Atlanta after Sherman's army evacuated in November 1864. While the Union soldiers headed south and east to Savannah, she traveled with fellow nurses and medical staff to Nashville. She arrived on November 16 and left the next day for a well-deserved month-long furlough.[525]

Carrie did not return to the South at the end of her time off. Instead, she received orders to report to the floating hospital *Nashville*, anchored at New Albany, Indiana. Located along the Ohio River opposite Louisville, Kentucky, the city thrived as a major shipbuilding hub and a center for army hospitals. Carrie remained aboard the *Nashville* until the vessel ceased operations in August 1865, then returned to her family in Iowa.[526] A few years later, perhaps inspired by wanderlust from her Civil War journeys, she followed one of her brothers to northern California. In 1873, she wed William H. Pollard, a widowed dentist with four children. The marriage ended three years later when William died, leaving her a widow with her own young daughter to raise. Carrie never remarried and settled in Maxwell, a town outside Sacramento. She lived until age eighty-two, dying in 1924.

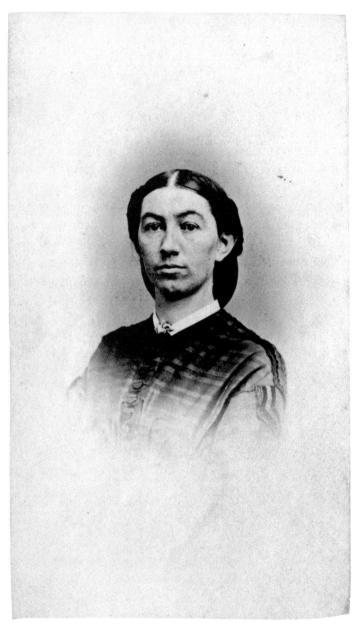

Margaret A. Egan Weed. *Carte de visite* (unmounted) by an unidentified photographer, about 1861–1865.

Collection of the U.S. Army Heritage and Education Center

You Should Always Be Ready to Die

In the spring of 1864, most inhabitants of Paducah considered themselves relatively safe from rebel attack. The city, located on Kentucky's northern border with Illinois, seemed far away from the front lines. Everything changed on Good Friday, March 25, when Nathan Bedford Forrest's Confederates appeared out of nowhere and stormed the place. As rebel raiders poured onto the grounds of military Hospital No. 1, they tore down fences and sent sharpshooters up into the four-story building. Inside, all hell broke loose as those who were mobile scrambled to get out. They included nurse Margaret "Maggie" Egan, who hastily exited the hospital—and came face to face with a rebel. "Halt," the soldier commanded as he leveled his musket in her direction. She had no choice but to obey. He led her away, picking up another nurse in transit.[527]

They were soon set free in an open field. By this time, the sharpshooters busied themselves by picking off Union soldiers holed up in a nearby fort. The federals lobbed artillery shells in response. Maggie and the other nurse were caught in the middle as bullets whizzed by and shells flew overhead. A rebel officer rode up and asked how they came to be in such an exposed position, so they told him. He suggested that they lie down to avoid being killed, then left the scene. Another Confederate appeared, and Maggie's terrified sister nurse told him she thought her time had come. "You should always be ready to die," he responded.[528]

Maggie had come into the world twenty-six years earlier in another precarious spot—a ship on the Atlantic Ocean. Newborn Maggie, along with her Scottish father and Irish mother, landed in New York, and they settled in the northern Illinois town of Lockport. Maggie grew up there with her younger sister, Ellen.[529]

When the war began, they became nurses under the auspices of the U.S. Sanitary Commission. In October 1861, Maggie and Ellen reported for duty at the post hospital at Jefferson City, Missouri. In January 1863, the sisters parted ways after Maggie received orders to Paducah, where medical authorities assigned her to the surgical ward of Hospital No. 1, located in a converted warehouse. Her patients included casualties from the ongoing Vicksburg Campaign.

The war literally landed at the front door of the hospital about a year later. Forrest's Confederates, numbering about 1,800 troops, raided Paducah for supplies and attacked its 650-man Union garrison at Fort Anderson. Maggie recalled the scene after the rebel left her and the other nurse in the field near the hospital: "We were so frightened that we could tell nothing about time. Near by us a cow was grazing. A ball struck her; she jumped high in the air, and with a loud bellow retreated in good order. We momently expected the same fate, but in spite of our fears we laughed at our strange condition. This was my first experience in raid or battle. Soon we saw the rebels retreating, loaded with plunder; but they also carried many dead and dying men, among them the lifeless body of General Thompson, covered with blood."[530] The "general" Maggie described was Col. Bert Thompson, one of the commanders of the raid, who had practiced law in Paducah before the war.[531] He had been seated on a favorite horse, in sight of his home, when struck by artillery fire from one the Union gunboats—the *Peosta* and the *Paw Paw*—in the nearby Ohio River.[532] Maggie continued, "As we were moving off the field a rebel, carrying a flag, said, 'Have you many Yanks?' 'Yes, sir!' I replied. 'Reinforcements are coming down the river.' This was repeated, and passed along the line, 'Reinforcements are coming!'" Maggie made her way with others, and they escaped across the river into Illinois. "We were not allowed to return until the next day; then it was to learn that the hospital, with all its contents, had been burned," she reported. Other buildings had also been destroyed.

Reassigned to Hospital No. 1, Maggie remained there into the summer of 1864, when she went home on furlough. She re-

turned to duty in October at the general hospital in Jeffersonville, Indiana. Here she met and fell in love with one of the hospital stewards, Alexander G. Weed.[533] He had been promoted to that position from the ranks of the Twenty-Fourth Wisconsin Infantry. The couple married on April 11, 1865. Maggie and George, a druggist, made their home in Beaver Dam, Wisconsin, after the end of their military service. They remained there until 1871, when they joined a group of about seventy men, women, and children in search of a better life. Known as the Northwestern Colony or Wisconsin Colony, its members migrated to Kansas, settled in Russell County, and founded the town of Russell. In 1883, the couple's only child died in infancy. Eight years later, George suffered a heart attack and succumbed to its effects at age fifty-three. Maggie lived on, passing the time with a local ladies' club and the Order of the Eastern Star, a Masonic organization. By this point, a former nurse who interviewed the widowed Maggie noted, "She is now 'gray,' and inclined to live in the past, and think over the scenes of war-times."[534] Maggie died of heart failure in 1914. She was seventy-six years old.

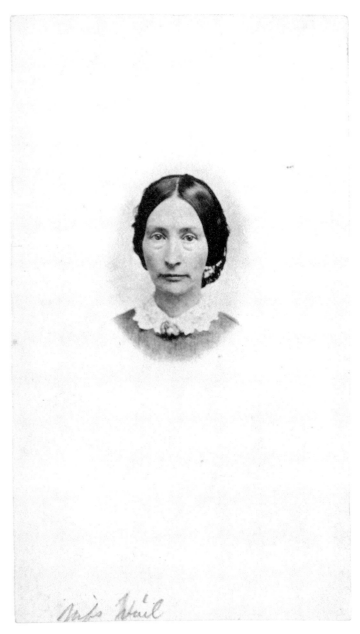

Melissa Catherine Vail Case. *Carte de visite* (unmounted) by an
unidentified photographer, about 1861–1865.

Collection of the U.S. Army Heritage and Education Center

Call to Arms

THE TELEGRAM TRANSMITTED FROM WASHINGTON, D.C., was urgent and unambiguous: "Come quickly if you can work hard."[535] Its recipient, Melissa Vail, responded promptly. The forty-six-year-old nurse from New York made preparations to leave her home in the Hudson River village of Rondout. Its sender, Dorothea Dix, the chief of army nurses in the Union capital, had issued the call to arms on May 10, 1864. Though the curt tone of the telegram was consistent with her brusque manner, it also reflected her immediate need for able-bodied nurses, as large numbers of wounded soldiers were in transit from Virginia to Washington hospitals. All were casualties from the six-day-old Wilderness Campaign, where Lt. Gen. Ulysses S. Grant had unleashed the Army of the Potomac against Gen. Robert E. Lee's rebels.

Melissa arrived in Washington on May 16 and met with Dix, who dispatched her to Judiciary Square General Hospital the same day. Thus began Melissa's second tour of duty as an army nurse. More than a year earlier, she had applied for a position and passed Dix's criteria, established in the Surgeon General's Circular No. 8—namely, older, healthy, educated women, matronly in appearance and dress.[536] Dix sent her off to Virginia for a nine-month stint, from March through December 1863. Melissa returned to New York upon the expiration of her service and might have remained at home for the duration of the war. But the telegram sent by Dix brought her back into action in the spring of 1864.

On May 17, Melissa embarked upon her duties at Judiciary Square. Engineers constructed the complex of buildings in the modern pavilion style, which featured a central corridor from

which emanated well-ventilated wards, housing a total of 510 beds. Within a week of her start date, more than twenty thousand casualties had been transported to Washington, D.C. Judiciary Square and other hospitals quickly filled beyond capacity. Though she left behind no known personal reflections of her experience, Melissa was an active participant during one of the severest trials of any medical staff in the capital during the war. She remained on duty through October. By this time, the major part of the fighting had passed, and the hospital populations were in a steady decline.

Melissa also worked in the city as an agent for two Soldiers' Relief Associations: one from New York and the other from Michigan, where she had family. Though her exact duties went unrecorded, authorities granted her access to any hospital in Washington, so she could provide succor to boys from the two states.[537] At some point, probably at the war's end, she left the capital and returned to her home in Rondout. A few years later she opened a practice to treat neuralgia and other ailments with electricity, vapor baths, and other methods.[538] In 1874, at age fifty-six, Melissa married a minister, William M. Case. The union lasted until his death in 1888. A few years later, she moved to Wayne County, Michigan, to care for a brother in failing health. She remained there after he died and until her own passing in 1898, at age eighty.[539]

Freedmen Teacher, High-Grade Nurse

A PALL OF GLOOM AND UNCERTAINTY DARKENED WASH-
ington, D.C., as accounts of horrific frontline fighting in Virginia
trickled into the city in early May 1864. In homes and hospitals, as
well as in businesses and official buildings across the Union capital,
citizens and soldiers braced for the onslaught of mass casualties.
Residents reacted to the grim news in different ways. One new-
comer, teacher Georgiana "Georgie" Willets, responded by working
through friends to obtain official permission to aid the wounded.
On May 12, according an acquaintance with whom she boarded,
Georgie burst into the house and exclaimed, "Here is a pass for
you and one for me, to go to Fredericksburg! A boat leaves in two
hours, and we must hurry!"[540] The acquaintance was Jane Gray
Swisshelm,[541] the hard-edged and highly opinionated journalist,
abolitionist, and advocate for women's rights. Although noted for
her poison pen, Jane had nothing but praise for the young teacher,
stating that "Georgie was not merely handsome. She was grand,
queenly," and adding of her life, "None was more pure, more noble,
than that of this beautiful, refined, strong, gentle girl."[542]

Georgie's good looks and cultured ways emerged from humble
origins. The eldest of three children born to a railroad conductor
and his wife in Rochester, New York, Georgie worked as a part-
time schoolteacher in Jersey City, New Jersey, at the start of the
war. In the autumn of 1863, at age twenty-three, she became a
missionary under the auspices of the American Tract Society and
traveled to Washington, D.C., for the sole purpose of educating
freedmen. Her first assignment, on November 1, 1863, was as
assistant to the man in charge of the school at Camp Barker, the
large refugee center for former slaves established by the society.[543]
The timing of her arrival coincided with the opening of a new

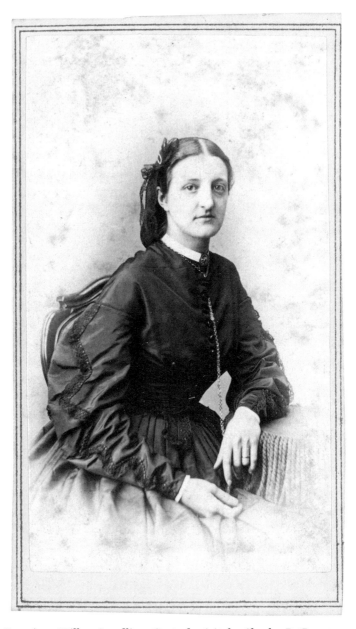

Georgiana Willets Stradling. *Carte de visite* by Charles DeForest Fredricks (1823–1894) of New York City, about 1862–1864.

Collection of the Library of Congress and the National Museum of African American History and Culture

school in nearby Freedman's Village, located across the Potomac River in Arlington, on the grounds of Confederate general Robert E. Lee's family estate.

Georgie became the first member of her family to serve the Union. Her youngest sibling, Charles, joined the army about the time she acquired a pass to go south.[544] Georgie had originally arranged the pass for herself and another New Jersey woman, nurse Cornelia Hancock.[545] But after Cornelia found permission through another source, Georgia invited Jane Swisshelm. The two packed clothing and supplies on the afternoon of May 12 and rushed to the Sixth Street wharf, only to find their transport filled with fresh troops. The officer in charge turned them away, with instructions to return the next day. They did, and found the transport again packed with soldiers—only this time, they were casualties returning from Virginia battlefields. Georgia and Jane dropped their bags and went to work dressing and wetting wounds until ambulances transported all the men to hospitals.

Thus began an intense chapter in Georgie's life as a nurse. She and Jane eventually boarded a transport and made their way to the Union base at Fredericksburg. There they met up with other nurses, including Cornelia Hancock, and reported for duty to the chief medical officer.[546] The women were assigned to different hospitals in town. Georgie started in a ward at St. Mary's Catholic Church on Princess Anne Street. With no training, she nonetheless quickly adapted as waves of the wounded and sick poured in from frontline positions as the Union's Army of the Potomac made slow but steady progress against its stubborn foes. Her duties were varied and relentless, from supervising cooks who prepared meals for hundreds of men to late nights standing, with lantern in hand, to guide the wounded down steep banks to transports heading back to Washington hospitals.

As the army continued its march toward the Confederate capital, Georgie and the rest of the medical corps followed. In late May, she left Fredericksburg for White House Landing, where she managed five wards. In mid-June she arrived at City Point and moved up the Appomattox River for duty in a complex of

hospitals. Here Georgie took charge of the Second Division, Second Corps Hospital, where she managed all the wards and the kitchen. She remained there through the rest of the year, with the exception of a three-week absence to recover from a bout of typhoid fever contracted from food or water contaminated by the feces of patients. Georgie gave her all to the men under her care. "I was a volunteer nurse receiving no pay for my services," she later noted, "spending my money freely for the soldiers wherever I could, yet I had to have my feed and shelter at Government expense and received rations like any soldier."[547] On December 17, 1864, her health compromised by army life, Georgie resigned and returned home to recuperate. Cornelia Hancock noted, "The character of her service was of high grade. It was not spasmodic or sensational but steady and persistent."[548] In other words, she was a dependable, reliable woman who could always be counted upon.

Looking back, Georgie's seven months as a nurse can be viewed as a pause in her larger work as a teacher. She soon returned to her true calling, the education of former slaves. In 1866 she taught at a freedmen's school in Lynchburg, Virginia. The superintendent, James M. Stradling, a Pennsylvania Quaker and antislavery man, became her husband in 1869. He had set aside the peaceful ways of his faith during the war and served as an officer in the First New Jersey Cavalry.[549] The newlyweds worked side by side at Bridgewater School—established for orphans of African American soldiers—in Bucks County, Pennsylvania. According to one report, most graduates went on to lead productive lives, more than a few as teachers in the South.[550]

In 1871, Georgie's teaching career ended with the birth of the first of their three children. She raised them at home and supported James after he left teaching for a new career as a publisher of textbooks and other volumes for youths. They eventually settled in Beverly, New Jersey. Georgie died in 1912, after a brief illness, at age seventy-one. James and two daughters survived her. Her remains rest in Arlington National Cemetery alongside those of James, who passed away in 1916.

Favorite Beauty

FUNDRAISERS HELD ACROSS THE NORTH PROVIDED CRITI-
cal financial support to the U.S. Sanitary Commission's relief
efforts for Union military men. The largest venues, a series of
popular fairs in major cities, lasted for days or even weeks and
brought in big money. Much smaller, though no less enthusiastic
events popped up in towns and rural communities. One such
fundraiser occurred in the northeastern Pennsylvania borough
of Catawissa. Here, in the summer of 1864, locals held a beauty
contest. The menfolk paid twenty-five cents each to cast a vote
for the prettiest girl, with the proceeds going to the commis-
sion. The ballot count revealed Harriet "Hattie" Reifsnyder as
the winner, by a wide margin of 280 votes.[551] The contest gained
national attention, praised in one newspaper as an innovation
and in another as an oddity.[552]

Hattie was more than just a pretty face. She worked as an army
nurse. The fourth of nine children born to a Catawissa merchant
and his wife, the twenty-one-year-old became the second in her
family to volunteer. A younger brother, George, served in a heavy
artillery regiment.[553] In May 1864, Hattie joined the staff of the
hospital transport *Connecticut*. The vessel shuttled thousands
of sick and wounded soldiers from the Army of the Potomac's
base of operations in City Point, Virginia, to Alexandria, Virginia;
Washington, D.C.; Baltimore; and other ports. Her arrival coin-
cided with the massive influx of casualties following the Battles
of The Wilderness, Spotsylvania, Cold Harbor, and other engage-
ments during Lt. Gen. Ulysses S. Grant's Overland Campaign.
Hattie owed her position to the *Connecticut*'s head nurse, Harriet
Sharpless, her older cousin. Sharpless had to be pleased with the
decision to bring Hattie into the sorority of nurses, for she proved

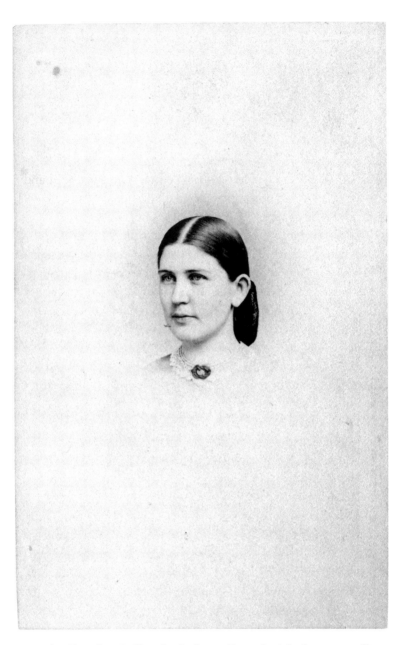

Harriet Sharpless Reifsnyder Jackson. *Carte de visite* (unmounted) by an unidentified photographer, about 1861–1865.

Collection of the U.S. Army Heritage and Education Center

her abilities aboard the ship. One hospital steward recalled that she "was most faithful & constant in caring for the sick & wounded in transit on this vessel." The chief surgeon of the *Connecticut* stated that Hattie "was careful and faithful in the performance of her duties, and won the regard and esteem of all the officers (medical) because of her devotion and efficiency."[554]

Hattie's sterling reputation came at a price. The rigorous duties, exposure to sickness and disease, and subsistence on soldiers' rations broke her health. In November 1864, she resigned and returned to Catawissa, where she eventually recovered. In 1868 Hattie married bank teller Edward Seymour Jackson. He had served in the 151st Pennsylvania Infantry during the war and survived the Battle of Gettysburg, in which his regiment suffered the loss of about three-quarters of its number. The newlyweds settled in Scranton and began a family that grew to include six children. Edward died in 1910, and Harriet passed away two years later from heart disease. She was sixty-nine years old. One of their children, Orton, may have been inspired by Hattie's war experience on the *Connecticut*. An 1893 graduate of the U.S. Naval Academy, he went on to a distinguished career that included service in World War I. He was the coauthor of the popular *Marvel Book of American Ships*.[555]

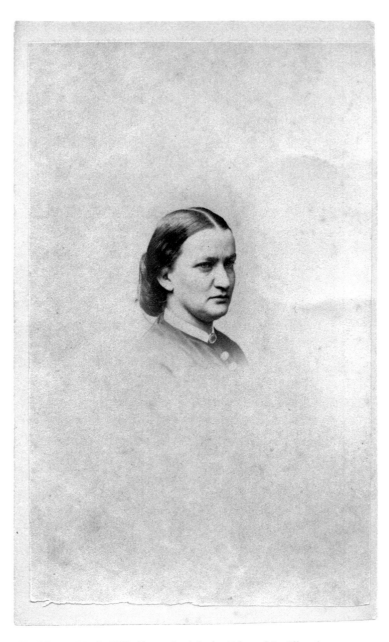

Dr. Nancy Maria Hill. *Carte de visite* by Edward L. Allen (1830–1914) of Boston, Massachusetts, about October 1865.

Foard Collection of Civil War Nursing

Future Doctor in Ward F

Lt. Gen. Ulysses S. Grant drained Washington's defenses of their troops to bolster his fighting forces for the 1864 Overland Campaign into the heart of Virginia. This move also deprived the federal capital of hospital supplies and other sanitary stores, as almost all surplus materials had been sent to the front, where they would be needed most. The loss of such items resulted in an acute shortage after waves of wounded men arrived in the city following the first major engagement of the campaign, the Battle of The Wilderness, in early May. No one perhaps felt the lack of supplies more than Nancy Hill and nurses at Armory Square Hospital. Many of the worst cases were brought there, because of its close proximity to the city's boat landing and railroad depot.

Nancy took action. She wrote to her family back home in Arlington, Massachusetts, about the critical shortage. Her mother, Harriet, arranged to have the letter read the next morning in the town's four churches. A biographer recounted what happened next: "Immediately the congregations were dismissed, and all went home, to return to the Town Hall bringing table-cloths, and linen, and cotton sheets,—the best they had. The ladies and gentlemen worked all day long making and rolling bandages and picking lint. Before nine o'clock that night two large dry-goods boxes, the size of an upright piano, were on their way to Washington by Adams Express, who took them free of charge."[556] Similar scenarios played out in towns across the North.

Nancy had arrived at Armory Hospital a year earlier. Summoned to Washington, D.C., to fill a vacancy, she arrived in April 1863 and took charge of Ward F, with its fifty-two beds. She remained there throughout the war. By all accounts, Nancy gained a reputation for efficiency. She also displayed compassion, as

evidenced by her intervention in the case of a young Kentucky soldier who had fallen sick and landed in her ward. The boy had been drafted into the service against the wishes of his mother, who had tried in vain to have him released from duty. The distraught woman argued that her husband and three older sons were already in the army—and that one of her boys had died. Nancy stepped in, according to an account published years later: "You shall hear from me soon, any mother who has sent a husband and three sons to the Army shall keep her baby at home." Three days later, the boy received an honorable discharge signed by Abraham Lincoln.[557]

When Nancy's service ended in August 1865, the head physician at Armory Square, Dr. D. Willard Bliss, suggested that she pursue a career in medicine. Nancy, now thirty-one and a graduate of Mount Holyoke Seminary, heeded his advice. She returned to Massachusetts and studied under Dr. Marie Zakrzewska, a pioneer female doctor and the founder of the New England Hospital for Women and Children.[558] Nancy became a medical student at the hospital and completed her studies at the medical department of the University of Michigan in Ann Arbor in 1874.[559] Nancy opened a practice in Dubuque, Iowa, and served the city for many years. Her patients included veterans from the late war. "As a physician she shows her love for many an old soldier's family now by her generosity," according to a news report.[560] Nancy lived until 1919, dying at age eighty-six.

The Indomitable Georgy Woolsey

On a May day in 1864, a long column of reinforce-
ments wound its way through Union-occupied Fredericksburg,
Virginia, on its way to the southern front. At one point on the
journey, the officers and men in the lead regiment happened upon
a group of Northern nurses who had paused from their arduous
duties to greet them. The women showered the soldiers with roses
of various colors and other spring flowers, gathered by the skirt-
and basketfuls from local gardens. One of the nurses, Georgeanna
"Georgy" Woolsey, reached out with a knot of blooms and fas-
tened it to the headstall of the commanding colonel's horse.[561] She
then tossed more flowers over various officers and men. "They
were delighted," Georgy wrote home to her mother, and added,
"They said; 'O! Give me one,' 'Pray give me one,' 'I will carry it
into the fight for you,' and another cheerily, 'and I will bring it
back again.'"[562] Three days later, a number of those same troops
returned to Fredericksburg in ambulances. Georgy and the other
caregivers met them with pails of soup and milk punch. Georgy
recalled: "'A different coming back, ma'am,' 'no roses to-day'; and
one said, pointing over his shoulder, 'The Lieutenant is there on
the stretcher, and he's brought the flowers back, as he promised.'
I went to his side, hoping to help a wounded man. The Lieuten-
ant lay dead, with a bunch of roses in the breast of his coat."[563]

This poignant moment was one in a long list recorded by
Georgy since she had joined the ranks of nurses three years ear-
lier. Her mother, Jane, inspired her to volunteer. A Virginia native
who hailed from generations of slaveholders, Jane had married
New Yorker Charles Woolsey, a prosperous sugar refiner.[564] His
tragic death in a steamboat fire left her a widow in Brooklyn with
eight children, including then six-year-old Georgy.[565] Though Jane

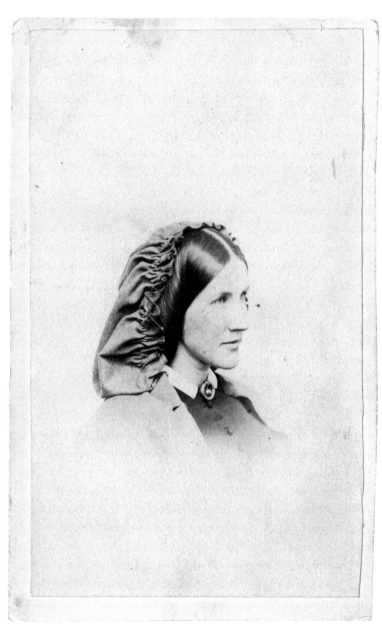

Georgeanna Muirson Woolsey Bacon. *Carte de visite* by an uniden-
tified photographer, about 1862–1864.

Special Collections, University of Arizona

had grown up in the South, she rejected slavery and the politicians who supported the "Peculiar Institution." She embraced abolitionism and instilled these beliefs in her children, along with courage, faith, and charity. Georgy possessed these characteristics in abundance—a perpetually happy child who grew into a vivacious young woman. It is perhaps no surprise that she numbered among the first to volunteer. Four of Georgy's siblings ultimately participated in the war effort, including her sisters Jane, Mary, and Eliza, as well as a brother, Charles, a cavalry officer and aide-de-camp. Even mother Jane served a stint as a nurse.[566]

Georgy joined under the auspices of the Women's Central Relief Agency of New York. After a month of training, she was assigned to Georgetown Hospital in Washington, D.C., and hit the ground running. Within a few months, five nurses reported to her. One admirer observed that Georgy possessed a "strength and sweetness, sound practical sense, deep humility, merriment, playfulness, a most ready wit, an educated intelligence" that distinguished her among peers.[567] Georgy added style to substance. Her "hospital costume," as she described it, featured a gray skirt and petticoats, Zouave jacket, and white apron with generous pockets.[568] The next two years were a whirlwind of activity for her: caring for patients in Georgetown and visiting area hospitals in her spare time; nursing typhoid victims and other sick and wounded men aboard the fleet of hospital transport vessels outfitted by the U.S. Sanitary Commission for the Peninsula Campaign; working far off the front lines at Lovell General Hospital in Portsmouth Grove, Rhode Island; and then returning to Washington to continue her service.

In July 1863, the Battle of Gettysburg resulted in staggering numbers of wounded soldiers. Georgy hurried off to the battlefield after she received a telegram suggesting her brother Charles had suffered an injury. Mother Jane accompanied her. In Baltimore they learned he had survived the battle unharmed. They continued on and, after a difficult twenty-four-hour journey, reported for duty at the Sanitary Commission's makeshift camp on the outskirts of Gettysburg. Georgy and her mother helped bring

order out of chaos and established systemized care in a rapidly changing environment. Before long, trains ran twice daily to Baltimore or Harrisburg, Pennsylvania, each packed with wounded men who had passed through the commission's hands. Georgy estimated that some sixteen thousand soldiers made it aboard the cars during her stay near the battlefield.[569]

Some soldiers never left camp. Georgy remembered one badly wounded Confederate who arrived in an ambulance after the departure of the day's last train. She "found him lying on his blanket stretched over the straw—a fair-haired, blue-eyed lieutenant, a face innocent enough for one of our own New England boys. I could not think of him as a rebel, he was too near heaven for that."[570] He lingered overnight and into the next day, the quietly slipped away. At one point his brother—also wounded, but not as seriously—joined him at the camp. The lieutenant passed away around sunset on July 17, and Georgy placed her hand over his heart to confirm what she already knew. His brother and comrades continued on the next leg of their odyssey as prisoners of war. Meanwhile, a small procession, including a chaplain and Georgy, accompanied the remains of the lieutenant to a nearby field for burial. The deed done and prayers uttered, a crude headboard with his name marked the spot: Henry J. Rauch of the Fourteenth South Carolina Infantry.[571] Urged to chronicle her experience, Georgy wrote *Three Weeks in Gettysburg* while the events remained fresh in her mind. The Sanitary Commission ordered ten thousand copies for distribution, intended to rally women across the North to keep up donations of supplies.[572]

Georgy continued her service through the rest of the war at a frenetic pace. She labored continuously in hospitals in Maryland, New Jersey, and the Washington, D.C., region, as well as at forward base camps in Virginia at Belle Plain and Fredericksburg. Of the many horrors Georgy witnessed, the vision of malnourished and abused prisoners of war from Belle Isle and Libby haunted her. The painful memories still lingered in early May 1865, when she visited Richmond to see the fallen capital. Her mother and

other family members and friends joined her. During her stay, she left carefully wrapped packages of editorials about the treatment of prisoners on the doorstep of Gen. Robert E. Lee's residence.[573]

On or about May 18, Georgy fell desperately sick for the first time during her service. Diagnosed with fever, one of her sisters believed she knew the underlying cause: "I think the last four years is the matter with her. It would not be human that she could endure, without some ill effects, the constant exposure and trials of that time."[574] Georgy's family feared for her life. They made her comfortable in a bed decorated with a small silk flag and roses, perhaps unintentionally recalling the joys and sorrows of Fredericksburg. She managed to pull through and, though considerably weakened, traveled to Washington and attended the Grand Review of the Union armies in late May. She and her family occupied a fancy box located near President Andrew Johnson and other political and military leaders.

A family friend, Dr. Francis Bacon, remained on call during Georgy's recuperation. Frank had earned his medical degree at Yale and served with distinction as a surgeon on the regimental and brigade levels.[575] In June 1867, Frank and Georgy married and settled in his hometown of New Haven, Connecticut. Active philanthropists, they established the Connecticut Training School for Nurses at New Haven Hospital in 1873. Georgy co-founded the Connecticut Children's Aid Society in 1892. On January 27, 1906, Georgy died in New Haven at age seventy-four. Frank survived her, living until 1912.

Georgy and her sister Eliza authored *Letters of a Family*, two volumes of collected correspondence that recounted the experiences of the Woolsey family and their circle of friends during the war. The first volume included comments by Georgy about the trail she and other women blazed as pioneer caregivers: "No one knows, who did not watch the thing from the beginning, how much opposition, how much ill-will, how much unfeeling want of thought, these women nurses endured. Hardly a surgeon whom I can think of, received or treated them with even com-

mon courtesy." Georgy continued, "Some of the bravest women I have ever known were among this first company of army nurses. They saw at once the position of affairs, the attitude assumed by the surgeons and the wall against which they were expected to break and scatter; and they set themselves to undermine the whole thing."[576]

Where Others Dared Not Go

FOR THREE DAYS IN JUNE 1864, THOUSANDS OF WOUNDED and sick soldiers poured into the newly established Union base at City Point in Virginia. All were victims of the heavy fighting that raged in front of Petersburg during a desperate push to destroy the Confederate army and end the war. Hundreds of black men in blue from the Ninth Corps numbered among them. Upon their arrival, they were removed to a makeshift hospital separate from the whites. It had little if any resources. "It was, however, in no other sense a hospital than that it was a dépôt for wounded men," observed one writer. "There was defective management and chaotic confusion. The men were neglected, the hospital organization was imperfect, and the mortality was, in consequence, frightfully large."[577] Stories of their suffering reached the nurses, many on the brink of exhaustion due to the overwhelming number of patients. No one volunteered to help the colored troops. Finally, a slight woman with a resonant voice, dressed in gray flannel, stepped forward. Helen Gilson knew by instinct and experience that her duty was plain. Fellow nurses pleaded with her not to go. They told her she would not survive. According to one source, Helen replied "that she could not die in a cause more sacred" and set out alone to aid the neglected men.

This was quintessential Helen, who often went were no others dared to go. Her early life experiences reveal a young woman who overcame adversity. Helen hailed from modest circumstances in Boston, where she and her two sisters became orphaned after heart-related ailments claimed the life of her father in 1849 and her mother two years later.[578] She went to work as head assistant at the all-boys Phillips Grammar School in Boston but left after several years, due to her own health issues. The start of the war

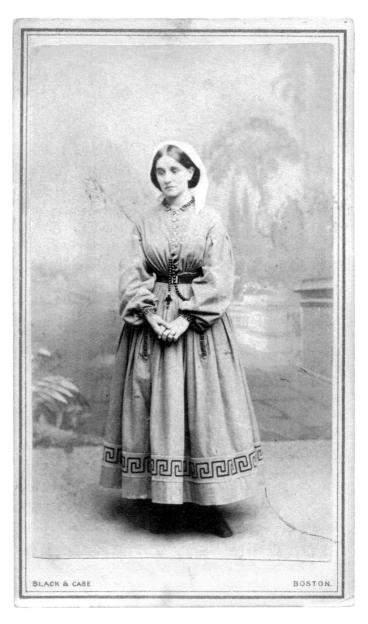

Helen Louise Gilson Osgood. *Carte de visite* by James Wallace Black (1825–1896) and John G. Case (1808–1880) of Boston, Massachusetts, about 1864–1866.

Collection of Michael J. McAfee

found her in the Boston suburb of Chelsea, in service as a governess to the three children of prosperous businessman and town mayor Frank B. Fay.[579] He was fourteen years her senior. According to his postwar reminiscences, Helen "expressed her strong desire to serve in the army as a nurse. She had noble qualities of mind and heart. She was a winning personality, and she was strong and brave, and we knew she would do good work there."[580] A letter of application was promptly sent to Dorothea Dix, the autocratic superintendent of army nurses in Washington, D.C. Dix invited Helen to join if she met the minimum age requirement of thirty-five. Helen, only twenty-six, did not qualify. The authors of the 1867 book *Woman's Work in the Civil War* noted that Helen's rejection was one of Dix's greatest miscalculations.[581] Helen remained in Chelsea, became active in local aid societies, and also worked as a contractor to make army clothing for soldiers.[582]

Meanwhile, Mayor Fay's life took a dramatic turn. When word reached him that several of his fellow townsmen had been wounded and killed in the July 18, 1861, skirmish at Blackburn's Ford along Bull Run in Virginia, he caught the next train to Washington, D.C., to bring them home.[583] The events that followed stirred his soul, for he was a philanthropist at heart. Time passed, and in April 1862, Helen received an urgent request from Dix to report to Washington. According to Mayor Fay, "Miss Dix was surprised to find her so young and attractive, and to her eyes so unfitted for service." Dix dismissed Helen as a serious candidate for a nurse and sent her off to a Washington hospital in an unofficial capacity, with no serious duties.[584] A chance conversation soon ended her administrative limbo. Later that spring in Virginia, Mayor Fay happened to be at Fortress Monroe, engaged in charity work, when he met Rev. Frederick N. Knapp, an influential member of the U.S. Sanitary Commission.[585] The mayor learned that Knapp needed recruits. He recommended Helen, and Knapp said to send her along.

Helen jumped at the chance. She headed south without Mayor Fay, who had returned to Chelsea. She soon arrived at White House Landing, the Union army's main supply base along the Pa-

munkey River outside Richmond. One of her first actions proved her mettle: "I saw the transport *Wilson Small* in the offing, and knew that it was full of wounded men; so, calling a boatman, and directing him to row me to the vessel, I went on board. A poor fellow was undergoing an amputation; and, seeing that the surgeon wanted help, I took hold of the limb, and held it for him. The surgeon looked up, at first surprised, then said, 'Thank you'; and I staid and helped him."[586] Toward the end of June 1862, Helen and others abandoned White House Landing after Gen. Robert E. Lee seized the offensive against his plodding nemesis, Maj. Gen. George B. McClellan. Helen found passage on a vessel and traveled downriver to the safety of Fortress Monroe, then promptly caught a tugboat headed up the James River to the new forward supply base at Harrison's Landing. Helen arrived on July 3 and found the Union army in full retreat at the end of the Seven Days Battles. "Our small tugboat on which we were packed came alongside the *Monitor*, which was anchored at Harrison's Landing. We were almost surrounded by gunboats, and the firing was kept up all about us. We could see the bursting shells and hear the explosions," she recalled.[587]

This was the first of many times when she came under hostile fire. The next day, July 4, in the face of the advancing enemy, Union forces made a chaotic and hasty withdrawal from the banks of the James River. "The shore was alive with troops, and steamers were constantly arriving for the transport of the sick and wounded who were lying on the ground, *to be counted by acres*," Helen observed.[588] Trainloads of the ill and injured kept on coming. Helen continued, "It was a touching sight to see these brave youth of our country, reduced by disease, come tottering towards us, entreating with imploring tones for a piece of bread or a cup of cold water. Everybody was in a whirl of activity, and the rush, heat, and confusion on shore one can never forget, as these overloaded trains arrived with their suffering freights of the wounded, who were fairly thrust upon these waiting boats."

Helen volunteered with others to accompany five hundred wounded men on the hospital steamer *Knickerbocker*. Onboard

was Mayor Fay, who had returned from Chelsea. They made the overnight trip to Washington, where the patients were carefully removed from the *Knickerbocker* and transported to area hospitals for further treatment. Reflecting on the massive withdrawal after the Seven Days Battles, the editor of Mayor Fay's wartime papers declared, "It was into such a holocaust of suffering and death as this that Mr. Fay and Miss Gilson began their hospital work."[589] Their highly effective partnership spanned the next three years as they traveled to battlefields in service of the sick and wounded—Antietam, Fredericksburg, Gettysburg, and elsewhere. They functioned as an independent relief agency in cooperation with the Sanitary Commission, which supplied them with resources when Mayor Fay's ran low.

That the commission allowed them to operate is remarkable, for its organizers believed in a single, unified system for soldiers' care. They realized, however, that Mayor Fay and Helen performed a critical function that the commission could not. As one of the commission's major fundraisers, Horace H. Furness,[590] explained, "Neither the Sanitary Commission nor the Medical Department, admirable as they both are, can alleviate all the misery caused by the war. In reality, about one-eighth of the sum total remains *unalleviated*." By supporting Mayor Fay and Helen, Furness argued, "we are helping to diminish that eighth, and in such a way as not to conflict with the method and discipline of the Medical Department, or with the grand federal principle of the Sanitary Commission."[591] The commission established the Auxiliary Relief Corps in 1864 to extend its battlefield reach. Mayor Fay, credited with the concept, directed the service for a time.

Furness made a special mention of Helen in his comments: "As a general rule, the battle-field is not the place for women; but no one who has ever seen Miss Gilson in the field hospitals can doubt that her case is the great exception to the rule. Never flustered, never complaining, always acting with impartiality, decision, and promptness, she moves about ministering to all wants, introducing order and method where all was confusion;

her hands never idle, her mind never resting, and her eyelids scarcely ever closing."[592] Numerous accounts of praise for "Miss Nellie" or "Sweet Helen Gilson" from soldier patients echoed Furness's sentiments. Clay MacCauley, a second lieutenant in the 126th Pennsylvania Infantry, was quoted as saying, "She had a rare power over the soldier's heart; it acknowledged her sway always. With us, her life was hidden from the world; it lay a constant sacrifice before every needy patriot friend, and rich were we who received its blessings."[593] Another soldier, unnamed in that same account, testified for many when he stated, "There is not a man in our regiment, who would not lay down his life for Miss Gilson."

The warmth she radiated reflected her true nature and Unitarian faith. "The more this experience comes to me," she wrote in one letter, "the more I am lifted into the upper ether of peace and rest; I am stronger in soul and healthier in body; yet, I have never worked harder in my life." In another missive she stated, "I have tested myself sufficiently under shot and shell to know that in danger I can be calm. And that is needed on the field."[594] Helen never lost sight of her own humanity. According to a biographer, "Miss Gilson's love of nature, and quick apprehension of its grandeur and beauty, never deserted her. She enjoyed sunset skies and wintry storms, the sound of waters and the perfume of flowers, with a keen and loving earnestness; and her sense of harmony, both in lights and sound, was made to minister to the comfort and pleasure of many a feeble sufferer whom such influences were still potent to reach."[595]

Perhaps her finest hour occurred in service to colored troops. The hospital camp at City Point, set up by the Medical Corps, did not measure up to snuff. During the earliest days of her efforts, surrounded by the dead and dying in temperatures hovering near the one hundred degree mark, she wrote, "The dust is intolerable. We have never endured so much. No roses here, nothing of beauty, only a parched and arid plain,—a mile square of hospital tents, filled with sick and wounded men."[596] Helen made it her business to bring this hospital camp up to the same standards

as those for the white soldiers. She introduced new policies to improve conditions and did so with the political acumen of a seasoned diplomat, in order to soothe the pride and prejudice of medical authorities. Under her leadership, kitchen and daily routines were established. Night after night, working by the flicker of candlelight, Helen moved quietly through the wards, alert for the faintest sounds that might signal a need for her attention. Her work brought down the mortality rate, and the colored hospital became one of the best at City Point. She spent most of the final year of the war ministering to the soldiers of the U.S. Colored Troops and area freedmen.

In the summer of 1865, Helen and Mayor Fay concluded their work. Fay continued his philanthropic efforts. He lived into the twentieth century and was fondly remembered by Chelsea citizens as the "War Mayor." In October 1866, Helen married Edward Hamilton Osgood, a Boston merchant active in the Sanitary Commission. Before long, the newlyweds looked forward to bringing their first child into the world. Helen's health, compromised by the rigors of army fieldwork, deteriorated as her pregnancy advanced. On April 20, 1868, she died at age thirty-two. A biographer recorded her last words: "When the hour came, she put her hand upon her forehead, felt the damp, and said calmly, 'This is death. The door is open, let me go.'"[597] The baby did not survive. Her devastated husband legally changed his name to Hamilton Osgood, attended medical school, and graduated in 1870. He remarried that same year and went on to become the father of a daughter. He rose to some prominence as a physician and died in 1907.

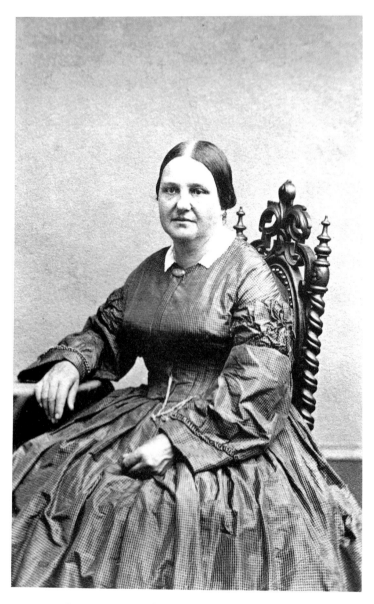

Anna Reich Carver. *Carte de visite* (unmounted) by an unidentified photographer, about 1861–1865.

Collection of the U.S. Army Heritage and Education Center

New Camp's Indefatigable Baker

New Camp buzzed with activity. In a remote section of the tidy tent hospital, nestled along the banks of Virginia's Hampton River near Fortress Monroe, Anna Carver fired up her stove for another day of baking. Loaves of fresh bread emerged in short order. By day's end, Anna had provided upward of thirty loaves, plus trays of biscuits—a herculean task by any measure. Her bread and biscuits were devoured by sick and wounded Union soldiers. "I can assure you they did not allow her bread to get stale on our hands," quipped a friend, the only other female volunteer at the hospital.[598] Anna beamed, and she later stated, "I am sure I never worked harder and it was a great pleasure to me to give our men something they could eat—their gratitude paid me for all my labor."[599] Anna's sentiment captures her spirit. Surviving letters written by her and friends with whom she worked during the war indicate that she was an orderly, self-sufficient individual, with a strong work ethic fueled by unbridled energy and patriotism.

Born in 1814 in eastern Pennsylvania to Jacob and Catharine Reich, Anna was one of ten children. Her large family, and the untimely death of her father when she was a girl, most likely contributed to forming the habits and behaviors for which she later became known. By the start of the Civil War, she had buried two husbands and married a third, farmer William Carver. They lived on a farm in Upper Merion in Montgomery County, located on the outskirts of Philadelphia. Unlike her prolific parents, Anna gave birth to a single child, a boy, with her first husband.[600] Anna began her war service in April 1861, shortly after the bombardment of Fort Sumter, when residents in Upper Merion organized the Army Aid Society. Anna numbered among its members, who

all wore a tiny silk Stars and Stripes, either on the left shoulder or arranged with looped ribbon on the front of a hat or bonnet. Anna sewed garments and quilts and, along with other towns-women. assembled bandages for soldiers.[601] The following year, Anna embraced a more active role through the auspices of the Penn Relief Association. A multidenominational charity formed by the Hicksite Friends, a sect of Quakers, it distributed goods and provided services to needy soldiers. Evidence suggests that Anna traveled to Washington, D.C., in service of this organization.[602]

Meanwhile, other motivated, independent woman seeking to improve the lives of suffering soldiers were on the move. One of them was Clara Barton. In late July 1862, she was deep into planning a relief mission to Maj. Gen. John Pope's Army of Virginia. She took on two assistants, one of them being Anna.[603] It is unclear how Barton came to offer Anna the position, for there is no record that the two had been previously acquainted. One explanation is that Barton, in the middle of her first major relief effort and scrambling to raise funds, secure supplies, and tend to myriad other details, took the recommendation of a friend who had become aware of Anna's abilities.[604] Anna's association with Barton lasted about three weeks, during which time she traveled as far south as Aquia Creek Landing and Fredericksburg in Virginia. It may be fairly stated that as a result, Anna was among the first to work with Barton at the beginning of the latter's eventful career, which culminated in the founding of the Red Cross.

Afterward, Anna returned to her husband and farm in Upper Merion for a brief respite. Weeks later, in early October, she teamed up with five other women who ventured 150 miles south and west to the battlefield of Antietam. They spent ten days caring for the large numbers of wounded, sick, and starved men sheltered in the crudest of conditions.[605] Anna continued her volunteer work in a series of missions, each lasting weeks at a time. Evidence suggests that most of her volunteer work occurred in Virginia, including Fredericksburg and nearby Falmouth. Her most memorable assignment was at New Camp, an auxiliary to

Hampton General Hospital, located about two miles away at Fortress Monroe. There were about 1,200 patients housed in some 460 tents when she arrived on June 17, 1864.

Anna set up her portable baker's shop with the practiced skill and confidence of a seasoned veteran. "Amply provided with cooking-stoves and cooking-utensils, and a rich supply of flour, meats, fruits, fowls, and delicacies," recalled a camp chaplain, Anna located herself "in the north-east corner of New Camp. Here, through the surgeon in charge, she soon had a comfortable tent erected, put up her cooking-stove, hung out the stars and stripes, and commenced operation on her own hook."[606] The chaplain continued, "Thus prepared, she set about the great work in good earnest, and baking bread and pies, and preparing all sorts of good things in best style, the heart of many a suffering soldier was made glad through her incessant labors and bountiful liberality. And having prepared her rich provisions, she would go round through the wards and look up the most needy patients, and with eagerness administer to their wants."[607] The volume and pace of her work took a toll on Anna. "Mrs. Carver is nearly used up, she works too hard and does not take any time to rest," a fellow nurse observed.[608] Still, Anna pushed herself, working until her flour barrels were empty, then returning home to resupply and return to the patients. The cycle continued until the hostilities ended.

Back in Pennsylvania, Anna suffered a series of ailments during the first few years after her return, including a bout with typhoid, a fall that injured a leg, and a stroke. All of these issues might have been related to the physical and emotional effects of the war, but she soldiered on and eventually recovered her health. Anna kept up with her many nurse friends and former patients. She visited New Camp on at least one occasion and toured the battlefields. She also took in the orphaned grandchild of one of her sisters.[609] Anna's health fell into decline about 1880. One day in the fall of 1883, she woke up, ate breakfast, and did some light cleaning around her house. Afterward, she lay down on a couch.

A few minutes later, she called out to her husband, who found her dying. Anna was sixty-eight.[610] A chaplain who observed her in action at New Camp many years earlier offered perhaps her finest tribute: "Possessed with a magnanimous spirit and a tender, sympathizing heart and a lofty patriotism, she was a *true friend* of the soldier, and delighted to give and labor for his comfort."[611]

Finding Her Soulmate at Hampton General

T‍HE SMALL NUMBER OF NURSES AND OVERWHELMING
volume of patients at Hampton General Hospital forced adminis-
trators to make tough choices about care. This included focusing
the efforts of nurses on only the worst cases as the women moved
between the wards.[612] For one nurse, this unfortunate reality may
have contributed to her becoming acquainted with her future
husband. Harriet Preston—a selfless, indefatigable, and pious
New York native—had worked in varied hospital environments
since April 1862. Her travels had taken her through the trials of
the Peninsula Campaign, working on hospital transports; the
bureaucracies of Washington, D.C.; and the relative comforts
of New England. By the middle of 1864, Harriet had landed in
coastal Virginia, where she worked at Hampton General and
other hospitals in the vicinity of Fortress Monroe.[613]

Meanwhile, an all-too-familiar wartime tragedy played out
about seventy-five miles north and west, on the outskirts of Rich-
mond. On the evening of June 29, 1864, Andrew Grogan took
charge of a picket line near camp, located along the frontline
entrenchments at Bermuda Hundred. Newly appointed as second
lieutenant, he and his comrades in the Sixth Connecticut Infantry
had recently arrived on the scene with the Army of the James.
Enemy troops fired on Andrew's picket during the night, and a
bullet tore into his thigh, ripped through muscle and tissue, and
shattered bone.[614] Surgeons amputated Andrew's left leg near
the hip, ending his career as a combat officer. As he recuper-
ated at Hampton General, he must have thought about his two
siblings, who had lost their lives in South Carolina the previous
year. Brother Charles, a first sergeant in the Sixth, suffered mortal
wounds in the arm and side at the Battle of Fort Wagner. Brother

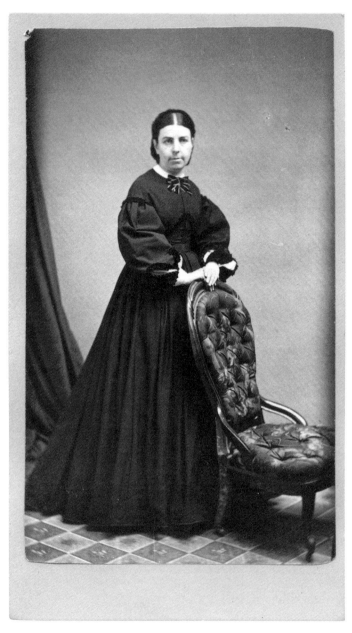

Harriet E. Preston Grogan. *Carte de visite* by an unidentified photographer, about 1864–1866.

Foard Collection of Civil War Nursing

Joseph, a sailor, drowned when his ironclad monitor *Weehawken* sank in a gale.

Andrew survived the loss of his leg. At some point during his recovery he met Harriet, and they became friends. The relationship continued through letters after he received his discharge in November 1864 and returned home to Bridgeport, Connecticut. Harriet left the service in September 1865, after three-and-a-half years on duty—longer than many soldiers. She made her way to Connecticut and married Andrew. They moved to Washington, D.C., where Andrew, a printer by trade, went to work at the Government Printing Office. But, like so many young men who had suffered severe wounds during the war, poor health forced him to quit his job. He and Harriet lived modestly off his veterans' pension benefits. Shortly before Christmas 1899, Andrew died at home with Harriet by his side, the final act in a drama that began thirty-five years earlier at Hampton General. The couple was childless. Andrew's body was interred at Arlington National Cemetery.[615] Harriet relocated to Bridgeport and moved in with her sister-in-law and another woman. She lived until age seventy-nine, dying in 1911 from pneumonia and heart disease. Her remains rest in Bridgeport.

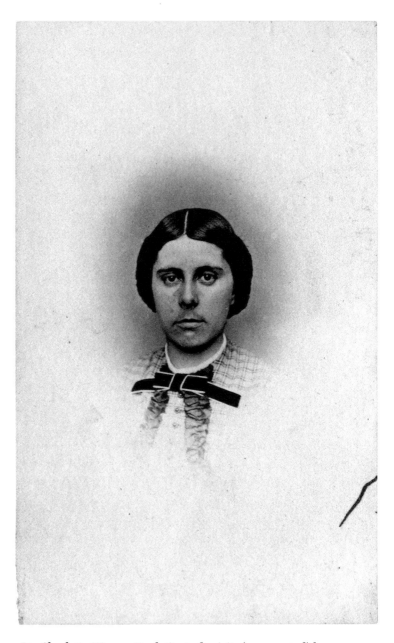

Dr. Charlotte Warner Ford. *Carte de visite* (unmounted) by an unidentified photographer, about 1861–1865.

Collection of the U.S. Army Heritage and Education Center

264

Journey from Mount Holyoke to the Naval School Hospital

Nurse Charlotte Ford did her share of letter writing and paperwork for patients, maybe more than most, as evidenced by letters that refer to her as "ward clerk."[616] How she came into that role might be explained by her education. Prior to joining the Union's nursing corps late in the war, she had studied at Mount Holyoke Female Seminary. Charlotte was one of four sisters who earned degrees from this progressive women's college in Massachusetts. Their father, Edwin Ford, paid the bills—and he could well afford it.[617] A gentleman farmer in Morris County, New Jersey, he managed a sprawling ancestral estate that dated back to colonial times. In 1857, when Charlotte turned twenty, he built Fordville, a spacious country home on the grounds of the estate.[618] Charlotte had little time to enjoy the new residence, as she soon went off to college. She returned with her degree in the summer of 1862 and considered her future.

Meanwhile, her only and older brother, Benjamin, joined the army. In September 1862 he enrolled in the state's Twenty-Seventh Infantry for a nine-month term. The regiment is well remembered for voluntarily extending its enlistment by a month to repel Gen. Robert E. Lee's Northern invasion. Though Benjamin and his fellow New Jerseyans were not called to fight in the culminating battle at Gettysburg, their willingness to do so stands as a tribute to their patriotism. Benjamin's stint in the army may have inspired Charlotte, who began her service in July 1864 at the Naval School Hospital in Annapolis, Maryland. Over the next ten months, she earned a reputation as a faithful and zealous worker on behalf of the sick and wounded patients in her ward. As an unofficial clerk, she penned uncounted letters to anxious women whose husbands, sons, and sweethearts were under her care.

For many women nurses, the war's conclusion ended their activities as caregivers. Not Charlotte. A few years after she received her discharge, she returned to school as a student at the Woman's Medical College of New York. She graduated in 1873, spent a year teaching physiology at her alma mater, and then opened her own practice in Springfield, Massachusetts. In 1876 she relocated the practice to a permanent home in Brooklyn, New York. An 1883 newspaper story reported that Charlotte numbered among forty-nine physicians in town,[619] a significant though small portion of the 841 doctors listed in the Brooklyn city directory.[620] Charlotte eventually retired and returned to Fordville, where she lived in the family home, along with her sisters and a few servants. She never married. In 1915, she succumbed to heart disease at age seventy-seven.

Raid on Magnolia Station

ONE JULY MORNING IN 1864, PASSENGERS ABOARD AN express train outside Baltimore were jolted upright after gunfire interrupted the gentle, rhythmic chug of the engine. In one of the cars, nurse Helen Noye peered out the window and observed rebel cavalrymen swarming the tracks. The troopers had organized the raid to disrupt Union railroads. They operated in coordination with a sizable Confederate army, commanded by Gen. Jubal Early. "Old Jube's" battle-hardened veterans had just beaten a hastily assembled federal force at Monocacy River, seventy-five miles west—and marched unopposed on undefended Washington, D.C. Helen was well aware of the situation. The threat posed by the invaders had prompted her and other nurses on duty at Annapolis, Maryland, to be evacuated for their safety. Now Helen was a captive in enemy hands.

Known as "Nellie" to friends and family, Helen began her wartime journey after the Battle of Antietam in September 1862. She left her well-to-do family in Buffalo, New York, to aid soldiers. At Smoketown Hospital she met volunteer Maria Hall, who supervised a ward. The two became close friends before Helen returned to Buffalo.[621] Meanwhile, Maria continued on at Smoketown and furthered her budding reputation as an outstanding nurse. During midsummer in 1863, she accepted a position at the military hospital in Annapolis, located at the U.S. Naval Academy. The campus had been closed earlier in the war for fear that it would fall into Confederate hands, and its cadets and faculty relocated to Newport, Rhode Island.

Maria offered Helen a position as her assistant, which was eagerly accepted. "Of the ten nurses when I was enrolled I was

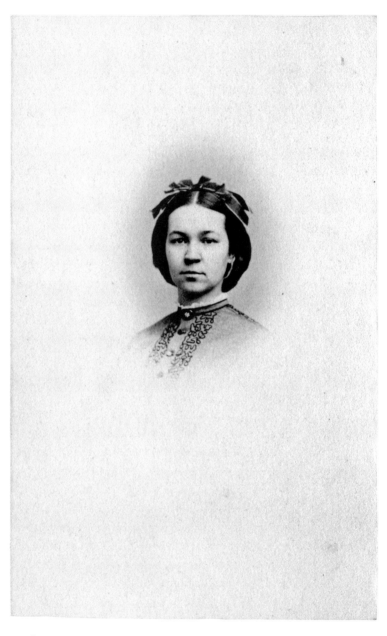

Helen Maria Noye Hoyt. *Carte de visite* (unmounted) by an uniden-
tified photographer, about 1861–1865.

Collection of the U.S. Army Heritage and Education Center

the youngest," Helen recalled, adding, "Miss Hall was also my room and working mate. Her patient spirit helped me to support and endure the trying duties of caring for the sick and wounded and of providing and rendering entertainment in the wards and chapel."[622] Helen proved an able assistant. According to one writer, she distinguished herself as a "very faithful, enthusiastic and cheerful worker."[623] In Washington, D.C., word of her abilities and youth—Helen was only twenty-three—caught the attention of Dorothea Dix, the chief of army nurses, who ruled her domain with an iron fist. She suspected that Helen might be under the official minimum age of thirty-five. Dix traveled to Annapolis and, Helen remembered, "expressed the desire to see the 'young nurse' as I was called. But I was spirited away by the nurses for fear she would order my removal on account of age."[624]

Helen may have escaped the wrath of Dix, but not the trials of the 1864 Overland Campaign into Virginia. Boatloads of casualties, carrying six hundred wounded and sick men at a time, landed at Annapolis after the Battles of The Wilderness, Spotsylvania, and Cold Harbor. "It is so painful here. Death, death, death and excruciating agonies constantly," she stated in a letter home.[625] Amputees suffered especially high mortality rates, Helen noted. On June 27, she described the final moments of Pvt. Sidney Allen of the Fifty-Ninth Massachusetts Infantry. He had been critically wounded ten days earlier in fighting near Petersburg. "My dear little Sidney Allen, both legs amputated, died last evening. So solemn and beautiful a death. I never was more affected. He was partly delirious, but recalled himself when spoken to. Constantly talked of home, and his poor legs in a wild, half-sensible manner which made it so painful. He was a lovely Christian and as he would rouse from his fits of stupor when we thought him almost gone he repeated passage after passage of scripture. Once he said, 'A window for me.' Said I, 'A light in the window, in the window[,] Sidney.' 'Oh yes! A light—a light!' said he. Spoke of going home to God where there would be no sorrow and grasping me by the arm convulsively said 'Come with me—don't let me go and leave you! Come, come!' His last words were 'Jesus, Jesus!' Then he

sank into perfect unconsciousness and lived but half an hour a 'plant-like life'—when to me the soul seems gone and only the breath convulses the chest. Oh, how many eyes I have closed. How many hands, folded for their last repose. Poor little Sidney, only nineteen and he said, 'If Mother knew this it would kill her.'"[626]

Less than two weeks later, Helen packed her bags and fled Annapolis in the wake of the Confederate invasion into Maryland. Unbeknownst to her, a detachment of about 130 rebel troopers of the First and Second Maryland Cavalry, commanded by Maj. Harry Gilmor of the latter regiment,[627] busied themselves by cutting telegraph wires and burning railroad bridges as Jubal Early's army advanced on the Union capital. Gilmor recalled the capture of Helen's train on July 11: "When within a mile and a half of the railroad bridge, where the Philadelphia, Wilmington and Baltimore Road crosses the Gunpowder, I discovered a passenger train coming on from Baltimore." Gilmor dispatched a captain and twenty troopers to intercept the train. "The capture was soon effected. Guards were then stationed all round, and I gave strict orders that no plundering should be done, threatening to shoot or cut down the first man I caught in anything of the sort. I also furnished the baggage-master with a guard, telling him to deliver to each passenger their property, and to unload the train."[628] Helen recounted what happened next: "A rebel soldier helped me off the train which was subsequently backed into the burning bridge over the river. Our baggage being placed on a hand car, we made our way to the river, where we stayed until morning, and were then taken by steamer to Havre de Grace." She added, "The appearance of the tilted stack of the engine above the wreck of the bridge is still strong in my memory."[629]

Helen rejoined her family in Buffalo, attending to her mother, who suffered ill health, "and did not return to the work to which I was heart and soul devoted."[630] In 1867, Helen married Birney Hoyt, who had served as a second lieutenant in the Sixth Michigan Cavalry. The two had met in Annapolis, where he had spent six months after suffering a wound at the Battle of Trevilian Sta-

tion in June 1864. Captured during the fight, he was held briefly at Libby Prison. The newlyweds settled in Grand Rapids, Michigan, where Hoyt went on to become a successful attorney and judge. He died in 1900. Helen joined him in death a quarter of a century later, in 1926, at age eighty-six. Four sons survived her.

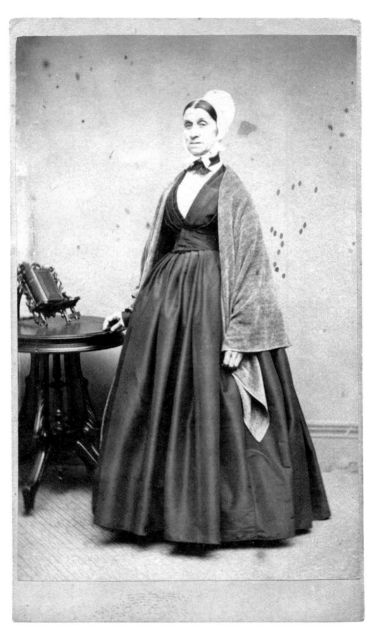

Sybil Jones. *Carte de visite* by an unidentified photographer, about 1862–1864.

Foard Collection of Civil War Nursing

Unspent Love

Major James Parnell Jones lingered only a short time after a rebel bullet struck him down during a battle near the Union capital on July 12, 1864. As his life ebbed away and he slipped out of consciousness, he sang a song, his family was told.[631] The lyrics went unrecorded. Considering his religious upbringing, they might have been a hymn learned from his mother, Sybil. A well-known Quaker missionary, the fifty-six-year-old mother of five had agonized over her eldest son's decision to go to war. Now he was dead, and Sybil struggled to come to terms with the loss.

Born and raised in Maine, Sybil "was possessed of much originality of thought and remarkable power of expression, and poetry and melody seemed inborn in her mental constitution," noted a biographer.[632] Though raised by Quakers, she flirted with Methodism early in life before reconnecting with her family's faith in the mid-1820s. By the early 1830s, she worked as a schoolteacher and might have made a career of it. Then she became acquainted with another Jones, a lover of books named Eli. A determined young man, he had started speaking at his local Friends meeting house in his teens to cure a speech impediment. He swiftly rose to become a spiritual and civic leader in China Lake, Maine. Sybil and Eli married in 1833 and eventually settled down on a nearby farm. They started a family in 1835, when James was born. Four more children followed, evenly divided between sons and daughters.

In 1840, Sybil answered an evangelical call and traveled to Canada with her church's blessing. Eli came with her. The trip marked the beginning of a missionary journey that lasted a lifetime, carrying them across North America and to other continents. Sybil and Eli become something of a dynamic duo as they ad-

dressed audiences of the faithful and the curious. Eli spoke with a clarity and knowledge of the Bible that appealed to the practical sensibilities of those to whom he preached. It was the charismatic Sybil, however, who packed meeting houses and other venues. She spoke with an emotional force that stirred passions. "It was a depth of feeling, yearning, love, and the tenderest sympathy, all aided by the queenliness of her person, the sweetness of her countenance, and the musical and poetic rhythm of her language, which so often melted the hearts, and brought tears to the eyes, of those who heard her," noted a biographer.[633] "She was a woman of rare sweetness and strength of character, and possessed great magnetism over the audiences she addressed," observed another writer, who added, "Few women, if any, before her had been summoned to so many widely separated places. She was well received by every nation and race. She addressed them boldly and powerfully, standing often where woman never stood before."[634]

Wherever Sybil and Eli went, they supported the antislavery movement, as did many of their fellow Quakers. The couple preached to men and women of color as early as 1846.[635] A three-month tour of Liberia in 1851 deepened their commitment to the cause of freedom. The 1850s also included visits to Great Britain, Ireland, and Europe. While in England, Sybil met Harriet Beecher Stowe, who had recently been thrust into stardom with the publication of *Uncle Tom's Cabin*. Stowe, who was informed by a friend that Sybil wanted to meet her, called on the Quaker. Stowe reported, "There was a mingled expression of enthusiasm and tenderness in her face which was very interesting. She had had, according to the language of her sect, a concern upon her mind for me." Stowe continued, "She desired to caution me against the temptations of too much flattery and applause, and against the worldliness which might beset me in London. Her manner of addressing me was like one who is commissioned with a message which must be spoken with plainness and sincerity."[636]

Meanwhile, in the United States, the issue of slavery deeply divided the nation. In late 1860 and early 1861, Sybil was hard

at work in the South when secession widened the breach and precipitated a constitutional crisis. She returned to Maine just a few weeks before the bombardment of Fort Sumter initiated civil war. The federal government's decision to suppress the armed rebellion by force precipitated a crisis within the Quaker community. Many were torn between allegiance to their nonviolent core beliefs and a desire to participate in fighting a war to preserve the Constitution, which provided a framework for their own freedoms. Sybil and Eli remained steadfast on the path to peace, in harmony with Quaker ways. Son James chose war, despite the protestations of his parents and others whom he deeply respected. He explained that the opportunity to emancipate the slaves by the sword could not be ignored. He remained convinced of the morality of his decision, even though it cost him his membership in the Society of Friends.[637]

James's enlistment in the army devastated Sybil and Eli, though all three remained close and regularly exchanged letters. James joined the Seventh Maine Infantry as a captain and rose to become the regiment's major. He distinguished himself in numerous battles and suffered wounds at Antietam and The Wilderness. His fatal wound during the Battle of Fort Stevens, on the outskirts of Washington, D.C., occurred somewhat haphazardly. He happened to be standing with a group of officers when a sharpshooter's bullet ricocheted off a tree above him, glanced downward, and struck him.[638] Sybil, who had previously kept the war at arm's length, turned to it with characteristic vigor in the absence of her son. "Her unspent love went out to all who were suffering on the field and in the hospitals, and she could not rest at home. Obtaining the needful credentials, she took up in a new form the arduous service of her active and consecrated life, bearing the gospel cheer to the wounded and dying in Philadelphia and Washington. She could tell the soldiers of her own son, and so touch their hearts, and her sympathy and love brought joy to many a poor sufferer," observed her nephew and biographer, Rufus Jones.[639]

In January 1865, Sybil set out on her errand of mercy to visit an estimated thirty thousand soldiers in a dozen hospitals in the capital region over a period of about four months. She also ministered to prisoners of war, Southern deserters, and refugees. One of her most memorable moments occurred at Stanton Hospital in Washington, where she encountered 1st Sgt. Eben Dinsmore.[640] A member of her son's company, he told her the story of how James sang during his last waking moments. Sybil happened to still be in Washington when John Wilkes Booth assassinated President Abraham Lincoln. She acted on an inner calling to deliver a message of peace to his widow and visited Mary Todd Lincoln at the White House. Sybil discovered her, and sons Robert and Tad, in the depths of grief. During a second visit, at Mary's invitation, she found the former first lady in bed, sunk in deep depression. Sybil reassured her of the power of Jesus and gently reminded Mary of her responsibilities to her surviving children. Sybil also stopped by the residence of Secretary Edwin M. Stanton and spoke briefly with him.[641]

Sybil left Washington soon afterward and went home to Maine. She did not stay long. In 1866, she toured both Washington and the former Confederate capital of Richmond on what her nephew Rufus described as a mission to "lift the skirts of darkness" from four years of war. Her visit included an audience with President Andrew Johnson.[642] Ever the globetrotter, Sybil and Eli toured Europe and the Middle East in the late 1860s. Though her health, always delicate, slowed her down, she carried the Quaker message of peace to cities large and small. This emphasized ministering to prisoners and advocating for the establishment of schools. The couple returned to America in 1869. Sybil continued her good work, despite her failing health. On November 3, 1873, she preached for a half hour at a meeting of the faithful in Windham, Maine. It was her final public appearance. At the conclusion of the meeting, recalled an eyewitness, "she stood and most impressively repeated a farewell hymn, dwelling upon the lines, 'Farewell, poor sinner.' Pausing,

she three times repeated these lines. None of us ever listened to a voice of such melody: it is indescribable—so solemn the message, so full of entreaty the tone."[643] The following month, she joined her beloved son James in death. She was sixty-five years old. Eli and her four remaining children survived her.

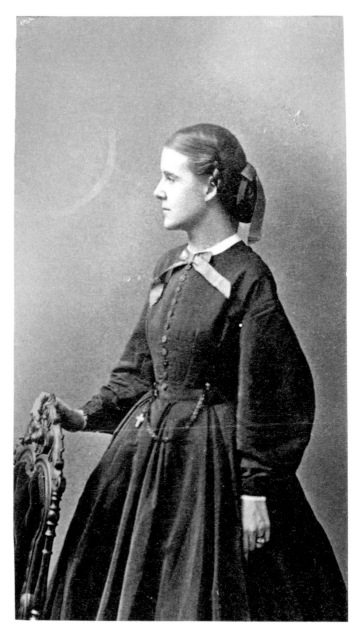

Emma Forbes Ware. *Carte de visite* (unmounted) by an unidentified photographer, about 1861–1865.

Collection of the U.S. Army Heritage and Education Center

Searching for Signs of the Raid
on Washington

ON THE EVENING OF JULY 12, 1864, EMMA WARE AND A
fellow nurse stood in the tower of the grand Smithsonian Castle
and scanned the horizon. They hoped to see the menacing artil-
lery fire of the Confederate army that was threatening the Union
capital, but instead were greeted by innocuous signal lights.[644]
Emma had arrived in Washington, D.C., just a few months earlier
from her native Massachusetts. A minister's daughter, she was
recognized for her intellectual gifts and self-reliance. One bio-
graphical sketch noted that "the range of her interests was very
broad, covering political, educational and religious themes. She
was a most ardent patriot."[645] Emma was the second member of
her immediate family to become directly involved in the war. Her
younger brother Charles, a Harvard graduate and staunch aboli-
tionist, supervised freedmen laborers on plantations in federally
occupied Port Royal, South Carolina.[646]

At some point after Charles left for the South, Emma applied
to the corps of nurses and was accepted. In April 1864, authorities
placed her in charge of Ward B, one of twelve barracks in Armory
Square Hospital, which sprawled across the grounds between the
Smithsonian Castle and the Capitol. Its location near city wharves
made it a convenient destination to which to deliver wounded sol-
diers transported from Virginia battlefields. Just a few weeks after
she embarked on her duties, unprecedented numbers of casualties
poured into the hospital as the spring campaign got underway.
They came from The Wilderness and other battlefields, where
Union and Confederate forces were locked in a death struggle as
the federals pushed on to Petersburg and Richmond. The first
wave of wounded—about 280 men—arrived on May 13. One of
Emma's sister nurses in Ward E recalled, "Our attendants, etc.,

were up all night bringing in and taking care of the wounded, who have been coming in all day." She added, "It made me feel sick and weak when I went into the ward to see almost every bed filled with a new patient and with a ghastly wound."[647]

Meanwhile, in Virginia, Gen. Robert E. Lee dispatched an entire Confederate army corps to threaten Washington, a move he hoped would draw federal troops away from the Richmond-Petersburg front and relieve pressure on his forces. Lt. Gen. Jubal Early and his Second Corps wound its way through the Shenandoah Valley and Maryland, fought a battle along the Monocacy River, and arrived on the northwestern outskirts of the Union capital. By the time Emma made the strenuous climb up the steps leading to the Smithsonian Castle's tower on the evening of July 12, the Union army's Sixth Corps had arrived on the scene and eliminated the enemy threat.

Emma left Armory Square on August 5, after a four-month stint in Ward B. She returned in the same capacity in January 1865 and served until the end of the war. In August 1865 she received a discharge and returned to her family in Milton, Massachusetts. Here she spent the next three decades as a tireless laborer to improve education for children. She also lobbied for better care for convalescents, which culminated in a home she founded in 1887.[648] When she died eleven years later, at age sixty, many in Milton grieved. One admirer paid tribute to Emma's life and services: "She was more than the woman of brilliancy and force: she was the affectionate, devoted, and inspiring friend. They know her bravery in suffering. They knew the courage and kindness of her heart. They knew, also, her great unselfishness."[649] The Daughters of Union Veterans chapter in Milton honored her by naming their local post the Emma Forbes Ware Tent.

A Missionary in Nashville

Sergeant Gill Bennett sat beneath the shade of a tree in his camp in Union-occupied Memphis on September 3, 1864, and wrote to his wife, Alma.[650] He scribbled—with paper on knee, as many soldiers did—about his health, war news, family, and home. He also included a pointed comment about a detail in her last letter to him. "I hardly understand what you mean by 'missionary,'" a somewhat bewildered Gill remarked.[651] Though the letter he quoted is lost to history, a note she penciled on her *carte de visite* provides the answer. She had joined the U.S. Christian Commission. The tone of her husband's comment suggests that she did not tell him about it until after the deed was done and Alma had reported for duty in Nashville—just two hundred miles away from his camp.

Alma Wolcott Bennett possessed a strong independent streak and a firm adherence to Christian values. A native of New York, she had relocated with her family to Wisconsin in 1854 and then to Floyd County, Iowa, in 1861. She had ambitions to become a schoolteacher. Gill, ten years Alma's senior, was a supportive husband, interested in the welfare of his wife. He also hailed from New York and had set down roots in Iowa. A whirlwind courtship in 1862 began in the spring, was sealed with a kiss on a hay bale, and ended in a wedding that summer. The marriage took place in Floyd County on August 25—less than a week after Gill enlisted in the army, and two weeks before he mustered into Company K of the Twenty-Seventh Iowa Infantry.[652] The regiment participated in varied retaliatory operations in Minnesota against Native Americans who had attacked settlers encroaching on their lands and way of life, as well as against Confederates in Mississippi, Louisiana, Arkansas, and elsewhere. In early 1864,

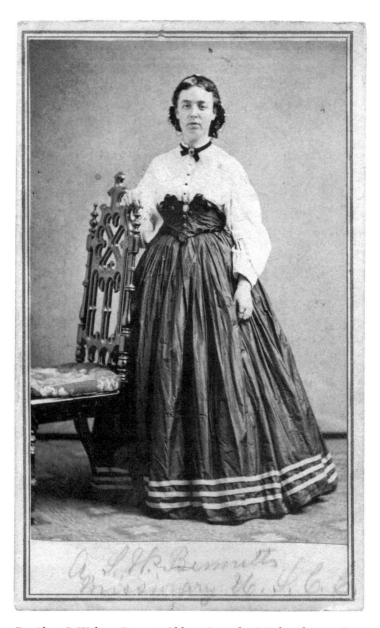

Dr. Alma S. Wolcott Bennett Olden. *Carte de visite* by Algenon S. Morse (1830–1922) of Nashville, Tennessee, about September 15, 1864.

Foard Collection of Civil War Nursing

the Iowans were heavily engaged in the Battle of Pleasant Hill during the Red River Campaign. By autumn, the regiment had moved to Tennessee.

Meanwhile, Alma had cast her lot with the U.S. Christian Commission. Considering her faith, it is perhaps not surprising that she became affiliated with this evangelical group, composed of volunteers who embraced the concept that caring for the sick and wounded opened a window to the soldiers' souls and a greater relationship with Jesus Christ. This approach to soldiers' care stands in contrast with the North's other leading relief organization, the secular U.S. Sanitary Commission. Alma might have been inspired to embrace healthcare by her mother, Augusta, who had practiced medicine back in New York.[653]

Alma began her service in July 1864. A month later, in Louisville, Kentucky, she received her commission, as well as advice from her supervisor: "Labor with all diligence to show yourself a worker approved by God and men. Keep yourself unspotted from the world. Let your conversation be with reserve and meekness and may God bless you and give you grace and strength to perform the duties assigned you."[654] Armed with these words of wisdom, Alma went on to serve a stint in charge of the diet kitchen in Nashville's Hospital No. 1 during the latter part of 1864. Hospital surgeons praised her work: "Her deportment while here has been such as to win for her universal respect and esteem."[655] She received a discharge for health reasons in December 1864. It is not known if she and Gill met during this time, as letters from that period are missing.

Gill also survived the war. Driven perhaps by wanderlust from their experiences, they headed west, settling in Elk Point, Dakota Territory, and started a family that grew to include six daughters and three sons. Seven of her children lived to maturity. The family eventually left the territory and lived for periods of time in Missouri and California. Sometime before 1880, Alma and Gill had become osteopaths, or members of the "school of the bones,"[656] a new branch of doctoring pronounced as radical by the medical establishment. Alma and Gill believed in the principle that

treatment of the musculoskeletal system without the use of drugs could cure most ills. The family claimed that Alma was the first female doctor west of the Mississippi River.[657]

Later in life, Alma became involved with the Women's Relief Corps, an auxiliary to the powerful Union veterans' group, the Grand Army of the Republic.[658] Gill passed away in 1910, after forty-eight years of marriage. Four years later, Alma wed widower Menzo A. Olden. The marriage was short lived, as Olden died in 1917 at age seventy-two. His remains were interred in an Oregon cemetery, next to his first wife.[659] Alma died at age eighty-four in 1929. She was buried, alongside Gill, in the Grand Army of the Republic section of Mount Hope Cemetery in San Diego. Alma Bennett Olden Tent No. 21 of the Daughters of Union Veterans of the Civil War is named in her honor.

Hidden Sacrifice

Sister Ignatius Farley remained on duty in the surgical ward long after her scheduled shift one autumn night in 1864. She tended to her tasks until a late hour, when she was finally relieved. Exhausted, she quietly made her way toward the sacristy, an anteroom off the chapel sanctuary used by priests to prepare for services.[660] She entered and closed the door softly behind her. There she paused, transfixed: "I stood fascinated by the unusual picture of seven professed Sisters, worn out from severe hospital duty, who were lying asleep on the floor, and soldier fashion, each Sister was enfolded in a blanket, while each weary head was resting upon a pillow made of leaves gathered on the campus. Over the sleeping group, which included the Superior, Mother de Chantal, there rested the soft roseate glow from the sanctuary lamp, gleaming through the glass panels of the closed door, and there was still lingering the delicate fragrance of the incense used in the adjoining chapel during the evening Benediction."[661] She added, "Not one of the sisters stirred as I tiptoed to my pallet beside the corridor door to prepare for a few hours rest before the approaching dawn. The next morning I learned that late in the afternoon the day before, the sisters had given up their cots and bedclothes to another contingent of wounded soldiers for whom they had found space in one of the corridors."[662]

Sister Ignatius happened to be the youngest of the Sisters of St. Joseph in Wheeling, West Virginia. She began life as Mary A. Farley,[663] born to Irish immigrants who worked a farm just south of town in neighboring Marshall County. She was the only one of their five children who entered church life. In 1863, at age twenty-one, Mary took her vows and joined her fellow Sisters of St. Joseph in the Wheeling Hospital. It had been chartered by the

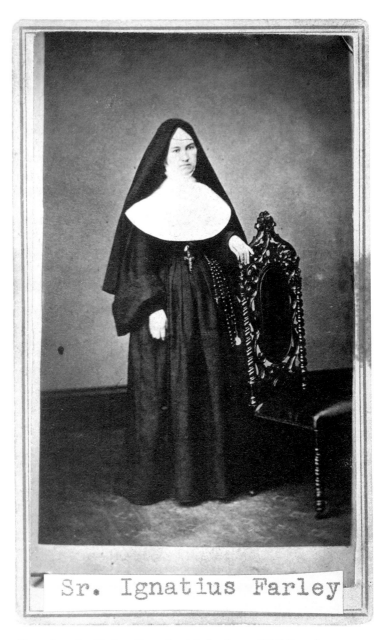

Sr. Ignatius Farley

Sister Ignatius Farley. *Carte de visite* by James W. Sellars (1840–1916) of Bellaire, Ohio, about 1863.

Collection of the Sisters of St. Joseph–Wheeling Archives

nuns in 1856 to serve the community. When the war came, according to Catholic historian Ellen Ryan Jolly, "they gave themselves whole-heartedly unto the labor of nursing the suffering soldiers of the Blue and the Gray back to health and strength."[664] One convalescing Confederate prisoner of war, noted Jolly, referred to the sisters as "Angels of the Wards."[665]

Assigned to the hospital in January 1863, Sister Ignatius first focused on preparing food and administering medicines under the direction of local physicians. She cared for a small number of soldiers in one section of the hospital and local townspeople in another. A radical change occurred in April 1864, when the federal government designated the facility as a post hospital. A few months later, in August, it became a full-fledged general hospital for military purposes. "The peaceful little hospital," Jolly reported, "now served as an 'Army Hospital' and instead of the sweet tranquility, and quiet comfort, that formerly characterized it, the immature hospital had suddenly been transformed into a surging mass of Blue uniformed soldiers, excited surgeons, endless rows of snow-white beds, upon which lay the human toll of many battles."[666]

The reorganization of the hospital for military purposes was timely. Its location, in proximity to Harpers Ferry and the battlefields of Virginia, resulted in a steady stream of patients. The Shenandoah Valley Campaign in the summer and autumn of 1864 increased the flow of injured and sick soldiers. They were cared for by Sister Ignatius and her companion nurses, who were paid by the government for their service. It was during these busy times that she and her fellow sisters often slept in makeshift quarters to make room for incoming patients. This routine continued into 1865.

Sister Ignatius remained in the St. Joseph Convent for the rest of her life. She occasionally told what she called her "war stories" to the younger nuns. When Jolly wrote *Nuns on the Battlefield* in the 1920s, she described Sister Ignatius's recollection of the episode in the sacristy as a "story of hidden sacrifice."[667] By this time, Sister Ignatius had been awarded a bronze medal by grate-

ful veterans of the Grand Army of the Republic and a pension by the federal government. In 1924, the Nuns of the Battlefield monument was dedicated in Washington, D.C. Though she did not attend the ceremony, the bronze relief honored her services and those of many other sisters. An inscription above the relief captured the spirit of their devotion: "They comforted the dying, nursed the wounded, carried hope to the imprisoned, gave in His name a drink of water to the thirsty."[668]

Upon her death on December 4, 1931, a day shy of her ninetieth birthday, she was recognized as one of the last three surviving nuns who had served as Civil War nurses. A few months later, *Catholic Action* magazine announced that a series of stained glass windows telling the story of Catholicism in America had been installed in the Sacred Heart Church in Pittsburgh, Pennsylvania. One of the panels, dedicated to the Civil War, includes the likeness of Sister Ignatius.[669]

Blood-Stained Skirts

Captain Will Gale made his way to the stately manor known as Carnton on the morning of December 1, 1864.[670] The elegant plantation home and grounds surrounding it were strewn with hundreds of dead, dying, and wounded Confederates. Only hours earlier, these men had been full of fight. Then came an unexpectedly desperate battle that claimed many lives—and forever changed Carnton and the nearby village of Franklin, Tennessee. Gale had been to Carnton once before. Years ago, he sat in one of the comfortable rooms and listened to an aged veteran tell tales of Andy Jackson and the great Battle of New Orleans in 1814.[671] Now, these same rooms and the broad halls that connected them were crammed with bloodied soldiers. Though they suffered, all were perhaps fortunate to have a roof overhead instead of a cold December sky.

They were also fortunate to have the presence of Caroline "Carrie" McGavock. A quintessential plantation mistress, she had, according to a minister who knew her, "ever enjoyed the advantages of wealth and social position."[672] Born in Mississippi and raised in Louisiana, she had ancestral roots in Tennessee through her maternal grandfather, Felix Grundy, a prosperous attorney and American statesman.[673] In 1848, at age nineteen, Carrie married John McGavock, a man fourteen years her senior. The son of Nashville's mayor and a one-time clerk for Grundy, he had recently inherited Carnton, named for the Irish hamlet from which his forefathers hailed.[674] The newlyweds began a family that eventually included five children, though only a son and a daughter lived to maturity. Slaves also resided on the grounds of Carnton. McGavock owned as many as forty-four men, women, and children of color, according to census records. After the war

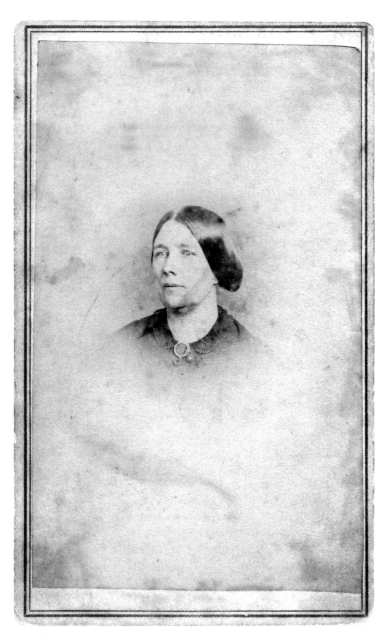

Caroline Elizabeth Winder McGavock. *Carte de visite* by Theodore
M. Schleier (1832–1908), about 1862–1864.

Collection of The Battle of Franklin Trust

came in 1861 and federal forces threatened Nashville and nearby Franklin, McGavock sent most of his slaves to Louisiana and Alabama to keep his property out of Union hands.[675] Nashville surrendered to the Union army in February 1862, the first Southern capital to fall. By late 1864, Tennessee was firmly in federal hands.

Meanwhile, in Georgia, the Union tightened its stranglehold on the state. Maj. Gen. William T. Sherman had taken Atlanta, cut loose from his supply base, and set out with his army on a march through the heart of Georgia that devastated the population and crippled the economy. Confederate Lt. Gen. John Bell Hood realized that his Army of Tennessee was no match for Sherman's forces. He turned northward and launched a major campaign in a bold bid to bring Tennessee back under the Southern banner.

Hood's movement came to a grounding halt in the fields and woods along the Harpeth River, near Franklin, on November 30, 1864. Capt. Gale, who, during the battle, served on the staff of Lt. Gen. Alexander P. Stewart,[676] recalled, "Our men were flushed with hope and pride and all thought they fought for Tennessee. They felt that the eyes of the men and women all over our country as was Tennessee, were upon them."[677] He added, "Charge after charge was made. A part of our division was shattered and recoiled, brothers bravely went forward in to the very jaws of death and came back, broken, and bloody. Again to be rallied by their heroic officers and again led forward to do what seems impossible or die."[678] The battle continued into the darkness. When it finally ended about midnight, Hood's army had suffered a staggering defeat that decimated its ranks. Its fighting days were effectively ended.

Carrie McGavock's ordeal, however, was just beginning. During the battle and through the night that followed, Carnton was transformed into a makeshift hospital. Gale, who had encamped nearby and visited the next day, recounted Carrie's story: "Every room was filled, every bed had two poor bleeding fellows, every spare space, nick and corner, under the stairs, in the Hall, everywhere, but one room for her and family—and when the noble old

house could hold no more, the yard was appropriated until the wounded and dead filled that and all were not yet provided for."[679] Gale continued, "Our doctors were deficient in bandages and she began by giving her old linen then her towels and napkins, then her shirts and tablecloths and then her husband's shirts and her own undergarments. During all this time, the surgeons plied their dreadful work, amid the sighs and moans and death-rattle of the stricken. Yet amid it all this noble woman the very impersonation of Divine Sympathy and tender pity, active and constantly at work to assist them all. During all the night neither she nor anyone of her household slept, but dispersed tea and coffee and such stimulants as she had and that too with her own hand. Unaffrighted by the sight of blood, unawed by the horrid wounds, unblanched by the ghastly death, she walked from room to room, from man to man, her very skirts stained with blood. The incarnation of pity and mercy—is it strange that all who were there praise her and call her blessed?"[680] Carrie got word that General Stewart and his staff were in the area and summoned them for breakfast. It was at this time that Gale returned to Carnton and learned of Carrie's contributions to the men. He recorded her superhuman efforts in a letter to his wife some weeks later, and it remains the most detailed account of her deeds.

Carrie, her husband, and other citizens of Franklin faced a new challenge in the aftermath of the fighting. The many hundreds of bodies hastily buried on the battlefield prevented farmers from continuing their labors. The graves were marked with crude wooden headboards, some of which had begun to rot away. Others were taken by locals who were desperate for firewood. Thus the identities of many of the dead Southern soldiers were lost. Townspeople rallied to rescue the remains. McGavock donated two acres of land adjacent to his family burial plot to create a cemetery for these fallen combatants. Between April and June 1866, local men were hired to tackle the grim task of disinterring and removing the bodies.[681] Information gleaned from about 1,500 gravesites was recorded in a leather-bound logbook and presented to Carrie. The safekeeping of this volume and care of

the Confederate cemetery became her charge. "Until the close of her life no sign of neglect showed in any part of the cemetery, it being her chief pleasure to see that no stray weeds crept upon the hallowed ground, and that the grass and enclosures showed in their careful keeping the love she bestowed upon that spot," noted an admirer in *Confederate Veteran*.[682]

Carrie's devotion to the cemetery continued until her death in 1905, at age seventy-five. She outlived John, who had passed away in 1893. Their grave marker stands prominently above the nearby soldiers' stones. As the years passed, Carrie's name and deeds receded from memory. Then, in 2006, more than a century after her death, author Robert Hicks introduced Carrie to a new generation of Americans in the novel *The Widow of the South*.

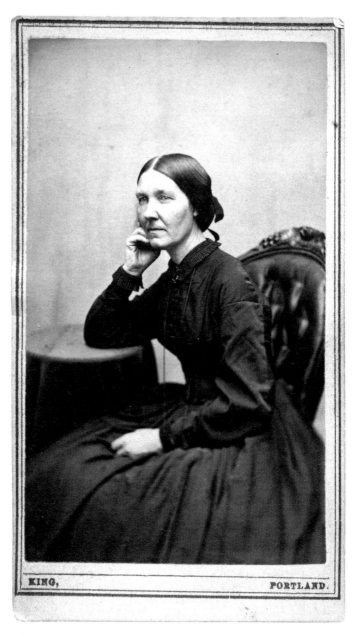

KING, PORTLAND.

Ruth Swett Mayhew. *Carte de visite* by Marquis Fayette King (1835–1904) of Portland, Maine, about 1864–1866.

Collections of the Maine Historical Society

Homecoming

VOLUNTEER NURSE RUTH MAYHEW LEFT HER RESIDENCE in Rockland, Maine, for war-torn Virginia one day in early December 1864. She traveled by foot, horse, and rail through windswept landscapes of leafless trees and then, in the face of advancing winter, by steamship across chilly seas to Southern shores. She eventually landed at the confluence of the James and Appomattox Rivers. Here she made her way to City Point, the sprawling winter quarters of the Army of the Potomac. Any anxiety she may have felt during the journey dissipated, for she knew the place and some of the relief workers and soldiers who inhabited it. "Back at City Point, again 'at home,'" she stated in her diary days before Christmas.[683]

City Point and similar places had been central to Ruth's life practically since the war began. Shortly after the bombardment of Fort Sumter in April 1861, citizens in the town of Rockland raised recruits for what became the Fourth Maine Infantry. Ruth, then a thirty-nine-year-old public schoolteacher, and two other women volunteered to accompany the regiment as nurses.[684] Ruth's enthusiasm appears to have been born of pure patriotism. Lingering grief and loneliness following the death of her beloved minister husband, Andrew, may have been a contributing factor. He had passed away five years earlier.[685] In June 1861, when the Fourth received orders to report to Washington, D.C., the three women were left behind. Rebuffed, Ruth and others turned to preparing supplies for soldiers in the field.

Meanwhile, in the city of Portland, citizens founded the Maine Camp and Hospital Association to support the state's soldiers. One of its most active members, Isabella Fogg, worked in the greater Washington area as an agent for the organization.[686] Ruth

teamed up with her before the end of the year. Isabella and Ruth wound up in an Annapolis, Maryland, military hospital, where spotted fever raged during the winter of 1861–1862. According to a biographer, "For more than three months did these heroic women remain at their post, on duty every day and often through the night for week after week, regardless of the infectious character of the disease, and only anxious to benefit the poor fever-stricken sufferers."[687]

In 1863, Ruth cared for sick and wounded Maine men after the Battle of Gettysburg. In her diary entry for July 21, her third full day at Gettysburg, she noted, "How much I enjoy my labor here with all its disagreeable accompaniments. It is such a pleasure to do anything to make the soldiers more comfortable."[688] Much of her stay in Gettysburg was a death watch. "I am very much discouraged about most of our Maine men—they seem weaker every day. Some of them are Christians and have been for a long time, some have sought a Savior while lying here, and some I am ashamed to say I have not conversed with. May God help me to do my duty, for sometimes the cross is heavy," she wrote in her diary on July 26.[689]

Less than two weeks later, most of the surviving Maine soldiers had been removed to more-permanent hospitals. On August 5, she had a brief respite and went sightseeing with a group guided by a gentleman affiliated with the U.S. Sanitary Commission. He "took us out to a part of the battlefield we had not seen. It was the hill where our signal corps were stationed and commands a fine view of the whole field," she noted in her diary. The position she described is probably Little Round Top, where Col. Joshua Lawrence Chamberlain and his Twentieth Maine Infantry had successfully fought off a Confederate assault that might have otherwise destroyed the Union army.

Ruth left for Washington soon afterward, rejoined the Army of the Potomac, and treated a steady stream of patients throughout the rest of the year. On January 1, 1864, she recorded in her diary, "How strange it seems to write this date! How swiftly have the scenes changed, and how much I have lived during the past

year. What has been its record against my name? Has anyone been made better or happier for my living? Has no one been made worse? What shall be in the coming year? I would not if I could lift the veil that shrouds my destiny, and yet I often find myself wishing I see the end of this remorseless war, and know how many more hearts must bleed."[690]

Ruth found an answer five months later, when the first waves of casualties rolled into hospitals in the wake of Lt. Gen. Ulysses S. Grant's Overland Campaign. During this deadly spring of 1864, she and other relief workers moved from Washington to Fredericksburg to White House Landing and, finally, on June 18, to City Point. Ruth was eventually assigned to the Depot Field Hospital, the largest of seven medical facilities. It spread over two hundred acres and housed up to ten thousand soldiers. Ruth tended to her patients with little downtime, snatching precious sleep when she could—though it was often interrupted by the sounds of distant cannonading. Keeping up her diary was a challenge. On one occasion, a sister nurse added a complimentary entry: "Poor dear Mayhew too tired to write in her diary so I write for her. No one is doing more than she for these poor sufferers. So quiet and gentle, she moves among them, giving food and nourishment to the most serious cases, but a kind word and a smile to all. The rest of us who are at work receive many a wise suggestion from her."[691] Ruth was also recognized for her soprano voice. "Many evenings while easing from the fatigue of the day," recalled one nurse, "Mrs. Mayhew with her rare sweet voice led the singing, and the chorus followed in our favorite songs." She added, "Owing to the quiet of the great hospital after dark the singing could be heard all over camp."[692]

By October, the unremitting routines drove Ruth to exhaustion. She left City Point for Rockland, Maine, to rest. She returned to City Point about December 18, to a homecoming of friendly faces. She remained in service throughout the remainder of the war. Then, after a brief stay in Maine, Ruth relocated to Ottawa, Kansas. Evidence suggests that she followed a fellow Rockland nurse, Orissa Packard, who had married the mayor of Ottawa.[693]

Ruth put her teaching skills to work at fledgling Ottawa University. In 1868, she became the matron in charge of the Indian Department, with its thirty students. A separate department was organized for white scholars.[694]

At some point Ruth left Kansas, returned to Maine, and went to work as matron at the Military and Naval Orphan Asylum in Bath. That institution had been founded by another of her nurse friends, Sarah S. Sampson. Ruth died in 1875 at age fifty-three. The epitaph on her tombstone is a tribute to her war service: "One of that devoted band of women who sacrificed all for the good of their country and their fellow man." Though she left behind no children, the Daughters of Union Veterans of the Civil War named one of their posts the Ruth Mayhew Tent in her honor.

From Handkerchiefs and Havelocks
to a Spoonful of Egg

In a Maryland hospital ward one December day in 1864, a young lady carefully held a spoonful of food in front of an emaciated soldier. She placed it into his mouth, and he chewed with a sense of wonderment. Astonished, he asked, "What *is* that?"[695] She had fed him an egg, the first he had seen or tasted in over a year. The soldier, a Union prisoner of war, had until very recently been held captive in one of the Southern camps. The young lady, twenty-eight-year-old Maria Hall, worked as head nurse of Hospital No. 1 in Annapolis. How she came to occupy the position is representative of high-society women who proved extremely capable caregivers.

A native Washingtonian, Maria grew up just a few blocks from the Capitol, the eldest daughter in a family well connected to the power elite. Her mother, Martha, died just a month after Maria came into the world, probably from complications in childbirth. Her maternal grandfather, Dr. Lewis Condit, had served as a New Jersey congressman.[696] Maria's father, wealthy attorney David Aiken Hall, moved easily in social circles that included Senators Daniel Webster and Stephen Douglas.[697] According to a District of Columbia historian, Hall abhorred the institution of slavery yet owned slaves: "He thought the slave owners should be compensated for their property. He would never hold slaves with the idea of buying and selling them, but owned them for use as servants, so as to keep them from being sold away from their families, and then encouraging them to buy their freedom by crediting them with wages each month." This narrative is common to owners who had no intention of ever releasing their slaves from bondage. In Hall's case, however, he appears to have been true to his word. The historian goes on to describe how Hall honored his contracts

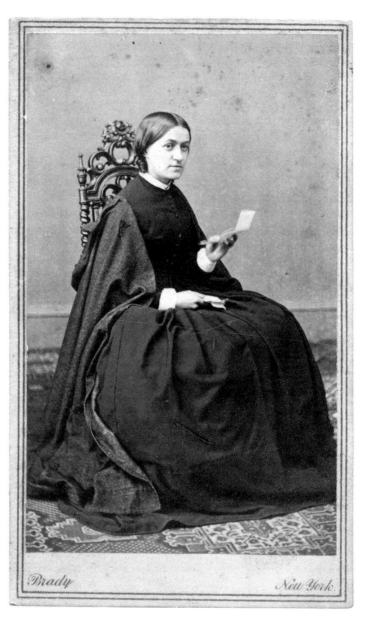

Maria Martha Condit Hall Richards. *Carte de visite* by Mathew B.
Brady (1822–1896) of New York City and Washington, D.C., about
1862–1865.

Foard Collection of Civil War Nursing

with slaves and assisted some of them and their families to reach freedom in Canada.[698]

After the Civil War began, Maria jumped into action. "I was a young woman in the first flush of enthusiastic devotion to the Union cause. With other Washington ladies I had made handkerchiefs and havelocks and scraped lint," she explained.[699] Maria also found inspiration in the works of Florence Nightingale and sought to follow her example. An early opportunity presented itself on her doorstep before the First Battle of Bull Run in July 1861. Maria's family, which had grown considerably after her widowed father remarried, provided temporary shelter to a sick soldier. Maria nursed him back to good health. The episode whetted her appetite for more, and she applied to chief of nurses Dorothea Dix for an appointment. Dix promptly rejected the application on the grounds of the young woman's age. Determined, Maria turned to Almira Fales, a prominent Washington philanthropist and nurse. Fales also followed Dix's policies and dissuaded the cultivated and attractive Maria from her ambitions. But Maria persisted, and Fales consented to allow her and one of her sisters to volunteer in a temporary hospital located in the stately Patent Office Building.[700] Maria proved herself in the makeshift wards of the grand building. When, at some point afterward, administrators moved to restrict volunteers from the hospital, they bumped her role up to paid nurse, in recognition of her performance.[701]

Maria might have remained in Washington for the rest of the war, but fate intervened in the summer of 1862. She joined other medical personnel to bring back sick and wounded soldiers from the Virginia Peninsula, where the Union army's long march to take Richmond and end the war sputtered out and ground to a halt a few miles short of the enemy capital. Maria served on the hospital vessels *Daniel Webster* and *Daniel Webster No. 2*—a coincidence, considering her father's friendship with the late, great senator. She saw firsthand the horrors of war at Harrison's Landing, a staging area for casualties who required transport to Washington for medical treatment.

After her work on the Peninsula ended, Maria returned home

to rest. Antietam interrupted her sojourn. After telegram exchanges and a hasty departure, Maria arrived on the battlefield but was unable to link up with the person she had arranged to meet.[702] Instead, she stumbled into a hospital where rebel soldiers were treated. Reluctant to care for them at first, she quickly realized the desperate condition of the enemy men and set loyalty aside in the interests of humanity. Maria served here and elsewhere through the month of September 1862. Early the following month she moved to Smoketown Hospital, a semi-permanent facility that emerged from the chaos and confusion of the initial emergency efforts.

In the hospital at Smoketown, Maria tended to the two hundred to three hundred patients housed in one of three wards. As the days and weeks ticked by and the nurses in the other two wards were called elsewhere, Maria's duties expanded. She impressed the patients in her care and a surgeon who impacted her career. Bernard A. Vanderkieft—a physician born and educated in his native Holland, who claimed service in the recent Crimean War—ran the Smoketown Hospital.[703] He appreciated her abilities as a caregiver and administrator. In May 1863, Smoketown shut its doors. Vanderkieft moved to eastern Maryland and a new assignment as head of the military hospital located in Annapolis, on the grounds of the Naval Academy. Maria returned home with a standing offer from Vanderkieft to join his nursing staff. While she pondered her future, the Battle of Gettysburg occurred. According to one biographer, "She was very solicitous to reach the front, and engage in field service; but not meeting with any encouragement, she yielded to the earnest solicitations of Dr. Vanderkieft."[704]

Maria spent the rest of the war in Annapolis. The time here marked the zenith of her service. She embarked on her duties in charge of Section 5, a grouping of outdoor tents for overflow patients. In May 1864 she advanced to become chief matron of the entire hospital. She had as many as four thousand patients at any given time, and ten to twenty assistants. "Her mind seemed to be in all parts of the hospital, and she recollected the peculiarities of

almost every case. Her judgment as to the fitness of her assistants was unerring, assigning to each such duties or such wards as she was best fitted for," noted one biographer.[705]

In this capacity Maria oversaw the care of starved, emaciated soldiers returning by ship from the notorious prisoner of war camps in the Confederacy, including Belle Isle, Libby, Florence, Salisbury, Wilmington, and Andersonville. "It is enough to touch any heart to see the ones we call *well* walk up from the boat, poor skeletons that can just crawl along, & have hardly mind or strength enough left to know that they have gotten back to 'God's Land' once more," she wrote to a friend shortly before Christmas 1864. In the same letter, Maria observed, "It is almost a painful pleasure to see with what eagerness the poor fellows grasp at apples & fruit of all description. They have been so long deprived of anything that is food, as if almost to lose the taste of the common comforts."[706]

By the time her service ended, Maria's own health suffered. She endured chronic fever for many months and never quite recovered from its effects. Still, she married a Connecticut paper manufacturer, Lucas Richards,[707] and started a family that grew to include two children who lived to maturity. Despite her success as a wife and mother, she averred, "I mark my Hospital days as my happiest ones, and thank God for the way in which He led me into the good work, and for the strength which kept me through it all."[708] Maria died in 1912 at age seventy-six.

Late in life, she circulated a story about how Dorothea Dix had called her to the White House in February 1862, following the death of President Abraham Lincoln's son Willie from typhoid. Lincoln's other young son, Tad, had also fallen ill, but not as severely as his late brother. Though the timeline she claimed and some of the anecdote's details appear accurate, her account has been disputed by some historians. The precise state of the elderly Maria's mental health and other faculties during the period when she recounted this tale is not known. Regardless of the veracity of the story, one might argue that it reinforced her connection to happier days.

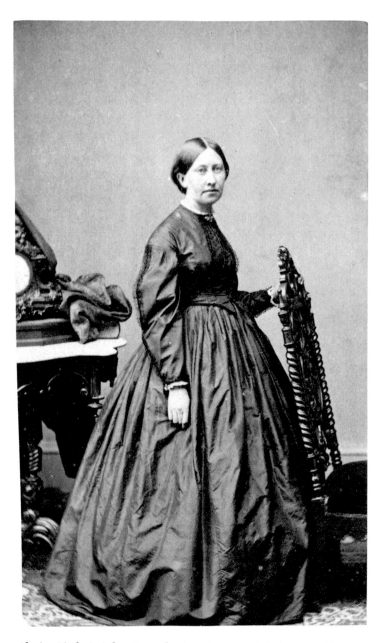

Almira Fitch Quinby. *Carte de visite* (unmounted) by an unidentified photographer, about 1861–1865.

Collection of the U.S. Army Heritage and Education Center

A Panorama of Tragedy and Comedy

ALMIRA QUINBY DESCRIBED HER NURSING EXPERIENCE
during the war as a study in contrasts. "We live a strange life—it's
impossible to describe it—as much like a rapidly moving pan-
orama of tragedy & comedy combined as anything I can liken it
to," she wrote to a relative, adding, "We were told that we never
should smile again after we entered the hospital but strange to
say I have laughed more in the time than I ever did before. We
laugh & cry alternately."[709] The hospital, in Annapolis, Mary-
land, occupied the former grounds of the U.S. Naval Academy,
which had been temporarily relocated to New England to keep
the cadets and professors far away from the Confederate forces.
By coincidence, New Englanders composed the majority of the
female nurses who served there.

Maine women dominated the ranks of nurses at Annapolis,
and their number included Almira. Born in the Portland area,
she grew up in nearby Stroudwater, the youngest of five children
raised by Anne and Moses Quinby. Her father, by faith a Univer-
salist and by profession an attorney, espoused the abolition of
slavery and played an active role in the Underground Railroad. A
staunch supporter of temperance, he joined another Portlander,
Neal Dow,[710] in the prohibition movement.[711] In November 1862,
Almira arrived in Annapolis to begin her war work. Though she
never disclosed the identity of the individual who told her she
would never smile again, one possible candidate is the woman
who hired her, Dorothea L. Dix, the chief of army nurses with
whom so many had a love-hate relationship.

Almira experienced the joys and sorrows of war, which she
recorded in her letters home. In one, she shared the joy of the
sisterhood of nurses: "You ought to see us at meal time. There

are seven ladies now who belong to our family, all intelligent & cultivated, as brilliant a circle as you'll often see. Hitherto we have all talked together, but now we have made a rule that not more than 6 shall talk at a time. If the seventh could only chronicle our table talk, we should pour out a precious volume every week. Our evenings are spent reading or writing—or else we assemble in one room & have a merry time."[712]

In another, she recounted a sorrowful scene upon the arrival of a transport filled with starved and half-naked Union prisoners of war released from Confederate camps: "If one wishes to see misery in its most aggravated form, let him stand and watch the freight as it is taken from a transport. Those who were supposed to have strength enough to crawl are formed into line and marched over to Parole Camp, a distance of four miles, accompanied by a guard on horseback, reminding one forcibly of a drove of cattle followed by drovers. Those who are in a little better condition, but unable to walk without assistance, are placed between two, who are a little more fortunate, and make their way slowly up to the wards. Others are jounced along on stretchers, without any covering than the few rags which they have left, while those who have finished the voyage and done their last service for their country are brought over in coffins and deposited in the dead house. I expect we shall have dreadful accounts of the sufferings of these men, judging from their personal appearance."[713]

During the war's final months, Almira reflected on her future return to Maine: "I expect civil life will seem so insipid, after so much excitement that I shall join the Regular Army after this campaign is over. One of the men said to me the other night that he hoped I would not get worn out, for we might have another war. I told him I did not think he ought to expect this set of Nurses to serve in two wars."[714] Almira did not remain in the army or participate in another war after she received her discharge in May 1865. She returned to her family in Stroudwater, where she lived quietly until her death in 1909, after a brief illness. She was eighty-one and unmarried.

An Editor of the Crutch

A SOLEMN PROCESSION OF AMBULANCES ROLLED TO THE beat of muffled drums as it approached the hospital cemetery in Annapolis, Maryland, one December day in 1864. Inside the vehicles, thirteen altogether, lay the remains of forty-three soldiers, all recently liberated Union prisoners of war. Some of these mistreated men had died en route from the South, and others barely survived their return to Northern soil. Throngs of tearful onlookers, with heads bowed and hats removed, paid their last respects. "We trust the scene may never be repeated," observed a newspaper correspondent, "while we take consolation in the thought, that these wronged and lamented brothers, died in ministering hands."[715] These words were part of a detailed report that appeared in the December 10 edition of the *Crutch*, the hospital's newspaper. A staff member associated with the publication, Louisa Titcomb, enjoyed a reputation as one of the facility's most respected nurses.

A veteran caregiver at age thirty, Louisa hailed from Portland, Maine. An admirer praised her as "a young lady of high culture and refinement" who, "from the beginning of the War, had taken a deep interest in working for the soldiers."[716] Her desire to help had come to the attention of Sister Adeline Tyler, a well-known Episcopal churchwoman and organizer.[717] In the autumn of 1862, she hired Louisa to serve on the staff of the army hospital in Chester, Pennsylvania. Eight months later, in mid-1863, Sister Tyler moved to the U.S. Army General Hospital, Division No. 1, in Annapolis and brought Louisa and other nurses with her. Louisa eventually became an assistant superintendent of the 1,562-bed facility.

On January 9, 1864, the inaugural issue of the *Crutch* was

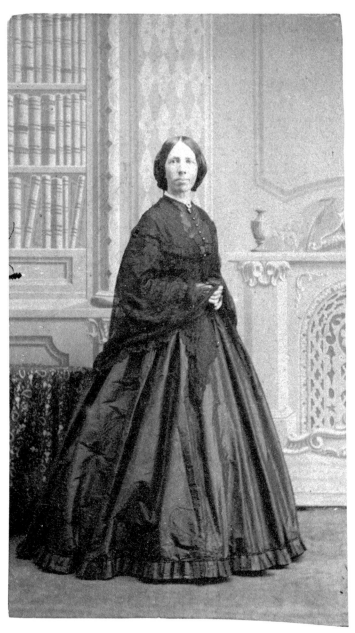

Louisa Titcomb. *Carte de visite* (unmounted) by an unidentified
photographer, about 1861–1865.

Collection of the U.S. Army Heritage and Education Center

printed. Described on the front page as "a weekly news and literary paper devoted to the interest of the soldier," the four-page publication included a variety of contents, from patriotic poems to humorous anecdotes to news items. During its seventy-one–issue run, three men served successively as the paper's editor and publisher. According to one source, Louisa was the one who edited the newspaper, which suggests she may have had a hand in selecting, copyediting, or proofing material. The *Crutch* ceased publication on May 6, 1865. It occupies a footnote in history as one of only 9 of the 192 Union army hospitals that published newspapers.[718]

Louisa received a discharge from the hospital four days later. She returned to Maine and settled in the village of Stroudwater in the Portland suburbs, where she lived with her cousin (and sister nurse from Annapolis), Almira Fitch Quinby.[719] Louisa became active in progressive causes, including temperance, women and children in need, and universal suffrage. She also held membership in the National Dorothea Dix Memorial Association and participated in at least one veterans' reunion before her death in 1905 at age eighty-four.[720]

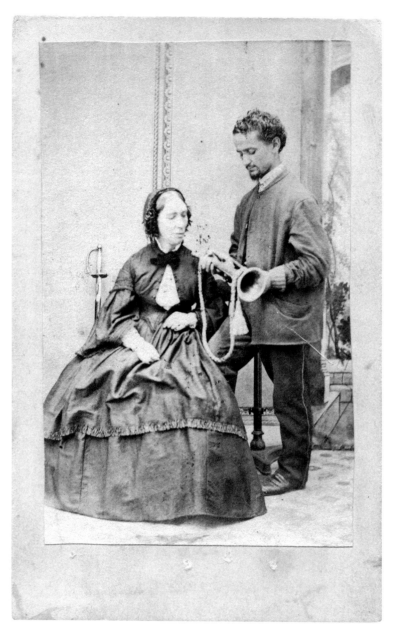

Eleanor Cole Houton Ransom and an unknown man. *Carte de visite* by an unidentified photographer, about 1865.

Foard Collection of Civil War Nursing

Cyclone of Death

The *North America* was sinking. The wind-whipped transport floundered in a raging storm off the Florida coast on December 22, 1864, and nothing could save it. In one of the cabins below the main deck, nurse Eleanor Ransom made her peace with God as the vessel pitched and tossed. She wrapped a cloak and shawl over her shoulders, donned a life preserver, and struggled up a stairway to the gale-swept main deck. There she found a large group of Union soldiers crying and praying as the end approached.[721] The sight of these doomed, helpless boys in blue shocked Eleanor to her core, for they were patients into whom she had poured her heart and soul. They affectionately called her "Mother," in recognition both of her devotion and her forty-nine years of age.

Eleanor could easily have been their biological mother. Details of her early life are sketchy. Born just after the end of the War of 1812, either in Maryland or Ohio to parents who hailed from Georgia, she moved to Indiana in her youth and came to call the Hoosier State home. In 1837, she married Stillman Ransom, a Vermonter who had relocated to the Midwest and taken up farming. They started a family that grew to include two daughters.[722] Eleanor responded to a call by Gov. Oliver P. Morton for nurses in late 1862. In February 1863, she received orders to report to Union-occupied Memphis, Tennessee, where she worked in army hospitals for more than a year and a half. Tireless and committed to the soldiers' care, Eleanor was forced to step away for brief periods on only two occasions: once for her own sickness, and another after the death of a daughter.

During the autumn of 1864, Eleanor received new orders to report to the medical director in New Orleans. She arrived in

November and recalled spending weeks "attending to poor prisoners brought up from Galveston who were so starved that many of them were idiotic and could not tell their own names or give any information of their friends at home."[723] Eleanor was soon assigned to the steamer *North America*, used to transport sick and wounded soldiers to the North for transfer to hospitals or release to their homes. On the evening of December 16, the vessel departed New Orleans with about 260 souls aboard, including more than two hundred soldier patients. The weather was pleasant at first, but fog soon rolled in and slowed the journey. Still, the *North America* managed to pass Key West without incident. Increasingly heavy seas and strong winds caused a leak in the forward section on the sixth day of the trip. Efforts by crewmembers to contain the damage failed, and they displayed distress signals. In the cabins below, the men braced for the worst. Eleanor later recalled "the unflinching courage of the soldiers in this awful cyclone of death."[724]

Meanwhile, an alert soldier who had been a sailor before he joined the army spotted the *Mary E. Libby*, a bark bound from Cuba to Maine with a cargo of molasses. The vessel was hailed that afternoon when the water pouring into the *North America* extinguished the fires that powered the engine.[725] The *Libby* collided with the *North America*, and here the first lives were lost as men drowned in a futile attempt to jump from one ship to another. When it became clear that the *North America* was beyond saving, all able-bodied men went to work to rescue as many individuals as possible.

Eleanor made her way into a lifeboat with other nurses: "The boat I went into came near being swamped. Two men manned the oars; a third gave the command, his voice so solemn and terror-stricken it was enough to pierce the hardest heart. The storm was so severe, and the waves rolling so fearfully, each word echoed over the sea and back into our hearts: 'Row, boys, row, row, row.' "[726] She looked back and glimpsed soldiers stranded on the deck of the floundering *North America*. The vast majority—194—drowned when it sank into a watery grave south and

east of Savannah, Georgia.[727] Only a handful of soldiers climbed aboard the lifeboats. Eleanor noted, "I can never efface from my memory that great number of men crying and praying on the deck and stairway." She added, "*They* were taken, and *I* was saved, which for months seemed to me a mystery."[728]

Eleanor was transported to New York with the other survivors, and officials then assigned her to a New England hospital. She recalled, "My health was so impaired by the shock and strain and the grief for my poor lost soldier boys that I was unable to do anything for some time."[729] She may have sat for this portrait during her convalescence. The man standing next to her, who may be a soldier or an attendant, presents a bugle for her inspection. The meaning of this scene has been lost in time.[730] Eleanor returned to good mental health and became well known known for Ransom Homes across the country, which aided women and children in need. She eventually settled in California and was a regular at veterans' functions, where she often told the story of the *North America* with such pathos that crowds of old men in blue were moved to tears. Eleanor died in 1909 from complications following a fall that injured her hip. She was ninety-four years old.[731]

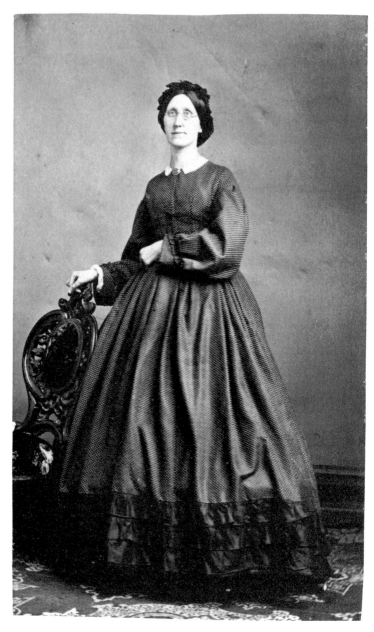

Rosanna Moore Billing. *Carte de visite* (unmounted) by an unidentified photographer, about 1861–1865.

Collection of the U.S. Army Heritage and Education Center

314

Typhus Martyr

Rosanna "Rose" Billing burned with fever as she lay in her bed at the Naval School Hospital at Annapolis, Maryland, one day in early January 1865. A veteran nurse, she had cared for countless soldier boys in this very same hospital. Now her life hung in the balance. Her journey there began three decades earlier in Washington, D.C. Her father, William, a paymaster's clerk in the War Department, served as colonel of the District of Columbia's militia and held several local government offices before his untimely passing in 1843, when Rose was about eleven years old. This left her mother, Rebecca, as sole parent to raise Rose and her four sisters.[732] When the war came, Rose expressed a strong desire to serve as a nurse. This perhaps came as no surprise to everyone who knew her, for she was a deeply sympathetic individual. They also knew Rose to be a frail and delicate woman. Fear for her daughter's health worried her mother, who reluctantly consented when Rose sought permission to serve.[733]

When the war was but a few months old, Rose joined the growing corps of nurses under the auspices of Dorothea Dix and the U.S. Sanitary Commission. In the autumn of 1861, she received her first assignment: at the Indiana Hospital, located in the Patent Office Building in Washington, D.C. She immediately proved her value. According to a biographer, Rose was "a young lady of most winning manners," described by a fellow nurse as "one of the most devoted and conscientious workers, she ever knew—an earnest Christian, caring always for the spiritual as well as the physical wants of her men."[734] Rose went on to serve as a nurse in Virginia, at Falls Church and Fredericksburg. In early 1863 she reported for duty in Annapolis. She inspired the staff with her faith and devotion, and she especially impressed surgeons by

bringing back fever patients considered to be hopeless cases. One source credited her with saving scores of soldiers.[735]

The long hours and emotional and physical strain took a toll on her health. Her biographer observed, "Though she herself felt that she was exceeding her strength, or as she expressed it, 'wearing out,' she could not and would not leave her soldier boys while they were so ill."[736] On two occasions Rose fell so dangerously sick that she had to take breaks from her duties to recover. Then, about New Year's Day 1865, Rose contracted typhus. She succumbed to its effects on January 14. She was thirty-two years old.

Word of her death spread throughout the nursing community, some of whom honored her as a martyr. Walt Whitman reported, "A lady named Miss or Mrs. Billings, who has long been a practical friend of soldiers, and a nurse in the army, and had become attached to it in a way that no one can realize but him or her who has had experience, was taken sick, early this winter, linger'd some time, and finally died in the hospital." He added, "It was her request that she should be buried among the soldiers, and after the military method. Her coffin was carried to the grave by soldiers, with the usual escort, buried, and a salute fired over the grave. This was at Annapolis a few days since."[737] Rose's remains were later removed to Washington's Congressional Cemetery and interred alongside her father and a brother who died in infancy.

The Kindest Charity

A STEADY INFLUX OF REFUGEES STRAGGLED INTO WASH-
ington, D.C., as Union forces converged on Richmond. They in-
cluded women with children in tow, and a few ladies attended by
servants. All looked for help wherever they could find it. Some of
these women found relief in a refuge located just a few blocks from
the Capitol—the Home for Wives and Mothers. The U.S. Sanitary
Commission had enlarged its services to include a shelter—the
Women's Department, to care for sick or exhausted nurses—as
part of the Soldiers' Home. The commission soon expanded it to
include accommodations for women of limited means who jour-
neyed to Washington with little more than the clothes on their
backs to visit hospitalized husbands and sons. This became known
as the Home for Wives and Mothers. A commission historian
declared that the home "has proved, in its working, one of the
kindest charities of the Commission."[738] In March 1865, during
the war's final weeks, twenty-six women, thirty-nine children,
and two servants inhabited the home. Most were headed to the
North in search of friends.[739]

The Home for Wives and Mothers was managed by a ma-
tron of uncommon executive ability, Charlotte Bradford. Single,
educated, and a vegetarian, fifty-one-year-old Charlotte hailed
from an esteemed Massachusetts family, rooted in colonial times,
whose members became patriots in the Revolution. The youngest
of four daughters born to a sea captain and his wife and raised in
the coastal town of Duxbury, she was influenced by antebellum
intellectuals and reformists. Transcendentalists Ralph Waldo
Emerson and Theodore Parker were acquaintances. Ardent anti-
slavery proponents visited her home, among them her brother-in-
law, Rev. Claudius Bradford, who befriended Frederick Douglass,

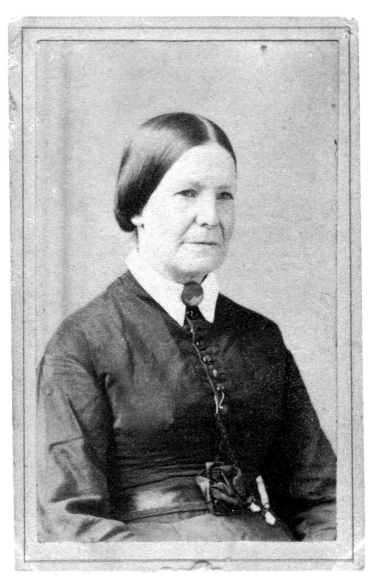

Charlotte Bradford. *Carte de visite* by Joseph Babb (1845–1888) of Boston, Massachusetts, about 1866.

Collection of the Duxbury Rural & Historical Society

William Lloyd Garrison, and other abolitionists. Charlotte, an outspoken advocate on the subject, had once called for an immediate end to the "Peculiar Institution."[740]

In early 1862, a few months after the death of her aged mother, Charlotte became directly involved in the war effort. She contacted another important connection in her family circle, Frederick N. Knapp, an influential leader in the U.S. Sanitary Commission.[741] Charlotte requested and received an assignment to the Transport Service, a fleet of vessels that carried casualties from the Peninsula Campaign in Virginia to hospitals in the Washington, D.C. region.[742] She joined other women and commission volunteers who provided care to the sick and wounded aboard the *Elm City* and *Knickerbocker* during the height of the campaign, which ended in failure after a series of engagements, known as the Seven Days Battles, in late June and early July 1862.

Charlotte continued her work in the Union capital. She served brief stints in several hospitals, including Armory Square, from which position she was dismissed after butting heads with the surgeon in charge. This conflict is notable, for Charlotte normally enjoyed good relations with the medical establishment. She even befriended Dorothea L. Dix, the highly capable though stubborn superintendent of army nurses, who made more enemies than friends. "I quite like her for all the people say about her," Charlotte wrote to her sister Elizabeth in September 1862.[743]

Charlotte next served at Seminary Hospital in Georgetown, where she discovered that her support from Dix alienated some nurses. "Have I written you how much I am in favor with Miss Dix? The worst of it is that the other nurses are jealous of her favor to me and say that I do not deserve it more than they, which is in fact the case," Charlotte wrote to Elizabeth in November 1862, adding, "I found very little to do when I came here and I found she had told them that I was beat out and they must pet me and let me rest." As a result, the surgeon in charge reduced the number of patients in her care to one. Charlotte bristled: "It was most absurd and I am afraid a reputation so undeserved will fall

as suddenly."[744] Hers did not. In May 1863, Charlotte received an appointment as matron of the Soldiers' Home. By this time, Dix had rubbed too many people the wrong way and had fallen out of favor. The proud chief confided her troubles to a sympathetic Charlotte.[745]

By all accounts, Charlotte excelled as matron. One admirer observed, "There was a quiet dignity about her which controlled the wayward and won the respect of all. Her executive ability and administrative skill were such, that throughout the realm where she presided, everything moved with the precision and quietness of the most perfect machinery. There was no hurry, no bustle, no display, but everything was done in time and well done." The writer added, "To thousands of the soldiers just recovering from sickness or wounds, feeble and sometimes almost disheartened, she spoke words of cheer, and by her tender and kind sympathy, encouraged and strengthened them for the battle of life."[746] Charlotte returned to her home and family after the end of the hostilities. She led a remarkably quiet life, shunning any recognition of her many contributions to the health and welfare of soldiers and their families. She died in 1893 at age seventy-nine.

A Literary Light Attends the Grand Review

For two days in May 1865, adoring citizens cheered the armies of Grant and Sherman as they marched in a glorious Grand Review through the streets of the Union capital. This was theater—pure Shakespeare—and its effects were magical. One woman in the throngs of spectators could appreciate the high drama perhaps more than most. Cynthia Bright Case, a keen student of literature who was celebrated in her circle of friends for her recitations of the bard's masterpieces, had come to the city to bear witness to the lowering of the curtain on the bloody stage of the Civil War. Cynthia knew firsthand the horrors of the war. During the better part of the previous year she had volunteered as a nurse on the hospital transport *Connecticut*.

Back in 1861, when the war began, she lived a comfortable life in Newark, Ohio, with her husband, Lucius, a prominent attorney in town. Cynthia enjoyed a sterling reputation among her peers: "A big brain, big hearted, talented woman, she was greatly loved and admired by all who knew her," noted a biographer.[747] The same writer also described her as intensely patriotic. Though her activities during the early part of the war went undocumented, she probably worked alongside other townswomen who gathered supplies and raised funds to provide relief to Ohio soldiers.

Fate intervened when Cynthia's husband died in the summer of 1864. In her early forties and childless, she decided to become a nurse. Just a few months later she received an assignment on the *Connecticut*. The vessel was a mainstay of the hospital fleet, transporting sick and wounded men from the battlefields in Virginia to Alexandria, Washington, D.C., and Baltimore for treatment. How she came to be selected for the position most likely is connected to the surgeon-in-chief of the vessel. Thomas B. Hood,

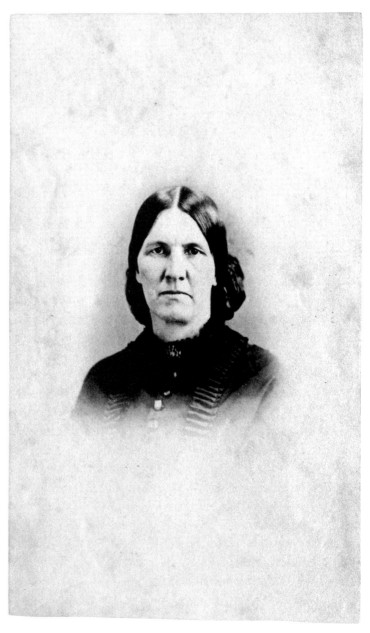

Cynthia Bright Case. *Carte de visite* (unmounted) by an unidentified photographer, about 1861–1865.

Collection of the U.S. Army Heritage and Education Center

an Ohio native, practiced medicine near Cynthia's hometown of Newark before the war.[748] Cynthia joined Surgeon Hood and the rest of the staff of the *Connecticut* on November 8, 1864, which happened to be the fifty-first birthday of her late husband. It was also election day.

Over the next seven months, she attended to thousands of patients from the front lines of Petersburg and Richmond. According to the chief surgeon of the *Connecticut*, "Her service was in the highest degree useful and capable."[749] Cynthia and her comrades often had a little time to spare after the *Connecticut* dropped off a load of patients and before it was restocked and shipped out again to Virginia. Such was the situation on May 22, 1865, when she and two other women left the vessel at Baltimore for the short trip by land to attend the Grand Review. The event took place the following two days.[750] Two months later, Cynthia received an honorable discharge. She settled in Washington, where, according her biographer, "she was the center of the literary spirits of the Capital."[751] Cynthia lived until about age ninety, dying in 1910. Her remains were interred in Arlington National Cemetery, in honor of her contributions as a war nurse.

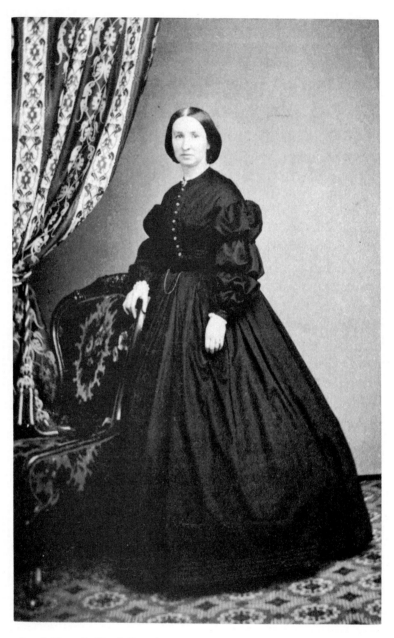

Annie Francis Kendall Freitag. *Carte de visite* (unmounted) by an
unidentified photographer, about 1861–1865.

Collection of the U.S. Army Heritage and Education Center

Annie and Fred

ON A JUNE DAY IN 1865, ANNIE KENDALL AND FREDERICK "Fred" Freitag stood before a pastor in Boston and took their vows of husband and wife.[752] This marriage, the first for both, came as the result of a relationship forged in the crucible of war. Annie Francis Kendall was a quintessential army nurse. In her early thirties when the hostilities began, she enjoyed a reputation as an intelligent and refined woman, concerned about the welfare of others. Following the lead of patriotic women in her hometown of Boston, she applied to become a nurse and promptly received a commission. In September 1862 she traveled to Pennsylvania and reported for her first assignment—at the military hospital in Chester, located on the outskirts of Philadelphia.[753]

Frederick Daniel Freitag had followed his parents in pursuit of a better life when they immigrated to America from their native Germany. Their journey brought them to Pennsylvania, where they settled on a farm in Lancaster. Weeks after rebel forces bombarded Fort Sumter in South Carolina, Fred, in his midtwenties, enlisted in the Keystone State's Thirtieth Infantry. He and his comrades faced their first combat about a year later in Virginia, during the Seven Days Battles, the culminating series of engagements of the Peninsula Campaign. Fred was wounded within that week. On June 29, 1862, during the fighting at White Oak Swamp, a bullet tore into his thigh and lodged deep in his body. Carried to Haxall's Landing, in preparation for a trip by steamer to Washington, D.C., he and other critically wounded soldiers fell into enemy hands on July 1. Initially imprisoned in Richmond, the serious nature of his wounds prompted Confederate officials to release him before the end of the month. He arrived in Washington, D.C., where surgeons tried and failed to remove the bullet.

Medical authorities then sent him to the hospital in Chester, to recover as best he could.[754]

Fred arrived in Chester in September 1862, the same month Annie began her service. Details of how they met and their initial attraction are not known. Fred may have been a patient in Annie's ward, or perhaps the two bumped into each other in another part of the hospital as Fred became more mobile. Two months later, Annie left Chester with new orders that took her to Baltimore's Camden Street Hospital. She worked there and elsewhere in the area, including the Naval School Hospital in Annapolis and at Harper's Ferry in West Virginia, through June 1864, when she tendered her resignation.[755]

Meanwhile, Fred completed his recovery at Chester and left the hospital in August 1863. He returned to his regiment and went on to fight in the Overland Campaign the following spring. In the rough-and-tumble landscape of the Battle of The Wilderness, he suffered his second combat wound on May 5, when a rebel bullet hit his left hand. A few weeks later, on June 1, as the army struggled on toward Petersburg and Richmond, a shell fragment hit him in the right foot—his third war wound. Fortunately for Fred, these two injuries were comparatively minor. The end of the regiment's three-year enlistment in mid-June took him and his comrades off the front lines and safely home to Pennsylvania. Despite his wounds, Fred returned to the army in March 1865 with a lieutenant's commission and an assignment to the Twenty-Fourth U.S. Colored Infantry. But the war was practically over, and the regiment spent its six-month enlistment period on guard duty, away from the front lines.

Fred and Annie probably corresponded while they were apart, though surviving letters are undiscovered as of yet. On June 7, 1865, Fred took a break from his military routine and married Annie. When the Twenty-Fourth was disbanded a few months later, the newlyweds set up home in the Boston suburb of Cambridge and started a family. Their son Joseph was born in 1869.[756] He grew up, earned a college degree, and became prominent in his chosen profession of civil engineering.

Annie marveled at Fred's physique and how he managed to lead an active, healthy lifestyle with a bullet in his hip and additional damage caused by his other two wounds. Everything changed in 1886, after Fred suffered a breakdown. A physician diagnosed him with consumption and declared him to be suffering from what Annie noted was a "distressing nervous condition"—perhaps post-traumatic stress disorder. She attributed his health issues to his war wounds and added, "he passed away [after] two years of extreme suffering, and utter dependence and disability."[757] Fred was forty-eight years old.[758] Annie lived until 1905, dying of kidney issues at age seventy-four. She was buried in Mount Auburn Cemetery in Cambridge, Massachusetts. This cemetery is the final resting place of other Civil War caregivers, including Dorothea L. Dix.

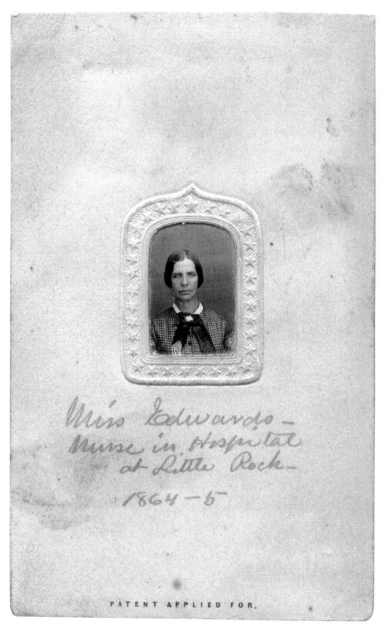

Miss Edwards—
Nurse in Hospital
at Little Rock—
1864—5

PATENT APPLIED FOR.

Sarah Jerusha Edwards. Tintype by an unidentified photographer, about 1862–1864.

Foard Collection of Civil War Nursing

In the Service of War Orphans

AFTER THE END OF HOSTILITIES IN MAY 1865, THE republic—preserved, reunited, and free of slavery—began the arduous journey toward reconciliation and reconstruction. It did so without the flower of a generation of citizen soldiers who perished on battlefields, in camps, and in hospitals. The honored dead left behind a significant number of orphaned boys and girls in desperate need of care. Among those who stepped forward to help them was Sarah Edwards, a pious woman whose own path in life had followed the westward expansion of young America. Born in rural Massachusetts soon after the War of 1812, Sarah grew up in the Congregationalist church. At an early age she devoted herself to missionary work, serving indigenous populations. She started in western New York State, where she had moved with her family, and later ventured to the Minnesota frontier. Sarah's unceasing and tireless activities contributed to one writer's observation that her "life was a busy one and seems to have been spent largely in the interest of the betterment of those about her."[759]

Sarah might have continued her work on the frontier, but the Civil War prompted her to offer her services as a delegate to the U.S. Christian Commission. In July 1864 she received her first assignment, a seven-month stint as a nurse at Totten Hospital in Louisville, Kentucky. Her service in Louisville ended in February 1865, when authorities transferred her and another nurse to the general hospital in Little Rock, Arkansas. Here, Sarah supervised all the wards and directed food preparations for as many as 1,300 patients at the height of its occupancy.[760] The indefatigable Sarah managed the assignment with characteristic competence. "She rendered the most valued services. She performed her duties to the sick soldiers in the most kindly, tender & efficient manner, and

to the perfect satisfaction of all concerned," noted the hospital's chief surgeon, Robert M. Lackey.[761]

In February 1866, Sarah received a discharge from the hospital and the Christian Commission, but her work was far from over. Her travels took her to Davenport, Iowa, where several hundred children were sheltered in the Soldiers' Orphans' Home. Though exact details of when and how she came to be involved are scant, evidence suggests that she initially went to Iowa to be with family and joined the staff of the orphans' home about 1869. Sarah worked with the war orphans until they moved out and started lives of their own. When the home expanded its mission to care for all orphans, she remained there. According to one source, she was the matron of the boys' cottage.[762] In the late 1880s, when she was in her early sixties, Sarah retired after about two decades at the home. She relocated to Waterloo, Iowa, and lived with a nephew and his family. Though slowed by age, she remained active in the local Congregationalist church until 1896, when she fell ill with influenza and succumbed to the disease just a few days before her seventy-ninth birthday.[763]

Notes

Preface

1. Personal interview with Ross Kelbaugh, October 6, 2018.
2. Nightingale, *Notes on Nursing*, 23.
3. *Hartford (Conn.) Courant*, May 7, 1860.
4. Nightingale, *Notes on Nursing*, iv.
5. Bacon and Howland, *Letters of a Family*, vol. 1, 142–146.
6. Bacon and Howland, *Letters of a Family*, vol. 1, 142–146.
7. Long, *Rehabilitating Bodies*, 180–209.
8. Epler, *Life of Clara Barton*, viii.
9. Holmes, "Doings of the Sunbeam."
10. *London Review*, August 9, 1862.
11. Raus, *Ministering Angel*, 12.
12. Swisshelm, *Half a Century*, 239–240.
13. Swisshelm, *Half a Century*, 239–240.

The Profiles

14. Brockett and Vaughan, *Woman's Work in the Civil War*, 280–281.
15. Brockett and Vaughan, *Woman's Work in the Civil War*, 283.
16. Almira's father, Ariel Newcomb (1779–1821), served as a captain in the War of 1812. Her mother was Sarah Norris (1782–1873). Almira married merchant Alexander McNaughton in 1828, and he died in 1832. She wed Leander Lockwood in 1837. They moved to Burlington, Iowa, and entered into the hotel business. Leander died in 1845. Following his death, she embarked on mission work in service of the Winnebago Indians at Fort Atkinson, Iowa. Two children by her first husband died young. Two more children were born to Almira and her second husband: Charles Henry Lockwood Fales (1839–1897) and Thomas Hart Benton (1842–1863). Newcomb, *Genealogical Memoir*, 295–296.
17. Almira was the second wife of Pennsylvania-born Joseph Thomas Fales (1805–1877). After Almira's death in 1868, he married her older sister, Emily Newcomb Miller Sackett (1807–1894). This was Emily's third marriage.
18. Brockett and Vaughan, *Woman's Work in the Civil War*, 113.
19. Pryor, *Clara Barton*, 71–73.
20. Newcomb, *Genealogical Memoir*, 295–296.

21. Brockett and Vaughan, *Woman's Work in the Civil War*, 281–282.

22. Born about 1843 in Iowa to Almira and her second husband Leander, Thomas Hart Benton Lockwood adopted the surname of his stepfather, Joseph Fales. Thomas began his war service on April 11, 1861, a day before the bombardment of Fort Sumter, when he joined the Fifth Battalion of the District of Columbia Militia Infantry for a three-month enlistment. Four days after the expiration of his three-month term, on July 15, he joined the Second Rhode Island Infantry when that regiment was stationed at Camp Brightwood in Washington, D.C. The Second fought at the First Battle of Manassas less than a week after Thomas enlisted in the regiment. He died on May 3, 1863, during the Battle of Salem Church, part of the Chancellorsville Campaign. Newcomb, *Genealogical Memoir*, 295–296.

23. Brockett and Vaughan, *Woman's Work in the Civil War*, 282.

24. Brockett and Vaughan, *Woman's Work in the Civil War*, 283.

25. Lincoln made brief remarks in reply to a speech by Pennsylvania governor Andrew Curtin on the portico of Jones House, a four-story hotel in Harrisburg.

26. In some versions of this story, Sallie is reported to have been motivated to enlist as a result of an appeal for nurses made by Lincoln during the course of his remarks. The author found no evidence that Lincoln spoke directly to the need for nurses as part of his visit to Harrisburg, and it seems unlikely that he would have done so in the context of the times, being some weeks before the attack on Fort Sumter that prompted a call to arms on both sides of the divided country. The individual who preserved the quote made by Sallie, William Robert Fuoss (1894–1980), was one of Sallie's Sunday school pupils. The quote appeared in the August 15, 1957, issue of the *Tyrone (Pa.) Daily Herald*.

27. *Tyrone (Pa.) Daily Herald*, February 4, 1909.

28. Sallie's parents, William Patterson Dysart (1804–1870) and Elizabeth Bell Dysart (1812–1875), lived a quiet life in Tipton, Pennsylvania. William's father, Arthur Patterson, served as an assemblyman in colonial times, and was related to Revolutionary War officer William Patterson. Sallie's maternal grandfather, Edward Bell, was an ironmaster and inventor who amassed large real estate holdings. *Tyrone (Pa.) Daily Herald*, December 20, 1932.

29. Lititz Seminary, which traces its roots to 1746 and the Moravian church, became Linden Hall in 1883. The school continues in operation in Lititz, Pennsylvania. Lewisburg Female Academy at Bucknell University opened in 1851 and later granted its students collegiate status, beginning in 1883.

30. The Twelfth Corps ceased to exist in the spring of 1864, when the War Department consolidated it with the Eleventh Corps, which had suffered a similar fate. The reorganized corps, the Twentieth, retained the star badge and served throughout the rest of the war.

31. Anna "Annie" Bell Stubbs (1839–1916) is profiled elsewhere in this

volume. Sarah "Sallie" Emily Chamberlin Eccleston (1840–1916) is perhaps best known for her work as a schoolteacher in Argentina after the war.

32. *Tyrone (Pa.) Daily Herald*, December 20, 1932.

33. According to William Robert Fuoss, "Miss Dysart, a very modest woman, rarely spoke of her Civil War experiences but, until her death she prize[d] letters from President Lincoln.... [One] bore, in clear, bold hands, the signature of the martyred Lincoln." *Tyrone (Pa.) Daily Herald*, August 15, 1957.

34. *Tyrone (Pa.) Daily Herald*, August 15, 1957.

35. Fowle married his first wife, Adeline Frances Gifford, in 1851. She died of consumption on February 26, 1860. Soon after the start of the war, he became an aide to Robert B. Forbes, a merchant marine who organized what he described as "a corps of sea-going men for drill and discipline." Though more than 150 recruits offered to enlist, and Forbes raised significant funds, he failed to convince Washington of its necessity and the organization disbanded. *Biographical Sketches of Representative Citizens*, 23–25; Forbes, *Personal Reminiscences*, 258–262.

36. *Biographical Sketches of Representative Citizens*, 23–25.

37. *Biographical Sketches of Representative Citizens*, 23–25. The meetings at Columbian College Hospital were reportedly first held in an upper room of a ward managed by nurse Rebecca Rossignol "Auntie" Pomroy. She is profiled elsewhere in this volume.

38. Holland, *Our Army Nurses*, 66–78.

39. Holland, *Our Army Nurses*, 66–78.

40. Holland, *Our Army Nurses*, 66–78.

41. *Boston Post*, February 7, 1904.

42. Holland, *Our Army Nurses*, 66–78.

43. New Hampshire native Alonzo Hall Quint (1828–1896) served as pastor of the Mather Congregational Church in Jamaica Plain, Massachusetts, prior to becoming the chaplain of the Second Massachusetts Infantry in 1861. His history of the regiment was published in 1867.

44. *Washington Star*, March 2, 1863; Hatch, "Sweet Singer of the War."

45. *Philadelphia Inquirer*, March 2, 1913.

46. National University merged with George Washington University in 1954.

47. *Evening Star* (Washington, D.C.), June 22, 1867 and October 17, 1873.

48. Lovett, "Soldiers' Free Library."

49. James, James, and Boyer, *Notable American Women*, vol. 1, 652–654.

50. Sister Tyler's movements on April 19, 1861, are drawn primarily from her biographical sketch in Brockett and Vaughan's *Woman's Work in the Civil War* and Brunk's profile in her unpublished dissertation, "Forgotten by Time." Brunk's analysis included an examination of Tyler's papers at the Maryland Historical Society in Baltimore. Brunk described Sister Tyler as "the Union's first nurse."

51. John Tyler (1779–1853) and Adeline Blanchard married in 1826. James, James, and Boyer, *Notable American Women*, vol. 3, 491–493.

52. James, James, and Boyer, *Notable American Women*, vol. 3, 491–493.

53. Brockett and Vaughan, *Woman's Work in the Civil War*, 241–250.

54. Brockett and Vaughan, *Woman's Work in the Civil War*, 241–250.

55. The private with the hip wound was Edmund Coburn of Company D. There is no evidence that he rejoined the Sixth before his three-month term of enlistment expired in August 1861. He did return to the army in the summer of 1862 with the Thirty-Third Massachusetts Infantry and transferred to the Veteran Reserve Corps in mid-1864. He was discharged in January 1865 and lived until 1913. The sergeant with the severe neck wound was John E. Ames, who served with Coburn in Company D. Though many official reports listed him as having been killed on April 19, he survived his wound and was sent home to Lowell, Massachusetts. He never completely recovered, however, and died on June 25, 1863.

56. Brunk, "Forgotten by Time," unpublished dissertation, 120–121.

57. *Sun* (Baltimore), April 18, 1862.

58. Sister Tyler made the statement in reply to an inquiry from a doctor about whether supplies to the hospital would be prioritized for Union patients, followed by Confederates. She refused to make any distinction for treatment or care. Her declaration of impartiality might have been respected and supported in normal circumstances. But in Baltimore and nearby Washington, paranoid officials removed men and women from positions of authority on the vaguest suspicions of disloyalty. Sister Tyler was one of the victims. Brunk, "Forgotten by Time," unpublished dissertation, 122–124.

59. Clark, "Hospital Memories."

60. Rev. Dr. Jacob Isadore Mombert (1829–1913) served as rector of Saint James from 1859 to 1869. Born in Germany and ordained in London, he had served a two-year stint in Québec, Canada, before his assignment to Lancaster. Following his time at Saint James, he continued his service in Germany and New Jersey. He authored numerous religious writings during his lifetime.

61. *Kane (Pa.) Leader*, March 29, 1888.

62. *Papers Read*, 413.

63. *Papers Read*, 413.

64. *Kane (Pa.) Leader*, March 29, 1888.

65. Sypher, *History of the Pennsylvania Reserve*, 322–323.

66. Rosina W. Hubley to Gov. Andrew Curtin, July 4, 1863, Hubley Letters; Patriot Daughters of Lancaster, *Hospital Scenes*, 32.

67. Rosina E. Hubley to President Abraham Lincoln, January 14, 1864, Abraham Lincoln Papers.

68. Mombert, *Authentic History*, 345.

69. *Philadelphia Inquirer*, July 6, 1874.

70. Lawrence, *Sketch of Life and Labors*, 66–68.

71. Lawrence, *Sketch of Life and Labors*, 66–68.

72. Catherine S. Lawrence pension file, Case Files, U.S. National Archives and Records Administration, hereafter NARA.

73. Lawrence, *Sketch of Life and Labors*, 124–126.

74. Johnson, "Sad Story of Redemption."

75. The author found no evidence of a genealogical connection between Kitt and Capt. Lawrence.

76. Lawrence, *Sketch of Life and Labors*, 146–147.

77. Lawrence, *Sketch of Life and Labors*, 124–126.

78. *New York Times*, May 11, 1863.

79. *New York Times*, May 11, 1863.

80. Many wounded veterans sold their portraits to earn money, as did philanthropic organizations, notably the U.S. Sanitary Commission and the Christian Commission. Leisenring, "Philanthropic Photographs."

81. Leisenring, "Philanthropic Photographs."

82. See Johnson, "Sad Story of Redemption," for facts, clues, and theories about the postwar lives of Fanny, Viana, and Sallie.

83. Lawrence, *Sketch of Life and Labors*, 171.

84. Lawrence, *Sketch of Life and Labors*, 59.

85. Lord and Brown, *Debates and Proceedings*, 383–384.

86. 1860 U.S. Census, NARA.

87. Lord and Brown, *Debates and Proceedings*, 383–384.

88. Charles Oltz (1843–1892) served a three-year enlistment in the Seventh Michigan Infantry. He suffered a wound on May 31, 1862, during the Peninsula Campaign at the Battle of Seven Pines, and another wound at the Battle of Gettysburg on July 3, 1863. He mustered out of the army in June 1864 and returned to Michigan. Charles Oltz military service record, Compiled Records, NARA.

89. Lanman, *Red Book of Michigan*, 198–200.

90. Lord and Brown, *Debates and Proceedings*, 383–384.

91. Lord and Brown, *Debates and Proceedings*, 383–384.

92. Lord and Brown, *Debates and Proceedings*, 383–384.

93. *Hillsdale (Mich.) Standard*, March 5, 1867.

94. Potter, "'I Thought It My Duty,'" 157.

95. Thomas Edwin Keen served in Company H of the First Nebraska Infantry. The regiment was converted to cavalry in October 1863. He returned to Pennsylvania after the war and worked as a carpenter in Pittsburgh. He never married.

96. Potter, "'I Thought It My Duty,'" 146.

97. Potter, "'I Thought It My Duty,'" 146.

98. Potter, "'I Thought It My Duty,'" 157.

99. Mary A. E. Woodworth pension file, Case Files, NARA.

100. Mary A. E. Woodworth pension file, Case Files, NARA.

101. Moore, *Women of the War*, 513–518.

102. The work of two bloggers, Ray Mullins in "Finding Annie" and Steve Soper in "3rd Michigan Infantry," helped the author gain valuable insights into Anna's genealogy. The pension file of Charles E. Hooks filled in and confirmed details provided by them. Charles E. Hooks, Case Files, NARA.

103. Brockett and Vaughan, *Woman's Work in the Civil War*, 747–753.

104. Brockett and Vaughan, *Woman's Work in the Civil War*, 747–753.

105. Etheridge enlisted on February 4, 1863, as a private in Company I of the Seventh Michigan Cavalry. He deserted on September 25, 1863, at Hartwood Church, Virginia. James Etheridge, military service record, Compiled Records, NARA.

106. *Ottawa (Ill.) Free Trader*, February 28, 1863.

107. *Ottawa (Ill.) Free Trader*, February 28, 1863.

108. Brockett and Vaughan, *Woman's Work in the Civil War*, 747–753.

109. An abolitionist's son born in Alabama, David Bell Birney practiced law in Philadelphia at the start of the Civil War. He began his military service as lieutenant colonel of the Twenty-Third Pennsylvania Infantry and soon rose to brigadier general and command of a brigade in Kearny's First Division of the Third Corps. Upon the death of Kearny, Birney advanced to command of the division. He died of disease in October 1864.

110. Marie Tepe is profiled elsewhere in this volume.

111. General Orders No. 48, First Division, Third Corps, Army of the Potomac, May 16, 1863, *War of the Rebellion*, series 1, vol. 51, pt. 1: 1275–1281.

112. Mulholland, *Story of the 116th Regiment*, 134–135.

113. The soldier, Pvt. Samuel Carter Holden (1841–1901), served in Company B of the Seventeenth Maine Infantry. *National Tribune* (Washington, D.C.), October 7, 1897.

114. Brockett and Vaughan, *Woman's Work in the Civil War*, 747–753.

115. *Reports of Committees...House...Second Session*, report no. 3763.

116. Charles E. Hooks pension file, Case Files, NARA.

117. Fanny Ricketts, manuscript diary, July 25–December 17, 1861, 4–6.

118. *Buffalo (N.Y.) Commercial Advertiser*, June 14, 1862.

119. John Tharp Lawrence (1788–1847) and Sarah Eliza Julia Ann Kennedy "Julia" Ricketts (1801–1886) married in 1818. Julia was distantly related to Fanny's husband. *Portrait and Biographical Record*, 622–623.

120. In 1840, James had married Harriet Josephine Pierce, the niece of future President Franklin Pierce. James and Harriet had one child, daughter Mary Brewerton Ricketts Graham (1842–1922).

121. Moore, *Women of the War*, 17–35.

122. Kentucky-born Robert Anderson (1805–1871) was hailed as a hero by the North after his deft maneuvering leading up to the bombardment of Fort Sumter and the subsequent honorable defense of the doomed garrison. He received his brigadier general's star afterward and went on to command troops in Kentucky prior to his retirement in 1863. Anderson famously re-

turned to Charleston Harbor and the ruins of Fort Sumter in 1865 to raise the same Stars and Stripes he had lowered in April 1861.

123. Edward Dickinson Baker (1811–1861) distinguished himself as a fiery orator and politician who served as a U.S. senator from Oregon when the war began. Eager to serve in the army, he became colonel and commander of the Seventy-First Pennsylvania Infantry and, in this capacity, served as a volunteer aide to Maj. Gen. Irvin McDowell at Bull Run. Three months later, during the October 21, 1861, Battle of Ball's Bluff, Baker instantly died after bullets struck him in the head and heart. His loss prompted government officials in Washington to form the Congressional Joint Committee on the Conduct of the War.

124. Moore, *Women of the War*, 17–35.

125. New York–born Edmund Kirby (1840–1863) graduated from West Point in May 1861 and had his baptism under fire at Bull Run. He went on to fight in the Peninsula and Maryland Campaigns of 1862 and suffered a mortal wound in May 1863 at the Battle of Chancellorsville. President Abraham Lincoln had sent him a commission as brigadier general for his gallantry, and the appointment took effect on May 23, 1863—the day Kirby died.

126. Despite his lack of military experience, wealthy philanthropist and politician James Samuel Wadsworth (1807–1864) served ably as a general who rose to command on the division level before he received a mortal wound during the Battle of the Wilderness.

127. *Buffalo (N.Y.) Commercial Advertiser*, June 14, 1862.

128. *Buffalo (N.Y.) Commercial Advertiser*, June 14, 1862.

129. *Richmond (Va.) Examiner*, December 18, 1861.

130. Julia Alexandra Lawrence Ricketts died on November 13, 1864. She was about seven years old.

131. Frémont, *Story of the Guard*, 223–224.

132. Cited in James, James, and Boyer, *Notable American Women*, vol. 3, 668–671.

133. *Daily Milwaukee News*, December 2, 1861; Richardson, *Secret Service*, 195.

134. John served as a U.S. senator representing California from 1850 to 1851. He was a Free-Soil Democrat.

135. *New York Times*, June 19, 1856.

136. *Hartford (Conn.) Courant*, June 27, 1856.

137. Thomas Hart Benton did not support John's bid for the presidency, much to Jessie's dismay, instead choosing to support fellow Democrat James Buchanan, who became the nation's fifteenth president. The senator did not live to see the end of Buchanan's single term. Benton died in 1858, his reputation among Democrats and many Missourians tarnished, due to his antislavery views, which had first publicly surfaced after the Mexican War. His support of the Compromise of 1850 contributed to the loss of

his Senate seat the following year. Benton soon returned to politics as a member of Congress but suffered defeat after he opposed the 1856 Kansas-Nebraska Act.

138. Samuel Grandin Johnston De Camp (1788–1871) of New Jersey graduated from the College of Physicians and Surgeons in New York City in 1808. His military career, which spanned four decades, began in 1823 and included service at various frontier posts. He retired as a major and surgeon in August 1862.

139. Massachusetts-born Rev. William Greenleaf Eliot (1811–1887) is best known for his role in founding Washington University in St. Louis, originally known as Eliot Seminary, in 1853. He graduated from Columbian College (today George Washington University) in 1831. He went on to earn a degree from Harvard Divinity School in 1834 and was ordained a Unitarian minister the same year. An abolitionist and staunch Unionist, he was actively involved in assisting men and women of color and supporting other social reforms. His participation in the organization of the Western Sanitary Commission was but one of his many civic contributions.

140. Eliot, *Story of Archer Alexander*, 121.

141. Wendte, *Thomas Starr King*, 190–191.

142. Frémont, *Story of the Guard*, 223–224.

143. Cited in James, James, and Boyer, *Notable American Women*, vol. 3, 668–671.

144. "Jessie Benton Frémont," 83–85.

145. *Wichita (Kans.) Daily Eagle*, December 31, 1902.

146. Holland, *Our Army Nurses*, 163–164.

147. 1860 U.S. Census, NARA.

148. Holland, *Our Army Nurses*, 163–164.

149. Brockett and Vaughan, *Woman's Work in the Civil War*, 396.

150. New York–born Richard Wilson Colfax (1830–1856) established the *Michigan City (Ind.) Transcript* in 1854, a Whig-leaning newspaper. He sold the publication a year later, and it was renamed the *Enterprise*. The author was unable to link him through genealogical records to Schuyler Colfax. A single reference appears in a story about Richard's sister, Harriet A. Colfax, printed in the October 10, 1890, issue of the *Everest (Kans.) Enterprise*. In it, Harriet is said to be a cousin to Schuyler Colfax.

151. Brockett and Vaughan's *Woman's Work in the Civil War* stated that Hattie had young children, but the author was unable to find any evidence in genealogical records or other documents that she had any offspring during her relatively brief marriage.

152. *Report to the Western Sanitary Commission*, 17–20.

153. Vermont-born Robert Hamilton Paddock (1814–1900) was a major in the Missouri militia and a contract surgeon for the U.S. Army. He graduated from Yale in 1837 and earned medical degrees from Castleton Medical College in Vermont (1843) and Berkshire Medical College in Massachusetts (1844).

154. Harriet R. Colfax pension file, Case Files, NARA.

155. The surgeon, John Field Randolph (1825–1880), was a career army doctor. Virginia born and Union loyal, he served throughout the war and at various posts afterward until his death. Harriet R. Colfax pension file, Case Files, NARA.

156. Brockett and Vaughan, *Woman's Work in the Civil War*, 397.

157. Curtiss-Wedge, *History of Fillmore County*, 1003–1005.

158 The identity of the man of color is unknown. *News and Citizen* (Morrisville and Hyde Park, Vt.), December 24, 1891.

159. Journalist and social reformer Mary Ashton Rice Livermore (1820–1905) befriended Safford in 1861. At the time, Livermore was deeply involved as an organizer with the U.S. Sanitary Commission in Chicago.

160. Livermore, "After the Battle"; Livermore, *My Story of the War*, 206.

161. Livermore, "After the Battle"; Livermore, *My Story of the War*, 206.

162. The Safford brothers were Alfred Boardman Safford (1822–1877) and Anson Pacely Killen "A. P. K." Safford (1830–1891). Their parents were Joseph Warren Safford (1775–1848) and Dyantha P. Little Safford (1790–1849).

163. Mary Ann Bickerdyke is profiled elsewhere in this volume.

164. Livermore, *My Story of the War*, 208–209.

165. Livermore, *My Story of the War*, 208–209.

166. Greenbie, *Lincoln's Daughters of Mercy*, 116–118.

167. Brockett and Vaughan, *Woman's Work in the Civil War*, 357–361. Livermore did not include this anecdote in *My Story of the War*.

168. Davidson, *A Century of Homeopaths*, 14–15.

169. Davidson, *A Century of Homeopaths*, 14–15.

170. Gorham Blake (1829–1897) of Massachusetts married Mary in Chicago. After their divorce, he moved to California and died in Oakland.

171. *News and Citizen* (Morrisville and Hyde Park, Vt.), December 24, 1891. In the original quote, "cheery" is spelled "cherry." The author made this correction for clarity.

172. *Moore's Rural New-Yorker* (Rochester, N.Y.), May 10, 1862.

173. Woman's Medical College / Medical College of Pennsylvania records, Drexel University.

174. *Philadelphia Inquirer*, November 16, 1861.

175. William Henry Williams of Charlestown, Chester County, Pennsylvania, was seventeen years old at the time of the accident.

176. *Philadelphia Inquirer*, November 12, 16, 1861; *New York Times*, November 19, 1861.

177. *Reading (Pa.) Times*, November 20, 1861.

178. Brockett and Vaughan, *Woman's Work in the Civil War*, 459.

179. Eddy, *History of the Sixtieth Regiment*, 65–66.

180. Brockett and Vaughan, *Woman's Work in the Civil War*, 459.

181. Adeline Blanchard Tyler is profiled elsewhere in this volume.

182. Brockett and Vaughan, *Woman's Work in the Civil War*, 459.

183. Jones B. Bonney, a carpenter born in Maine, joined Company D of the Seventh Iowa Infantry in the summer of 1861.

184. *Biographical Review*, 414–416; Pierce, *Field Genealogy*, 1029.

185. Ohio-born physician Robert M. Lackey (1835–1895) graduated from Rush Medical College in Chicago in 1861. He began his war service in May 1861 as a private in the Twelfth Illinois Infantry for a three-month enlistment. The following year, he became surgeon of the Ninety-Eighth Illinois Infantry but left after a short time to serve as chief surgeon in several hospitals, including in Little Rock, Arkansas, his last assignment during the war.

186. The other nurse, Sarah J. Edwards, is profiled elsewhere in this volume. Mary E. Bonney Hancock pension file, Case Files, NARA.

187. *United States Christian Commission*, 44.

188. *Biographical Review*, 414–416.

189. Turner, "Harriet Reifsnyder Sharpless."

190. Joseph Sharpless (1808–1900) was the proprietor of Sharpless Foundry, a manufacturer of stoves and other iron items. In 1836 he married Mary Ellen Foster Sharpless (1817–1901). *Biographical Sketches of Leading Citizens*, 556–558.

191. Benjamin Franklin Sharpless (1841–1922) enlisted as a corporal in Company A of the Sixth Pennsylvania Reserves (Thirty-Fifth Pennsylvania Infantry) in April 1861. He mustered out of the regiment in June 1864.

192. Charles Steward Fornwald (1842–1926), served as a private in Company A of the Sixth Pennsylvania Reserves (Thirty-Fifth Pennsylvania Infantry) and, after the war, as historian of the Grand Army of the Republic's Post 250 in Bloomsburg. Brief histories of some of its members, including Hattie, was included in a "Memory Book" transcribed by George A. Turner of the Columbia County Historical and Genealogical Society. The transcription appears on the society's website.

193. The veteran was not named. *Altoona (Pa.) Tribune*, December 10, 1906.

194. Brockett and Vaughan, *Woman's Work in the Civil War*, 741–742.

195. *Altoona (Pa.) Tribune*, December 10, 1906.

196. *Altoona (Pa.) Tribune*, December 10, 1906.

197. *Altoona (Pa.) Tribune*, December 10, 1906.

198. *New Orleans Crescent*, January 20, 1862.

199. *Tennessean* (Nashville), June 28, 1889.

200. Felix Grundy (1777–1840) and Ann Phillips Rodgers Grundy (1779–1847) had ten children. Felicia, born in 1820, was the youngest of their seven daughters.

201. *Clarksville (Tenn.) Chronicle*, July 19, 1873.

202. William Eakin (1810–1849) hailed from Londonderry County, Ireland. He came to America about 1822 with his family and settled in Nashville about 1836. He and Felicia married in 1842. Thomas, *Old Days in Nashville*, 92–93; Burdette, "The Eakin Family," 119.

203. Robert Massengill Porter, M.D., (1818–1856) graduated from Harvard in 1838 with a Bachelor of Arts degree. He married Mary Wharton that same year, and their union ended tragically after she died only a few months after they wed. He earned his medical degree from the University of Pennsylvania in 1845 and joined the staff of the University of Nashville about 1850. Davenport, "Cultural Life in Nashville"; Lindsley, *Address on the Life and Character*, 4–47.

204. The landmark 1911 series, *Photographic History of the Civil War* by Francis Trevelyan Miller, noted that Felicia "labored without stint as president of the Women's Relief Society, first of Tennessee, and then of the entire Confederate States." This statement appears to provide the basis for later claims that Felicia founded a soldier relief organization for the entire Confederate States. The author has found no direct evidence that she did so.

205. Bickham, *Rosecrans' Campaign*, 55–56.

206. Janney, "Lost Cause."

207. *Tennessean* (Nashville), November 25, 1908.

208. Lucina's sons were Oscar Fitz Nicholas (1841–1907) and Levi Emerson Meacham (1846–1920).

209. Lucina B. Meacham pension file, Case Files, NARA.

210. *Memorial Record*, 627–628; Cutter, *American Biography*, 7–9.

211. According to Lucina's pension file, Case Files, NARA, her Baltimore service included stints at two general hospitals, McKim's Mansion and the Continental Hotel.

212. Moore, *Women of the War*, 261.

213. The account in *Women of War* identified this guard as "Captain Norton." The narrative suggests that Belle knew him prior to the events at Shiloh. It is possible that he is Addison S. Norton (1821–1874), who started his war service in the Seventeenth Illinois Infantry as captain of Company A. He went on to command his regiment as colonel. Belle's husband, William, also served as an officer in the Seventeenth.

214. Moore, *Women of the War*, 262–263; *San Francisco Call*, May 22, 1898.

215. The individual quoted here is identified as F. W. Burrington. *Indianapolis Journal*, April 25, 1897.

216. *Springfield (Mass.) Republican*, July 28, 1864.

217. Leonard Fulton Ross (1823–1901) had his first military experience in the Mexican War as an officer in the Fourth Illinois Infantry. The original colonel of the Seventeenth Illinois Infantry, he then moved to brigade command during the fight for Fort Donelson. He went on to become brigadier general and command on the division level before he resigned his commission in July 1863. He subsequently became a successful cattle farmer near Avon, Illinois.

218. Moore, *Women of the War*, 256–257.

219. Moore, *Women of the War*, 256–257.

220. Moore, *Women of the War*, 256–257.

221. Moore, *Women of the War*, 256–257.

222. Moore, *Women of the War*, 256–257.

223. *San Francisco Call*, May 22, 1898.

224. Moore, *Women of the War*, 267.

225. Moore, *Women of the War*, 267–268.

226. Moore, *Women of the War*, 267–268.

227. Brown, "Major Belle Reynolds."

228. Moore, *Women of the War*, 269–270.

229. Simon, *Personal Memoirs*, 112–113.

230. *Harper's Weekly*, May 17, 1862.

231. Simon, *Personal Memoirs*, 112–113.

232. Rebecca R. Pomroy to Almira S. Belcher, May 1862, Rebecca R. Pomeroy Papers. Almira Sale Belcher (1838–1902) married Rebecca's son George in 1863.

233. Boyden, *War Reminiscences*, 15–16.

234. Boyden, *War Reminiscences*, 22–23.

235. Boyden, *War Reminiscences*, 46–47.

236. Rebecca R. Pomroy to Almira S. Belcher, April 23, 1862, Rebecca R. Pomeroy Papers.

237. Her father was Samuel Holliday (1788–1832). Her mother was Dorcas Norton Holliday (1790–about 1855).

238. Rebecca married Daniel Frederick Pomroy (1815–1860) about 1836. Their first child, George King Pomroy, was born in 1839. Two years later a second son, William F. Pomroy, came into the world, followed by daughter Clara J. Pomroy in 1848.

239. Rebecca R. Pomroy to Almira S. Belcher, April 23, 1862, Rebecca R. Pomeroy Papers.

240. Rebecca R. Pomroy to Almira S. Belcher, May 1862, Rebecca R. Pomeroy Papers.

241. The exact nature of Ray's Fredericksburg wound is not detailed, which suggests it was minor. Dewitt C. Ray military service record, Compiled Records, NARA.

242. Boyden, *War Reminiscences*, 148–154.

243. George King Pomroy (1839–1901), a peacetime sailor, started his war service with the Thirteenth Massachusetts Infantry in August 1861. In July 1862 he received a promotion to second lieutenant in the Third U.S. Infantry and advanced to first lieutenant the following year. George K. Pomroy military service record, Compiled Records, NARA.

244. Boyden, *War Reminiscences*, 246.

245. Boyden, *War Reminiscences*, 248–249.

246. Wormeley, *Other Side of the War*, 111.

247. Wormeley, *Other Side of the War*, 99.

248. Wormeley, Latimer, and Curtis, *Recollections of Ralph Randolph Wormeley*, 50.

249. James M. Grymes graduated about 1856 from the School of Medicine at Georgetown College in Washington, D.C. He barely outlived the Peninsula Campaign, dying on February 6, 1863, at age thirty-four. His remains are buried in the Congressional Cemetery in Washington, D.C.

250. Wormeley, *Other Side of the War*, 77–78.

251. Wormeley, *Other Side of the War*, 77–78.

252. Wormeley, *Other Side of the War*, 115.

253. *New York Times*, August 6, 1908.

254. Wormeley, "Napoleon's Return."

255. Rebecca Wiswell to Almeda Pearson Shepard (1816–1893), August 12, 1862, Wiswell Papers. The author edited the various quotes from Rebecca's letters in this profile for spelling and punctuation.

256. Charles Pearson Shepard enlisted as a private in Company E of the First U.S. Sharpshooters in September 1861. The regiment is familiarly known as "Berdan's Sharpshooters" for Col. Hiram C. Berdan (1824–1893), who founded it and a brother regiment, the Second U.S. Sharpshooters. A full version of Charles's Malvern Hill wounding includes details omitted here for brevity. Brown, *History of Penacook*, 298–301.

257. Holland, *Our Army Nurses*, 298–302; *World* (New York City), October 30, 1897; *Earth* (Burlington, Vt.), November 5, 1897.

258. Rebecca Wiswell to Almeda Shepard, August 12, 1862, Wiswell Papers.

259. Rebecca Wiswell to Charles P. Shepard, March 7, 1863, Wiswell Papers; Holland, *Our Army Nurses*, 298–302. The author was unable to find any record of Washington Gay in period census files or other documents.

260. *World* (New York City), October 30, 1897.

261. Rebecca Wiswell pension file, Case Files, NARA.

262. Minor, "As the War Ended."

263. Sorrel, *Recollections*, 276.

264. According to the 1860 U.S. Census Slave Schedules, William Mahone owned seven slaves, ranging in age from one to forty-five years old.

265. *Times Dispatch* (Richmond, Va.), February 21, 1911.

266. This story appeared in numerous newspapers in 1887, such as the *Argus-Leader* (Sioux Falls, S.D.), July 30, 1887.

267. Other sources note "All Mine and Otelia's." Luebke, "William Mahone"; *St. Louis Railway Register*, March 1, 1884.

268. Luebke, "William Mahone.

269. *Los Angeles Times*, September 21, 1892.

270. "Adèle Douglas Letter," online.

271. "Adèle Douglas Letter," online.

272. *Richmond (Va.) Dispatch*, November 13, 1856.

273. Irish-born James Shields (1806–1879) is the only individual in American history to serve three different states as senator: Illinois, Minnesota, and Missouri. Notorious for almost fighting a duel with Abraham Lincoln, he distinguished himself as a military officer in the Mexican War and the Civil War. Lawyer and career politician John Slidell (1793–1871) was born in New York and settled in Louisiana as a young man. A staunch advocate of Southern rights, he resigned his U.S. Senate seat after his adopted state seceded from the Union and accepted a position as a diplomat to France for the fledgling Confederate States. In November 1861, he was captured aboard the *Trent* while traveling to France, imprisoned in Boston's Fort Warren, and soon released amid concerns that his capture, and that of fellow diplomat James Mason, would provoke war with Britain. *Ottawa (Ill.) Free Trader*, November 29, 1856.

274. James, James, and Boyer, *Notable American Women*, vol. 3, 509–510.

275. Peacock, *Famous American Belles*, 183–184.

276. Peacock, *Famous American Belles*, 186.

277. *Pittsburgh Gazette*, October 3, 1862.

278. Gaston lived until 1885. His wife Tillie (Matilda Ensell Gaston) died in 1867. *Commemorative Biographical Record*, 835.

279. Grzyb, *Rhode Island's Civil War Hospital*, 14, 23.

280. Arthur R. Tuell (1835–1907) mustered into Company F of the First Rhode Island Infantry as a private on April 17, 1861, and ended his three-month enlistment on August 1. Daniel Chase Denham Jr. (1835–1911) mustered into Company L of the Ninth Rhode Island Infantry as a private on May 26, 1862, and mustered out on September 2 at the conclusion of his three-month term.

281. Cynthia R. Denham pension file, Case Files, NARA; *Newport (R.I.) Mercury*, February 11, 1911; *New England Farmer* (Boston), July 18, 1863.

282. Holstein, *Three Years in Field Hospitals*, 11–12.

283. *Philadelphia Inquirer*, June 26, 1898.

284. Meginness, *History of Lycoming County*, 293.

285. *Norristown (Pa.) Weekly Herald*, August 20, 1894.

286. Holstein served in Company G of the Seventeenth Pennsylvania Militia. Bates, *History of Pennsylvania Volunteers*, 1147–1148.

287. The six ladies were Mrs. Rachel P. Evans, Mrs. Anna Carver, Mrs. Isaac W, Holstein, Miss Sallie H. Roberts, Miss Lizzie Brower, and Miss Sarah Priest. Holstein, *Three Years in Field Hospitals*, 11–12.

288. Holstein, *Three Years in Field Hospitals*, 17–18.

289. *Philadelphia Inquirer*, October 15, 1936; Historical Society of Montgomery County, *Historical Sketches*, 223–224.

290. Holstein, *Three Years in Field Hospitals*, 93–94.

291. Treese, *Valley Forge*, 20–21.

292. Historical Society of Montgomery County, *Historical Sketches*, 230–231.

293. Heyworth, "Solemn Vow at Camp Butler."

294. *Journal Gazette* (Mattoon, Ill.), May 26, 2008.

295. Sarah Gregg, Civil War diary.

296. Richard, *Busy Hands*, 176–180.

297. *Ottawa (Ill.) Free Trader*, December 12, 1863.

298. David R. Gregg (about 1807–1895) served in Company F of the Tenth Illinois Infantry from April to July 1861. He immediately reenlisted as a private in Battery C of the First Illinois Light Artillery and received a disability discharge in March 1863. Before the end of the year he signed on as a corporal in Company I of the Fifty-Third Illinois Infantry and mustered out in July 1865. William P. Gregg (about 1830–1900) began his Civil War service as a corporal in Company A of the Eleventh Illinois Infantry from April to July 1861. He soon reenlisted as a private in Battery D of the Second Illinois Light Artillery. In May 1862, he transferred to Battery M in his father's First Light Artillery regiment as a first sergeant. He is listed as having deserted the regiment in September 1862. William P. Gregg military service record, Compiled Records, NARA.

299. Heyworth, "Solemn Vow at Camp Butler"; Sarah Gregg, Civil War diary.

300. Heyworth, "Solemn Vow at Camp Butler"; Sarah Gregg, Civil War diary.

301. Kincaid, "Camp Butler."

302. Sarah Gregg, Civil War diary.

303. The officer, Cuban-born Federico Fernández Cavada (1831–1871), started as a captain in the Twenty-Third Pennsylvania Infantry. A capable artist, he served a stint with the Union army's Balloon Corps. As lieutenant colonel of the 114th Pennsylvania Infantry, he was court-martialed on charges of misbehavior in the face of the enemy at Fredericksburg and dismissed from the army, but the order was later withdrawn. He went on to fight at the Battle of Gettysburg and fell into enemy hands. His 1864 book, *Libby Life*, details his time as a prisoner of war. He survived the war, returned to his native Cuba, and became general and commander-in-chief of forces fighting against Spanish rule. Cavada was eventually captured and executed.

304. *Wellington (Ohio) Enterprise*, March 30, 1898.

305. *Kansas City Daily Tribune*, May 26, 1897; *Miltonvale (Kans.) Tribune*, March 30, 1894.

306. *Miltonvale (Kans.) Tribune*, March 30, 1894; Melchiori, "Death of 'French Mary.'" The author was unable to locate any evidence of Bernhard Tepe's military service in the British Army.

307. 1900 U.S. Census, NARA. In this census, the government asked the year of immigration, and Maria's entry included the date 1853.

308. *Reading (Pa.) Times*, March 19, 1897.

309. *Buffalo (N.Y.) Sunday Morning News*, April 25, 1897.

310. *World* (New York City), December 17, 1893.

311. *World* (New York City), December 17, 1893.

312. Rauscher, *Music on the March*, 34; *Western Veteran* (Topeka, Kans.), April 11, 1894.

313. Rauscher, *Music on the March*, 68.

314. An abolitionist's son born in Alabama, David Bell Birney practiced law in Philadelphia at the start of the Civil War. He began his military service as lieutenant colonel of the Twenty-Third Pennsylvania Infantry and soon rose to brigadier general and command of a brigade in Kearny's First Division of the Third Corps. Upon the death of Kearny, Birney advanced to division command. He died of disease in October 1864.

315. Anna Etheridge is profiled elsewhere in this volume.

316. General Orders No. 48, First Division, Third Corps, Army of the Potomac, May 16, 1863, *War of the Rebellion*, series 1, vol. 51, pt. 1: 1275–1281.

317. Rauscher, *Music on the March*, 68.

318. Richard Leonard pension file, Case Files, NARA.

319. Thomas Francis de Burgh Galwey (1846–1913) noted the woman's name as Annie in his reminiscences. He may have misremembered the name or confused her with Anna "Annie" Etheridge, who occupied a similar position in the Third Michigan Infantry. Galwey, *Valiant Hours*, 212.

320. *Wellington (Ohio) Enterprise*, March 30, 1898.

321. *Wellington (Ohio) Enterprise*, March 30, 1898.

322. *Wellington (Ohio) Enterprise*, March 30, 1898.

323. *World* (New York City), December 17, 1893.

324. *World* (New York City), December 17, 1893.

325. *National Republican* (Washington, D.C.), December 16, 1862.

326. Bailey, "Caleb Blood Smith."

327. Barrows, *History of Fayette County*, 585–587.

328. *Documents of the General Assembly*, 1226–1227.

329. George F. Watton (1829–1902). *Indianapolis Journal*, July 13, 1902.

330. *Indiana State Sentinel* (Indianapolis), January 6, 1862.

331. *Evening Star* (Washington, D.C.), December 13, 1862; *Huron Reflector* (Norwalk, Ohio), January 6, 1863.

332. *New York Herald*, December 26, 1862.

333. *New York Herald*, December 26, 1862.

334. *New York Herald*, December 26, 1862.

335. Bailey, "Caleb Blood Smith."

336. *Cincinnati Enquirer*, September 11, 1878.

337. *Report to the Western Sanitary Commission*, 33.

338. The date of her arrival is estimated, based on a review of documents in her pension file. Caroline C. Hagar Edwards pension file, Case Files, NARA.

339. Brockett and Vaughan, *Woman's Work in the Civil War*, 704–706.

340. Forman, *Western Sanitary Commission*, 120–123.

341. Brockett and Vaughan, *Woman's Work in the Civil War*, 704–706.

342. Chapman Brothers, *Portrait and Biographical Album*, 303–304; Albert G. Edwards pension file, Case Files, NARA.

343. Chapman Brothers, *Portrait and Biographical Album*, 303–304; Albert G. Edwards pension file, Case Files, NARA; *Marshall County News* (Maysville, Kans.), May 12, 1905.

344. *Marshall County News* (Maysville, Kans.), April 3, 1903.

345. *Marshall County News* (Maysville, Kans.), May 12, 1905.

346. Stearns, *Lady Nurse of Ward E*, 92, 161, 174, 235.

347. Susan's parents were John Marsh (1802–1852) and Caroline Kidder Marsh (1805–1885). Her brother, Henry Francis Marsh (1831–1900), worked as a stationer, according to the 1850 U.S. Census, NARA.

348. The doctor, Acting Asst. Surg. Henry Alfred Robbins (1839–1911), became a prominent physician in Washington, D.C., after the war. Susan E. Marsh pension file, Case Files, NARA.

349. Stearns, *Lady Nurse of Ward E*, 161–162.

350. Dr. Nancy Maria Hill (1833–1919) is profiled elsewhere in this volume.

351. National Association of Army Nurses of the Civil War, *Forty-Fourth National Encampment*.

352. Susan E. Marsh pension file, Case Files, NARA.

353. The chief surgeon, Maine-born Dr. Simon Lock Lord (1826–1893), graduated with a medical degree from Bowdoin College in 1852 and furthered his studies at Tremont Medical School in Boston and Jefferson Medical College in Philadelphia. At the start of the Civil War he resided in Wisconsin, where he joined the state's Thirteenth Infantry as assistant surgeon in late 1861. The task fell to him to convert the existing building on Adams Street in Memphis, Tennessee, into a hospital. He served as chief surgeon from October 1862 until March 1863, when his own poor health prompted his resignation. He soon returned to duty with the Thirty-Second Wisconsin Infantry and served in this capacity until his health forced him to resign in September 1864. Simon L. Lord military service record, Compiled Records, NARA; *Portrait and Biographical Album*, 333–337.

354. *Chicago Tribune*, March 9, 1863.

355. Logan, *Part Taken by Women*, 363.

356. *Reports of Committees of the Senate*, report no. 2481.

357. The patient was Charles M. Kendall (1842–1914). He served as a private in Company K of the Twenty-Ninth Wisconsin Infantry. Wounded during the Vicksburg Campaign in the May 1863 Battle of Champion Hill, he received a disability discharge in May 1865. Charles M. Kendall military service record, Compiled Records, NARA; Moore, *Women of the War*, p, 478.

358. Grace Alberta Buckley (1872–1953). According to an unverified genealogical record on Ancestry.com, she married LeMoyne Bradford Ellis (1878–1961).

359. *In Honor of the National Association*, not paginated.

360. Guilford Dudley Jennings (1841–1871) began his military service as a corporal in Company C of the Third Wisconsin Infantry. His wounding at the Battle of Chancellorsville on May 3, 1863, ended his combat career. In July 1864 he joined the Veteran Reserve Corps as a second lieutenant and ended his service in April 1867 with a brevet, or honorary, rank of captain for Chancellorsville.

361. Dexheimer, *Sketches of Pioneer Wisconsin Women*, 18–21.

362. Jane's mother was Ann MacIntyre Jennings (1814–1891), and her father was John Ellis Jennings (about 1808–1894). Dexheimer, *Sketches of Pioneer Wisconsin Women*, 18–21.

363. Dexheimer, *Sketches of Pioneer Wisconsin Women*, 18–21.

364. Doctor Willard Bliss (1825–1889) was given "Doctor" as his first name in honor of the physician present at his birth, according to his obituary in the February 21, 1889, edition of the *Evening Star* (Washington, D.C.). He started the war as surgeon of the Third Michigan Infantry and soon advanced to brigade surgeon under the command of Maj. Gen. Phil Kearney. He left this position shortly thereafter to work in Washington, D.C., where he supervised construction of the Armory Square Hospital and became its director. He remained in the nation's capital after the war and was recognized for his expertise with bullet wounds. His handling of the Garfield case received favorable worldwide press at the time but was widely condemned in 2011 by Candice Millard in *Destiny of the Republic*.

365. Dexheimer, *Sketches of Pioneer Wisconsin Women*, 18–21.

366. Epler, *Life of Clara Barton*, 300.

367. Butterfield, *History of Green County*, 567–568.

368. *Inter Ocean* (Chicago), August 3, 1898.

369. Janet Jennings to Clara Barton, January 9, 1912, Clara Barton Papers.

370. Janet Jennings House nomination form, National Register of Historic Places Nomination Forms.

371. Swisshelm, *Half a Century*, 251–253.

372. *New-York Tribune*, May 22, 1863. The letter was written on May 19, 1863. It appeared in newspapers across the North during the weeks that followed.

373. *New-York Tribune*, May 22, 1863.

374. *Chicago Tribune*, December 23, 1863.

375. Swisshelm, *Half a Century*, 35.

376. The slave trade in the District of Columbia was abolished as part of the Compromise of 1850. On April 16, 1862, President Abraham Lincoln signed the District of Columbia Compensated Emancipation Act, which freed slaves in Washington.

377. Swisshelm, *Half a Century*, 74–75.

378. *New York Herald*, February 22, 1853.

379. Orsini, *Life of the Blessed Virgin Mary*, 733.

380. Swisshelm, *Half a Century*, 239–240.

381. Swisshelm, *Half a Century*, 239–240.

382. Swisshelm, *Half a Century*, 3.

383. *Buffalo (N.Y.) Commercial Advertiser*, March 6, 1866.

384. Henry Ingersoll Bowditch (1808–1892) graduated from Harvard in 1828 and became an early and active participant in the movement to abolish slavery. During the Civil War, he promoted improvements in medical care through his pamphlet, *A Brief Plea for an Ambulance System for the Army of the United States*. He was inspired to write the pamphlet after the death of his son, 1st Lt. Nathaniel Bowditch of the First Massachusetts Cavalry, after the 1863 Battle of Kelly's Ford in Virginia. Bowditch was the first visiting physician at Carney Hospital. Winsor, *Bibliographic Contributions*, No. 46, 10.

385. Elizabeth Ann Bayley Seton (1774–1821) was the first native-born U.S. citizen to be canonized by the Roman Catholic Church.

386. The other nuns were Loyola Ritchie and Blandina Davaux. Sister Loyola left for Detroit in 1844 and died there five years later, a victim of a cholera epidemic. Newspaper reports suggest that Davaux remained in Boston into the late 1860s.

387. Holloran, *Boston's Wayward Children*, 67–71.

388. Hannefin, *Daughters of the Church*, 48.

389. The hospital was established with funds provided by Andrew Carney (1794–1864), an Irish American who had amassed a fortune as a clothier and real estate investor. The hospital remained in operation in Boston for ninety years and served soldiers from the Spanish-American War and World War I.

390. Hannefin, *Daughters of the Church*, 127.

391. *Boston Post*, March 22, 1875.

392. Raus, *Ministering Angel*, 32.

393. The Women's Central Association of Relief, or WCAR, was founded in April 1861 in New York City by British-born Dr. Elizabeth Blackwell (1821–1910), the first women in the United States to earn a medical degree. In June 1861, the federal government followed the lead of WCAR and established the U.S. Sanitary Commission, or USSC. A year later, WCAR became a branch of the USSC.

394. Raus, *Ministering Angel*, 12.

395. New York–born Susan Emily Hall (1826–1912) is credited by several sources as being the first woman to volunteer as a nurse, presumably under the auspices of the Women's Central Association of Relief. She had reportedly studied under Dr. Elizabeth Blackwell. Susan survived the war, but, according to Hattie, her health was forever compromised. Still, she outlived Hattie, as well as her husband, Robert E. Barry (1833–1905). He was a veteran of the Civil War who served as a light artillery private in the Chicago Board of Trade Battery, also known as Stokes' Battery for its original captain, James H. Stokes. According to one report, the two met during the war after Robert was wounded.

396. Raus, *Ministering Angel*, 13.

397. Raus, *Ministering Angel*, 23–24.

398. Raus, *Ministering Angel*, 34.

399. The soldier was Henry G. Potter, a sergeant in Company A of the Seventy-Fourth Indiana Infantry. He suffered a severe wound in his right leg on September 20, 1864, during the Battle of Chickamauga. He survived an amputation and mustered out of the army in June 1865. He lived until 1911. Raus, *Ministering Angel*, 9.

400. Raus, *Ministering Angel*, 9.

401. Raus, *Ministering Angel*, 58.

402. Henry Clay May (1830–1894) of Bath, New York, graduated from Michigan University in 1856 and joined a medical practice in Corning, New York, the following year. He and Phebe married in 1859. Henry started his war service as surgeon of the Fifth New York Infantry—popularly known as Duryée's Zouaves after its commander, Col. Abram Duryée- in February 1862. He resigned due to ill health in August 1862, then returned to the army a month later as assistant surgeon of the 145th New York Infantry. He went on to receive a commission as assistant surgeon in the U.S. Medical Corps and ended his service in October 1865 with a brevet rank of captain.

403. Mrs. H. C. May to Arnold A. Rand, August 29, 1886, Gregory A. Coco Research Collection.

404. Mrs. H. C. May to Arnold A. Rand, August 29, 1886, Gregory A. Coco Research Collection.

405. James Agett Jr., the elder of Phebe's two older brothers, enlisted in the Eighth New York Heavy Artillery in June 1863 and was killed a year later. He was the second of Phebe's siblings to die. In 1847, the family's eldest child, Lydia, committed suicide at age twenty.

406. Arnold Augustus Rand (1837–1917) of Boston, Massachusetts, started his war service as a private in the Fourth Battalion, Massachusetts Volunteer Militia, in 1861. He went on to become colonel and commander of the Fourth Massachusetts Cavalry by the end of the war. Afterward, he earned a law degree and practiced as an attorney before becoming vice president of the John Hancock Life Insurance Company. He is best remembered for his role is assembling the MOLLUS Collection, which today is located at the U.S. Army Heritage and Education Center at Carlisle Barracks, Pennsylvania.

407. Mrs. H. C. May to Arnold A. Rand, August 29, 1886, Gregory A. Coco Collection.

408. The sister nurse, Anna M. Holstein, is profiled elsewhere in this volume. Phebe M. May pension file, Case Files, NARA.

409. In addition to Emily, the nurses were Mary E. Dupee, Eunice D. Merrill, Susan Newhall, Mary Pierson, Almira Quinby (profiled elsewhere in this volume), Louise Titcomb (profiled elsewhere in this volume), Rebecca R. Usher, and Adeline Walker. All survived the war, with the exception of Walker, who succumbed to typhoid on April 28, 1865. The surgeon, Bernard

Albert Vanderkieft (1829–1866), graduated from the Military Medical School in Utrecht, Holland, and completed his medical studies in Belgium. He emigrated to the United States in 1861 and almost immediately entered the Union army as assistant surgeon in the Fifty-Third New York Infantry. The following year he advanced to surgeon of the 102nd New York Infantry but soon left that regiment to join the U.S. Medical Corps. Highly regarded by his peers and superiors, he ended the war with a brevet rank of lieutenant colonel. The death of his wife, according to his obituary in the September 18, 1866, edition of the *New York Times*, contributed to his early demise. Brockett and Vaughan, *Woman's Work in the Civil War*, 461–462.

410. Emily's parents were Susan McLean Dana (1816–1905) and Oscar Fingal (or Fitzalan) Dana (1815–1899). Her father served in the law division of the U.S. Internal Revenue Service after the Civil War. Her great-grandfather was John Winchester Dana (1739–1813), and one of his sons was Judge Judah Dana (1772–1845). A Dartmouth graduate, Judah became an attorney and judge on Maine's Supreme Court. Judge Dana was appointed U.S. senator to fill the unexpired term of Ether Shepley upon the latter's resignation to become chief justice of Maine's Supreme Court. Judge Dana's senatorial stint lasted from December 1836 to March 1837. His daughter, Emily Wheelock Dana, lived from 1816 to 1842.

411. Richard Henry Dana entered the U.S. Naval Academy in March 1863 and died less than a month later, at age sixteen. Dana, *Dana Family in America*, 349.

412. Brockett and Vaughan, *Woman's Work in the Civil War*, 462.

413. Emily W. Dana pension file, Case Files, NARA.

414. The other three representatives, according to the Maine Bureau of Veterans' Services, are Revolutionary War patriot Hannah Watts Weston (1758–1855), World War II Women Air Force Service Pilot (WASP) Patricia A. Chadwick Erickson (1920–2013), and Sgt. Annette M. Bachman of the Maine Army National Guard.

415. Willard and Livermore, *Woman of the Century*, 707–708.

416. Willard and Livermore, *Woman of the Century*, 707–708.

417. Willard and Livermore, *Woman of the Century*, 707–708.

418. The exact quote suggests Mary might have stayed at the academy: "In 1859 she received the offer of a position as teacher of French and music in an academy in Morganfield, Ky. The girl replied that she was an abolitionist. The offer was repeated and she accepted. When she returned home the next year she left many cherished friends and kept up a warm correspondence until it was hushed by the gun which was fired on Fort Sumter." Willard and Livermore, *Woman of the Century*, 707–708.

419. William T. Jewett (born 1841) enlisted at age twenty-one as a private in Company E of the Fourth Michigan Cavalry. He mustered into the regiment on August 8, 1862, and died in Nashville on December 13, 1862. On October 28, 1862, Edward E. Jewett (1829–1866) enlisted at age thirty-three

as a private in Company C of the 124th Ohio Infantry. He mustered into the regiment in December 1862, and the following autumn he was transferred to the Veteran Reserve Corps. He mustered out in August 1865.

420. William Carter Otterson, M.D., (1828–1898) of Long Island, New York, hailed from a family of physicians. An 1853 graduate of the College of Physicians and Surgeons in New York, he left his practice in Brooklyn soon after the war began. In addition to his time in Nashville's Hospital No. 8, he also served with the Ninth Army Corps during the Vicksburg Campaign and the Twentieth Army Corps during Maj. Gen. William T. Sherman's "March to the Sea."

421. The author of the sketch that included this quote, Emma Stark Hampton (1843–1925), served a term as president of the Woman's Relief Corps. She did not reveal the name of the veteran. *Journal of the Twenty-Fourth National Convention*, 367–370.

422. *Journal of the Twenty-Fourth National Convention*, 367 370.

423. Marilley, *Women's Suffrage*, 152–153.

424. Marilley, *Women's Suffrage*, 152–153.

425. Higginson, *Cheerful Yesterdays*, 264–265.

426. *Observer* (London, England), October 1, 1837.

427. Phelps, *Players of a Century*, 214.

428. *Racine (Wis.) Daily Journal*, November 12, 1860.

429. This report was reprinted in the March 26, 1862, edition of a Mississippi newspaper, the *Natchez Weekly Courier*.

430. Harvard-educated Thomas Wentworth Higginson (1823–1911) was a militant abolitionist, as evidenced by his membership in the Secret Six, or Secret Committee of Six, who funded John Brown's 1859 raid on Harpers Ferry, Virginia. Higginson started his military service in September 1862 as a captain in the Fifty-First Massachusetts Infantry, but he left after only a few months to accept the colonelcy of the First South Carolina Infantry (Thirty-Third U.S. Colored Infantry).

431. Higginson, *Cheerful Yesterdays*, 264–265.

432. The regiment was later designated the Thirty-Third U.S. Colored Infantry.

433. Dr. Seth Rogers to his family, April 4, 1863, "Letters of Dr. Seth Rogers."

434. Higginson left South Carolina for his home in Massachusetts about May 1864 and resigned in October of the same year. Rogers resigned his commission in late December 1863 and lived until 1893.

435. *Daily Dispatch* (Richmond, Va.), October 26, 1864; *Nashville (Tenn.) Union*, January 27, 1865; *Quad-City Times* (Davenport, Iowa), August 30, 1903.

436. *Evening Star* (Washington, D.C.), August 3, 1903.

437. Robertson, *Michigan in the War*, 205.

438. Battery Noble was named in his honor. Jane S. Noble pension file, Case Files, NARA.

439. William Gundlach (1839–1918) of Company A served as the senior color corporal during the assault at Knoxville. Schneider, *Incidental Flag History*, 8–9.

440. Jane S. Noble pension file, Case Files, NARA.

441. The author was not able to locate Martha's pension papers in the files of the National Archives in Washington, D.C., but did find evidence of its existence in congressional records. *Reports of Committees…House…First Session*, report no. 1236; 1880 U.S. Census, NARA.

442. Robertson, *Michigan in the War*, 205.

443. Robertson, *Michigan in the War*, 205; Stocker, *From Huntsville to Appomattox*, 228.

444. A Harvard-educated Unitarian minister, Charles Alfred Humphreys (1838–1921) served as the chaplain of the Second Massachusetts Cavalry from July 1863 to April 1865. Captured at Aldie, Virginia, in July 1864, he was a prisoner of war for three months. Humphreys, *Field, Camp, Hospital, and Prison*, 11.

445. Stewart, *Philanthropic Work*, 6–7.

446. Stewart, *Philanthropic Work*, 15–16.

447. Stewart, *Philanthropic Work*, 16–17.

448. Humphreys, "Charles Russell Lowell."

449. Stewart, *Philanthropic Work*, 41.

450. Humphreys, *Field, Camp, Hospital, and Prison*, 11.

451. Oscar C. DeWolf (1836–1910) served as surgeon of the Second Massachusetts Cavalry. Emerson, *Life and Letters*, 66.

452. Carlotta Russell Lowell lived until 1924.

453. Stewart, *Philanthropic Work*, 48.

454. *New York Times*, October 13, 1905.

455. *Philadelphia Inquirer*, December 23, 1863.

456. Brockett and Vaughan, *Woman's Work in the Civil War*, 345.

457. "Anna Maria Ross." Her mother was Mary Root of Chester, Pennsylvania, and "her mother's uncle, Jacob Root, held a captain's commission in the Continental army." A search of records in the National Archives finds a Jacob Root listed as a member of the Second Battalion of Chester County Militia in 1780.

458. "Anna Maria Ross."

459. "Anna Maria Ross."

460. "Anna Maria Ross."

461. Bates, *Martial Deeds of Pennsylvania*, 1036.

462. Sarmiento, *Historical Sketch*, 9.

463. "Death of an Estimable Lady."

464. *Philadelphia Inquirer*, December 31, 1863.

465. Optic, *Student and Schoolmate*, vol. 15 (May 1865), 141.

466. The man was not identified. As Mary was matron of the Third Division hospital in the Third Corps, it is reasonable to assume that he served in a regiment attached to this command. The Third Corps was led during this period by Maj. Gen. William Henry French (1815–1881). Moore, *Women of the War*, 319.

467. "Two of Our Sanitary Heroines." The story compared Mary with another nurse, Jane Currie Blaikie Hoge (1811–1890). Hoge represented the system-oriented nurse to Mary's focus on individualized care.

468. Joshua Leonard Husband (1814–1880) and Mary Morris married in 1841.

469. Henry Morris Husband (1842–1919) served as a private in the Twenty-Third Pennsylvania Infantry for a three-month enlistment from April to July 1861, then joined the Ninety-Ninth Pennsylvania Infantry and mustered out in July 1865. John Leonard Husband (1843–1916) enlisted in the Seventy-Second Pennsylvania Infantry in the summer of 1861 and left the regiment with a disability discharge in the autumn of 1862.

470. Brockett and Vaughan, *Woman's Work in the Civil War*, 290–291.

471. Brockett and Vaughan, *Woman's Work in the Civil War*, 290–291.

472. "Two of Our Sanitary Heroines."

473. The other nurse, Cornelia Hancock, and Mary tended to soldiers during the Overland Campaign, which is when this event occurred. Foster, *New Jersey and the Rebellion*, 785–786.

474. "Two of Our Sanitary Heroines."

475. Moore, *Women of the War*, 331.

476. Livermore, *My Story of the War*, 520–523.

477. The veteran—lawyer and politician Frank Lane Wolford (1817–1895)—served as colonel of the First Kentucky Cavalry during the war. This quote is taken from a January 22, 1886, speech he made on the floor of the U.S. House of Representatives in support of Mary's pension application. *Congressional Record*, 844–845.

478. Baker, *Cyclone in Calico*, 12–15.

479. Chase, *Mary A. Bickerdyke*, 5.

480. James, James, and Boyer, *Notable American Women, 1607–1950*, vol. 2, 144–146; *Weekly Hawk-Eye and Telegraph* (Burlington, Iowa), April 12, 1859.

481. James, James, and Boyer, *Notable American Women, 1607–1950*, vol. 2, 144–146; *Weekly Hawk-Eye and Telegraph* (Burlington, Iowa), April 12, 1859.

482. Mary Ann Bickerdyke, incomplete memoir, Mary Ann Bickerdyke Papers.

483. *Davenport (Iowa) Weekly Republican*, November 19, 1901.

484. *Congressional Record*, 844–845.

485. Eliza Emily Chappell Porter (1807–1888) of New York, a devout Christian, relocated to the Michigan frontier as a young woman to educate settlers. Thus began a long career in Michigan, Illinois, and Wisconsin. When the war commenced, Eliza became involved behind the scenes with the Sanitary Commission and later in the field. Her husband, Jeremiah Porter (1804–1893), a Congregationalist minister, was active during the war as a chaplain.

486. Henshaw, *Our Branch*, 72.

487. Livermore, *My Story of the War*, 516.

488. Brockett and Vaughan, *Woman's Work in the Civil War*, 175–176.

489. Chase, *Mary A. Bickerdyke*, 28.

490. The medical director was Dr. Asher M. Goslin (1830–1894), who served as surgeon of the Forty-Eighth Illinois Infantry. Mary A. Bickerdyke pension file, Case Files, NARA.

491. Holland, *Our Army Nurses*, 532.

492. *Daily Herald* (Delphos, Ohio), July 28, 1897.

493. Annie Bell to her mother, February 15, 1864, Annie Bell Stubbs Papers.

494. Annie's parents were Martin Bell (1808–1873) and Eliza McKnight (1811–1898).

495. Lewisburg Female Academy at Bucknell University opened in 1851 and granted its students collegiate status beginning in 1883.

496. Logan, *Part Taken by Women*, 371.

497. Annie Bell to her mother, February 15, 1864, Annie Bell Stubbs Papers.

498. Leisenring, "Philanthropic Photographs."

499. Annie Bell to her mother, February 15, 1864, Annie Bell Stubbs Papers.

500. Foard, "A Hospital Scene's Backstory."

501. George Eastman Stubbs worked as a contract surgeon in the Medical Department of the Cumberland, beginning in May 1863. He accepted a commission from the army as a volunteer assistant surgeon in May 1865 and served in this capacity until he received a discharge in January 1866.

502. "Journal of the sayings & doings of Ward 4, Section C, McDougall Hospital, Fort Schuyler, N.Y., as kept by Lizzie E. Brewster, Lady Nurse," Brewster Family Papers.

503. Zenas Skinner military service record, Compiled Records, NARA.

504. E. Jones, *Brewster Genealogy*, 202–203; Grzyb, *Rhode Island's Civil War Hospital*, 85.

505. The others were Mary Thomas Brewster Long (1834–1873), who was the eldest Brewster sibling, and Ada Augusta Brewster (1842–1929), who followed Lizzie in the order of the seven children who survived into adulthood.

506. Elizabeth B. Scribner pension file, Case Files, NARA.

507. "Journal of the sayings & doings of Ward 4, Section C, McDougall Hospital, Fort Schuyler, N.Y., as kept by Lizzie E. Brewster, Lady Nurse," Brewster Family Papers.

508. "Journal of the sayings & doings of Ward 4, Section C, McDougall Hospital, Fort Schuyler, N.Y., as kept by Lizzie E. Brewster, Lady Nurse," Brewster Family Papers.

509. 1880 U.S. Census, NARA; E. Jones, *Brewster Genealogy*, 202–203.

510. Sarah Low to Mrs. Abbott, February 25, 1863, Sarah Low Papers; Stearns, *Lady Nurse of Ward E*, 200.

511. Scales, *History of Strafford County*, 210.

512. According to the June 15, 1887, issue of the *Boston Weekly Globe*, philanthropist Hannah Elizabeth Stevenson (1807–1887) "was the associate and personal friend of William Lloyd Garrison, Wendell Phillips, Rev. Theodore Parker, and Mrs. Lydia Maria Child. She bore the name of an abolitionist when it cost so much to be one. Gentle, mild, yet outspoken and positive in her denunciation of wrong, she was one of that small but noble band of Christian women, who, in the early days, warmly championed the cause of the slave."

513. Nathaniel Low Jr. (1838–1890) served in the Eleventh New Hampshire Infantry until May 1864, when he joined the U.S. Quartermaster's Department. He mustered out in February 1866.

514. Vance, "'They Set Themselves,'" unpublished thesis, 21–22.

515. Sarah Low to her mother, September 25, 1862, Sarah Low Papers.

516. Sarah Low to Mrs. Abbott, February 25, 1863, Sarah Low Papers.

517. Vance, "'They Set Themselves,'" unpublished thesis, 31–32.

518. Sarah Low to Mrs. Abbott, February 25, 1863, Sarah Low Papers.

519. Abbott, *First Regiment New Hampshire Volunteers*, 269–270.

520. Sarah Low to her mother, October 21, 1863, Sarah Low Papers.

521. Sarah Low to her mother, June 12, 1864, Sarah Low Papers.

522. Northam Colonist Historical Society, *Sarah Low*.

523. The agent, Annie T. Wittenmyer (1827–1900), distinguished herself by organizing special diet kitchens in a number of hospitals. She became involved in social reform after the war. The head doctor, Asst. Surg. Charles C. Byrne (1837–1921) of Maryland, was a career army medical officer who retired as a brigadier general in 1901. Carrie Wilkins pension file, Case Files, NARA.

524. Carrie Wilkins pension file, Case Files, NARA.

525. Carrie Wilkins pension file, Case Files, NARA.

526. Carrie Wilkins pension file, Case Files, NARA.

527. The other nurse is identified as "Miss McLeary." Holland, *Our Army Nurses*, 345–349.

528. Holland, *Our Army Nurses*, 345–349; *Russell (Kans.) Informer*, December 25, 1914.

529. Her sister was Ellen Delia Egan McCleve (1848–1923).

530. Holland, *Our Army Nurses*, 345–349.

531. Born in 1829, Albert P. "Bert" Thompson started his Confederate service as lieutenant colonel of the Third Kentucky Infantry. He advanced to colonel in late 1862, after the regiment's senior officer, Lloyd Tilghman, received a promotion to brigadier general and brigade command. Thompson remained in charge of the Third until his death in Paducah, Kentucky.

532. Neuman, *Paducahans in History*, 62–63; *New York Times*, April 1, 1864.

533. Alexander George Weed, born in Ballston Spa, New York, in 1836, relocated to Iowa with his parents in childhood and resided in Wisconsin when the war began. He started his war service in July 1862 as a private in Company A of the Twenty-Fourth Wisconsin Infantry. In March 1863 he was promoted to hospital steward, and in September 1863 he transferred to the Veteran Reserve Corps.

534. Holland, *Our Army Nurses*, 345–349.

535. Melissa V. Case pension file, Case Files, NARA.

536. Issued in Washington, D.C., on July 8, 1862, by Surgeon General William A. Hammond, the circular established strict guidelines for "service in the Women's Department for nursing in the military hospitals of the United States." Surgeon General's Office, *Report on the Hygiene*, 104–105.

537. Melissa V. Case pension file, Case Files, NARA.

538. *Kingston (N.Y.) Daily Freeman*, April 9, 1874.

539. Melissa V. Case pension file, Case Files, NARA.

540. Georgiana Willets Stradling pension file, Case Files, NARA; Swisshelm, *Half a Century*, 300.

541. Jane Swisshelm is profiled elsewhere in this volume.

542. Swisshelm, *Half a Century*, 302, 325.

543. The American Tract Society became involved in what amounted to a refugee crisis in early 1862 as escaped slaves poured into Washington, D.C., from the South. The philanthropic organization established a school in Duff's Green Row, located in the northern part of the capital. It became Camp Barker, which today is the U Street corridor and the location of the African American Civil War Museum. Georgie served as assistant to Anson Martin Sperry (1836–1916), a New Hampshire abolitionist.

544. Charles Henry Willets (born about 1845) enlisted as a sergeant in Company A of the Thirty-Seventh New Jersey Infantry in May 1864 and mustered out at the end of his hundred-day term in October 1864.

545. New Jersey–born Cornelia Hancock (1840–1927) began her career as an army nurse in 1863, following the Battle of Gettysburg, and continued her service through May 1865. She opened a school for freedmen in South Carolina after the war, and she went on to become involved in charity work. She also was president of the National Association of Army Nurses of the Civil War, an organization that fought for government benefits for veteran nurses.

546. The chief medical officer was Surg. Edward Barry Dalton (1834–1872), a doctor educated at Harvard and the College of Physicians and Sur-

geons of New York. He began his war service in 1861 as assistant surgeon of the Thirty-Sixth New York Infantry and advanced to surgeon before leaving the regiment to join the U.S. Volunteers Medical Staff in the spring of 1863. He ended his service in the summer of 1865. His death at age thirty-seven was attributed to disease contracted during his years in uniform.

547. Georgiana Willets Stradling pension file, Case Files, NARA.

548. Georgiana Willets Stradling pension file, Case Files, NARA.

549. Stradling, *His Talk with Lincoln*, xxvii–xviii, 26.

550. Paul, *Pennsylvania's Soldiers' Orphan Schools*, 439–441.

551. The author's analysis of 1860 U.S. Census numbers on Ancestry. com revealed 1,788 souls listed as residents of Catawissa, composed of 903 women and 885 men. Eliminating women and boys who would have been about eighteen or younger in 1864, the tally of eligible male voters is 528. Assuming soldier and sailor enlistments, deaths, and other factors, 280 votes is easily a two-to-one margin.

552. *Jeffersonian* (Stroudsburg, Pa.), August 8, 1864; *Sun* (Baltimore), July 21, 1864.

553. Her father was merchant George Reifsnyder (1805–1856). Her mother was Harriet Sharpless (1814–1878). Her youngest brother, George W. Reifsnyder, enlisted in the Third Pennsylvania Heavy Artillery in February 1864 and mustered out in November 1865.

554. The hospital steward, Edward P. Waller, had served as commissary sergeant of the 101st New York Infantry prior to joining the medical corps. Thomas Beal Hood (1829–1900) served as assistant surgeon of the Seventy-Sixth Ohio Infantry prior to joining the medical corps. He eventually became a full surgeon and mustered out of the army in 1866. Harriet S. R. Jackson pension file, Case Files, NARA.

555. Orton Porter Jackson (1873–1925) rose to the rank of captain and served in this capacity during World War I, when he received the Distinguished Service Medal as chief of staff to the commander-in-chief of the Asiatic Fleet. His remains rest in Arlington National Cemetery.

556. Holland, *Our Army Nurses*, 83–85.

557. *In Honor of the National Association*, 70.

558. Berlin, Germany, native Dr. Marie Elisabeth Zakrzewska (1829–1902) established the first general training school for nurses in America at the New England Hospital for Women and Children in 1872. "She was the never-flagging advocate of great reforms," noted the May 18, 1902, edition of the *Boston Post* after her death at age seventy-three.

559. Holland, *Our Army Nurses*, 83–85.

560. *National Tribune* (Washington, D.C.), September 22, 1892.

561. The colonel of the Eighth New York Heavy Artillery, 36-year-old Peter Augustus Porter, had earned a law degree from Harvard and served in the New York legislature prior to commanding the regiment. He also had a half-brother in the Confederate army, Brig. Gen. John Breckenridge

Grayson, who died of tuberculosis soon after he entered the service. Less than a month after Georgy affixed a bunch of roses to the bridle of his horse, Porter died while leading a charge at the Battle of Cold Harbor. When his remains were recovered, six bullets were found in his body. Cozzens, *Colonel Peter A. Porter*, 49.

562. Bacon, *Letters of a Family*, vol. 2, 595–596.

563. Bacon, *Letters of a Family*, vol. 2, 595–596.

564. Charles Williams Woolsey (1840–1907) was the youngest child and only son born to Jane and Charles Woolsey. He joined the 164th New York Infantry as a lieutenant and later served on the staffs of Generals Seth Williams and George G. Meade. He ended the war as a captain and brevet lieutenant colonel. He went on to become an attorney and was active in civil affairs and the Grand Army of the Republic.

565. Dwight, *History of the Descendants*, 1100–1101.

566. Her nurse sisters were Jane Stuart Woolsey (1830–1891), Mary Elizabeth Watts Woolsey Howland (1832–1864), and Eliza Newton Woolsey Howland (1835–1917), the wife of Col. Joseph Howland (1834–1896) of the Sixteenth New York Infantry. Brother Charles William Woolsey Jr. (1840–1907) began his service in November 1862 as a first lieutenant in the 164th New York Infantry. He spent the majority of his time as an aide to Brig. Gen. Seth Williams, who served as the assistant adjutant general of the Army of the Potomac and inspector general on the staff of Lt. Gen. Ulysses S. Grant. Her mother, Jane Eliza Newton (1801–1873), married Charles William Woolsey in 1827. She was pregnant with Charles Jr. when her husband perished on January 13, 1840, in a fire aboard the luxury steamboat *Lexington* on Long Island Sound, which claimed the lives of an estimated 139 people.

567. Brockett and Vaughan, *Woman's Work in the Civil War*, 341.

568. Bacon, *Letters of a Family*, vol. 1, 106.

569. Bacon, *Three Weeks at Gettysburg*, 9.

570. Bacon, *Three Weeks at Gettysburg*, 16–18; Bacon, *Letters of a Family*, vol. 2, 533.

571. Henry Josiah Rauch, the son of Rev. Michael and Elizabeth Hiller Rauch, began his service in the Fourteenth South Carolina Infantry as third lieutenant of Company B in September 1861. His older brother, Corp. Samuel Noah Rauch, served in the same company and was captured at Gettysburg. Another brother, Pvt. Jacob Ingleman Rauch, also served in that company. His service record indicates he enlisted in November 1864 and surrendered at Appomattox Court House. He lived until 1925. Henry Josiah Rauch, Samuel Noah Rauch, and Jacob Ingleman Rauch military service records, Compiled Records, NARA.

572. Bacon, *Letters of a Family*, vol. 2, 534.

573. Bacon, *Letters of a Family*, vol. 2, 694–695, 702.

574. Bacon, *Letters of a Family*, vol. 2, 714.

575. Francis Bacon started his war service in April 1861 as assistant sur-

geon of the Second Connecticut Infantry. Upon the expiration of his three-month term of enlistment, he joined the Seventh Connecticut Infantry as its surgeon. He left the regiment the following year to become a brigade surgeon and served in this capacity until he tendered his resignation in August 1864.

576. Bacon, *Letters of a Family*, vol. 1, 142–144.

577. Clapp, "Helen L. Gilson... Part II."

578. Asa Gilson (1794–1849) died of dropsy, or edema, which suggests he succumbed to congestive heart failure. His wife, born Lydia Cutter in 1798, died in 1851 of heart disease. They married in 1819. Three children were born to them: Mary Ann Gilson Holmes (1824–1906), Helen in 1835, and Caroline A. Gilson Hollis (1843–after 1920).

579. Franklin Brigham "Frank" Fay (1821–1904) was mayor of Chelsea from 1861 to 1863. He headed up the Auxiliary Relief Corps from May 1864 to January 1865. Prominent in veterans' affairs and social reform causes, including prison reform, the abolition of capital punishment, and prevention of cruelty to animals, he served in both houses of the Massachusetts legislature.

580. Reed, *War Papers*, 25.

581. Brockett and Vaughan, *Woman's Work in the Civil War*, 71.

582. Brockett and Vaughan, *Woman's Work in the Civil War*, 134.

583. The men belonged to the Chelsea Light Infantry, also known as the Chelsea Volunteers. It became Company H of the First Massachusetts Infantry.

584. Reed, *War Papers*, 25. Mayor Fay recalled that Dix sent Helen to Columbian College Hospital, where she worked for highly respected nurse Rebecca Pomroy (profiled elsewhere in this volume).

585. Frederick Newman Knapp (1821–1889) graduated from Harvard in 1843 and Harvard Divinity School four years later. A Unitarian minister, Knapp served as superintendent of the U.S. Sanitary Commission's Special Relief Department. It helped soldiers readjust to civilian life and supported disabled veterans and their families.

586. Clapp, "Helen L. Gilson... Part I," 457. The *Wilson Small* belonged to a fleet of hospital vessels operated under the auspices of the U.S. Sanitary Commission.

587. Reed, *War Papers*, 29.

588. Reed, *War Papers*, 29.

589. Reed, *War Papers*, 29. 28.

590. Horace Howard Furness (1833–1912) of Philadelphia graduated from Harvard in 1854. He married into a wealthy family that had built a fortune in ironmaking. He is best known for his work as a Shakespearian scholar. He served as editor of a series of annotated Shakespeare plays, known today as the Furness Variorum Shakespeare.

591. Clapp, "Helen L. Gilson... Part I," 463.

592. Clapp, "Helen L. Gilson... Part I," 463.

593. Clay MacCauley (1843–1925) became acquainted with Helen after

the Battle of Antietam. He started his war service as a sergeant in Company D of the 126th Pennsylvania Infantry just a month before the battle and advanced to second lieutenant in early 1863. He fell into enemy hands during the Battle of Chancellorsville in May 1863, and his captors paroled him after ten days. He went on to become a Unitarian minister and missionary. Clapp, "Helen L. Gilson...Part I," 459, 461.

594. Clapp, "Helen L. Gilson...Part I," 459, 461.

595. Clapp, "Helen L. Gilson...Part II," 566.

596. Clapp, "Helen L. Gilson...Part II," 567–568.

597. Clapp, "Helen L. Gilson...Part II," 571; James, James, and Boyer, *Notable American Women*, vol. 1, 44.

598. Emily Thomas Amies to Mrs. Louisa Marietta Kellogg Langworthy, November 6, 1864, E. T. Amies Letters. The letter was transcribed by Elizabeth Leech of Mercer Island, Washington.

599. Anna R. Carver to Mrs. Louisa M. Kellogg Langworthy, February 6, 1865, Anna R. Carver Papers.

600. Anna's first husband is known only by his surname, Hamer or Hammer. They were wed in the early 1830s, and the marriage ended after a few years with his death. The name of their son is not known, though his life dates are: 1831–1882. He served in the Civil War, according to a letter in the Anna R. Carver papers, written by Anna to Louisa Langworthy on March 9, 1865: "My own dear son is now at Little Rock and I have not heard from him for four months. If he should fall in the hands of the enemy I trust the Lord will raise up a kind friend to administer to his wants." Anna's second marriage, to Austin G. Britton (also spelled Britten, Brittain, and Button) occurred in 1839 and ended with his death in 1855. She wed William Carver (1806–1893) in 1857.

601. Historical Society of Montgomery County. *Historical Sketches*, 220–221.

602. Brockett and Vaughan, *Woman's Work in the Civil War*, 647.

603. Barton's other assistant, Baptist minister and missionary Cornelius M. Welles, was born in Wethersfield, Connecticut, about 1829. According to *Woman's Work in the Civil War*, he was a teacher in the first African American school in Washington, D.C. He was working with sick and wounded soldiers in Washington when Clara Barton engaged him as an assistant. In 1863, his health failing, he left the East for California to recover his health but died on November 26, 1863, the first official Thanksgiving Day. Brockett and Vaughan, *Woman's Work in the Civil War*, 119.

604. Clara Barton Papers; Oates, *Woman of Valor*, 53–68.

605. The other five women who journeyed with Anna to Antietam were Lizzie Brower, Rachel P. Evans, Anna Morris Ellis Holstein (profiled elsewhere in this volume), Sarah Priest, and Sallie H. Roberts. Historical Society of Montgomery County. *Historical Sketches*, 225–226.

606. Billingsley, *From the Flag*, 121–122.

607. Billingsley, *From the Flag*, 121–122.

608. Emily T. Amies to Mrs. Louisa M. Langworthy, November 6, 1864, E. T. Amies Letters.

609. Anna's sister was Susanna Reich (1808–1883), who married David Fadley (1807–1847). Susanna and David's son, Heinrich "Henry" Fadley (1839–1865), was married and had a daughter, Susan "Sudie" Fadley (1862–1881), who went to live with Anna.

610. Lizzie C. Moore to John Henry Rich, October 14, 1894, Anna R. Carver Papers.

611. Billingsley, *From the Flag*, 121–122.

612. Billingsley, *From the Flag*, 120.

613. Specific hospitals mentioned in Harriet's pension file include General Hospital in New Haven, Connecticut; Union Hospital in Georgetown in Washington, D.C.; Mt. Pleasant Hospital in Washington, D.C.; and the Fortress Monroe–area hospitals—Chesapeake, Hampton, Hygeia, and McClellan. Harriet S. R. Jackson pension file, Case Files, NARA.

614. Cadwell, *Old Sixth Regiment*, 79; Andrew Grogan military service record, Compiled Records, NARA.

615. *Evening Star* (Washington, D.C.), December 20, 1899.

616. Letters of the Eighth New York Infantry, Civil War Collection. Transcribed by the History Department, Genesee County, New York.

617. Edwin Ford (1801–1886) and his wife, Jane Pierson (1799–1875), raised five daughters and a son. Charlotte was the couple's second daughter and third-eldest child.

618. Fordville was entered into the National Historical Register of Historic Places in 1978.

619. *Brooklyn (N.Y.) Daily Eagle*, March 25, 1883.

620. The author determined this number, based on a search of the 1883 *Brooklyn Directory*. The book includes 838 individuals listed as physicians and three as doctors.

621. Maria Hall served at the Smoketown Hospital for nine months, beginning in October 1862. Helen met her at some point during this period.

622. "Army Nurse Sketch of Helen M. Noye Hoyt," Helen M. Noye Hoyt Papers.

623. Brockett and Vaughan, *Woman's Work in the Civil War*, 456.

624. "Army Nurse Sketch of Helen M. Noye Hoyt," Helen M. Noye Hoyt Papers.

625. Helen M. Noye to "Dear Ones at Home," July 4, 1864, Helen M. Noye Hoyt Papers.

626. "Army Nurse Sketch of Helen M. Noye Hoyt," Helen M. Noye Hoyt Papers. This quote has been revised with minor punctuation changes for readability and to correct the spelling of "Sidney" (Helen wrote "Sydney"). New York–born Sidney Allen enlisted in Company G of the Fifty-Ninth Mas-

sachusetts Infantry on March 1, 1863. His parents, Gideon and Louisa, and two younger brothers survived him.

627. Harry W. Gilmor (1838–1883) was born on his family's estate, Glen Ellen, located just north of Baltimore. A member of the Baltimore County Horse Guards at the outset of the war, he was imprisoned for a time following the Baltimore Riots on April 19, 1861. Upon his release, he went south and became a successful cavalry commander. Captured during the Antietam Campaign in 1862, he returned to duty in time to fight at Gettysburg with the First and Second Maryland Infantries. During the battle, he served as provost of occupied Gettysburg. The capture of Magnolia Station is remembered as a daring raid. Seven months later, in February 1865, he was captured in the Shenandoah Valley during another railroad raid and spent the duration of the war as a "guest" at Fort Warren, along Boston Harbor. After he gained his release, Gilmore returned to Baltimore and served as the city's police commissioner. He died at age forty-six. His obituary in the March 5, 1883, edition of the Baltimore *Sun* declared, "Whatever elsewhere may befall the fame of Colonel Gilmor as a gallant and partisan officer, in the South at large, and in the valley particularly, he will continue to be a hero of a hundred tales of knightly adventure."

628. Gilmor, *Four Years in the Saddle*, 194. Aboard Helen's train was Union Maj. Gen. William Buell Franklin (1823–1903), who was convalescing from a leg wound received during the Battle of Mansfield, Louisiana, the decisive fight in the failed Red River Campaign. He escaped Gilmor's raiders the next day.

629. "Army Nurse Sketch of Helen M. Noye Hoyt," Helen M. Noye Hoyt Papers.

630. "Army Nurse Sketch of Helen M. Noye Hoyt," Helen M. Noye Hoyt Papers.

631. R. Jones, *Eli and Sybil Jones*, 177–178.

632. Robinson, *Friends of a Half Century*, 227–228.

633. Robinson, *Friends of a Half Century*, 227–228.

634. *National Cyclopædia*, 480–481.

635. *Sun* (Baltimore), January 13, 1846.

636. Stowe, *Sunny Memories*, 254–255.

637. Curtis, "A Quaker."

638. Curtis, "A Quaker."

639. R. Jones, *Eli and Sybil Jones*, 171.

640. Peacetime farmer Eben R. Dinsmore began his military service in December 1862 as a private in Company B of the Seventh Maine Infantry. In the summer of 1864, he transferred to the First Maine Veteran Volunteer Infantry upon the consolidation of the depleted Fifth, Sixth, and Seventh Maine Infantries. He suffered wounds in the Battle of the Wilderness and the Siege of Petersburg.

641. R. Jones, *Eli and Sybil Jones*, 179–181.

642. R. Jones, *Eli and Sybil Jones*, 183.

643. R. Jones, *Eli and Sybil Jones*, 283.

644. Stearns, *Lady Nurse of Ward E*, 304–305.

645. *Christian Register* (Boston), November 10, 1898.

646. Charles Pickard Ware (1840–1921) transcribed the tunes and lyrics of numerous slave songs during his time in South Carolina. He and fellow abolitionists William Francis Allen (1830–1899) and Lucy McKim Garrison (1842–1877) edited *Slave Songs of the United States*, the first volume of its kind. It was published in 1867.

647. Stearns, *Lady Nurse of Ward E*, 249.

648. *Christian Register* (Boston), November 10, 1898.

649. *Christian Register* (Boston), November 10, 1898.

650. Gilbert Potter Bennett (1834–1910) was born in New York and moved with his family to Iowa prior to 1855. At his enlistment, he listed his residence as Osage in Mitchell County, Iowa, which shares a border with Floyd County. He mustered out of the army in June 1865.

651. Gilbert P. Bennett to Alma S. Wolcott Bennett, September 3, 1864. Biggs, *Letters from Gill*, 90–91.

652. "Iowa, County Marriages, 1838–1934," "FamilySearch" database; Gilbert P. Bennett military service record, Compiled Records, NARA.

653. Augusta Laura Perkins (1822–1883) married James Keeler Wolcott (1813–1883) in 1843. Alma was born two years later.

654. Annie Wittenmyer to Alma Bennett, August 1, 1864, Bennett Family Papers.

655. "Petition from the U.S. General Hospital No. 1, Nashville, Tenn.," dated September 1864, Bennett Family Papers.

656. *Weekly Graphic* (Kirkville, Mo.), January 16, 1891.

657. 1880 U.S. Census, NARA; Biggs, *Letters from Gill*, ix.

658. *Argus-Leader* (Sioux Falls, S.D.), January 25, 1912.

659. Wisconsin-born Menzo Alfred Olden (1845–1917) was married first to Mary J. Moore Olden (1846–1908). They had two sons.

660. Jolly, *Nuns of the Battlefield*, 174–175. Ellen Ryan Jolly was a Catholic historian and chairwoman of the committee that erected the Nuns of the Battlefield monument in Washington, D.C., in 1924. A similar version of Sister Ignatius's story appears in Kelly, *Song of the Hills*, 218. According to a footnote added by Kelly, the sisters slept not in the sacristy, but in the sanctuary. It had been separated by doors from the main body of the chapel, which had been converted into sleeping quarters. The author used the Jolly version because it includes an additional description of the nuns sleeping "soldier fashion." Also, the reference to Mother de Chantal (1833–1917), born Jane Keating of Ireland, dates the story to the autumn of 1864. Keating had arrived in Wheeling early in that year.

661. Jolly, *Nuns of the Battlefield*, 174–175.

662. Kelly, *Song of the Hills*, 218.

663. Also spelled "Farrelly." Sister Mary Ignatius pension file, Case Files, NARA.

664. Jolly, *Nuns of the Battlefield*, 170–171.

665. Email to the author from Jon-Erik Gilot, director of archives and records, Diocese of Wheeling-Charleston, June 16, 2016; Sister Mary Ignatius pension file, Case Files, NARA; Jolly, *Nuns of the Battlefield*, 170–171.

666. Jolly, *Nuns of the Battlefield*, 176.

667. Jolly, *Nuns of the Battlefield*, 174–175.

668. *Daily Northwestern* (Oshkosh, Wis.), October 11, 1924.

669. "American Catholic History in Stained Glass."

670. William Dudley Gale (1819–1888) began his Confederate service in the fall of 1862, serving on the staff of Lt. Gen. Leonidas Polk, his father-in-law. After Polk was killed in action on June 14, 1864, during the Atlanta Campaign, Gale joined the staff of Lt. Gen. Alexander P. Stewart.

671. William D. Gale to his wife, Katherine Polk Gale, January 14, 1865, Gale and Polk Family Papers, 1815–1865.

672. McNeilly, "Mrs. Caroline E. W. McGavock."

673. Virginia-born Felix Grundy (1777–1840) began his law career in Kentucky and served in the state legislature and state court of appeals before he moved to Nashville, Tennessee, in 1807. He went on to become a member of the U.S. Congress, as both a representative and a senator, and was the thirteenth attorney general of the United States during President Martin Van Buren's administration. "There was nothing remarkable in his manner," reported the December 21, 1840, edition of the *Nashville (Tenn.) Banner* on his passing. "His style of speaking was the plain or common style, yet he never failed, in an important cause, to enchain the attention of his audience. He possessed an unusual share of wit and humor—but it was not generally the wit 'that loved to play[,] not wound.'"

674. Carnton took its name from Carntown, located near Glenarm in Tickmacrevan Parish, County Antrim, Ireland. Gower, *Pen and Sword*, 6–7.

675. 1860 U.S. Census Slave Schedules, NARA; Battle of Franklin interpretive marker.

676. Tennessee-born and West Point–educated Alexander Peter Stewart (1821–1908) entered the Confederate army as an artillery major in 1861 and soon advanced to brigadier general and brigade command. He eventually received a promotion to major general and division command in the corps commanded by Lt. Gen. Leonidas Polk in the Army of Tennessee. After Polk was killed in action at Pine Mountain, Georgia, in June 1864, Stewart took command as acting lieutenant general. After the Battle of Franklin, the remnants of the army were sent to Lt. Gen. Joseph E. Johnston to participate in the Carolinas Campaign. Stewart went on to command the Army of the Tennessee until the end of the war. Afterward, he served stints as chancellor of the University of Mississippi and commissioner of Chattanooga and

Chickamauga National Military Park. A modest man who shunned notoriety, he was known as "Old Straight" by his men.

677. William D. Gale to his wife, Katherine Polk Gale, January 14, 1865, Gale and Polk Family Papers, 1815–1865. The second reference to Tennessee has been modified for readability. It originally appeared as "Ten."

678. William D. Gale to his wife, Katherine Polk Gale, January 14, 1865, Gale and Polk Family Papers, 1815–1865.

679. William D. Gale to his wife, Katherine Polk Gale, January 14, 1865, Gale and Polk Family Papers, 1815–1865.

680. The original appearance of "doctors" was "drs." William D. Gale to his wife, Katherine Polk Gale, January 14, 1865, Gale and Polk Family Papers, 1815–1865.

681. Farmer and Virginia native George W. Cuppett (1833–1899) and his two younger brothers, Marcellus and Polk, along with Robert Sloan, successfully bid $5 per body to remove and re-inter the remains, according to a letter written by George the year he died. The letter is in the holdings of the Battle of Franklin Trust. George led the group. Marcellus was stricken with fever during the project and died. His remains rest in the cemetery with the soldiers. Gilfillan, "Civil War Personality."

682. Morris, "Good Samaritan at Franklin."

683. Ruth Swett Mayhew, Civil War scrapbook, Raymond H. Fogler Library.

684. The other women were Orissa A. Packard Sheldon (1838–1875) and Jennie Grafton (life dates unknown). Eaton, *History of Thomaston*, 40–41; Schultz, *This Birth Place*, 276–277.

685. Rev. Andrew W. Mayhew (1821–1856) was a Congregationalist, recalled a nephew in a transcribed letter included in Ruth Swett Mayhew's Civil War scrapbook, Raymond H. Fogler Library. Mayhew was listed as a student at the Congregationalist Theological Seminary in Bangor, Maine, according to the 1850 U.S. Census, NARA, thereby confirming the nephew's statement. The institution is also known as the Bangor Theological Seminary.

686. Isabella Morrison Fogg (1823–1873) earned a distinguished reputation during the war for her contributions to the Maine Camp and Hospital Association, the Maine Soldiers' Relief Agency, and the U.S. Christian Commission. She also authored a grimly accurate eyewitness report of conditions after the Battle of Antietam to the Maine Soldiers' Relief Agency. In January 1865, while aboard the hospital ship *Jacob Strader* on the Ohio River, she accidently fell through an open hatch and permanently damaged her spine. Her son, Hugh Morrison Fogg (1844–1880), began his military service as a private in Company D of the Sixth Massachusetts Infantry. He suffered a serious wound and the amputation of his left leg at the Battle of Cedar Creek on October 19, 1864.

687. Brockett and Vaughan, *Woman's Work in the Civil War*, 506.

688. Ruth Swett Mayhew, Civil War scrapbook, Raymond H. Fogler Library.

689. Ruth Swett Mayhew, Civil War scrapbook, Raymond H. Fogler Library.

690. Ruth Swett Mayhew, Civil War scrapbook, Raymond H. Fogler Library.

691. Ruth Swett Mayhew, Civil War scrapbook, Raymond H. Fogler Library. The May 21, 1864, entry is believed to be in the hand of nurse Sarah S. Sampson (1832–1907). Her husband, Lt. Col. Charles Augustus Ludlow Sampson (1825–1881), served in the Third Maine Infantry.

692. A. Smith, *Reminiscences of an Army Nurse*, 112.

693. Orissa A. Packard was one of the three women who volunteered as nurses when the Fourth Maine Infantry formed in 1861. Packard married Henry Franklin Sheldon (1831–1917), a Kansas pioneer who served in various city offices, including five terms as mayor of Ottawa.

694. "Manuscript of the Early History of Ottawa University," unpublished.

695. The prisoner of war was not identified by name. Martha M. C. Hall to Mrs. Ames, December 20, 1864, Civil War Vertical File Manuscripts.

696. Dr. Lewis Condit (1772–1862) graduated from the University of Pennsylvania and practiced medicine in Morris County, New Jersey. Active as a New Jersey state legislator and as a congressman in the U.S. House of Representatives almost continuously from 1805 until 1838, he started in politics as a member of the Democratic-Republican Party. He later identified with anti–Andrew Jackson forces, Whigs, and, on the eve of the Civil War, with the Constitutional Union Party that nominated John Bell and Edward Everett for U.S. president and vice-president. Condit also held membership in the American Colonization Society.

697. David Aiken Hall (1795–1870) of Grafton, Vermont, graduated from Middlebury College and moved to Washington, D.C., as a young man to practice law. He remained in the city for the rest of his life. He was an avid horticulturist. His first wife, Susan Apthorp Bulfinch (1790–1829), was a daughter of the noted American architect Charles Bulfinch, designer of the first U.S. Capitol Dome and other prominent structures. His second wife, Martha Maria Condit (about 1816–1836), gave birth to Maria, Hall's first child. Two years after Martha died, Hall married Abigail Wolcott Ellsworth (1814–1874), a granddaughter of Supreme Court Chief Justice Oliver Ellsworth. She gave birth to seven children and outlived Hall. *Records of the Columbia Historical Society*, 167–170.

698. *Records of the Columbia Historical Society*, 166–171.

699. Richards, "Lincoln Cheers His Sick Boy." Havelocks are cloth coverings attached to a cap, with a flap to protect the neck from the sun or bad weather.

700. The Patent Office Hospital was also known as the Indiana Hospital,

from the large number of Hoosier soldiers treated there. Though the name of the sister who volunteered with Maria is not listed, she is probably one of two stepsisters born to Maria's father and his third wife, Abigail—either Ellen Ellsworth Hall Curtis (1840–1900) or Alice Lindsley Hall Wyckoff (1842–1920). Brockett and Vaughan, *Woman's Work in the Civil War*, 448–454. Almira Fales is profiled elsewhere in this volume.

701. Moore, *Women of the War*, 397–408.

702. That party was Ellen Matilda Orbison Harris (1816–1902) of the Ladies' Aid Society of Philadelphia, Pennsylvania. The two had become acquainted during their service aboard the hospital transports.

703. Bernard Albert Vanderkieft (1829–1866) graduated from the Military Medical School in Utrecht, Holland, and completed his medical studies in Belgium. He emigrated to the United States in 1861 and almost immediately entered the Union army as an assistant surgeon in the Fifty-Third New York Infantry. The following year he advanced to surgeon of the 102nd New York Infantry but soon left the regiment to join the U.S. Medical Corps. Highly regarded by his peers and superiors, he ended the war with a brevet rank of lieutenant colonel. The death of his wife, according to his obituary in the September 18, 1866, edition of the *New York Times*, contributed to his early death.

704. Moore, *Women of the War*, 397–408.

705. Moore, *Women of the War*, 397–408.

706. Martha M. C. Hall to Mrs. Ames, December 20, 1864, Civil War Vertical File Manuscripts.

707. Lucas Richards (about 1825–1895) had been widowed twice before his marriage to Maria. His first wife died in 1863. His second wife, Martha D. Billings, passed away in 1870.

708. Brockett and Vaughan, *Woman's Work in the Civil War*, 448–454.

709. Almira F. Quinby to Andrew, November 18, 1864, Almira F. Quinby Letters.

710. Reformist Neal Dow (1804–1897) is best known as the "Father of Prohibition" and the "Napoleon of Temperance." A politician who had served two terms as mayor of Portland and was also a state legislator, Dow became colonel of the Thirteenth Maine Infantry in 1861. He advanced to brigadier general, suffered wounds in a failed assault against Port Hudson in Louisiana, and fell into enemy hands soon after he recovered. He resigned his army commission in late 1864 and returned to his prohibition work. He was the nominee of the Prohibition Party for president in 1880.

711. Quinby, *Genealogical History*, 287.

712. Almira F. Quinby to Andrew, November 18, [1864?], Almira F. Quinby Letters.

713. Almira F. Quinby to her brother Thomas, April 2, 1863, in "Letters from a Nurse."

714. Almira F. Quinby to Andrew, Nov. 18, 1864. Almira F. Quinby Letters.

715. *Crutch* (Annapolis, Md.), December 10, 1864.

716. Brockett and Vaughan, *Woman's Work in the Civil War*, 461.

717. Adeline Blanchard Tyler is profiled elsewhere in this volume.

718. The author consulted chapter 5 of Spar, *Civil War Hospital Newspapers*.

719. Almira Fitch Quinby (1828–1909) is profiled elsewhere in this volume.

720. *National Tribune* (Washington, D.C.), August 16, 1894.

721. Holland, *Our Army Nurses*, 511–514.

722. 1850 U.S. Census, NARA; *Highland Park (Ca.) Herald*, December 22, 1906. Born in 1811, Stillman Ransom's exact death date in not known.

723. Eleanor C. Ransom pension file, Case Files, NARA; *Daily Signal* (Crowley, La.), September 6, 1905.

724. *National Tribune* (Washington, D.C.), February 8, 1894.

725. The soldier, John W. Stewart (1840–1927), served as a private in Company L of the Eleventh New York Cavalry. T. Smith, *Story of a Cavalry Regiment*, 197–200.

726. Holland, *Our Army Nurses*, 511–514.

727. *New York Times*, December 30, 1864.

728. *New York Times*, December 30, 1864.

729. *Daily Signal* (Crowley, La.), September 6, 1905.

730. According to an email to the author by renowned collector Dr. Michael R. Cunningham of Louisville, Kentucky, the sword visible in the background is a Model 1840 sword for sergeants, who were non-commissioned officers. The horn appears to be a regulation bugle, complete with cord. The man is attired in a privately purchased sack coat that appears to be fastened with rubber buttons instead of brass. He also wears a pair of officer's trousers.

731. *Los Angeles Herald*, March 17, 1909.

732. Her parents were William Wright Billing (1801–1843) and Rebecca K. Billing (1810–1887). Harper, *History of the Grand Lodge*, 343–344.

733. Brockett, *Woman's Work in the Civil War*, 460.

734. Brockett, *Woman's Work in the Civil War*, 460. The fellow nurse was Maria M. C. Hall (profiled elsewhere in this volume).

735. *Yakima (Wash.) Herald*, October 19, 1893.

736. Brockett, *Woman's Work in the Civil War*, 460.

737. Whitman, *Complete Prose Works*, 60–61.

738. Wormeley, *United States Sanitary Commission*, 231–232.

739. Ravenscroft, "All of Our Women," unpublished thesis, 49.

740. Ravenscroft, "All of Our Women," unpublished thesis, 14.

741. New Hampshire–born Frederick Newman Knapp (1821–1889) was married to Charlotte's niece, Lucia Alden Bradford. He graduated from Harvard in 1843, attended Harvard Divinity School, and became a Unitarian minister. His duties with the U.S. Sanitary Commission included emergency relief work and inspection tours, in which he was especially proficient.

742. Ravenscroft, "All of Our Women," unpublished thesis, 17.

743. Charlotte Bradford to Elizabeth Bradford, September 15, 1862, Bradford Family Collection.

744. Charlotte Bradford to Elizabeth Bradford, November 2, 1862, Bradford Family Collection.

745. Ravenscroft, "All of Our Women," unpublished thesis, 26–27.

746. Brockett and Vaughan, *Woman's Work in the Civil War*, 732.

747. *Washington Post*, March 1, 1910.

748. Thomas Beal Hood (1829–1900), a graduate of the medical department of Western Reserve University, started his war service as assistant surgeon of the Seventy-Sixth Ohio Infantry. He made Washington, D.C., his home after the war and went on to become dean of Howard University College of Medicine, a post he held from 1881 until his death.

749. Cynthia B. Case pension file, Case Files, NARA.

750. Recker and Whistler, *Shadowing Grant*, 262.

751. *National Tribune* (Washington, D.C.), March 10, 1910.

752. Rev. Chandler Robbins, D.D., (1810–1882) was the Unitarian pastor of Boston's Second Church for many years.

753. Annie's younger brother, Joseph Richards Kendall (1838–1912), joined the army the same month. He served as an officer in the Forty-Fourth Massachusetts Infantry. Annie F. Kendall pension file, Case Files, NARA; Moore, *Woman of the War*, 454.

754. Annie F. Kendall pension file, Case Files, NARA; Moore, *Woman of the War*, 454.

755. Annie F. Kendall pension file, Case Files, NARA; Moore, *Woman of the War*, 454.

756. Joseph Kendall Freitag (1869–1931).

757. Annie F. Kendall pension file, Case Files, NARA.

758. Annie F. Kendall pension file, Case Files, NARA.

759. *Waterloo (Iowa) Courier*, December 23, 1896.

760. The other woman, Mary Ellen Green Bonney Hancock, is profiled elsewhere in this volume. Sarah J. Edwards pension file, Case Files, NARA; Mary E. Bonney Hancock pension file, Case Files, NARA.

761. Robert M. Lackey (1835–1895) served as chief surgeon in several hospitals during the war, including Little Rock, his last posting. Sarah J. Edwards pension file, Case Files, NARA.

762. Sarah J. Edwards pension file, Case Files, NARA.

763. *Waterloo (Iowa) Courier*, December 23, 1896.

References

Books and Unpublished Manuscripts

Abbott, Rev. Stephen G. *The First Regiment New Hampshire Volunteers in the Great Rebellion*. Keene, N.H.: Sentinel, 1890.

Alcott, Louisa May. *Hospital Sketches*. Boston: J. Redpath, 1863.

Allen, William Francis, Charles Pickard Ware, and Lucy McKim Garrison, eds. *Slave Songs of the United States*. New York: A. Simpson, 1867.

Bacon, Georgeanna W. *Three Weeks at Gettysburg*. New York: Anson D. F. Randolph, 1863.

Bacon, Georgeanna W., and Eliza W. Howland. *Letters of a Family*, 2 vols. n.p., 1899.

Baker, Nina B. *Cyclone in Calico: The Story of Mary Ann Bickerdyke*. Boston: Little, Brown, 1952.

Barrows, Frederic I. *History of Fayette County, Indiana: Her People, Industries, and Institutions*. Indianapolis: B. F. Bowen, 1917.

Bates, Samuel P. *History of Pennsylvania Volunteers, 1861–5*, vol. 5. Harrisburg, Pa.: R. Singerly, 1871.

Bates, Samuel P. *Martial Deeds of Pennsylvania*. Philadelphia: T. H. Davis, 1876.

Bickham, William D. *Rosecrans' Campaign with the Fourteenth Army Corps, of the Army of the Cumberland: A Narrative of Personal Observations, with an Appendix, Consisting of Official Reports, of the Battle of Stone River*. Cincinnati: Moore, Wilstach & Keys, 1863.

Biggs, Terrie. *Letters from Gill*. Charleston, S.C.: CreateSpace Independent Publishing Platform, 2016.

Billingsley, Amos S. *From the Flag to the Cross; or Scenes and Incidents of Christianity in the War*. Philadelphia: New-World, 1872.

Biographical Review of Lee County, Iowa. Chicago: Hobart, 1905.

Biographical Sketches of Leading Citizens of the Seventeenth Congressional District Pennsylvania. Buffalo, N.Y.: Biographical Publishing, 1899.

Biographical Sketches of Representative Citizens of the Commonwealth of Massachusetts. Boston: Graves & Steinbarger, 1901.

Bowditch, Henry I. *A Brief Plea for an Ambulance System for the Army of the United States: As Drawn from the Extra Sufferings of the Late Lieut. Bowditch and a Wounded Comrade.* Boston: Ticknor & Fields, 1863.

Boyden, Anna L. *War Reminiscences, or, Echoes from Hospital and White House.* Boston: D. Lothrop, 1887.

Brockett, Linus P., and Mary C. Vaughan, *Woman's Work in the Civil War: A Record of Heroism, Patriotism, and Patience.* Philadelphia: Zeigler, McCurdy, 1867.

Brooklyn Directory for the Year Ending May 1st, 1883. New York, Lain, 1883.

Brown, David A. *History of Penacook, N.H., from Its First Settlement in 1734 up to 1900.* Concord, N.H.: Rumford, 1902.

Brunk, Quincealea Ann. "Forgotten by Time: An Historical Analysis of the Unsung Lady Nurses of the Civil War." Ph. D. dissertation, University of Texas at Austin, 1992.

Butterfield, Consul W. *History of Green County, Wisconsin.* Springfield, Ill.: Union, 1884.

Cadwell, Charles K. *Old Sixth Regiment: Its War Record, 1861–5.* New Haven, Conn.: Tuttle, Morehouse & Taylor, 1875.

Cavada, Federico Fernández. *Libby Life: Experiences of a Prisoner of War in Richmond, Va. 1863–64.* Philadelphia: King & Baird, 1864.

Chapman Brothers. *Portrait and Biographical Album of Marshall County, Kansas.* Chicago: Chapman Bros., 1889.

Chase, Julia A. *Mary A. Bickerdyke, "Mother."* Lawrence, Kans.: Journal Publishing, 1896.

Commemorative Biographical Record of Washington County, Pennsylvania. Chicago: J. H. Beers, 1893.

Congressional Record Containing the Proceedings and Debates of the Forty-Ninth Congress, First Session, vol. 17. Washington, D.C.: Government Printing Office, 1886.

Cozzens, Frederic S. *Colonel Peter A. Porter: A Memorial Delivered before the Century in December, 1864.* New York: D. Van Nostrand, 1865.

Curtiss-Wedge, Franklyn. *History of Fillmore County, Minnesota*, vol. 2. Chicago: H. C. Cooper Jr., 1912.

Cutter, William R. *American Biography: A New Cyclopedia*, vol. 11. New York: American Historical Society, 1922.

Dana, Elizabeth E. *The Dana Family in America.* Boston: Wright & Potter, 1956.

Davidson, Jonathan. *A Century of Homeopaths: Their Influence on Medicine and Health.* New York: Springer-Verlag, 2014.

Dexheimer, Florence C. *Sketches of Pioneer Wisconsin Women*. Fort Atkinson, Wis.: W. D. Hoard & Sons, 1925.

Documents of the General Assembly of Indiana, pt. 2, vol. 2. Indianapolis: Joseph J. Bingham, 1863.

Dwight, Benjamin W. *The History of the Descendants of John Dwight of Dedham, Mass.*, vol. 2. New York: John F. Trow & Son, 1874.

Eaton, Cyrus. *History of Thomaston, Rockland, and South Thomaston, Maine, from Their First Exploration, A.D. 1605; with Family Genealogies*, vol. 2. Hallowell, Maine: Masters, Smith, 1865.

Eddy, Richard. *History of the Sixtieth Regiment New York State Volunteers*. Philadelphia: J. Fagan & Son, 1864.

Eliot, William G. *Story of Archer Alexander: From Slavery to Freedom*. Boston: Cupples, Upham, 1885.

Emerson, Edward W. *Life and Letters of Charles Russell Lowell*. Boston: Houghton Mifflin, 1907.

Epler, Percy H. *The Life of Clara Barton*. New York: MacMillan, 1917.

Forbes, Robert B. *Personal Reminiscences*. Boston: Little, Brown, 1882.

Forman, Jacob G. *Western Sanitary Commission: A Sketch*. St. Louis, Mo.: R. P. Studley, 1864.

Foster, John Y. *New Jersey and the Rebellion: A History of the Services of the Troops and People of New Jersey in Aid of the Union Cause*. Newark, N.J.: Martin R. Dennis, 1868.

Frémont, Jesse B. *Story of the Guard: A Chronicle of the War*. Boston: Ticknor & Fields, 1863.

Galwey, Thomas F. *Valiant Hours: Narrative of "Captain Brevet," an Irish-American in the Army of the Potomac*. Harrisburg, Pa.: Stackpole, 1961.

Gilmor, Col. Harry. *Four Years in the Saddle*. New York: Harper & Brothers, 1866.

Gower, Herschel. *Pen and Sword: The Life and Journals of Randal W. McGavock*. Nashville: Tennessee Historical Commission, 1959.

Greenbie, Marjorie B. *Lincoln's Daughters of Mercy*. New York: G. P. Putnam's Sons, 1944.

Grzyb, Frank L. *Rhode Island's Civil War Hospital: Life and Death at Portsmouth Grove, 1862–1865*. Jefferson, N.C.: McFarland, 2012.

Hannefin, Daniel. *Daughters of the Church: A Popular History of the Daughters of Charity in the United States, 1809–1987*. Brooklyn, N.Y.: New City, 1989.

Harper, Kenton N. *History of the Grand Lodge and of Freemasonry in the District of Columbia, with Biographical Appendix*. Washington, D.C.: R. Beresford, 1911.

Henshaw, Sarah E. *Our Branch and Its Tributaries; Being a History of*

the Work of the Northwestern Sanitary Commission and Its Auxiliaries. Chicago: Alfred L. Sewell, 1868.

Hicks, Robert. *The Widow of the South.* New York: Warner Books, 2006.

Higginson, Thomas W. *Cheerful Yesterdays.* Boston: Houghton Mifflin & Co., 1898.

Historical Society of Montgomery County. *Historical Sketches,* vol. 1. Norristown, Pa.: Herald, 1895.

Holland, Mary A. G. *Our Army Nurses.* Boston: B. Wilkins, 1895.

Holloran, Peter C. *Boston's Wayward Children: Social Services for Homeless Children, 1830–1930.* Rutherford, N.J.: Fairleigh Dickinson University Press, 1989.

Holstein, Anna M. H. *Three Years in Field Hospitals of the Army of the Potomac.* Philadelphia: J. B. Lippincott, 1867.

Humphreys, Charles A. *Field, Camp, Hospital, and Prison in the Civil War, 1863–1865.* Boston: Geo. H. Ellis, 1918.

In Honor of the National Association of Civil War Army Nurses. Atlantic City, N.J.: Yeakel, 1910.

Jackson, Orton P., and Frank E. Evans, *Marvel Book of American Ships.* New York: Frederick E. Stokes, 1917.

James, Edward T., Janet Wilson James, and Paul S. Boyer, eds. *Notable American Women, 1607–1950: A Biographical Dictionary,* 3 vols. Cambridge, Mass.: Belknap Press of Harvard University Press, 2014.

Jennings, Janet. *Abraham Lincoln: The Greatest American.* Madison, Wis., Cantwell, 1909.

Jennings, Janet. *The Blue and the Gray.* Madison, Wis., Cantwell, 1910.

Jolly, Ellen R. *Nuns of the Battlefield.* Providence, R.I.: Providence Visitor, 1927.

Jones, Emma C. Brewster. *The Brewster Genealogy, 1566–1907,* vol. 1. New York: Grafton, 1908.

Jones, Rufus M. *Eli and Sybil Jones: Their Life and Work.* Philadelphia: Porter & Coates, 1889.

Journal of the Twenty-Fourth National Convention of the Woman's Relief Corps. Boston: Griffith-Stillings, 1906.

Kelly, Sister Rose Anita. *Song of the Hills: The Story of the Sisters of St. Joseph of Wheeling.* Wheeling, W.Va.: Sisters of St. Joseph, 1962.

Lanman, Charles. *Red Book of Michigan: A Civil, Military, and Biographical History.* Detroit: E. B. Smith, 1871.

Lawrence, Catherine S. *Sketch of Life and Labors of Miss Catherine S. Lawrence.* Albany, N.Y.: Parsons, 1893.

Lindsley, John B. *An Address on the Life and Character of Robert M. Porter, M.D.* Nashville, Tenn.: E. Vallette, 1856.

Livermore, Mary A. *My Story of the War: A Woman's Narrative.* Hartford, Conn.: A. D. Worthington, 1889.

Logan, Mrs. John A. *The Part Taken by Women in American History.* Wilmington, Del.: Perry-Nalle, 1912.

Long, Lisa A. *Rehabilitating Bodies: Health, History, and the American Civil War.* Philadelphia: University of Pennsylvania Press, 2004.

Lord, William B., and David W. Brown. *Debates and Proceedings of the Constitutional Convention of the State of Michigan, Convened at the City of Lansing, Wednesday, May 15th, 1867,* vol. 1. Lansing, Mich.: John A. Kerr, 1867.

"Manuscript of the Early History of Ottawa University." Unpublished manuscript, n.d. Ottawa University Collection, Ottawa, Kansas.

Marilley, Suzanne M. *Women's Suffrage and the Origins of Liberal Feminism in the United States, 1820–1920.* Cambridge, Mass.: Harvard University Press, 2014.

Meginness, John F., ed. *History of Lycoming County, Pennsylvania.* Chicago: Brown, Runk, 1892.

Memorial Record of the County of Cuyahoga and City of Cleveland, Ohio. Chicago: Lewis, 1894.

Millard, Candice. *Destiny of the Republic: A Tale of Madness, Medicine, and the Murder of a President.* New York: Doubleday, 2011.

Miller, Francis T. *The Photographic History of the Civil War,* 10 vols. New York: Review of Reviews, 1911.

Mombert, Jacob I. *An Authentic History of Lancaster County.* Lancaster, Pa.: J. E. Barr, 1869.

Moore, Frank. *Women of the War: Their Heroism and Self-Sacrifice.* Hartford, Conn.: S. S. Scranton, 1867.

Mulholland, St. Clair A. *Story of the 116th Regiment, Pennsylvania Infantry.* Philadelphia: F. McManus Jr., 1899.

National Association of Army Nurses of the Civil War, *Forty-Fourth National Encampment, Grand Army of the Republic.* Atlantic City, N.J.: Yeakel, 1910.

National Cyclopædia of American Biography, Being the History of the United States, vol. 2. New York: James T. White, 1921.

Neuman, Fred G. *Paducahans in History.* Paducah, Ky.: Young, 1922.

Newcomb, John B. *Genealogical Memoir of the Newcomb Family, Containing Records of Nearly Every Person of the Name in America from 1635 to 1874.* Chicago: Knight & Leonard, 1874.

Nightingale, Florence. *Notes on Nursing: What It Is, and What It Is Not.* Boston: William Carter, 1860.

Northam Colonist Historical Society. *Sarah Low: Dover's Civil War Nurse.* n.p., 1962.

Oates, Stephen B. *A Woman of Valor: Clara Barton and the Civil War.* New York: Free Press, 1994.

Optic, Oliver, ed. *The Student and Schoolmate & Forrester's Boys & Girls Magazine,* vols. 15 and 16. Boston: Joseph W. Allen, 1865.

Orsini, Abbé. *Life of the Blessed Virgin Mary, Mother of God: With the History of the Devotion to Her.* New York: D. & J. Sadlier, 1872.

Papers Read Before the Lancaster County Historical Society, January 4, 1907, vol. 11, no. 1. Lancaster, Pa.: Lancaster County Historical Society. Reprinted from *New Era,* 1907.

Patriot Daughters of Lancaster. *Hospital Scenes after the Battle of Gettysburg.* Philadelphia: Daily Inquirer, 1864.

Paul, James L. *Pennsylvania's Soldiers' Orphan Schools.* Philadelphia: Claxton, Remsen & Haffelfinger, 1876.

Peacock, Virginia T. *Famous American Belles of the Nineteenth Century.* Philadelphia: J. B. Lippincott, 1901.

Phelps. Henry P. *Players of a Century: A Record of the Albany Stage.* Albany, N.Y.: Joseph McDonough, 1880.

Pierce, Frederick C. *Field Genealogy,* vol. 2. Chicago: Hammond, 1901.

Portrait and Biographical Album of Rock County, Wisconsin. Chicago: Acme, 1889.

Portrait and Biographical Record of Lee County, Illinois. Chicago: Biographical Publishing, 1892.

Pryor, Elizabeth B. *Clara Barton, Professional Angel.* Philadelphia: University of Pennsylvania Press, 1988.

Quinby, Henry C. *Genealogical History of the Quinby (Quimby) Family in England and America.* New York, 1915.

Raus, Edmund J., Jr. *Ministering Angel: The Reminiscences of Harriet A. Dada, a Union Army Nurse in the Civil War.* Gettysburg, Pa.: Thomas, 2004.

Rauscher, Frank. *Music on the March, 1862–'65, with the Army of the Potomac, 114th Regt. P.V., Collis' Zouaves.* Philadelphia: William F. Fell, 1892.

Ravenscroft, Carolyn. "All of Our Women Are Not Florence Nightingales." Master's thesis, Simmons College, Boston, 2013.

Recker, Stephen, and Simon M. Whistler. *Shadowing Grant: Reminiscences of the United States Hospital Transport Service in the Civil War, 1864–65.* Gilbert, Ariz.: Software Miracles, 2016.

Records of the Columbia Historical Society, vol. 5. Washington, D.C.: Columbia Historical Society, 1901.

Reed, William H., ed. *War Papers of Frank B. Fay, with Reminiscences*

of Service in the Camps and Hospitals of the Army of the Potomac, 1861–1865. Boston: George H. Ellis, 1911.

Report to the Western Sanitary Commission on the General Military Hospitals of St. Louis, Mo. St. Louis: E. P. Studley, 1862.

Reports of Committees of the House of Representatives for the First Session of the Fifty-Second Congress, 1891–'92, vol. 4. Washington, D.C.: Government Printing Office, 1892.

Reports of Committees of the House of Representatives for the Second Session of the Forty-Ninth Congress, 1886–'87, vol. 1. Washington, D.C.: Government Printing Office, 1887.

Reports of Committees of the Senate of the United States for the Second Session of the Fifty-First Congress, 1890–'91, vol. 3. Washington, D.C.: Government Printing Office, 1891.

Richard, Patricia L. *Busy Hands: Images of the Family in the Northern War Effort*. New York: Fordham University Press, 2003.

Richardson, Albert D. *The Secret Service, the Field, the Dungeon, and the Escape*. Hartford, Conn.: American Publishing, 1865.

Robertson, John. *Michigan in the War*. Lansing, Mich.: W. S. George, 1882.

Robinson, William, ed. *Friends of a Half Century: Fifty Memorials, with Portraits of Members of the Society of Friends, 1840–1890*. London, England: Edward Hicks, 1891.

Sarmiento, Ferdinand L. *Historical Sketch of the Soldier's Home, in the City of Philadelphia*. Philadelphia: Soldiers' Home, 1886.

Scales, John. *History of Strafford County, New Hampshire, and Representative Citizens*. Chicago: Richmond-Arnold, 1914.

Schultz, Jane E., ed. *This Birth Place of Souls: The Civil War Nursing Diary of Harriet Eaton*. New York: Oxford University Press, 2010.

Schneider, Col. Frederick. *Incidental Flag History of the Flags and Color Guard of the Second Michigan Infantry, 1861–5*. Lansing, Mich.: M. E. Gardner, 1905.

Simon, John Y., ed. *Personal Memoirs of Julia Dent Grant (Mrs. Ulysses S. Grant)*. Carbondale: Southern Illinois University Press, 1988.

Smith, Adelaide W. *Reminiscences of an Army Nurse during the Civil War*. New York: Greaves, 1911.

Smith, Thomas W. *The Story of a Cavalry Regiment: "Scott's 900" Eleventh New York Cavalry*. Chicago: W. B. Conkey, 1897.

Sorrel, G. Moxley. *Recollections of a Confederate Staff Officer*. New York: Neale, 1905.

Spar, Ira, M.D. *Civil War Hospital Newspapers: Histories and Excerpts of Nine Union Publications*. Jefferson, N.C.: McFarland, 2017.

Stearns, Amanda A. *The Lady Nurse of Ward E.* New York: Baker & Taylor, 1909.

Stewart. William R. *Philanthropic Work of Josephine Shaw Lowell.* New York: MacMillan, 1911.

Stocker, Jeffrey D., ed. *From Huntsville to Appomattox: R. T. Coles's History of 4th Regiment, Alabama Volunteer Infantry.* Knoxville: University of Tennessee Press, 1996.

Stowe, Harriet Beecher. *Sunny Memories of Foreign Lands,* vol. 1. Boston: Phillips, Sampson, 1854.

Stradling, James M. *His Talk with Lincoln.* Cambridge, Mass.: Riverside, 1922.

Surgeon General's Office. *A Report on the Hygiene of the United States Army, with Descriptions of Military Posts.* Circular No. 8. Washington, D.C.: Government Printing Office, 1875.

Swisshelm, Jane G. *Half a Century.* Chicago: Jansen, McClurg, 1880.

Sypher, Josiah R. *History of the Pennsylvania Reserve Corps: A Complete Record of the Organization.* Lancaster, Pa.: Elias Barr, 1865.

Thomas, Jane H. *Old Days in Nashville, Tennessee: Reminiscences.* Nashville, Tenn.: Methodist Episcopal Church, South, 1897.

Treese, Lorett. *Valley Forge: Making and Remaking a National Symbol.* University Park, Pa.: Pennsylvania State University Press, 1995.

United States Christian Commission, for the Army and Navy, for the Year 1865, Fourth Annual Report. n.p., n.d.

Vance, Katelynn Ruth. "'They Set Themselves to Undermine the While Thing': Gender and Authority in the Work of Union Female Nurses in the Civil War." Master's thesis, University of New Hampshire Scholars' Repository, University of New Hampshire.

The War of the Rebellion: A Compilation of the Official Records of the Union and Confederate Armies, 128 vols. Washington, D.C., 1894–1922.

Wendte, Charles W. *Thomas Starr King: Patriot and Preacher.* Boston: Beacon, 1921.

Whitman, Walt. *Complete Prose Works.* Philadelphia: David McKay, 1897.

Willard, Frances E., and Mary A. Livermore, eds. *A Woman of the Century: Fourteen Hundred Seventy Biographical Sketches Accompanied by Portraits of Leading American Women in All Walks of Life.* Buffalo, N.Y.: C. W. Moulton, 1893.

Winsor, Justin. *Bibliographic Contributions.* Cambridge, Mass.: Library of Harvard University, 1897.

Wormeley, Katharine P. *The Other Side of the War with the Army of the Potomac*. Boston: Ticknor, 1889.

Wormeley, Katharine P. *The United States Sanitary Commission: A Sketch of Its Purposes and Its Work, Compiled from Documents and Private Papers*. Boston: Little, Brown, 1863.

Wormeley, Katharine P., Elizabeth Wormeley Latimer, and Ariana Wormeley Curtis. *Recollections of Ralph Randolph Wormeley, Rear-Admiral, R.N.* New York: Nation, 1879.

Articles

"American Catholic History in Stained Glass." *Catholic Action* (March 1932): 14.

"Anna Maria Ross." *Harper's New Monthly Magazine* (November 1865): 722–726.

Bailey, Louis J. "Caleb Blood Smith." *Indiana Magazine of History* (September 1933): 213–239.

Brown, Clara S. "Major Belle Reynolds." *Midland Monthly* (August 1898): 108.

Burdette, Benjamin L. "The Eakin Family." *Ansearchin' News*, Memphis Genealogical Society (July–September 1965): 119.

Clapp, P. M., "Helen L. Gilson: A Memorial, Part I." *Old and New* (April 1872), 457–463.

Clapp, P. M. "Helen L. Gilson: A Memorial, Part II." *Old and New* (May 1872): 566–571.

Clark, Eudora. "Hospital Memories I." *Atlantic Monthly* (August 1867): 145.

Curtis, Peter H. "A Quaker and the Civil War: The Life of James Parnell Jones." *Quaker History* (Spring 1978): 35–41.

Davenport, F. Garvin. "Cultural Life in Nashville on the Eve of the Civil War." *Journal of Southern History*, Southern Historical Association (August 1937): 330–331.

"Death of an Estimable Lady." *Portrait Monthly of the New York Daily News* (March 1864): 135.

Foard, Chris. "A Hospital Scene's Backstory, Revealed." *Military Images* (Spring 2017): 52–53.

Gilfillan, Kelly. "Civil War Personality: George Cuppett, Exhumer for Confederate Cemetery." *Franklin Homepage* (November 23, 2014). https://franklinhomepage.com/civil-war-personality-george-cuppett-exhumer-for-confederate-cemetery/.

Hatch, Mary R. P. "A Sweet Singer of the War." *National Magazine* (April 1912): 110–112.

Heyworth, Kathleen. "Solemn Vow at Camp Butler." *Military Images* (Winter 2017): 14–16.

Holmes, Oliver W. "Doings of the Sunbeam." *Atlantic Monthly Magazine* 12 (July 1863): 8.

Humphreys, Charles A. "Charles Russell Lowell." *Harvard Monthly* (February 1886): 185.

Janney, Caroline E. "The Lost Cause." *Encyclopedia Virginia* (July 27, 2016). https://www.encyclopediavirginia.org/lost_cause_the/.

"Jessie Benton Frémont." *Hesperian* (January–March 1903): 83–85.

Johnson, William Page, II. "A Sad Story of Redemption." *Fare Facs Gazette* (Winter 2015): 1–17.

Kincaid, William I. "Camp Butler." *Journal of the Illinois State Historical Society* (October 1921–January 1922): 382–385.

Leisenring, Richard, Jr. "Philanthropic Photographs: Fundraising during and after the Civil War." *Military Images* (Spring 2018): 50.

"Letters from a Nurse." *New England Family History* (April 1912): 750–757.

"Letters of Dr. Seth Rogers, 1862, 1863." *Proceedings of the Massachusetts Historical Society* 43 (October 1909–June 1910): 385–386.

Luebke, Peter C. "William Mahone (1826–1895)." *Encyclopedia Virginia* (July 19, 2016). https://www.encyclopediavirginia.org/Mahone_William_1826-1895/.

Livermore, Mary A. "After the Battle of Fort Donelson." *Ladies' Repository* (May 1868): 376–381.

Lovett, Robert W. "The Soldiers' Free Library." *Civil War History* (March 1962): 54–63.

McNeilly, Rev. James H. "Mrs. Caroline E. W. McGavock." *Confederate Veteran* (April 1905): 177–179.

Melchiori, Marie V. "The Death of 'French Mary.'" *Military Images* (July–August 1983): 14–15.

"Ministering Angels." *Military Images* (Spring 2015): 5–15.

Minor, Berkeley. "As the War Ended." *Confederate Veteran* (October 1922): 367–368.

Morris, Dr. N. E. "The Good Samaritan at Franklin." *Confederate Veteran* (December 1922): 448.

Mullins, Ray. "Finding Annie (My Search for a Vivandière)." *Annie Etheridge* (November 20, 2016). https://annieetheridgeblog.wordpress.com.

Potter, James E. "'I Thought It My Duty to Go': The Civil War Letters of Thomas Edwin Ken of the First Nebraska Volunteer Infantry." *Nebraska History* 81 (2000): 134–169.

Richards, Mrs. Lucas (Martha M. C. Hall), "Lincoln Cheers His Sick Boy." *Delineator* (February 1921): 11–12.

Turner, George A. "The Grand Army of the Republic Col. Ent Post No. 250 Department Pennsylvania: 'Memory Book.'" *Columbia County Historical and Genealogical Society* (n.d.). https://colcohist-gensoc .org/wp-content/uploads/GARPost250.pdf.

Turner, George A. "Harriet Reifsnyder Sharpless: A Civil War Nurse from Bloomsburg." *Columbia County Historical and Genealogical Society* (n.d.). https://colcohist-gensoc.org/wp-content/uploads /Harriet_Sharpless_Civil_War_Nurse.pdf.

"Two of Our Sanitary Heroines." *American Phrenological Journal* (September 1867): 100–102.

Wormeley, Katherine P. "Napoleon's Return from St. Helena: An Eye-Witness's Account of a Memorable Event." *Putnam's Monthly* (July 1908): 387–393.

Manuscript Collections

Amies, E. T. Letters. Historical Society of Montgomery County, Norristown, Pennsylvania.

Barton, Clara. Papers. Library of Congress, Washington, D.C.

Bennett Family Papers. Terrie Biggs Collection, La Grande, Oregon.

Bickerdyke, Mary Ann. Papers. Library of Congress, Washington, D.C.

Bradford Family Collection. Duxbury Rural & Historical Society, Duxbury, Massachusetts.

Brewster Family Papers. Yale Collection of Western Americana, Beinecke Rare Book and Manuscript Library, Yale University Library, New Haven, Connecticut.

Carver, Anna R. Papers. Jan Rich Knight Collection, Pittsfield, Massachusetts.

Case Files of Approved Pension Applications of Civil War and Later Navy Veterans. U.S. National Archives and Records Administration, Washington, D.C.

Civil War Vertical File Manuscripts. Special Collections & College Archives, Musselman Library at Gettysburg College, Gettysburg, Pennsylvania.

Compiled Military Service Records. U.S. National Archives and Records Administration, Washington, D.C.

Gale and Polk Family Papers, 1815–1865. Southern Historical Collection, Wilson Library, University of North Carolina at Chapel Hill.

Gregg, Sarah. Civil War Diary of Mrs. Sarah Gregg. Abraham Lincoln Presidential Library, Springfield, Illinois.

Gregory A. Coco Research Collection. Gettysburg National Military Park, Gettysburg, Pennsylvania.

Hoyt, Helen M. Noye. Papers. William L. Clements Library, University of Michigan, Ann Arbor.

Hubley, Rosina W. Letters. Faye and Ed Max Collection, Honey Brook, Pennsylvania.

Letters of the 8th New York Infantry. Civil War Collection, History Department, Genesee County, New York.

Lincoln, Abraham. Papers. Library of Congress, Washington, D.C.

Low, Sarah. Papers. New Hampshire Historical Society, Concord.

Mayhew, Ruth Swett. Civil War Scrapbook. Special Collections Department, Raymond H. Fogler Library, University of Maine at Orono.

National Register of Historic Places Nomination Forms. National Park Service, U.S. Department of the Interior, Washington, D.C.

Pomroy, Rebecca R. Papers. Foard Collection of Civil War Nursing, Magnolia, Delaware.

Quinby, Almira F. Letters. Archives & Special Collections, Augustus C. Long Health Sciences Library, Columbia University, New York City.

Ricketts, Fanny. Manuscript Diary. Manassas National Battlefield Park, Manassas, Virginia.

Stubbs, Anna Bell. Papers. Foard Collection of Civil War Nursing, Magnolia, Delaware.

U.S. Census Population Schedules. U.S. National Archives and Records Administration, Washington, D.C.

Wiswell, Rebecca. Letters. Foard Collection of Civil War Nursing, Magnolia, Delaware.

Woman's Medical College / Medical College of Pennsylvania Records. Drexel Libraries E-Repository and Archives, Drexel University, Philadelphia.

Newspapers and Periodicals

Altoona (Pa.)Tribune
Argus-Leader (Sioux Falls, S.D.)
Boston Post
Boston Weekly Globe
Brooklyn (N.Y.) Daily Eagle
Buffalo (N.Y.) Commercial Advertiser
Buffalo (N.Y.) Sunday Morning News
Chicago Tribune
Christian Register (Boston)
Cincinnati Enquirer
Clarksville (Tenn.) Chronicle

The Crutch (Annapolis, Md.)
Daily Dispatch (Richmond, Va.)
Daily Herald (Delphos, Ohio)
Daily Milwaukee News
The Daily Northwestern (Oshkosh, Wis.)
Daily Signal (Crowley, La.)
Davenport (Iowa) Weekly Republican
The Earth (Burlington, Vt.)
Evening Star (Washington, D.C.)
Everest (Kans.) Enterprise
Harper's Weekly
Hartford (Conn.) Courant
Highland Park (Ca.) Herald
Hillsdale (Mich.) Standard
Huron Reflector (Norwalk, Ohio)
Indiana State Sentinel (Indianapolis)
Indianapolis Journal
Inter Ocean (Chicago)
The Jeffersonian (Stroudsburg, Pa.)
Journal Gazette (Mattoon, Ill.)
Kane (Pa.) Leader
Kansas City Daily Tribune
Kingston (N.Y.) Daily Freeman
London Review
Los Angeles Herald
Los Angeles Times
Marshall County News (Maysville, Kans.)
Michigan City (Ind.) Transcript
Miltonvale (Kans.) Tribune
Moore's Rural New-Yorker (Rochester, N.Y.)
Nashville (Tenn.) Banner
Nashville (Tenn.) Union
Natchez (Miss.) Weekly Courier
National Republican (Washington, D.C.)
National Tribune (Washington, D.C.)
New England Farmer (Boston)
New Orleans Crescent
New York Herald
New York Times
New-York Tribune
News and Citizen (Morrisville and Hyde Park, Vt.)
Newport (R.I.) Mercury

Norristown (Pa.) Weekly Herald
Observer (London, England)
Ottawa (Ill.) Free Trader
Philadelphia Inquirer
Pittsburgh Gazette
Pittsburgh Saturday Visiter
Quad-City Times (Davenport, Iowa)
Racine (Wis.) Daily Journal
Reading (Pa.) Times
The Reconstructionist (Washington, D.C.)
Richmond (Va.) Dispatch
Richmond (Va.) Examiner
Russell (Kans.) Informer
San Francisco Call
Springfield (Mass.) Republican
St. Louis Railway Register
The Sun (Baltimore)
The Tennessean (Nashville)
Times Dispatch (Richmond, Va.)
Tyrone (Pa.) Daily Herald
Washington Post
Washington Star
Waterloo (Ia.) Courier
Weekly Graphic (Kirkville, Mo.)
Weekly Hawk-Eye and Telegraph (Burlington, Iowa)
Wellington (Ohio) Enterprise
Western Veteran (Topeka, Kans.)
Wichita (Kans.) Daily Eagle
The World (New York City)
Yakima (Wash.) Herald

Online Sources

"The Adèle Douglas Letter." The Official "Rebel Rose" O'Neale Web Site. onealwebsite.com/RebelRose/Gaston.htm.
Ancestry.com. "Ancestry." https://www.ancestry.com.
Ancestry.com. "Fold3." https://www.fold3.com.
Ancestry.com. "Newspapers." https://www.newspapers.com.
The Church of Jesus Christ of Latter-Day Saints. "FamilySearch." https://www.familysearch.org/en/.
Historical Data Systems. "American Civil War Research Database." civilwardata.com.
Soper, Steve. "3rd Michigan Infantry." www.oldthirdmichigan.org.

Acknowledgments

Portrait photography is at the core of this book. The journey to locate these original wartime images is where this project began. Along the way I met private collectors, stewards of institutional collections, and others who made these rare artifacts available to me. Contributions from private collectors' holdings account for about 60 percent of the images pictured here.

One individual above all deserves my sincere gratitude and appreciation. Chris Foard, a nurse by profession, has spent more than three decades collecting Civil War nursing memorabilia. He has amassed a considerable depth of knowledge through his acquisition of more than 3,000 items, including a significant group of images. I selected thirty-four of them for inclusion, almost half of the total in this volume. I will long remember the summer day in 2014 when Chris visited my home with his photographs. As we pored over the portraits of these courageous women one by one, Chris shared details of their service and lives that revealed his passion for the subject with infectious energy and enthusiasm. This volume could not have happened without Chris. I am honored to have the opportunity to bring to these pages the results of his years of dedication to preserve and make public such a significant body of original material, a unique contribution to American history. As the project neared its conclusion, many of the images moved to the Liljenquist Family Collection at the Library of Congress.

Other individuals also made important contributions of images. Two are well known to the Civil War photo-collecting community: Michael J. McAfee and Rick Carlile. They inspire me as a collector and have shared images for other projects with which I have been involved. Joining them are other generous men and women with whom I have become acquainted through associations with my fellow collectors, my position as editor and publisher of *Military Images* magazine, and as a result of this volume: Tom Glass, John Hennigar, Kathleen Heyworth, Dr. Anthony Hodges, Faye and Ed Max, and Theresa and Dale Niesen.

The remaining 40 percent of the images came from institutional collections. The bulk of them—twenty-three—are held by a single source, the U.S. Army Heritage and Education Center in Carlisle Barracks, Pennsyl-

vania. I had the great fortune of working with Operations Clerk Marlea D. Leljedal, with whom I traded numerous emails to make arrangements for digital scans from the massive collection of the Military Order of the Loyal Legion of the United States (MOLLUS), Massachusetts Commandery.

Thanks are also due to other kindly and efficient stewards. Jon-Erik Gilot, director of archives and records at the Diocese of Wheeling-Charleston, West Virginia, provided a portrait of and biographical information about Sister Ignatius Farley. Joanna Stephens, curator of the Battle of Franklin Trust, made available the wartime *carte de visite* of Carrie McGavock. Carolyn Ravenscroft, archivist and historian of the Duxbury Rural & Historical Society in Duxbury, Massachusetts, shared her knowledge and portraits of Charlotte Bradford. Reference librarian Denise LaFrance of the Dover Public Library in Dover, New Hampshire, made available letters connected to Sarah Low. Cameron Mitchell, archives and special collections assistant at the Augustus C. Long Health Sciences Library, Columbia University, New York City, provided copies of the Almira F. Quinby letters. John Heiser, who heads up the Gettysburg National Military Park Library and Research Center, sent a copy of an important postwar letter written by Phebe May. Park Ranger Jim Burgess, museum specialist at the Manassas National Battlefield Museum, gave me access to a transcription of the Fanny Ricketts diary.

During the course of research into the lives of the nurses, I met some of their descendants and other individuals. They include Jan Rich Knight, Elizabeth Leech, and Marilyn Rich, who provided a wealth of letters and information about their ancestor, Anna Reich Carver. Cliff McCarthy shared information related to Belle Reynolds. John Banks, Barbara Powers, and George Glastris provided details about the life and times of Maria Hall. I often found posts by blogger Maggie MacLean, author of the "History of American Women" website, a helpful starting point into my research.

At the very beginning of this project, in August 2016, I met Maxine Getty at the Civil War Heritage Music Gathering & Encampment in Windham, New York. The annual event brings together musicians, artists, authors, and others, thanks to John and Sharon Quinn and the strong support of their community. Maxine and I had a lively conversation. I came away impressed by her passion for the subject of Civil War nurses and more motivated than ever to find their photos and stories. Maxine sent links to many helpful sites, including the nurses' portraits at the U.S. Army Heritage and Education Center. I am thankful for her involvement.

I am grateful to the staff of the Johns Hopkins University Press for all

of their efforts. Robert J. Brugger, editor emeritus, has always been an enthusiastic advocate. I am deeply appreciative of his unflagging support during the better part of the last two decades. Laura Davulis, acquisitions editor–history, guided the manuscript through the review and editorial processes. Kathleen Capels brought her considerable copyediting skills into play to fine tune my words. Publicity manager Kathryn Marguy and production editor Hilary S. Jacqmin worked with me to promote the book. Esther P. Rodriguez, editorial assistant, managed a number of requests efficiently and with grace.

Bella, our beloved pug, lay in her bed beneath my desk through much of this project. Though age had ended her days of hiking battlefields and sections of the Appalachian Trail, she continued to be my alarm clock and morning routine companion until she snored and grunted her last in February 2017. My entire family has always been supportive. Carol, my mother, has been and continues to be a driving force behind my pursuits. The biggest thank you of all, though, is reserved for my wife Anne. Her implicit faith and trust in me, and the support and love that flows as a result, enables me to go forward confident in the belief that bringing these Americans from another time back to life through pictures and stories is a worthy pursuit.

All of these individuals, and many others not mentioned here, assist me in ways large and small in my ongoing mission to highlight the extraordinary actions of ordinary Americans of the Civil War generation. Through their portraits and personal accounts we can better appreciate the awful calamity that consumed our country and cost us dearly in blood and treasure. Their contributions and sacrifices profoundly reshaped a nation and defined who we are today.

Index

Page numbers in italics refer to photographs.